STUART DAVIS In Full Swing

HARRY COOPER
BARBARA HASKELL

National Gallery of Art, Washington

Whitney Museum of American Art, New York

DelMonico Books · Prestel, Munich, London, New York

STUART DAVIS: *IN FULL SWING* IS ORGANIZED BY THE NATIONAL GALLERY OF ART, WASHINGTON, AND THE WHITNEY MUSEUM OF AMERICAN ART, NEW YORK.

At the Whitney Museum of American Art, New York, and the National Gallery of Art, Washington

Major support is provided by the Henry Luce Foundation.

The Terra Foundation for American Art also provided generous support.

—

In New York

The exhibition is sponsored by Morgan Stanley.

Major support is provided by The Paul and Karen Levy Family Foundation.

Significant support is provided by the Philip and Janice Levin Foundation and Ted and Mary Jo Shen.

Generous support is provided by Cheryl and Blair Effron, Karen and Kevin Kennedy, Garrett and Mary Moran, and Laurie M. Tisch.

Additional support is provided by the Alturas Foundation, Jeanne Donovan Fisher, Judy and Stanley Katz, and Lynn and Nick Nicholas.

Major endowment support is also provided by the Barbara Haskell American Fellows Legacy Fund.

—

In Washington

The exhibition is made possible by Altria Group in celebration of the 75th Anniversary of the National Gallery of Art.

—

The exhibition catalog is made possible by the Henry Luce Foundation.

Additional support is provided by the Wyeth Foundation for American Art.

Exhibition dates

Whitney Museum of American Art, New York | June 10–September 25, 2016

National Gallery of Art, Washington | November 20, 2016–March 5, 2017

de Young, Fine Arts Museums of San Francisco | April 8–August 6, 2017

Crystal Bridges Museum of American Art, Bentonville, Arkansas | September 16, 2017–January 8, 2018

Library of Congress Control Number: 2015050067

ISBN 978-3-7913-5510-8 (hardcover)

ISBN 978-0-89468-405-0 (softcover)

Opposite title page: Stuart Davis, New York, December 8, 1941, photograph by Arnold Newman, Arnold Newman Collection/Getty Images

Produced by the Publishing Office, National Gallery of Art, Washington | www.nga.gov

Judy Metro, *editor in chief*
Chris Vogel, *deputy publisher and production manager*
Sara Sanders-Buell, *photography rights coordinator*
John Long, *print and digital production associate*
Mariah Shay, *production assistant*
Katie Adkins, *program assistant*

Designed by Wendy Schleicher
Edited by Julie Warnement

Typeset in Sabon MT Pro and ITC Franklin Gothic and printed on Gardamatt 150 gsm. Printed and bound in Italy by Verona Libri

Hardcover edition published in association with DelMonico Books, an imprint of Prestel Publishing, a member of Verlagsgruppe Random House GmbH

Prestel Verlag
Neumarkter Strasse 28
81673 Munich
Germany
Tel: 49 89 41 36 0
Fax: 49 89 41 36 2335
prestel.de

Prestel Publishing Ltd.
14–17 Wells Street
London W1T 3PD
United Kingdom
Tel: 44 20 7323 5004
Fax: 44 20 7323 0271

Prestel Publishing
900 Broadway, Suite 603
New York, NY 10003
Tel: 212 995 2720
Fax: 212 995 2733
E-mail: sales@prestel-usa.com
prestel.com

10 9 8 7 6 5 4 3 2 1

STUART DAVIS

CONTENTS

STUART DAVIS WAS AN AMERICAN ORIGINAL. Born in Philadelphia and raised in East Orange, New Jersey, he dropped out of high school to study in Manhattan with Robert Henri, the legendary teacher who urged his many and varied students (from Edward Hopper to George Bellows) to read literature and philosophy, sketch daily life, and above all break free of convention to find their own voice. The experience confirmed Davis's independence as well as his love of the American scene—not the white, rural, nostalgic "American Scene" that would come to dominate art in the 1930s but the messy, multi-racial scene of New York streets and Newark jazz joints. Davis embraced Walt Whitman as "our one big artist" and hoped to capture "the thing Whitman felt," so it may be no accident that, like Whitman, Davis gravitated to ports and docks (in his beloved Glouces-ter, Massachusetts) as well as to streets and taverns. His other great formative influence—the Armory Show of 1913 in New York—threw him off balance for good, opening a window onto the expressive colors and abstract forms of European modernism. Com-bine all this and you have Davis in a nutshell: a world citizen always searching for the abstract in the concrete, always transmuting the particular rhythms of American life into the universal experience of *art*.

It would be hard to think of a better artist to be jointly presented by the Whitney Museum of American Art and the National Gallery of Art—two institutions that, despite differences in scope and mission, share a dedication to the art of this country across media and over the generations. When Barbara Haskell and Harry Cooper, curators at the Whitney and the Gallery, respectively, proposed to add their own Stuart Davis exhibition to a distinguished history of retrospectives and monographs, we eagerly agreed. The result is an exhibition and a book that depart in significant ways from their predecessors.

This catalog is notable for its combination of interpretive gambit and factual detail. Drawing on a wealth of new archival material generously supplied by Earl Davis, the artist's son, the authors have given us, in two major essays and a detailed chronology, what is effectively a first critical biography of the artist. The exhibition is unusual for its focus and restraint: not quite a retrospective, it omits Davis's decade of apprenticeship in favor of the series of breakthroughs that made him, by 1960, the dean of nonaligned American art, aware of all movements yet beholden to none. The book and exhibition are conceived as a pair: the former presents Davis's work in chronological order while the latter often strays from that path in order to explore Davis's habit of recycling much earlier work into new configurations.

Such an effort, of course, is not possible without many collaborators both inside and outside our institutions. The serial aspect of the exhibition required very specific loans, and we are grateful for the generous response from private lenders and a pantheon of American museums as well as one important European collection. We are especially thankful for the collaboration of two museums, the de Young at the Fine Arts Museums of San Francisco and Crystal Bridges Museum of American Art in Bentonville, Arkansas, whose decision to host the exhibition gave it a geographical range befitting Davis's importance as an American original. Finally, the exhibition at the Whitney Museum of American Art and the National Gallery of Art would not have been possible without the remarkably generous support of the Henry Luce Foundation, with additional support from the Terra Foundation for American Art. At the Whitney the exhibition is also proudly sponsored by Morgan Stanley, with significant support from the Paul and Karen Levy Family Foundation, the Philip and Janice Levin Foundation, Ted and Mary Jo Shen, Cheryl and Blair Effron, Karen and Kevin Kennedy, Garrett and Mary Moran, and Laurie M. Tisch, kind support from the Alturas Foundation, Jeanne Donovan Fisher, Judy and Stanley Katz, and Lynn and Nick Nicholas, and endowment support from the Barbara Haskell American Fellows Legacy Fund. At the Gallery we are immensely grateful to Altria Group for its sponsorship of the exhibition in honor of our seventy-fifth anniversary. The catalog is made possible by the Henry Luce Foundation, with additional support from the Wyeth Foundation for American Art. We are indebted to all of these partners for helping us present the visual and intellectual feast of Stuart Davis's lifework to new audiences in a new century.

ADAM D. WEINBERG, ALICE PRATT BROWN DIRECTOR
WHITNEY MUSEUM OF AMERICAN ART

EARL A. POWELL III, DIRECTOR
NATIONAL GALLERY OF ART

Addison Gallery of American Art,
 Phillips Academy, Andover
Amon Carter Museum of American Art,
 Forth Worth
The Art Institute of Chicago
The Baltimore Museum of Art
Lawrence B. Benenson
Brooklyn Museum
The Chrysler Museum of Art, Norfolk
Cincinnati Art Museum
Cleveland Museum of Art
The Columbus Museum, Georgia
Currier Museum of Art, Manchester
Dallas Museum of Art
The Detroit Institute of Arts
Estate of the Artist
Aaron I. Fleischman
Herbert F. Johnson Museum of Art,
 Cornell University, Ithaca
Hirshhorn Museum and Sculpture
 Garden, Washington
Pitt and Barbara Hyde
Indiana University Art Museum,
 Bloomington
Joslyn Art Museum, Omaha
Los Angeles County Museum of Art
Memorial Art Gallery of the University
 of Rochester
The Menil Collection, Houston
The Metropolitan Museum of Art,
 New York
Milwaukee Art Museum
Munson Williams Proctor Arts Institute,
 Museum of Art, Utica
Museo Thyssen-Bornemisza, Madrid
Museum of Fine Arts, Boston
The Museum of Modern Art, New York

Myron Kunin Collection of American Art
Neuberger Museum of Art, Purchase
 College, State University of New York
The Newark Museum
Norton Museum of Art, West Palm Beach
Pennsylvania Academy of the Fine Arts,
 Philadelphia
Philadelphia Museum of Art
The Phillips Collection, Washington
Portland Museum of Art, Maine
Private collections
Phyllis and Jerome Lyle Rappaport
Reynolda House Museum of American
 Art, Winston-Salem
Rose Art Museum, Brandeis University,
 Waltham
San Francisco Museum of Modern Art
Fayez Sarofim
Seattle Art Museum
Sheldon Museum of Art, University
 of Nebraska-Lincoln
Ted and Mary Jo Shen
Smithsonian American Art Museum,
 Washington
Solomon R. Guggenheim Museum,
 New York
Terra Foundation for American Art, Chicago
The University of Arizona Museum of Art,
 Tucson
Jan T. and Marica Vilcek
Virginia Museum of Fine Arts, Richmond
Wadsworth Atheneum Museum of Art,
 Hartford
Walker Art Center, Minneapolis
Whitney Museum of American Art,
 New York
Yale University Art Gallery, New Haven

The Present is already obsolete but the Past is not Because what we call the Past is what we deeply regard as eternal.

STUART DAVIS, 1957[1]

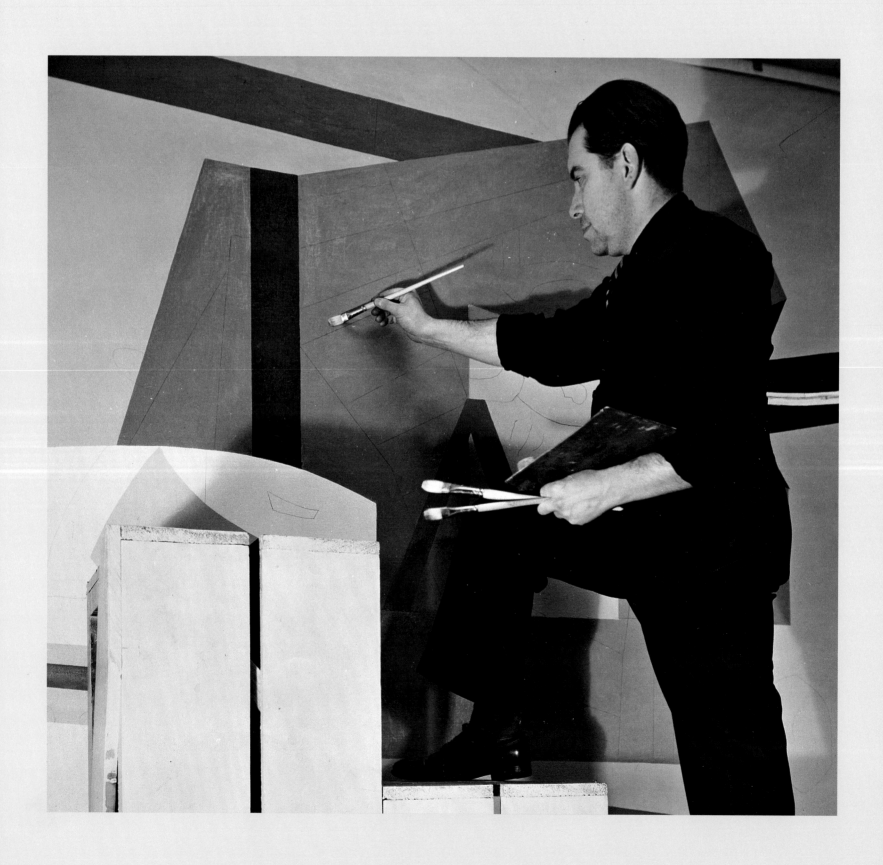

QUOTIDIAN TRUTH Stuart Davis's Idiosyncratic Modernism

BARBARA HASKELL

STUART DAVIS HAS BEEN CALLED ONE OF THE GREATEST PAINTERS of the twentieth century and the best American artist of his generation, his art hailed as a precursor of the rival styles of pop and geometric color abstraction. As this dual paternity suggests, Davis achieved a rare synthesis: an art that is resolutely abstract yet at the same time exudes the ebullient spirit of popular culture. Like other American artists during the first part of the twentieth century, Davis faced the choice between realism and the new forms of abstraction that were emerging, particularly in Europe. Even as he embraced the idea of art as an autonomous expression whose meaning resided exclusively in its formal properties, he remained conflicted, seeing in abstraction's rejection of objective reality a disregard for art's social role. His genius was to invent a third path, one that harnessed the grammar of abstraction to the speed and simultaneity of modern American life. In the process, he produced an art that was more universal and more true to contemporary experience than the populist paintings most critics in the 1920s and 1930s saw as the quintessential expression of American life. It was an uphill battle for legitimacy, which Davis fought through his art and in his prolific and often pugnacious writings. Yet even as abstraction's ascent after World War II vindicated Davis's tenacity, his approach remained singular. By finding a way to communicate experiences of modern everyday life with abstract imagery, Davis solved the dilemma of how to be a modern artist in the world without denying the world.

Davis was born in Philadelphia, the son of artists. His aesthetic values had their origin in his childhood exposure to the city's newspaper illustrators in his father's circle who would form the core of Ashcan realism, and later in his studies in New York with the leader of that circle, Robert Henri. Davis dropped out of high school after his freshman year to enroll in Henri's art school. An impressionable sixteen year old, he embraced his teacher's philosophy that art is a signpost "toward greater knowledge," whose quality depends on its ability to reveal amid life's everyday experiences those rare moments of clarity and happiness "when we seem to see beyond the usual."[2] By locating the origin of art in everyday urban experience, Henri nurtured in his students "a critical sense toward social values," according to Davis.[3] Even after Davis adopted a modern aesthetic vocabulary, he remained faithful to Henri's tenet that art must "mean something to the human race."[4] Long after he left Henri's orbit, Davis continued to claim that art's quality was directly proportional to the "human profundity of its content."[5] The ideology lay at the core of Davis's lifelong insistence that he was a realist whose paintings derived from the objective subject matter of lived experience.

Davis's goal of expressing what he called "human values through form" was fully compatible with the realism he practiced at the beginning of his career, when he was a

rising star within Henri's circle of students, depicting the dynamics and complexities of modern life with a quick, bravura brushwork that revealed the influence of his mentor (see page 151).[6] As with Henri's other protégés, Davis found his subjects in unfashionable, ethnic neighborhoods, which for him were the African American saloons in the red-light districts along Palisades Avenue in Hoboken and Arlington Avenue in Newark. There he heard the sounds of ragtime and blues, whose synthesis of rhythmic structure and spontaneity he would seek to emulate in his art. Something of the music's sadness and power crept into his earliest pictures. Their suggestion of sexual tension and foreboding—especially in his self-portraits and watercolors (fig. 1)—set his work apart from his peers, who often avoided the unsettling, psychological realities of modern life in favor of its lighthearted side.

A little more than three years after Davis entered Henri's art school, the 1913 Armory Show opened in New York. The sense of freedom Davis experienced in encountering the show's selection of vanguard European painting initiated a reevaluation of the realism practiced by Henri and his circle.[7] Concluding that his mentor's emphasis on subject matter at the expense of formal coherence was a weakness, Davis vowed to become a vanguard artist. With the work of Paul Gauguin, Vincent van Gogh, and Henri Matisse as his guide, he embraced nonassociative color, boasting later that he "soon learned to think of color more or less objectively so that [he] could paint a green tree red without batting an eye."[8] By 1916, under the influence of Paul Cézanne and the early cubist work of Pablo Picasso, Davis was tilting perspective, simplifying form into discrete spatial units, and experimenting with juxtaposing assorted views of a scene on a single canvas. These so-called multiple-view paintings lacked pictorial unity, but they precipitated a philosophical insight that allowed Davis to reconcile his dual commitment to realism and abstraction. He credited cubist simultaneity with the idea, but faulted

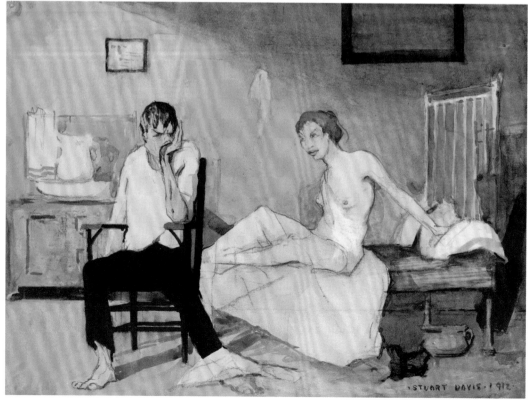

1

the style for its limited focus on visible phenomena, which ignored what he believed was true about perception—that it involves the totality of one's consciousness. He reasoned that if his art were to be truly realistic, it must include his ideas, emotions, and memories of other experiences. In 1918, he codified the theory, declaring that the subject of a modern picture is not an isolated, observable object but a "mental concept" that includes the artist's memories and mental associations.[9] An object or event in the external world initiates an idea that has no counterpart in the visible realm but is nevertheless real. As Davis explained it, "A work of art is not a description of the objective world... [It] is an objective record of the total awareness of that world by a man."[10] For art to truly reflect modern experience, Davis felt, artists must strive to depict not only "visual things" but also "things heard, uncalculated free associations, calculated logical things, art, music, the dynamics of New York City, etc."[11]

Before Davis could successfully put this theory into practice, he had to master the vocabulary of modern art—arbitrary color, simplified form, reduced spatial recession—a process he later conceded took him "an awful long time."[12] To expedite it, he began in 1920 to write down his thoughts about the nature and formal properties of art in a journal, in accord with the conviction of Henri and his circle that the laws of color and composition could be quantified. Hardesty Maratta's color system, Jay Hambidge's doctrine of dynamic symmetry, and Denman Ross's theory of design had been taught with great enthusiasm at Henri's school and adopted by many of Davis's friends. Fiercely independent, Davis preferred formulating his own rules, which he developed across more than 10,000 pages of private notes during the course of his career. In proposing answers to questions about art's structural principles and the social and philosophical responsibilities of artists, he often would reprise ideas in multiple entries or cycle back to ideas he had written down years prior, sometimes even citing his previous work. Frequently he would star the page on which he had written what he felt was a particularly important concept. Despite his devotion to working out his theories through writing, and in contrast to many of the other artists in Henri's circle such as John Sloan and George Bellows who loyally adhered to the dictates of theoretical systems, Davis's rules functioned for him solely as guideposts. "To study the systems of other men is useless," he explained.[13]

If your picture is merely a chart illustrating these premises it will be lifeless. The theory must be burned in the fires of reality before it becomes alive—so—in painting if you want to do something other than the rules you have laid down, do not hesitate for an instant—but—the thinking in terms of these will give a speed & momentum to your work you could not otherwise have.[14]

Following his revelatory experience at the Armory Show and his enthusiastic embrace of the modernist aesthetic, Davis entered a period of self-imposed apprenticeship that stretched into the early 1920s, during which his paintings remained primarily "laboratory work," as one contemporaneous critic called them, reprocessing ideas already expressed by other artists, mostly European.[15] One major exception was a group of still lifes that conveyed the bold immediacy of popular culture. Convinced that the unprecedented proliferation of advertisements, mass-market products, and commercial packaging uniquely expressed "the immediate life of the day," Davis set out to "copy

the nature" of modern life by using "letters, numbers, canned goods labels, [and] tobacco labels" as subject matter.[16] Among these quotidian items, the packages of cigarette paper and loose tobacco—products many people at the time regarded as quintessentially American—were what caught Davis's attention, and from their labels he created paintings in 1921 that were, by his own account, "really original American work" (pls. 1–4).[17] Davis described these paintings as "direct descendants of [Walt] Whitman our one big artist," adding that he too felt "the thing Whitman felt" and was determined to "express it in pictures—America—the wonderful place we live in."[18] Three years after completing his tobacco pictures, Davis experimented with applying the design strategies of advertising and marketing to other objects by crisply outlining the forms of electric bulbs, bottles of Odol mouthwash, and fruit, and placing the images within shallow, stage-like settings as if they were commodities being advertised in newspapers and magazines (pls. 6–9).

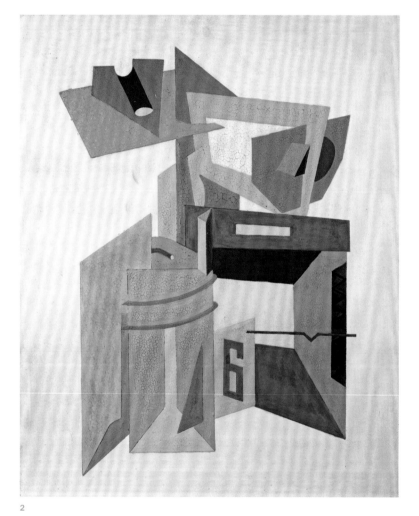

2

Sales of vanguard American art were rare during this period, forcing Davis to eke out a living by securing odd jobs as a freelance illustrator until a yearlong stipend from Gertrude Vanderbilt Whitney in 1927 allowed him to focus exclusively on his art, resulting in a dramatic turn in his aesthetic direction. Holed up in a cramped room and largely free from interruption, he lost track of the identity of the household objects he was painting—a percolator, matches, and an arrangement of a rubber glove, electric fan, and egg beater—and began to see them exclusively as flat, geometric planes set at angles to one another. This perception led him to conclude that the emotional appeal and interest of all subjects—"the real physical source of [their] stimulus"—lay in their planar geometries and spatial relationships (fig. 2).[19] Postulating that people perceive space as shape and see forms existing in that space in terms of linear direction, he determined that subjects have their "emotional reality fundamentally through our awareness of such planes and their spatial relationships."[20] Stripping his subjects down to their geometric shapes and arranging them so that they suggested only minimal spatial recession gave his so-called egg-beater still lifes more objective coherence than anything he had done previously. His reliance on abstract geometric forms was not unprecedented, but the other artists who worked in this manner were either living in Europe—Picasso, El Lissitzky, and Man Ray, for example (see page 164)—or had abandoned painting, as was the case with Marcel Duchamp. Within the American context, Davis was singular. His claim that "many of the younger [American] artists are similarly interested" became true just a few years later, but Davis blazed the trail, serving as the "solid citizen for a group a bit younger who were trying to find their stride," as David Smith would put it.[21]

Whitney's purchase in 1928 of two of Davis's earlier landscape paintings provided him with sufficient funds to travel to Paris.[22] For twelve months, he depicted Parisian streetscapes with the same angled geometries he had used in his egg-beater still lifes, while softening the severity of those paintings with a confectionary palette and whimsical calligraphy (see pls. 18–24). The sojourn solidified his commitment to angular variation as a vocabulary, but its most significant contribution to Davis's development was in dispensing with any lingering sense of inferiority he had in relation to European artists, leading him to later characterize his time in Paris as the one outstanding event of his artistic life. Yet it was back on his native soil, his European adventure cut short by strained finances, where Davis experienced his next transformative insight. After the serenity and slow pace of Paris, the enormity and chaos of New York initially appalled and depressed him. "Everything in Paris was human size, here everything was inhuman," he wrote. "It was difficult to think either of art or oneself as having any significance whatever in the face of this frenetic commercial engine."[23] But as he began to acclimate to New York, he recognized in the turbulent heterogeneity of the city something fundamental about the character of modernity and his affinity for it as an American. Technological advances in transportation and communication—telephones, cinema, radios, and air travel—had radically altered human perception by compressing time and space, making it possible to experience seemingly countless events taking place around the world almost simultaneously. Davis saw urban life as particularly imbued with modernity's new forms, lights, spaces, and speeds. Convinced that "the life of the city dominates modern living and penetrates the culture of the epoch," he swiftly recovered from his post-Paris malaise and embraced the "impersonal dynamics of New York City" in which he had come of age as an artist.[24] "Having been born over here, with all this going on around you, you have a need for it," he said.[25] "I like tension. If there isn't any around, I feel vacant."[26]

Indeed, Davis's identity as an American was seminal in shaping the character of his art. "Art can only have validity when it is regional in character," he declared, echoing the American philosopher John Dewey whose theory that "locality is the only universal" had initiated the call in America in the 1920s for indigenous subjects and forms of expression.[27] The presumption that art could only find meaning in the local underlay Davis's later claim that the Armenian American painter and once close friend Arshile Gorky was "essentially a man without a country—no topical subject."[28] Davis had no such problem. Like earlier American modernists such as Arthur Dove, Georgia O'Keeffe, Marsden Hartley, Charles Sheeler, and Charles Demuth, whose paintings expressed national identity, Davis's art communicated a distinctly American experience. But rather than conveying it as his predecessors had done through recognizable subjects associated with the "Great American Thing"—whether the factories and cities of the country's burgeoning industrial landscape or its natural splendor—Davis communicated what he perceived as uniquely modern and American through abstract forms that were "the product of real experiences in moving through space, by walking, seeing, touching, hearing, and the sense of reality which these experiences bring."[29] As he later explained: "I have enjoyed the dynamic American scene for many years past, and all of my pictures (including the ones I painted in Paris) are referential to it. They all have their originating impulse in the impact of the contemporary American environment."[30] To those who criticized his adoption of a European modernist vocabulary as unrelated to

American culture, he pointed out that modern European art was part of the American environment. "Why should an American artist today be expected to be oblivious to European thought when Europe is a hundred times closer to us than it ever was before?" he asked.[31] When critic Henry McBride derided Davis's art as "French," the artist fired back:

I was born here as were my parents and their parents before, which fact makes me an American whether I want to be or not... Over here we are racially English-American, Irish-American, German-American, French, Italian, Russian or Jewish-American and artistically we are Rembrandt-American, Renoir-American and Picasso-American. But since we live here and paint here we are first of all, American.[32]

Communicating his experience of modern America required Davis to infuse his art with a sense of speed and simultaneity. By 1930, he had solved the lack of pictorial cohesion in his multiple-view pictures and was successfully expressing simultaneity by juxtaposing various views of a scene, either in bipartite compositions such as *House and Street* (pl. 30) or in works such as *Summer Landscape* (pl. 26) that amalgamated multiple images of the harbor and shoreline of Gloucester, Massachusetts, where he summered most every year from 1915 to 1934. Expressing movement and speed was more difficult. Having established angles as the building blocks of his for-

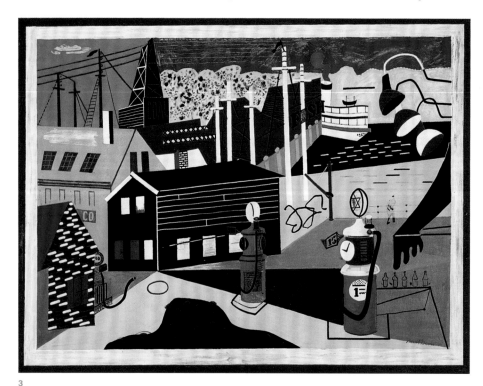

3

mal language in his egg-beater and Paris pictures, he now embraced their extension into triangles as tools for suggesting more complicated spatial direction and movement (fig. 3). "All observations are triangular in character. Triangulation ... exists in time and hence is sequential," he wrote.[33] By distilling his subjects into sequences of small triangles, he was able to suggest movement between two and three dimensions without violating the integrity of the picture plane. Not content with limiting himself to depicting the flux and simultaneity of single subjects, he assembled heterogeneous vignettes of New York and Paris, each presented as a discrete image occupying a separate area of the canvas (pl. 27 and page 170). These works conveyed his simultaneous memories and experiences of the two cities, but their general lack of pictorial unity exposed the difficulty of consolidating mental concepts of radically different places and times into a single picture. Davis solved the problem in a series of black-and-white lithographs whose compositions were packed so tightly with urban images that they formed an interlocking pastiche whose parts could not be easily separated (fig. 4). His disregard in these lithographs for gravity, scale, and the laws of perspective owed much to the precedent of Joan Miró, whose work Davis had seen in Paris and again in October 1930 at

FIG. 3 *Landscape with Garage Lights*, 1931–1932, oil on canvas, Memorial Art Gallery of the University of Rochester (pl. 31)

FIG. 4 *Barber Shop Chord*, 1931, lithograph, Whitney Museum of American Art, New York, Purchase with funds from Philip Morris Incorporated, 77.84

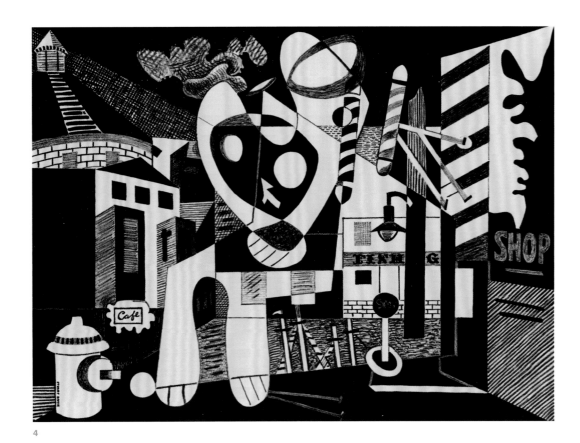

4

New York's Valentine Gallery. But whereas Miró had blended reality and fantasy in order to communicate his dreams, Davis joined together images of external reality to portray the fragmented, cacophonous experience of modernity.

Notwithstanding this surge of arresting formal breakthroughs—all generated in Davis's pursuit of an art that synthesized realism and abstraction to express the disjunction, flux, and dynamism of modern life—his achievement went largely unheralded outside a small circle of like-minded artists. Exhibitions of his work by Edith Halpert at her pioneering Downtown Gallery garnered mixed reviews at best, and most paintings went unsold. With the deepening of the Great Depression, Davis's financial situation, which always had been precarious, became more desperate as sales plummeted and the nation's search for solace and uplift in predominantly realistic depictions that harkened back to the country's rural heritage created an even stronger head wind against his approach. In December 1934, *Time* magazine published a cover story lauding regionalism as an authentic American movement that was replacing "deliberately unintelligible" foreign-based styles and promoting painters such as Thomas Hart Benton as exemplary (see page 176).[34] Never one to shy from confrontation, Davis engaged Benton in a series of acrimonious exchanges over a period of months in the press. From Davis's perspective, regionalism's emulation of Renaissance-derived painting techniques, combined with its "uncritical and uncreative" subject matter, made it anachronistic and ill suited to depicting modern life.[35] "A people's art is not to be achieved by turning art into illustration," he wrote.[36] If art were to have cultural value, Davis maintained, "it must be done in the light of real discoveries of modern art, not in the light of calendar lithography of the last century."[37]

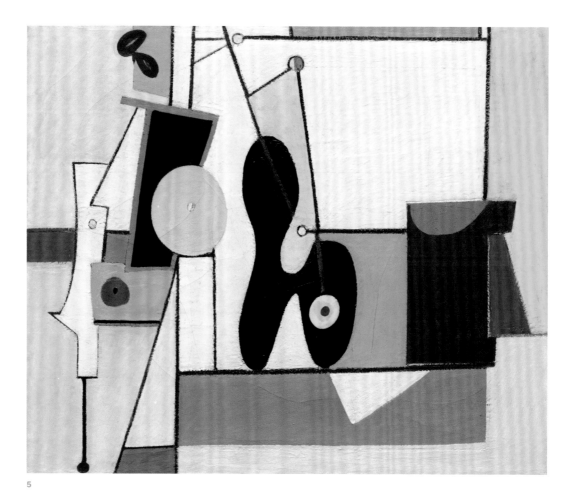

5

Davis's art and his advocacy of modernist aesthetic principles made him a celebrity within the community of vanguard artists in the 1930s. Yet even there he was somewhat of an outlier, notwithstanding his de facto membership with Gorky and John Graham in a trio that Willem de Kooning dubbed the "Three Musketeers."[38] Davis's insistence on painting "concrete things, American things" — "what I see in America ... I paint the American Scene" — was decidedly at odds with the ambitions of most of his vanguard colleagues.[39] The difference in approach is apparent when comparing Gorky's *Organization* (fig. 5) with Davis's large-scale *New York Mural* (pl. 32), which he made for the 1932 Museum of Modern Art (MoMA) exhibition of mural designs, organized to generate commissions for artists in this country. Davis's painting consisted of recognizable images associated with New York politics — specifically with Al Smith, the state's four-term governor and 1928 Democratic candidate for president, whose name Davis had prominently included in two paintings that immediately preceded *New York Mural*. Thus, unlike Gorky, Davis embraced the impure blend of high and low culture, casting his mural as a billboard by exploiting the flat, bold style of advertising. The effect recalled the poster portraits Demuth had made of his artist friends a few years earlier (fig. 6) — a semblance that hints at the ongoing influence on Davis of the artist he credited as important to his early artistic development.[40]

During the early 1930s, when Davis created *New York Mural*, he primarily lived on a fifty-dollar-a-week stipend from Halpert, which she paid in exchange for his yearly output of watercolors and all but one of his oil paintings. As the Depression intensified and sales of art became increasingly infrequent, she cut her payments to him. Like many others in similar circumstances, Davis turned to collective action as the only way to attain

economic security. Between 1934 and 1940, he threw himself into political activism on behalf of artists' economic rights and freedom of expression, serving as a leading member of the Unemployed Artists Group and the Artists' Committee of Action, vice president of the Artists Union, editor of the left-wing journal *Art Front*, and executive secretary and ultimately president of the American Artists' Congress, all the while authoring more than twenty articles on art and the economic, philosophical, and political issues facing artists. He later described this period as "meetings, articles, picket lines, internal squabbles. Everything was hectic. Lots of work done, but little painting."[41]

Although prevailing public taste during these years favored realistic depictions of daily life and historical events, Davis's major production—and accompanying aesthetic breakthroughs—involved large-scale murals that pushed into abstraction. A few months after the close of MoMA's exhibition of mural designs, Donald Deskey commissioned Davis to create a mural for the men's lounge of Radio City Music Hall. Appropriate to the site, Davis filled the mural with images associated with masculine pastimes—smoking, cars, barbershops, card playing, and sailing. His initial plan of executing the mural in large pieces of linoleum was rejected owing to fire regulations—but the idea of cutting shapes out of linoleum most likely influenced the simplicity and muted palette of the final mural, which consisted of a limited number of white, black, gray-blue, and maroon images fit together like a jigsaw puzzle, their sharply chiseled, thick outlines and diagrammatic flatness suggesting an oversized comic strip (pls. 34, 35, and page 172). As with his contemporaneous studio work, Davis ignored the real-life proportions of the objects he depicted, explaining later that his intention was

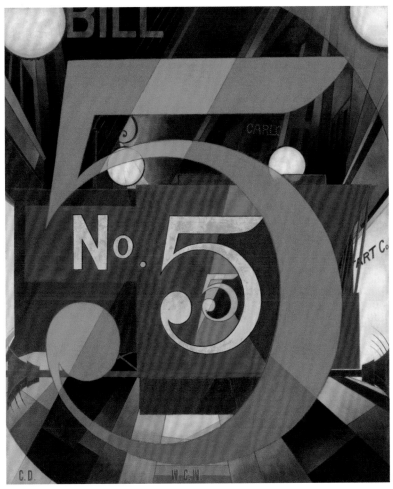

to place these various elements into juxtapositions with each other in a way which one often does in remembering a scene or event and the incidents related to it... certain aspects of it are exaggerated and others are suppressed. The scene is rearranged and recomposed according to the importance and meaning which the different elements have.[42]

Deskey was slow to approve the design, leaving Davis with only a month to complete the mural, which was installed without him and titled by an advertising executive *Men without Women*, a designation Davis disliked and changed to *Mural* decades later.

Davis's next mural, which initiated an even more decisive change in his style, was produced under the auspices of the Federal Art Project (FAP), a division of the Works Progress Administration (WPA) established under President Franklin D. Roosevelt to employ impoverished artists. Davis worked for the easel section of the project from September 1935 until the fall of 1936, when Burgoyne Diller, supervisor of the FAP's New York mural division, commissioned him to paint a fourteen-and-a-half-foot-long mural

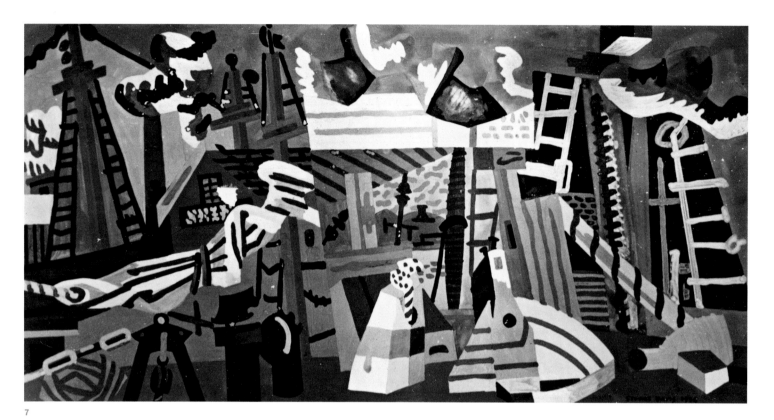

7

for one of the basement meeting rooms of the government-funded, low-income housing project in the Williamsburg district of Brooklyn that had broken ground that April.[43] In his sketches for the mural, Davis overlapped motifs of Gloucester's waterfront to create an allover, continuous surface of advancing and receding forms, none more dominant than the other (fig. 7). His likely model was Fernand Léger's *La Ville* (see page 182), which had been included a year earlier in the artist's October 1935 retrospective at MoMA. Davis had seen the painting twice before—in the solo exhibition of Léger's work that the Société Anonyme had organized in 1925 for New York's Anderson Galleries, and in the 1927 *Machine Age Exposition* held in a storefront on West 57th Street. While in Paris from 1928 to 1929, Davis had exchanged studio visits several times with the French artist he later called "the most American painter painting today."[44] During Léger's trip to New York for his MoMA retrospective, Davis again met with him and negotiated on his behalf with the FAP to hire him as a muralist. In December, Davis used his position as editor of *Art Front* to publish a translation of the speech Léger had given at MoMA a few days after his exhibition opened in which he declared that abstraction was a new realism, uniquely suited to expressing modern life—an idea Davis had long promoted. Like Davis, Léger believed that technological developments had changed the way people see the world by bringing information about events that happened far away and at different times in immediate proximity to one another, and that ordering the resulting "pandemonium," as Léger called it, was the artist's social responsibility.[45] That Léger remained on Davis's mind through 1936 is evident from the application he filled out that November for a Guggenheim Foundation Fellowship in which he (mis)stated that he had studied in Paris with the French artist. Not surprisingly, in beginning the design for his Williamsburg mural, Davis turned to the strong hues and densely layered flat planes of *La Ville* as a way of depicting modernity's "new materials, new spaces, new speeds, new time relations, new lights, and new colors."[46]

In the finished version of his Williamsburg mural, *Swing Landscape* (pl. 40), Davis achieved a taut dualism between flatness and spatial recession by treating the space between objects as flat planes of vibrant color, equal in visual intensity to the objects themselves, and by overlapping all the composition's forms so that they became fragmented shapes that seemed to dance across the canvas surface as if to the syncopated polyrhythms of big-band jazz—an effect that was, despite the inspiration, markedly different from *La Ville*. Whereas Léger's painting was largely angular and mechanistic, *Swing Landscape* was animated and playful, its dazzling colors and decorative embellishments provoking a rush of exhilaration and freedom. "Pictures of this kind, indeed all genuine art, help to keep the eye of the beholder alive, force him to make observations, and give value to aspects of nature which everyday preoccupations too often leave unnoticed," Davis wrote.[47] *New York Times* critic Edward Alden Jewell concurred, noting in his review of FAP murals that *Swing Landscape* "swings…this non-objective inebriant cancels everything else within range."[48]

Davis made two more murals in the 1930s: for the broadcasting room of New York's public radio station, WNYC, and for the Hall of Communications at the 1939 New York World's Fair. In both projects, he treated line as shape. "Every line is a three dimensional form the same as area or shape, he explained."[49] In his World's Fair mural, *History of Communication*, line became the sole agent for creating form and spatial direction. He had used the technique before, in his 1932 black-and-white paintings (pl. 36 and page 171), but the 140-foot length of the World's Fair mural and its unusual employment of white lines on a black background made the equivalence of line and shape particularly striking (see page 184).

A few months after the fair opened, Davis's life changed, beginning with his August 1939 termination from the FAP because his employment had reached the maximum amount of time allowed. The following April, he resigned from the American Artists' Congress, the organization he had presided over since 1937, after the group voted to support the Soviet Union's invasion of Finland the previous November. With his time no longer consumed by politics or employment, Davis was free to focus exclusively on his art, a situation that became more tenable following his 1941 reconciliation with Halpert after a nearly six-year hiatus, during which he had tried to market his art with little success. New works such as *Report from Rockport* (pl. 47) and *Hot Still-Scape for Six Colors—7th Avenue Style* (fig. 8) radiated a joyous euphoria, their dazzling color harmonies and animated motifs exuding delight in what Davis called "the many beauties in the common things in our environment."[50]

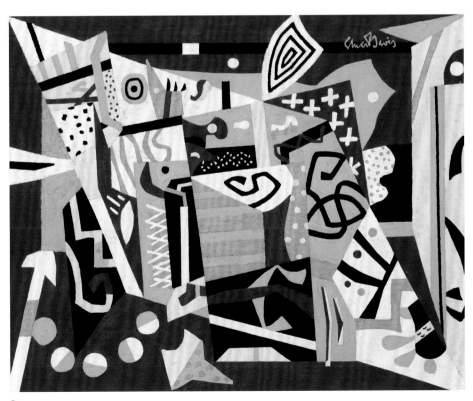

In creating these paintings, Davis introduced a dramatic new way of working (one that Harry Cooper analyzes in detail in his essay in this volume). Since the mid-1910s, when Davis stopped painting in situ, he had been an inveterate sketcher, carrying a note pad with him at all times in order to quickly record his impressions of people or scenes. He used these sketches as a treasury of images for later paintings, often executed years after the initial sketch was made—as in his 1931 painting *House and Street*, based on a sketch he made in 1926.[51] Reasoning that he could use oils in the same way he used his sketches, as source material for new work, Davis announced in 1938 his intention to make pictures that would "contain the major proportions of some of my earlier works as [their] basis, thus bringing out the esthetic essence which was confused by other details."[52] He based the practice on what he called the "Theory of the Neutral Subject," declaring that "all configurations are valid."[53] At first, he hewed closely to the configuration of the earlier work—as in *Landscape* (pl. 36) and its brightly colored successor, *Shapes of Landscape Space* (pl. 42). By 1940, he was regularly appropriating the proportions of work from decades earlier to create paintings that were radically different from their progenitors. He likened the recycling of older compositions to jazz improvisations, explaining that "it's the same thing as when a musician takes a sequence of notes and makes many variations on them."[54]

Up until 1940, even the most seemingly abstract of Davis's work had retained vestiges of recognizable imagery—a ladder, a barbershop pole, ship's rigging, ropes, and a lobster pot in *Swing Landscape*, for example, or a saxophone, clarinet, musical notes, and electrical wiring in his WNYC mural. With the onset of World War II in Europe and the arrival in this country of artists fleeing Nazi aggression, Davis began to search for more abstract forms of expression that would be "inter-epochal, international and inter-racial" and yet retain the vibrant spirit and freedom he associated with America; "[e]normous changes are taking place which demand new forms and it is up to artists living in America to find them," he wrote.[55] He rejected the pure geometric formalism of Piet Mondrian and his followers on the grounds that these artists sought to depict static, eternal values that denied the character of the universe as "a complex system of relations in continuous motion," as Davis described it.[56] Their attempt to reify abstract, metaphysical ideals was flawed because "an ideal order would be timeless, and art exists in time."[57] Davis considered Mondrian's notion that one "could get rid of all the paraphernalia of pictural usage and still have a satisfactory painting left" to be "preposterous."[58] Reprising Dewey, he urged artists to find the "universal in the particular," arguing that the universal can only be understood through its particular manifestations.[59] "The local exists only as a type of the universal," Davis asserted.[60] "To find more profound relations in Nature does not mean destruction of the particular."[61] The challenge he set for himself was to be "aroused by reality" but to "negat[e] that reality in the creation of a new reality, the work of art."[62] He described the change in his approach:

My early landscapes showed enthusiastic emotion about the color-texture-shape-form of associative entities such as sky, sea, rocks, figures, vegetation. The purpose was to make a record of things felt and seen so that the total associations of the moment could be

experienced. Today I disassociate the painting experience from general experience and attain a universal objective statement that transcends … time and place.[63]

Davis's ambition to create art that transcended the specificity of time and place accorded with his commitment to visually control the kaleidoscopic sensations of modern life, which he saw as destabilizing. "Our need today is to balance these new sources of perception," he wrote.[64] Building on the hypothesis that ordering the chaos and flux of life was key to human happiness, Davis theorized that art's role was "to give concrete expression by example … that a real order and harmony can be achieved between man and environment."[65] In giving formal balance and cohesion to the fragmentation and cacophony of life, art provided reassurance that "the human spirit is still capable in the midst of the most horrible disorder of visualizing order and harmony."[66] The idea was among the most fundamental to Davis's conception of art's purpose and his artistic goal, as evident in its appearance in his writings, in one form or another, since 1920, when he proposed in a letter that the "appreciation of art" is "simply a matter of desire for order as a relief from the apparent and possible chaos of everyday affairs."[67] Nearly twenty years later, he would write in a similar vein: "The appetite which Art satisfies is the hunger for physical stability in the space of the three-dimensional world."[68] By 1940, Davis had designated "constructive order" as the primary subject matter of art, and had equated the happiness and confidence derived from it with art's value.[69] "The social meaning of art," he asserted, "consists of the affirmation of joy felt in the successful resolution of a problem. This expression has social meaning because it gives concrete proof of the possibility of establishing order in certain aspects of man's relationship to nature. Such expression is a moral force and provides courage for life to those who experience it."[70] Contending that art "mak[es] life keener" by "creat[ing] real order in a disordered world," Davis credited it with giving viewers an enhanced experience of life by verifying "that a human being has a specific power."[71] Accordingly, he attributed the "profound humanity" of Johann Sebastian Bach's music to its having transmuted the negative aspects of life into a structured, cerebral order.[72] He similarly applauded jazz musicians for putting popular, anecdotal, or sentimental songs into a "human order," and even went so far as to credit the structural logic of blues as the reason the music's bleak themes did not inspire mass frustration.[73]

Establishing order over the fragmented cacophony and disunity of experience was not, for Davis, synonymous with making static art. By 1942, he was achieving what he called "physical equilibrium in tension" by making the shapes in seminal works such as *Arboretum by Flashbulb* (pl. 48) and *Ultra–Marine* (pl. 49) equal in size, color intensity, and decorative embellishments, and dispersing them evenly across his canvases so that the viewer's eye was kept in constant motion.[74] "Instead of a center focus … all parts of the field of observation are centers of focus, serial centers," he wrote. "The keynote of the total quality, the drama, is equality."[75] Making a picture that was perceived as an indivisible whole was radical in 1942. Not until Jackson Pollock created his first drip painting in 1947 would another American painter jettison cubism's centralized format in favor of an allover picture possessing an equality of interest across its entire surface. Following John Lane's pioneering study of Davis in the 1970s, scholars have routinely credited gestalt concepts of perception with influencing the artist's adoption of this

format on the assumption that he became immersed in the theory after he started teaching at the New School in 1940, the epicenter of its study.[76] Yet no evidence exists that Davis had more than a superficial knowledge of gestalt theory: he had no books on the subject in his library and appears to have had no interaction at the New School with the movement's chief proponents. Given that he introduced the allover format in late 1936, four years before he began teaching there, and never wrote extensively about gestalt theory in his journals, as he had done in the 1930s with Marxism, for example, Davis most likely used the word "gestalt" as did most Americans, as a synonym for "unified whole," with little understanding of the theory itself. Indeed, the fundamental principle of gestalt perception—that the mind reduces the complexity of visual experience to simple forms in order to process information and create meaning—is the inverse of the "serial centers" Davis sought in his paintings.

A seismic shift in dominant attitudes toward abstract art occurred in the New York art world in the mid-1940s in response to the totalitarian regimes in Europe whose propaganda machines demonized abstraction as alien, suspect, and degenerate. Their concomitant popularization of a kind of heroic realism in service to their pernicious ideologies and their harsh suppression of abstract tendencies spurred a positive assessment of abstraction in the United States, where it came to be regarded, in part, as symbolic of the tenets of free thought and free expression that were at the core of the nation's identity, and upon which rested the nation's conception of itself as a defender of liberty in the face of advancing totalitarian repression.

The art world's newfound acceptance of abstraction was a boon for Davis, bringing him both critical and financial success. After years of poverty, he finally earned enough from his art to require him to pay income tax. But years of excessive drinking took their toll on his health and reduced his productivity, so that even as he found himself vindicated for his stalwart commitment to abstraction, he seemed to suffer an aesthetic block. Between January 1945 and autumn 1946, he all but stopped writing in his journal and he completed only two works: *For Internal Use Only* (pl. 50) and its study, *G & W*. His impasse was exacerbated by the retrospective of his work hosted by MoMA in October 1945. Although turnout for the private reception set records and critical response was generally favorable, the sense among many people was that "it is hard to guess where [Davis] can go...He can't just go on being more so of what he is," as critic Maude Kemper Riley put it.[77] For the first time in his career, Davis was compared unfavorably to younger artists. Six months before Davis's MoMA retrospective opened, the influential critic Clement Greenberg had hailed Pollock as "the strongest painter of his generation and perhaps the greatest one to appear since Miró."[78] Reviewing Davis's show, Greenberg dismissed the older artist's work as "decorative to the point where it is hardly easel-painting any more."[79] The exhibition gave Davis "pause," according to the reviewer for *Vogue*, initiating a reassessment of his art.[80] In the five years following the close of the show, he completed only eleven small-scale works. *The Mellow Pad* (pl. 51), which he had started four months before the retrospective opened, would take him until 1951 to finish.

The problem Davis faced was how to reconcile his desire to "grant the reality and joy giving quality of normal appearances" with his resolve not to illustrate specific subject matter.[81] As he put it:

[T]he direct application of these Truths [about subject matter's neutrality] has been the problem. With subject correctly seen as Neutral, a tendency to ignore specific subject develops. This had to be corrected. Subject is the condition for experience and reaction to it... To say that Subject is Neutral is not to say that it does not exist... This means that the specific character of subject is not shied away from, but is accepted in Logic terms.[82]

Davis determined that words, divorced from narrative and context, could infuse his art with the vitality of commonplace experience without engaging in what he called the "subjectively particular."[83] He had included words in his paintings many times before as product names or signage. His Paris pictures, which constituted a third of his retrospective, abounded in street typography. One, *Rue Lipp*, cleverly incorporated words of Davis's own invention: a poster advertising the recently published book of poems by his friend Robert Brown, and "bierre hutt," which he inscribed in the image of a top hat within a beer mug. He had practiced the same insider humor in *Summer Landscape* by inscribing "Bob Brown" in small letters on a life preserver, and in 1932 he had incorporated into *American Painting* (pl. 37) the lyrics "it don't mean a thing if it ain't got that swing" from Duke Ellington's popular jazz song. In 1946, Davis extended the practice, beginning a series of small-scale pictures in which he embedded the word "pad" (fig. 9).

Davis completed only four of these paintings before he was hospitalized for alcohol abuse in midsummer 1949, a health crisis acute enough that, with rare exception, he shortly thereafter gave up drinking. Six months after his release from the hospital in August, he inaugurated a new style of painting that echoed many of the qualities of Matisse's *Jazz* portfolio that he had seen in October 1948 in MoMA's show of its recently

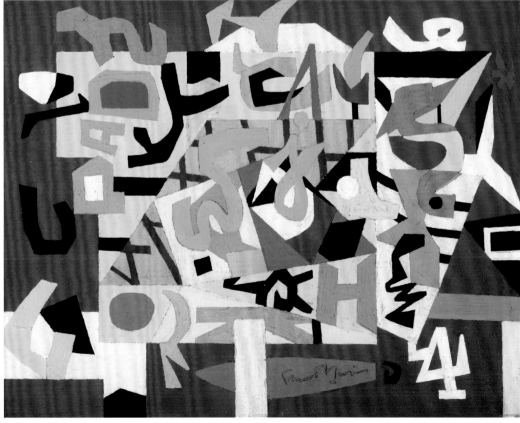

9

acquired European prints. Taking his cue from the brilliant coloration and simplicity of the French artist's impressions, Davis replaced the small shapes that had marked his recent compositions with expansive planes of highly saturated, dazzling color. His first painting in this new direction was *Little Giant Still Life* (pl. 52), based on a matchbook cover advertising Champion spark plugs. Reducing his palette to a few colors in addition to black and white, he created a fast-moving surface of receding and advancing planes held in check by a red border around the painting's perimeter. Other paintings followed in quick succession, their crisply demarcated and unadorned shapes possessing a spontaneity and structural clarity akin to that in jazz. Color replaced angles and triangles as Davis's agent of spatial position. Already in 1923, he had observed that "in applying the colors to the canvas one is making statements of advancing and retiring planes" and he had spent much of the early 1940s diagramming and analyzing color's spatial properties in his journals.[84] After 1950, he entrusted color almost exclusively with creating space, controlling its advancing and receding properties to ensure that all areas of his pictures were perceived simultaneously, as a single impression. "What is required is that all areas be simultaneously perceived by the spectator. You see things as a unit at the same time. What there is, *all* at the same time," Davis told an interviewer.[85] By manipulating color, he created the impression that the shapes in his paintings were spatially moving forward and backward at enormous speed. As he explained in 1961:

[Color] doesn't play any part in and by itself [in my work]; my color is not decorative… Even just two colors can define a front and back space, though which is front and which is back is irrelevant. What is important is that the two colors are not in the same place… They're either in front or in back but they change as you look at them.[86]

One critic likened the velocity of Davis's emphatic, clearly defined planes of assertive color, visually pushing into the viewer's space, to a "good sock on the jaw."[87]

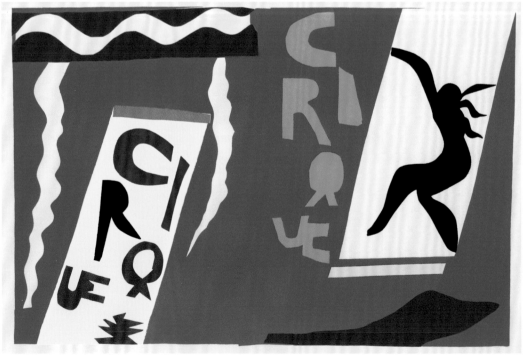

10

FIG. 10 Henri Matisse, *Circus*, plate II from the illustrated book *Jazz*, 1947, pochoir, The Museum of Modern Art, New York, Gift of the artist, 1948

Little Giant Still Life was dominated by the word "champion," the name of the product whose ad Davis used as the basis for his design. Never before had he given words so much prominence in his paintings. Matisse's *Jazz* prints provided a precedent by likewise treating letters and words as dominant design elements, either as block letters integrated into the compositions or as adjacent texts written in Matisse's large cursive script (fig. 10). Validated in his new direction by the French artist, Davis embraced words as central to his art. In thrusting them onto center stage, he gave priority to their shapes rather than to their meanings. To signal that the word "champion" was not the exclusive subject of *Little Giant Still Life*, he painted three diagonals through the word and added an *X* in the painting's lower right-hand corner. "Physically words are also shapes," he explained.[88] They are "a form, an analogue, of physical architecture."[89] Incorporating words into his art allowed Davis to introduce what he called "the human element" without resorting to recognizable imagery.[90] "We see words everywhere in modern life; we're bombarded by them," he told an interviewer.[91] "Words … are an important part of the subject matter of our daily experience."[92] Critic Brian O'Doherty likened the words in Davis's pictures to "neon signs that have flashed briefly and then stayed on. One looks at them as if entering a familiar city after a weary drive."[93] Yet however much the hard-edge forms and bold graphics of Davis's word paintings resembled billboards and road signs, after *Little Giant Still Life*, he ceased to derive his imagery from the world of advertising and mass media with the exception of a group of works stemming from a *Fortune* magazine commission to create a painting on the "glamour of packaging" (pls. 70–74).[94] Indeed, in contrast to the pop artists, for whom Davis's work is often seen as an antecedent, he rarely depicted products or packing after 1950, preferring to communicate the vitality and exuberance of low culture without the limitations of specific subject matter.

Just as shapes occurred to Davis in the act of painting, so, too, did words. As he explained, "anchor[ing]" his experiences in "concrete object[s]" did not mean that he "exclud[ed] contextual ideas that occurred while contemplating them."[95] Not surprisingly, many of the words that appear in his compositions refer to his ideas about painting and the painting process. When asked about the meaning of the words in his 1951 *Visa* (pl. 53), for example, he explained that the word "else" accorded with his idea that any subject matter was valid and that something else might be possible; "amazing" referred to the kind of painting he wanted to look at; and "continuity" to the experience of seeing the same thing in paintings of completely different subject matter and style.[96] A similar logic exists for other words that came into his mind while painting and feature in his art: used to be-now, any, facil-it is, speed, new, drawing, eraser, lines thicken, it, tight, unnecessary, compl. Nevertheless, while acknowledging that words possess associations and "analogies of meaning," Davis used them less as conceptual signifiers than as abstract corollaries to the composition's visual rhythms.[97] "The meaning of a picture is in its total aspect, not in the individual terms which compose it," he wrote.

I have used words in many of my pictures, and in all cases they are used in the same sense and feeling as the nonword shapes… Whatever specific context of meaning they have is changed into their context of meaning as a part of the total meaning of the picture… Art does not rob the square [or word] of its everyday meanings, it enlarges the scope of its usefulness in enriching our experience with common things.[98]

Davis's stature as a leading American artist accelerated with these word pictures: between 1952 and 1954 alone, major articles on him appeared in *Art News*, *Art Digest*, and *Time* magazine; he represented the United States at the Venice Biennale along with three other artists; and he received both a Guggenheim Foundation Fellowship and a mural commission from Drake University. Hailed by critics, surrounded by admirers, and with his art selling at a brisk clip, he was not threatened by the rising prominence of the new generation of abstract expressionist painters, alongside whose work his paintings were frequently exhibited. He admired the large scale, freedom, and "uneasy cohesion" of their canvases and he conceded "that artists of talent and ability work in that manner."[99] His opinion of individual artists, particularly Pollock and de Kooning, was often more favorable than not, and he based several paintings and sketches on works by de Kooning, Franz Kline, Mark Rothko, and William Baziotes.[100] Nevertheless, as a man who "saw sides and took them," as O'Doherty remarked, Davis did not remain silent in the face of what he deemed to be abstract expressionism's abnegation of art's social role.[101] Davis considered "survival … the struggle to keep alive on the planet" to be "mankind's basic need."[102] Art's value depended on the degree to which it satisfied this need. From his perspective, "art is great or beautiful when its meaning supports and strengthens some aspect of our adjustment to nature and society."[103] Just as he had lambasted regionalism and the Mexican mural movement in the 1930s for being culturally reactionary because the artists resorted to an obsolete vocabulary, so too did he speak out in the 1950s against abstract expressionism's emphasis on subjective states, which he felt denied the artist's role to keep "alive one of the important faculties of man by cultivating it and, by his work, continue to give objective proof day by day of the possibility of enjoyment of the form and color of our environment."[104]

By 1957, when the Walker Art Center opened its Davis retrospective, the art world once again had begun to shift, with younger artists chafing at what had become the hegemony of abstract expressionism and rebelling against its perceived sanctimonious pieties, which were being further advanced by the movement's second-generation practitioners. Davis's retrospective came at an opportune time. The show's curator H. H. Arnason described the artist's work of the previous fifteen years as being "of the greatest importance and excitement," a claim he backed by selecting thirty-nine of the show's fifty-five paintings from the years 1946 through 1956.[105] *Saturday Review* critic James Thrall Soby agreed, describing Davis as an artist who got "a second wind in midcareer and is not pushed aside in terms of public and professional esteem by younger men," and rejoicing that Davis had suddenly "jumped to his feet again, spryer and more inimitable than ever" after a decade in which his work seemed to stagnate.[106] The accolades were prescient: by the end of the decade, a new generation of artists had emerged—Ellsworth Kelly and Frank Stella for example—who were creating abstract geometric paintings that, like Davis's, eliminated the spatial effect of figures on a field in favor of single-impression paintings perceived as pictorial wholes.

After his retrospective, Davis's paintings became even more expansive, owing in part to the joy he felt at being the father of a toddler and to being able to work in a large studio for the first time in his life. He continued to base the majority of his paintings on preexisting motifs, explaining that he could work "from Nature, from old studies and paintings of my own, from photographs, and from other works of art. In each case the process consists of a transposition of the spirit of the forms of the subject into a

FIG. 11 *Blips and Ifs,*
1963–1964, oil on canvas,
Amon Carter Museum
(pl. 83)

coherent, objective color-space continuum, which evokes a direct sensate response to structure."[107] By 1957, he was occasionally selecting a closeup or inverted section of an earlier motif: *Blips and Ifs* (fig. 11), for example, was based on a section of *Standard Brand* (pl. 79); Davis's black-and-white versions of *Pochade* (pl. 76) derived from the lower-center and lower-right segments of his 1956–1958 oil of that title (pl. 75). The result was a simplification of imagery, whose clarity and visual impact he furthered by reducing his palette to three colors—red, green, and yellow, plus black and white. As

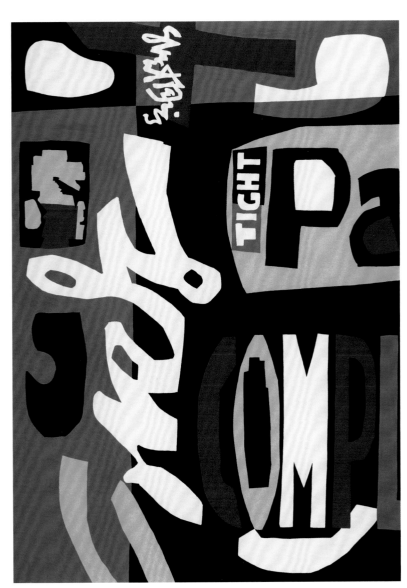

11

with all of Davis's paintings, a sense of wonder and exuberance permeates these canvases, which exude what the artist described as "the joy of optical exercise…Art Form Play in harmony with the scope of modern consciousness."[108] Throughout his career, Davis's goal as an artist had been to affirm the positive aspects of life and to reassure viewers of his work "that things are right or beautiful."[109] By replacing recognizable imagery with abstract shapes and words, he created universal and timeless correlatives of those momentary flashes of joy and elation that people experience when they feel most alive and in harmony with their surroundings. "What is the universal anyhow," Davis once asked, "except our own sense of equilibrium in relation to diverse subject matter?"[110] Davis's paintings, rooted in the pleasurable response to color and to the elemental spatial relations of everyday things, provide continuing affirmation that even in the midst of the chaos and fragmentation that have only grown more acute in our own era, unity and order can be achieved and joy remains attainable.

I am grateful to Jason Best, Harry Cooper, and Sasha Nicholas for their careful reading of this essay; to Sarah Humphreville for her editorial suggestions and for preparing the endnotes alongside interns Anna Blum and Olivia Chuba; and to Leon Botstein for proposing the essay's title.

1. Stuart Davis Papers, reel 14, March 18, 1957, Fogg Art Museum, Harvard University Art Museums, Gift of Mrs. Stuart Davis (hereafter cited as SDP, Harvard). All rights reserved by the President and Fellows of Harvard College. Some pages of the Stuart Davis Papers are dated; others are not. Dates in brackets that follow "undated" are the author's estimate based on the sequence of journal entries on the given reel. Some pages of the Harvard journals are numbered; most are not. Page numbers are not given here to avoid confusion.

2. Robert Henri, *The Art Spirit: Notes, Articles, Fragments of Letters and Talks to Students, Bearing on the Concept and Technique of Picture Making, the Study of Art Generally, and on Appreciation*, compiled by Margery Ryerson (New York: Harper and Row, 1984), 13.

3. Stuart Davis, *Stuart Davis*, American Artists Group Monographs, no. 6 (New York: American Artists Group, 1945), n.p.

4. Stuart Davis, quoted in Brian O'Doherty, "Major American Artist: Davis's Work Was Never Out of Date—He Anticipated Movements in Art," *New York Times*, June 26, 1964.

5. SDP, Harvard, reel 5, April 5, 1942.

6. SDP, Harvard, reel 1, June 11, 1935.

7. Davis wrote of his "experience of Freedom" in seeing the Armory Show; quoted in *1913 Armory Show: 50th Anniversary Exhibition* (exh. cat., Henry Street Settlement, New York; Munson Williams Proctor Arts Institute, Museum of Art, Utica, NY, 1963), 95.

8. Stuart Davis, quoted in James Johnson Sweeney, *Stuart Davis* (exh. cat., Museum of Modern Art [MoMA], New York, 1945), 10.

9. Stuart Davis, "Man on an Ice Floe," SDP, Harvard, reel 2, undated [1939 or 1940] and reel 11, undated [1951 or 1952]. See the chronicle in this volume, note 55, for further information.

10. SDP, Harvard, reel 6, March 8, 1943.

11. Stuart Davis, "Remarks about My Painting S*omething on the Eight Ball*," April 17, 1954, 8, Downtown Gallery Records, Archives of American Art, Washington and New York (hereafter cited as AAA).

12. Davis, quoted in Sweeney 1945, 10.

13. Stuart Davis, Autograph manuscript diary, October 28, 1922, MA 5062, 167, Department of Literary and Historical Manuscripts, The Morgan Library and Museum, New York (hereafter cited as SDD, The Morgan).

14. SDD, The Morgan, May 1920, 3.

15. Forbes Watson, "Art Notes," *World*, December 13, 1926.

16. SDD, The Morgan, March 29, 1921, 38–39; March 12, 1921, 18; and March 11, 1921, 15.

17. SDD, The Morgan, May 29, 1921, 39. For identification of cigarettes with American culture, see Barbara Zabel, "Stuart Davis's Appropriation of Advertising: The *Tobacco* Series, 1921–1924," *American Art* 5, no. 4 (Autumn 1991): 56–67.

18. SDD, The Morgan, May 29, 1921, 39.

19. Davis, quoted in Sweeney 1945, 17.

20. Davis, quoted in Sweeney 1945, 17.

21. Davis to Edith Halpert, August 1, 1927, Estate of the Artist Archives, Fort Lee, NJ, and New York (hereafter cited as EAA). All rights reserved. © Estate of Stuart Davis/Licensed by VAGA, New York, NY. For David Smith quotation, see "Atmosphere of the Early Thirties," in Garnett McCoy, *David Smith* (New York: Praeger, 1973), 86.

22. While Davis was in Paris, his funds were augmented by his parents and by an additional $500 from Whitney.

23. Davis, quoted in Sweeney 1945, 22.

24. Stuart Davis, quoted in Cecelia Ager, "Stuart Davis," *Vogue* 107, no. 2 (January 15, 1946): 126; Davis, quoted in Sweeney 1945, 22.

25. Davis, quoted in Sweeney 1945, 21.

26. Stuart Davis, quoted in Brian O'Doherty, *American Masters: The Voice and the Myth in Modern Art* (New York: E. P. Dutton, 1974), 69.

27. SDP, Harvard, reel 3, January 28, 1940; John Dewey, "Americanism and Localism," *The Dial* 68 (June 1920): 684–686.

28. Stuart Davis Calendar, January 16, 1951, EAA.

29. Wanda M. Corn, *The Great American Thing: Modern Art and National Identity, 1915–1935* (Oakland: University of California Press, 2001); Stuart Davis, "Mural for Hall of Communications, New York World's Fair (working notes and diagrams) (1939)," in Diane Kelder, ed., *Stuart Davis* (New York: Praeger, 1971), 88.

30. Stuart Davis, "The Cube Root," *Art News* 41, no. 18 (February 1–14, 1943): 33–34.

31. Davis, quoted in Sweeney 1945, 23.

32. Henry McBride, "Work of Four American Painters," *Sun*, November 30, 1929; Stuart Davis, "Dear Mr. McBride," *Creative Art* 6, no. 2 (February 1930): suppl. 34–35.

33. Stuart Davis, "September 20, 1932," in Kelder 1971, 60.

34. "U.S. Scene," *Time* 24, no. 26 (December 24, 1934): 26.

35. SDP, Harvard, reel 1, September 30, 1937.

36. SDP, Harvard, reel 2, March 9,1938.

37. Stuart Davis, "Abstract Painting Today," April 20, 1940, 8, Emanuel Benson Papers, AAA.

38. Willem de Kooning, quoted in James T. Valliere, "De Kooning on Pollock," *Partisan Review* 34, no. 4 (Fall 1967): 603.

39. Davis to Edith Halpert, November 10, 1941, EAA; Davis, quoted in Sweeney 1945, 23.

40. Davis 1945.

41. Davis, quoted in Sweeney 1945, 29.

42. Stuart Davis, "Mural for Studio B, WNYC (working notes) (1939)," in Kelder 1971, 92.

43. Davis worked on the Williamsburg project for over a year and a half. Earlier assumptions that the mural was initially intended for the faculty lounge at Brooklyn College likely owed to its being briefly displayed at the college after it was rejected from the Williamsburg site. For further information, see Stuart Davis Calendar, 1937 and 1938, EAA; Ani Boyajian and Mark Rutkoski, eds., *Stuart Davis: A Catalogue Raisonné*, vols. 2 and 3 (New Haven, CT: Yale University Art Gallery; Yale University Press, 2007), 2:622–627 and 3:289–294.

44. Davis, quoted in O'Doherty 1982, 73.

45. Fernand Léger, quoted in Louis Cheronnet, "La publicité moderne: Fernand Léger et Robert Delauney," *L'Art Vivant* (December 1, 1926): 800; reprinted in Fernand Léger, "On Modern Advertising," trans. Liesl Yamaguchi, in *Léger: Modern Art and the Metropolis*, ed. Anna Vallye (exh. cat., Philadelphia Museum of Art, 2013), 110.

46. Stuart Davis to Jerome Klein, quoted in Klein, "Stuart Davis Criticizes Critic of Abstract Art," *New York Post*, February 26, 1938.

47. Stuart Davis, "Bass Rocks," in *Stuart Davis: Landscape, Bass Rocks*, Contemporary American Painters Series (New York: Jack C. Rich, 1942), n.p., in Stuart Davis Scrapbook, Stuart Davis Papers, AAA (hereafter cited as SDP, AAA).

48. Edward Alden Jewell, "Commentary on Murals: Exhibition at the Federal Art Gallery Presents WPA New York Region Survey," *New York Times*, May 29, 1938.

49. SDP, Harvard, reel 2, April 24, 1938.

50. Stuart Davis, "Hot Still-Scape for Six Colors—7th Ave. Style," *Front Matter* 12, no. 8 (December 1940): 6.

51. *House and Street* is based on *Sketchbook 6-34 (Drawing for "House and Street")*, Collection, The Morgan Library and Museum, New York.

52. SDP, Harvard, reel 2, July 25, 1938.

53. SDP, Harvard, reel 8, July 26, 1947, and November 8, 1946.

54. Stuart Davis, quoted in Dorothy Gees Seckler, "Stuart Davis Paints a Picture," *Art News* 52, no. 4 (Summer 1953): 74.

55. SDP, Harvard, reel 6, April 1, 1943; Davis, "The Cube Root," 1943, 34.

56. SDP, Harvard, reel 2, June 30, 1939.

57. Stuart Davis, quoted in "Is There a Revolution in the Arts?," interview transcript, *Town Meeting* 5, no. 19 (February 19, 1940): 13. Arthur E. Bestor moderated the radio broadcast, and Aaron Copland, Walter Damrosch, Stuart Davis, Clifton Fadiman, William Lyon Phelps, and Albert Sterner participated.

58. Stuart Davis, "Memo on Mondrian," in *Arts Yearbook* 4 (New York: Art Digest, 1961), 67. Davis's information about Mondrian's ideas did not extend beyond basic concepts. As a result, he seems to have been unaware of the parallels between Mondrian's views and his own. For a discussion of Davis and Mondrian, see John R. Lane, *Stuart Davis: Art and Art Theory* (exh. cat., Brooklyn Museum, New York, 1978), 47–54.

59. SDP, Harvard, reel 6, April 4, 1943.

60. SDP, Harvard, reel 6, January 15, 1943.

61. SDP, Harvard, reel 4, January 27, 1942.

62. SDP, Harvard, reel 6, April 4, 1943.

63. SDP, Harvard, reel 7, undated [July 1943].

64. SDP, Harvard, reel 4, September 1941.

65. SDP, Harvard, reel 3, undated [January 1940].

66. SDP, Harvard, reel 3, undated [January 1940].

67. Davis to Hazel Foulke, December 30, 1922, EAA.

68. Davis, "Mural for Hall of Communications," in Kelder 1971, 88.

69. Davis, "Mural for Studio B, WNYC (working notes) (1939)," in Kelder 1971, 92.

70. Stuart Davis, "Mural for Hall of Communications," Kelder 1971, 84–85.

71. SDP, Harvard, reel 3, undated [January 1940]; SDP, Harvard, reel 4, March 1942.

72. SDP, Harvard, reel 5, Easter 1942.

73. SDP, Harvard, reel 4, September 1941.

74. SDP, Harvard, reel 7, May 31, 1946.

75. SDP, Harvard, reel 6, January 3, 1943.

76. John R. Lane, "Stuart Davis: Art Theory" (PhD dissertation, Harvard University, 1976). Lane drew on this research for his catalog *Stuart Davis: Art and Art Theory* that accompanied the retrospective of Davis's work at the Brooklyn Museum (New York 1978).

77. Over 1,500 guests attended the opening reception of Davis's retrospective, the largest number in five years. See Ager, "Stuart Davis," 1946, 81; Maude Kemper Riley, "Stuart Davis Retrospective," *Limited Edition*, no. 4 (November 1945), 2.

78. Clement Greenberg, "Art," *Nation* 160, no. 14 (April 7, 1945): 397.

79. Greenberg, "Art," *Nation* 161, no. 20 (November 17, 1945): 533–534.

80. Ager, "Stuart Davis," 1946, 126.

81. SDP, Harvard, reel 4, April 1, 1942.

82. SDP, Harvard, reel 8, July 4, 1947.

83. SDP, Harvard, reel 7, undated [July 1943].

84. SDP, Harvard, reel 1, February 26, 1923.

85. Stuart Davis, quoted in Frederick S. Wight, "Profile of Stuart Davis," *Art Digest* 27, no. 16 (May 15, 1953): 23.

86. Stuart Davis, quoted in Katharine Kuh, "Stuart Davis," in *The Artist's Voice: Talks with Seventeen Artists* (New York: Harper and Row, 1962), 58.

87. Elaine de Kooning, "Stuart Davis: True to Life," *Art News* 56, no. 2 (April 1957): 41.

88. Davis, quoted in Kuh 1962, 52.

89. SDP, Harvard, reel 14, October 27, 1960.

90. SDP, Harvard, reel 1, March 13, 1923.

91. Davis, quoted in Kuh 1962, 52.

92. Davis, "Something on the Eight Ball," 1954, Downtown Gallery Records, AAA, 6.

93. Brian O'Doherty, "Art: Paintings of the Honk and Jiggle," *New York Times*, May 1, 1962.

94. Stuart Davis, tape recorded interview with James Elliott, spring 1961, EAA.

95. Stuart Davis, "The Painters Write: Stuart Davis," in Ray Bethers, *Pictures, Painters, and You* (London: Pitman Publishing, 1948), 226.

96. Stuart Davis, "Re Painting *Visa*," November 3, 1952, 2, Downtown Gallery Records, AAA.

97. Davis, "*Something on the Eight Ball*," 1954, Downtown Gallery Records, AAA, 7.

98. Davis, "*Something on the Eight Ball*," 1954, Downtown Gallery Records, AAA, 5–7.

99. Davis, quoted in Wight 1953, 23; Stuart Davis, draft of talk for Color in Art in Science, a summer course taught by Professor Filipowski, Massachusetts Institute of Technology (MIT), July 30, 1958, EAA.

100. Davis based his 1959 oil paintings *Town and Country* and *White Walls* on sketches he made of de Kooning's *Suburb in Havana* and Kline's *Delaware Gap*, respectively. See Boyajian and Rutkoski 2007, 2:442 and 3:373–374. Davis also made sketches of Rothko and Baziotes works. See SDP, Harvard, reel 9, February 4, 1950, and February 5, 1950; and reel 10, May 1, 1950.

101. O'Doherty, "Major American Artist," 1964.

102. SDP, Harvard, reel 4, January 7, 1942; SDP, Harvard, reel 3, January 7, 1941.

103. SDP, Harvard, reel 2, June 30, 1939.

104. Davis, "Bass Rocks," 1942, in SDP, AAA.

105. H. H. Arnason, *Stuart Davis* (exh. cat., Walker Art Center, Minneapolis, 1957), 9.

106. James Thrall Soby, "Stuart Davis," *Saturday Review* 11, no. 45 (November 9, 1957): 32.

107. SDP, Harvard, reel 6, November 21, 1942.

108. SDP, Harvard, reel 3, June 30, 1940.

109. SDP, Harvard, reel 2, undated [February or March], 1940.

110. SDP, Harvard, reel 4, April 1, 1942.

John Wingate (showing a reproduction of the painting *Memo*):
Can you tell me what it means, sir?

Stuart Davis: *Well, this is what you'd call a beat-up subject,
meaning by that that I think I've drawn it and painted it probably
a dozen times in twenty-five years.*

"NIGHTBEAT," WOR TV, 1957[1]

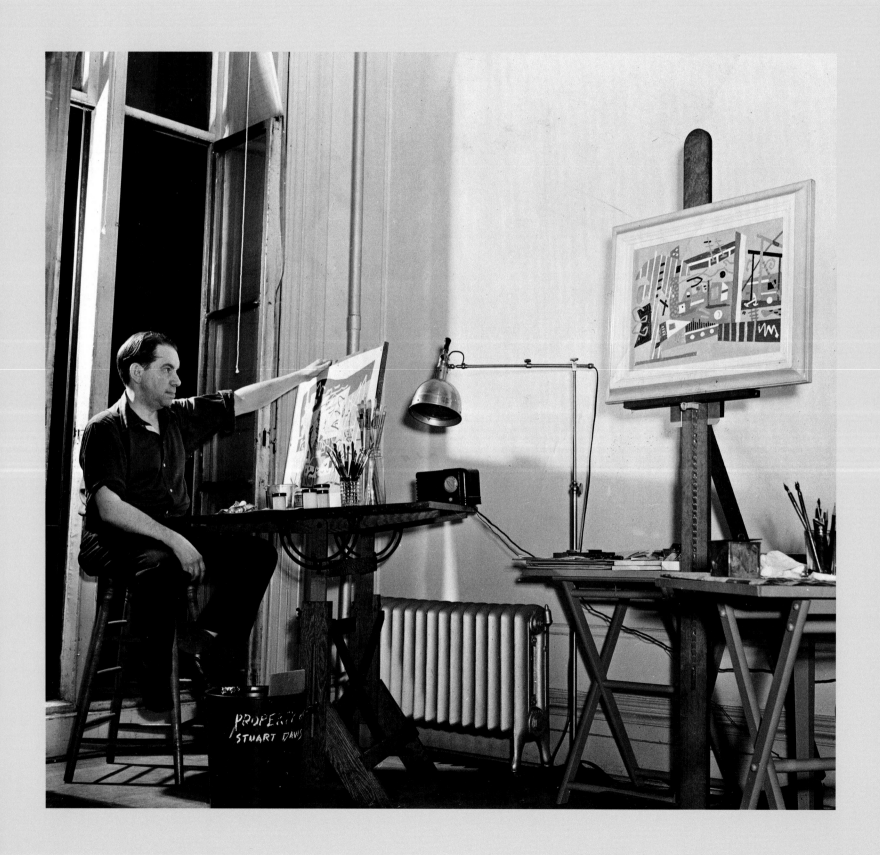

HARRY COOPER

DAVIS DEFLECTS THE INTERVIEWER'S QUESTION AS DEFTLY AS ANY POLITICIAN. Asked about the meaning of *Memo* of 1956 (pl. 69), he offers up the distraction of a colorful term—"beat-up subject"—and proceeds to give *its* meaning instead. After all, what modern artist would want to answer the question of meaning, which presumes that artworks can be decoded, their essence translated into another language? But if this is an evasion, it is also an answer, or the hint of one, for while "beat-up subject" may lead away from the painting in question, it also points toward the group of works to which it belongs. Let us call it the *Memo* group. In effect, Davis suggests that meaning will be found, if at all, not in any given work but in the relations between works, in their grouping. He continues:

The original subject … was simply a normal landscape in Gloucester, Massachusetts… This is obviously the elegant lines of schooners and their rigging. Unfortunately, they're no longer present, they don't use 'em anymore. The foreground had its origins in some buildings and the ground and certain nautical elements that happened to be strewn about.

At this point Wingate presses Davis, asking if he can understand "why the average man would not see … the riggings of the schooners." Davis retreats, rescuing the average man along the way: "There are no riggings of schooners here; I was only describing the origins of the subject." Wingate: "What *is* there?" Davis: "What is here is an objective order consisting of colors in different positional relationships. That's a tangible, physical thing, a thing that makes it a … piece of public property. The particular order of this painting is established by a subjective determination, as in all art." Wingate: "As you see it in other words?" Davis: "Well, as you feel it." So ends the round.

Davis is toying with Wingate. In revealing the figurative origins of the painting, he begins to offer the kind of decoding Wingate has requested, but in the next breath he retracts it, lamenting that schooners are "no longer present." The phrase is ambiguous, and it turns out he means two things by it. First, they are no longer used for fishing in Gloucester. (Their replacement by diesel-powered vessels was already underway by 1915, when Davis began summering there.)[2] Second, they are not shown in the picture, which is just a formal organization, an abstraction. (So much for their elegant lines being "obviously" there.) Are these two things connected? Did Davis leave the schooners behind because history left them behind?

Wingate does not ask, but time and tense do seem to be on Davis's mind. Note his choice of words in talking about the painting: *this, here, present, is*. It is the language of immediacy and presentation, not distance and representation. Davis says *here*,

Wingate says *there*, Davis responds *here*—a little tug of war under the veneer of 1950s banter. (The interview is full of such telling moments, and much of the credit is due to Wingate, a brilliant and tragic figure in New York broadcasting.)[3] *Depiction was then, abstraction is now*, Davis seems to say, even if his abstraction never quite escapes its origins in depiction. In a double disappearing trick, the schooners have left *Memo* just as they have left Gloucester. A subject has been beaten.

MOTIVE

It is difficult to think of an artist who returned to his own work more persistently than Davis. While this self-recycling has never been a secret, its extent did not become clear until the publication of the catalogue raisonné of the artist's work in 2007. As Earl Davis, the artist's son, tallies it up in the preface, "Most significant and surprising … was the discovery … that a full 71 percent of the oil paintings and caseins on canvas … from 1940 to 1964 were actually based on compositions … first drawn or painted during the 1920s or early 1930s."[4] If we include the later 1930s (and there is no reason not to), the count is closer to 80 percent.

Let us be clear what this is *not*. It is not the modernist habit of painting a series over weeks or months, as Claude Monet did with his poplars along the Epte, although that is a related practice, one which produced some of Davis's major work (the tobacco paintings and the egg-beater still lifes). Nor is it the actual reworking of older canvases, as Jackson Pollock did with the 1947 *Galaxy*, pouring paint over an earlier brushed painting, although repainting was not unknown to Davis either, the most dramatic example being *American Painting* of 1932/1942–1954 (pl. 37). Nor is it the phenomenon of a motif cropping up repeatedly in an artist's oeuvre as if of its own volition. In 1956 Davis's longtime dealer, Edith Halpert, mounted a show called *The Recurrent Image* that attempted to demonstrate just such an unconscious dynamic. The exhibition's leaflet juxtaposed details of paintings by Davis from 1953 and 1928 with a squatting figure from one of his 1920 Cuban watercolors (misdated 1919 on the cover), thus proposing a figurative genealogy for a particular curved form in his work (fig. 1). Asked about the exhibition by Harlan Phillips in an extensive oral history conducted in 1962, Davis replied, "The idea didn't bowl me over, I must say."[5]

No, what concerns us here is not an uncannily recurrent image but a deliberately recursive artist, one who reached back—way back—in order to move forward. When did Davis start to work that way? Why did he do it so publicly, admitting on television to something normally associated with a lack of inspiration and imagination?[6] What motivated his choices of earlier works? How did he repeat or transform them? What did he get out of it? These are central questions for anyone trying to understand Davis's distinctiveness, his paradoxical originality. They boil down to a single question, one of intention or purpose: Why did he do it?

To attempt an answer, we will look at the two major categories of recursion in Davis's work. First, starting in 1939, he began taking his old sketches of Gloucester and its schooners, mostly from 1932, as the basis for new work. Two years later, starting in 1941, he opened another tunnel in the mine, this time going back earlier, to his 1921–1922 cubist paintings. In each case, he continued to work these veins for two decades, into the 1960s. (He died in 1964.) We will look closely at some of the individual works and

1

groups of works involved, treating them as case studies. Along the way, we will explore the ideas that informed Davis's art, writings, and statements—ideas like permutation, contradiction, dialectics, influence, abstraction, signification, and recursion itself—and we will search his biography for clues to his intentions. Finally, we will explore one unusual case of nonrecursion for whatever help it may offer in the negative. But let us begin with a comparative glance at two other artists who could not stop repeating themselves.

TWO CASES

The degree of Davis's recursion may be "unprecedented," as Earl Davis suggests, but there are at least two artists in the modern era who come close.[7] One is Jean-Auguste-Dominique Ingres. "After 1850 (which is to say for the last seventeen years of his life) he undertook no new compositions, spending his time instead redoing through replicas and variants the contents of his published catalogue: the 1851 *Works of J.-A.-D. Ingres.*"[8] Another is Medardo Rosso: "Rosso's oeuvre comprises fewer than fifty subjects, all of which he conceived between 1881 and 1906. For the remaining twenty-two years of his career he devoted himself to recasting and varying these models in a myriad of visual possibilities."[9] These cases suggest that redoing is a late-style phenomenon, a retirement into tinkering. The implications are unflattering. Of course, we can always answer that a given late work departs significantly from its earlier model, but defensiveness only gets us so far. In order to plumb the issue of motive, we should face the repetition head on.

To their credit, that is exactly what the scholars just cited do. For Rosalind Krauss, Ingres was driven to repeat by the ideal of capturing universal truth in pure form. His 1860 remark acidly expresses this perfectionism, with its implicit critique of his previous work: "I am taking up again the picture of *Raphael and La Fornarina*, my last edition of this subject, which will, I hope, cause the others to be forgotten." In Krauss's

deconstructive analysis, the dreamt-of goal, doubly represented by the art of Raphael and classical sculpture, constantly evades Ingres's grasp, leading only to further attempts, because the ideal of universal truth, like that of pure presence or ultimate origin, has repetition at its core: "Its status as a model is that it is repeatable." And so Ingres "like a frantic stutterer, repeated the initial, excessively static vocable of his tale."[10]

Rosso's self-repetition was driven not by an external ideal, Sharon Hecker argues, but rather by the artist's psychological and physical identification with his work. In giving up original modeling for reproductive casting in 1906, Rosso did not abandon his Paris atelier; rather, he converted it into a foundry where he would recast earlier works, welcoming the accidents and accretions normally banished or burnished away. At well-attended soirées the artist grappled with wax and plaster, fire and molten metal. In this spectacular identification of artist and work, Hecker finds a healthy egoism, a "longing for Narcissus, for self-reflection." And yet, she concludes darkly, "the process became an endless Echo-and-Narcissus-like pursuit of the object that could only end with the artist's death."[11]

However different they may be, both of these accounts view repetition as obsessively directed to an unreachable goal, and suggest that the drive is released by a particular event. In the case of Ingres, it was the publication of the 1851 catalog of his complete work, a strange project by Achille Réveil, with Ingres's involvement, to translate the corpus of his paintings into reductive, clear-line engravings. Hecker is more circumspect about a trigger for Rosso, but she dwells on the Rodin-paranoia theory, by which Rosso was "fixated on the notion that Rodin had not acknowledged his debt to him," a debt apparently confirmed by the strong resemblance between Rosso's *Bookmaker* circa 1894 and Auguste Rodin's 1898 *Monument to Balzac*.[12] Rosso would deny Rodin new ideas by refusing to produce any at all.

While Davis is obviously a very different artist, let us keep Ingres and Rosso in mind as representing opposite motives for recursion: the urge to erase mistakes versus the embrace of experiment and accident. Let us also keep in mind the shared premises of their respective interpreters: that recursion is a compulsion, and that its onset is significant and bears looking into.

ONSET: POVERTY AND POLITICS

On July 25, 1938, Davis jotted down some exhortations to himself, probably never intended for publication, and indeed unpublished until now. He resolved to make paintings that would, he wrote,

1 – Be liked by French artists

2 – Be distinctly American

3 – Be easy to execute

4 – Be large in size

5 – Contain the major proportions of some of my earlier works as its basis, thus bringing out the esthetic essence which was confused by other details

Davis expands on each point, writing about the last one: "To extract esthetic essence from earlier works. To save time by using material already on hand. To improve my

standing by raising the critical opinion of the value of my past work."[13] One could not hope for a clearer statement of intention. Davis's recursive habit, it turns out, was a deliberate plan to boost production, call attention to earlier work, and improve on that work by simplifying and clarifying it. Of these goals, we can dismiss the third, at least for now, since Davis's recursions tend to add rather than subtract complexity. We are left with pragmatism and careerism. End of story—or is it?

To put this remarkably frank note in context, let us dip into Davis's biography. In the summer of 1938, we find him working hard as a government muralist. Having labored through the spring to finish *Swing Landscape* (pl. 40), originally intended for a Brooklyn housing project but now destined for a show of Federal Art Project work, he receives, in June, another FAP commission, this time to paint a mural for WNYC, New York City's municipal radio station (pl. 41). By August he finishes the design. He is also thinking about a mural for the Hall of Communications at the 1939 World's Fair and serves on a jury to select other artists for an exhibition there. Despite the demand for his talents, he struggles to make ends meet. He is drinking heavily and has been recently diagnosed with high blood pressure. He and his second wife, Roselle, share a rat-infested apartment on 7th Avenue and 13th Street in Manhattan. It is a third-floor walk-up, not easy for hauling ice to the icebox or coal to the stove. Having managed the previous year to get the art dealer Samuel Kootz to pay him a $50 debt, Davis is now reduced, once again, to making fabric designs for Kootz's textile company. With the eighteen-month limit on his employment by the FAP looming, he testifies to Congress (in vain) in February 1938 on behalf of a permanent federal arts bill.[14] By 1940, he and his wife are begging friends to buy paintings and accepting handouts from them when they do not. "The public is no better than an omelet," Davis declares bitterly, and perhaps hungrily, in the newspaper *PM* in August of that year.[15] Davis himself is, to put it simply, a beat-up subject.

Given what must have been the galling gap between his poverty and his prestige—at age forty-six, he is admired by such younger artists as Willem de Kooning, Philip Guston, and Arshile Gorky—it is no wonder that Davis is looking for a turnaround. With three decades of work and dozens of unsold paintings behind him, why not recycle the past rather than strive for another breakthrough that would only be ignored by the market again? Davis's note, born of hardship and ambition, is a decisive shift, one that would reshape his career more than he could have realized.

Something else is shifting in the summer of 1938. With Europe on the eve of war and the Soviet Union, despite its opposition to Hitler, behaving more like an autocratic empire than the keeper of a noble experiment, it is a time of crisis for American left-wing intellectuals and artists. Davis has been central to these circles ever since joining the John Reed Club in 1933. He has done more organizing, writing, speaking, meeting, and marching than painting, taking on a string of leading roles in the Artists Union, the Artists' Committee of Action, their magazine *Art Front*, and the American Artists' Congress, to which he has just been elected president in December of 1937. From that pulpit he fights to improve the living conditions of artists and to make their voices heard on issues of concern.

While not a member of the Communist Party, Davis is as engaged with Marxism as any major American artist. He applies concepts of dialectical development and

internal contradiction to matters of composition, as we will see, and he grapples with Marx's economic and social theories directly. A note from his journals dated August 25, 1938, finds him fending off reflectionism, the vulgar (as it is often called) Marxist view of art as a superstructure that simply mirrors changes in the basic realities of economics and class: "Art comes from non-art. But art reacts on the non-art and changes it… The saying of Marx that the task of philosophy is not merely to explain the world but to change the world, applies very strongly to art. Art is by its very nature a revolutionary agent."[16] The phrase "by its very nature" is key: as a confirmed modernist, Davis believes that art must answer to itself rather than to politics.[17] The task of squaring this art-first modernism with his Marxism is not easy, and having to defend his work from charges of bourgeois formalism is tiresome for him. By March 11, 1940, soured by political events, Davis is fed up with Marx: "To Marxism all art is an illusion which masters the rotten nature of the base it rests on… What rot and what escapism … and what an under-evaluation of man in this philosophy which says to each historical epoch, Your culture is a mere reflection of your limitations."[18]

What happens around and between these two journal entries constitutes a familiar litany: the Moscow show trials in the spring of 1938 (which Davis publicly supports in a letter to the *New Masses*, for which he and photographer Paul Strand collect some 150 signatures); the Munich Agreement in September ("Chamberlain sold out world Democracy to Fascism," Davis notes in his journal); the Nazi-Soviet nonaggression pact of August 1939 (a blow that Davis tries to deflect by arguing that the Artists' Congress should limit itself to issues of art and culture); and the Soviet invasion of Finland in the spring of 1940 (which the Artists' Congress endorses on April 4 despite Davis's best efforts).[19] That endorsement is the last straw. Davis quits the congress the next day, bringing his active political life to an end. Some thirty other artists soon follow. By the summer his about-face is clear, his tone pugnacious.[20] "There is nothing like a good solid ivory tower for the production of art," he writes on June 2. And a year later: "If any care to call this viewpoint 'art for art's sake,' let them make the most of it."[21]

It is time to face the question we have been circling—namely, what to make of the fact that Davis's recursive turn, planned in 1938 and put into practice (as we are about to see) the following year, coincided with his rejection of Marxism and politics. Both shifts involved a turn inward, suggesting that his recursion was no accident of timing but a flight from current events, a retreat from the world that his murals of the past five years—with their saxophones and motorcars, newspapers and microphones, skyscrapers and campaign symbols—had sought to engage in some detail. Instead he embraced art about art, or at least art about art about still lifes and old boats.

But to paint with such a broad brush is to miss the complexity of the moment. In the July 1938 note about boosting his own artistic production, we see Davis at once on the brink of his disaffection with Marxism and at his Marxist best. His demystification of creativity is palpable: "When the impulse to create has been analyzed the data should then be used to carry on the execution of the impulse in an objective manner without further subjective search."[22] His class analysis is clear-eyed. Art must appeal "to a cultured audience, the upper bourgeoisie and technical experts," he reminds himself, even as he maintains a populist stance in public, writing to the *New York Times* that "artists today … don't want an art that means nothing and that is not for the masses."[23] He

knows that the bohemian avant-garde, as the critic Clement Greenberg wrote in 1939 in his own Marxist moment, is tied to the bourgeoisie that it disdains "by an umbilical cord of gold."[24] As if to sharpen that class irony, Davis takes the tone of a worker who has just realized the value of his labor and must make a note: "save time by using material already on hand." He is also his own foreman, running the assembly line (as he indicates in elaborating on point 3): "allow speed in production with the result of more pictures which is both an artistic and commercial asset." Without Marx's labor theory of value or analysis of class, could Davis have grasped so clearly what had to be done to survive—or, in Marx's terms, to *reproduce* himself?

Davis was tired of being an impoverished muralist and labor leader. The man who had proudly predicted in 1922 that he would become "America's artist" had produced only sixteen paintings in the five years between 1933 and 1937, most of them small harbor scenes.[25] The solution was to go back to the future. But the fact that he would continue to work in a recursive way for the next quarter century, long after he had achieved security and even some renown, still demands explanation. The question of motive cannot be retired just yet.

PRIMAL HARBOR SCENE

Most commentators speak of 1940 as the start of Davis's recursions. It is a handy date, and indeed it saw the production of two of Davis's most important recursive paintings: *Report from Rockport* (pl. 47), based on the circa 1929 *Town Square* (pl. 25), and *Hot Still-Scape for Six Colors—7th Avenue Style* (page 11, fig. 8), based on the 1928 *Egg Beater No. 2* (pl. 15). However, a closer look reveals two recursive paintings (along with several related gouaches) from 1939: *Shapes of Landscape Space* (pl. 42), from the *Memo* group, and the now-lost *Harbor Landscape*. In both cases Davis returned to the pages of a sketchbook that he had filled along the so-called North Shore of Massachusetts in 1932.[26] (In the former case there was also an intermediary painting, from 1935, as we will see.)

This means that the starting block of Davis's recursions, the scene to which he returned first, was Gloucester and its schooners, those impressive, multimasted sailing vessels designed for fishing. The etymology of "schooner" is unknown but the word seems to have originated in a Gloucester shipyard.[27] In his brief 1945 autobiography, Davis recalled his first visit in 1915:

[Gloucester] had the brilliant light of Provincetown, but with...the architectural beauties of the Gloucester schooner...I do not refer to its own beauty of form, but to the fact that its masts define the often empty sky expanse...They make it possible for the novice landscape painter to evade the dangers of taking off into the void as soon as his eye hits the horizon. From the masts of the schooners the artist eventually learns to invent his own coordinates when for some unavoidable reason, they are not present.[28]

The schooners are disappearing again, unavoidably! This time, there is a third explanation (in addition to the two he gave Wingate in 1957): Davis seems to have stopped going to Gloucester regularly in the later 1930s.[29] For the first half of the decade, however, it was still his refuge from New York, where he was too busy for easel painting.

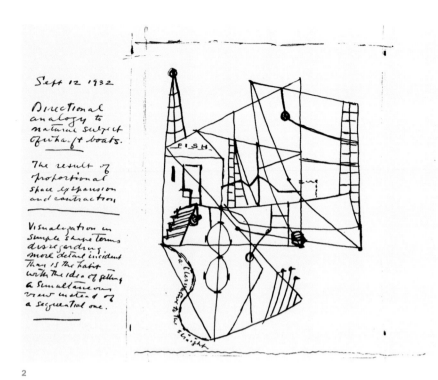

Sept 12 1932

Directional analogy to natural subject of wharf boats.

The result of proportional space expansion and contraction

Visualization in simple shape terms disregarding more detail incident than is the habit — with the idea of getting a simultaneous view instead of a sequential one.

2

As a draftsman on the North Shore he was prolific, filling some twenty sketchbooks with harbor scenes between 1931 and 1936, several of which he retrieved to compose his greatest mural, *Swing Landscape* of 1938.[30] It is no surprise that he turned to the same sketches when he began to look for a subject to beat up in 1939.

The sketch that he chose to kick off the *Memo* group is from September 12, 1932 (fig. 2). More than a drawing, it includes marginal notes, written in energetic cursive, that touch on two of Davis's abiding theoretical interests, "proportional space expansion and contraction" and "getting a simultaneous view instead of a sequential one." Let us consider the former point (Barbara Haskell's essay in this volume treats the latter). The sketch is a nice demonstration of his idea that space in a drawing or painting, rather than being given by a perspective scheme, should emerge from a flux of near and far played out on the page or canvas. As he put it in 1956, using a well-worn term from Hegel and Marx, "front-back position is dialectical."[31] In this sketch, the deepest space seems to be at center, where two small ladders of rigging cleave together, while the rest of the configuration reaches out to us as it approaches the edges of the page. But this is only one reading, and it is quickly canceled if we follow the principal diagonals that crisscross the image from bottom to top in a reversed Z, guiding us more traditionally into depth from some levers in the foreground to the shed in the middle distance to the tackle hanging in the background—all while keeping us (in a third reading) on the surface, which the backward Z emphasizes.

Another page from the same sketchbook, more abstract and schematic, lays bare this braiding of surface and depth, near and far (fig. 3). In this little diagram, which he would revisit several times before enshrining it in the 1962 painting *Unfinished Business* (pl. 81), Davis takes the grid of Renaissance perspective and pulls and twists it out of shape.[32] At lower left a pavement of four squares recedes in more or less proper perspective, while at top right a flying pennant, joined to the pavement by a wedge-like hinge, undoes any recession. In the remaining corners, the letters X and O hold court.

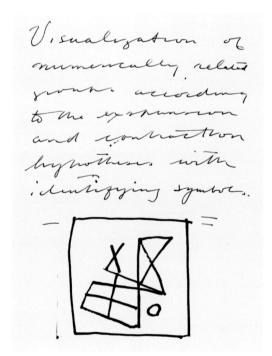

Visualization of numerically related groups according to the expansion and contraction hypothesis with identifying symbols.

3

A marginal inscription referring to "the expansion and contraction hypothesis with identifying symbols" makes it clear that the *X*, with its dynamic radiating arms, stands for spatial expansion, while the self-contained *O* stands for contraction.[33]

It was the diagonal that activated the flux between the two, as Davis noted on another sketchbook page: "The mode of expression is by means of angular variation … creating space … which is either expansive or contractive according to the point of observation."[34] John Lane describes this sketchbook as one in which Davis "further developed his thinking about the central role of the angle in design," something that had already been on his mind for at least a year.[35] For Davis, it seems, the epitome of angularity was rigging. It diagonally connected verticals (masts) to horizontals (decks), and it appealed to his love of equipment as well.[36] Rigging was strong and flexible. You could pull and twist it. It held things up and linked them. You could crawl all over it.[37]

Just as lines of rigging converge at the upper left of the *Memo* sketch, there is a similar moment at the bottom right of a sketch that spawned another group, the *Midi* group (fig. 4). If we rotate the latter sketch 90 degrees counterclockwise and then mirror-reverse it, relocating the point of convergence to the upper left, we arrive at a configuration very like that of the former. Davis nodded to the connection when he titled a small 1940 painting in the *Midi* group *Shapes of Landscape Space #3* (pl. 45), thus linking it to *Shapes of Landscape Space* of the *Memo* group from the previous year. Further, *Midi* (pl. 61), the final painting in the *Midi* group, shares the same dimensions, year (1954), and palette (more or less) as *Tournos* (pl. 60), the penultimate painting of the *Memo* group.

Finally, *memo* and *midi* are both four-letter words beginning with *m*. Such intergroup visual-verbal play reflects Davis's love of permutation.[38] "Any move you make is as important as any other move," he once reminded himself.[39] As a young man he was so dedicated to chess that, as he recalled, "I would dream about it at night, make combinations in my sleep. It can get very wearing."[40]

THE MEMO GAME

We have seen how Davis elevated certain Gloucester sketches in retrospect, using them as the basis for several later groups of work (*Memo*, *Midi*, *Unfinished Business*). It seems plausible that he did this to call attention to them as milestones, as manifestos that both declared and enacted his theories. With their strong lines and spiky silhouettes, these graphic configurations burn themselves into memory — and if they do not, then perhaps a little repetition will help, a deeper carving of the glyph. In repeating himself, Davis was reminding everyone of his key inventions.

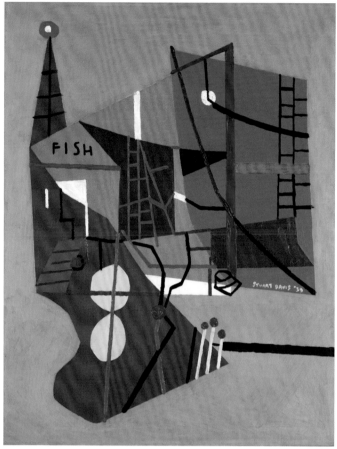

5

6

This account would seem especially fitting for the *Memo* group. (The word *memorandum*, as originally used in Middle English manuscript notations, meant *to be remembered*, a note to the future about the past.)[41] After all, the four paintings in the group, almost identical in size and shape, remain remarkably true to the 1932 sketch, with color serving as the most notable source of variety. A closer look, however, reveals more than mere reinscription with variation. Considered as a series, the *Memo* group is a chess game between two opponents, line and color, or more broadly, drawing and painting, played out in four moves, with the original sketch as starting position.

Move 1. In *Landscape* of 1932/1935 (fig. 5), Davis translates the sketch into a black-and-white painting on canvas, making the lines uniformly thick and deleting the words within the sketch (the *FISH* sign) and on its margins (the theoretical notes). The effect is to convert the sketch into an autonomous work, to make it both more impressive and a little more abstract, more surface *pattern* than rendered *picture*.[42]

Move 2. *Shapes of Landscape Space* of 1939 (fig. 6) introduces color, dividing the motif into regions of brown, orange, blue, and red all set against a green ground. By using these colors to slice the image into smaller chunks, into shapes of landscape space, Davis makes it more digestible, more picture than pattern. Accordingly, he brings back the fish sign to help convey the setting, and he adds knobs to the levers in the foreground as if inviting us to reach out and operate his space machine. The function of color here is in keeping with Davis's belief that drawing is primary and inventive, color secondary and instrumental. "Interesting work must be a <u>DRAWING</u>," he notes, while color is simply "the <u>Means</u> by which ideal space relations are made visible."[43]

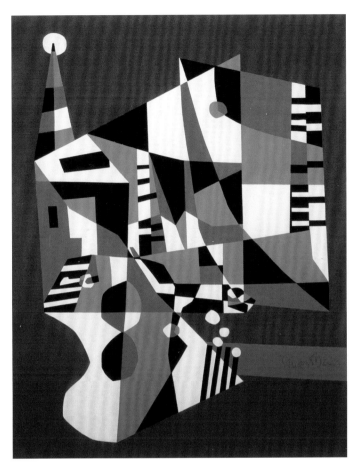

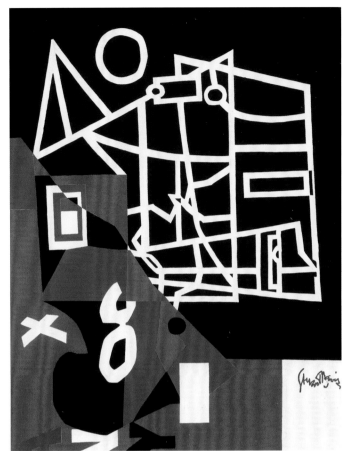

7

8

FIG. 5 *Landscape*,
1932/1935, oil on canvas,
Brooklyn Museum (pl. 36)

FIG. 6 *Shapes of Land-
scape Space*, 1939, oil
on canvas, Neuberger
Museum of Art (pl. 42)

FIG. 7 *Tournos*, 1954,
oil on canvas, Munson
Williams Proctor Arts
Institute, Museum of Art
(pl. 60)

FIG. 8 *Memo*, 1956,
oil on linen, Smithsonian
American Art Museum
(pl. 69)

The game is suspended for fifteen years.

Move 3. In *Tournos* of 1954 (fig. 7), Davis uses color to opposite effect, making the image less legible by turning it into a patchwork of black, white, blue, and green that sparkles and dazzles, while the red background offers none of the relief provided by the muted green in the previous painting. The title suggests this reversal in the role of color as well as a turning in the game from picture back to pattern. Drawing is suppressed: there are no painted or drawn lines, only linear edges where color planes happen to join. Many of these edges read like arrises, those sharp ridges where planes meet in the crumpled space of cubism, and indeed this is precisely the kind of painting that opened up Davis to perennial charges of being nothing more than a late cubist. This is also the kind of painting that Wingate must have had in mind when he baited Davis by reminding him that a reviewer had compared him to "grandma ... making a patchwork quilt." Davis refused to take offense, insisting, "It was a legitimate thing, the quilt, let's not disdain it." The key patch in Davis's quilt is the upper half of a figure eight, which seems to derive in the sketch from a line of rope winding around cleats, and which has been quartered into the basic colors of the composition.

Move 4. In *Memo* of 1956 (fig. 8), Davis brings the series to a close by returning to its linear origins — but only in the upper half and in negative fashion (white on black) — while treating the lower half entirely in terms of colored shape. Significantly, *Memo* started with line alone, as three photographs of the work in process testify.[44] (Davis almost always worked this way, starting with a drawing on canvas that he would then translate into color and occasionally preserve as a purely black-and-white painting

too.) It was only midway through the painting process that the work split into its two halves, reflecting a fundamental split in Davis's art. Both halves of the painting still derive from the Gloucester sketch, but they connect awkwardly. To underscore the bicameral structure of the painting, Davis extends the split to the sides of the canvas and adds opposing symbols, an O at the top and an X at the bottom, which now seem to stand not just for expansion and contraction but for contradiction itself.[45] Areas of color and lines are presented as opposing forces, no longer partners in a project of legibility. The opponents play to a draw, which is how tic-tac-toe, the game of X's and O's, usually ends. In this new context, the figure eight takes on symbolic value as well, suggesting infinity, but its circuit has been slightly interrupted, leaving a loose end — one that we will gather up at the end.

Stepping back from the game, whether it is chess or tic-tac-toe, we can see its shape: from all line (move 1) to a balance of line and color area (move 2) to all color (move 3) and back to balance, sharpened into contradiction (move 4). The first player is the bold one while the second keeps trying to reestablish equilibrium. And yet what makes this a progression rather than a back-and-forth that simply comes to a halt is that the last move (*Memo*) is not a replay of the second (*Shapes*) but a criticism of it. True, color areas in *Memo* share the canvas with linear elements, just as they did in *Shapes*, and to that extent it repeats the earlier work. But line and color in *Memo*, rather than interpenetrating, stay in their respective corners, like antagonists kept at bay. Their intermingling in *Shapes* (according to the implicit critique of *Memo)* was a false or premature synthesis, one that painted over the tension between the two terms rather than acknowledging it.

Let us go a step further: *Memo* proposes that not until drawing has been negated (become a negative image, white on black) can it hope to coexist with color at all.[46] This notion of simultaneous negation and preservation, or preservation through negation, challenges all normal logic, which is precisely why it has its own name in philosophy: sublation (*Aufhebung*). That was the word used by Hegel to describe what he regarded as the fundamental pattern of human progress, whether in history or aesthetics. He defined sublation, the engine of dialectical advancement, as "an annulling … at the same time conservative and elevating in its operation." According to a leading Hegel scholar, sublation is best defined as the cancelation or suspension (whether mutual or one-way) of a concept or thesis by its opposite or antithesis, resulting *not* in a synthesis (Hegel never used the term in that context, contrary to common belief) but in "a whole in which both [the thesis] and its opposite survive as moments," a whole "invariably higher than, or the truth of, the item(s) sublated."[47]

To the extent that *Memo* achieves such a state of integration, advanced but still provisional, whole yet still divided, it does so by sublating drawing, the original or primary term for Davis in the drawing-painting opposition, with color. The thickly drawn negative image in the upper half of *Memo* is what drawing looks like when it has been thoroughly permeated by color — not literally by color itself but by the principle of color, at least its leading principle for artists since the nineteenth century, that of the simultaneous contrast of adjoining areas (in this case black and white) without the intermediary of bordering lines. We have gone from tic-tac-toe to dialectics.

We know that Davis, who never seems to have mentioned Hegel, would have imbibed the philosopher's concept of progress through opposition, negation, and contradiction from Marx, who famously converted Hegel's dialectics into his own dialectical materialism.[48] A note from 1937 finds Davis at his most Hegelian: "By dialectics is meant the process by which esthetic form develops… It starts with the presence of 2 opposing space systems which establish a specific planal [sic] relationship. This primary contradiction in unity is the initial impulse in a dynamic process which continues through contradictions to develop."[49] As with much of Davis's theory, this is not easy to parse, nor do we need to do so here. The point is that Davis thought in dialectical terms, that he believed in opposition or contradiction (related to but stronger than tension or contrast) as the engine of aesthetic progress.

We also know that Davis regarded the opposition between linear elements and color areas as a fundamental one in his work. As he told Phillips:

When I painted in Paris… the lines and the areas were two different things… I've found the answer to that because I don't make any distinction between lines and areas. I find them to be the same things. Well, it took me years to do that. I used to solve it by color intervals. A line could take a place because it had a greater contrast to its surroundings than a larger area. *Now* I don't think about that at all. I only use a few colors, and they all hold up all over the picture whether they are lines, or whether they are areas, so I solved that by logic and years of wondering what the hell it all meant.[50]

Here is a passage worth parsing, one of the few in which Davis describes the arc of his formal development. The "now" of the statement is 1962, which locates the 1956 *Memo* at the prior moment described, when Davis was making progress but still hewing to a distinction between line and area, balancing them out.[51]

It was only in his last works—the 1963 *Contranuities* (pl. 82) and the 1963–1964 *Blips and Ifs* (pl. 83)—that Davis finally let go of the line-area distinction. But this strange fashion of forsaking—"I don't think about that"—is easier said than done. How does he manage it? One way is by magnification, that is, enlargement plus cropping, which is exactly what *Blips and Ifs* does to a portion of *Standard Brand* of 1961 (pl. 79). This widens the lines until they become undeniable areas in themselves. It is as if Davis took his own injunction at the top of *The Paris Bit* (pl. 78) to heart: "lines thicken." We might add, looking at the green, red, and black lines of *Pochade* (pl. 75): "lines color." (No doubt Davis picked up on Piet Mondrian's dramatic shift in 1941, a year after he moved from London to New York, from black to colored line, dissolving the dualities at the basis of his classic work; the two men bonded in 1942 over their shared interest in jazz.)[52] At this point, with the distinction between line and area gone, the association of color and area is ipso facto broken, and Davis in the 1960s is free to regard all elements, "whether they are lines, or whether they are areas," as color.

Memo came in the mid-1950s, during the "years of wondering what the hell it all meant." It is indeed a memorandum, not just a memento, and its Hegelian message is clear: *don't fear contradiction*. Asked about his reading habits by Phillips in 1962, Davis expressed his fondness for Dostoyevsky, Chekhov, and Gogol, explaining that he liked them not for "the heavy jive" (Phillips had immediately associated these Russians with the words *deep* and *moody*) but because "they were full of the dynamics of contradiction

which appealed to me… which is stimulating and not depressing."[53] Contradiction is normally regarded as a problem, whether in aesthetics or logic; for Davis, the sometime Marxist, it was a blessing.

Let us take the final step: *Memo* is a Marxist abstraction. Like the schooners, the Marxism is present in its absence. (Canceled and preserved: such is Hegel's mind-bending logic.) It has disappeared and keeps disappearing. *Marx* is a four-letter word beginning with *m*.

NAILED TO THE TABLE

Davis's second recursive campaign begins in 1942 with *Arboretum by Flashbulb* (pl. 48), *Ultra–Marine* of 1943 (pl. 49), and a third painting of similar style and proportions, *Ursine Park* of 1942, now lost. It continues with the small duo *Pad #1* and *Pad #2* of 1946, and then takes off in the 1950s with over a dozen major paintings. All of these go back to his small cubist paintings of the early 1920s, and once again we must ask why. Why beat up on these unimpressive canvases? At first glance, it would seem hard to

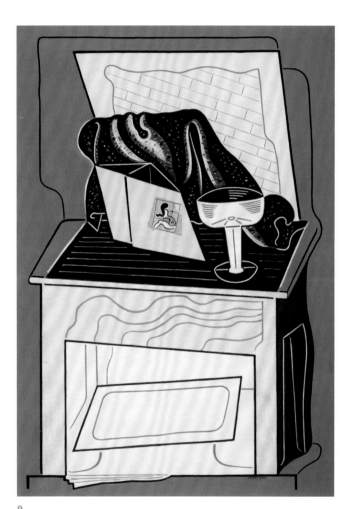

9

imagine a body of work more different from the line drawings of Gloucester, and yet Davis's early cubist efforts share many of the same qualities: they present a busy scene of tension and dynamism, a space of ambiguous flux between near and far, a play of contraction and expansion. Indeed Davis would not have seen the Gloucester harbor as he did if it had not been for his prior encounter with cubism, which was his greatest formative influence. As with the recursion to Gloucester, this one is deeply dialectical, a matter of both preservation and cancelation. By the time Davis gets done with cubism, as with the harbor, it is not there anymore, but its vestiges remain.

We will turn shortly to one of the groups in this campaign, the *Rapt* group. But first let us consider a precursor to the cubist recursions, a little-noticed prior episode, partial and imperfect, involving a single 1925 painting, *Super Table* (fig. 9). This work has been recognized as a key painting for Davis, a gateway to maturity made at a time of growing confidence. What makes it equally important for our purposes is that it represents his first backward glance to his cubist apprenticeship.

Dipping back into the biography, in 1925 we find the thirty-two-year-old artist meeting and, against his mother's strong wishes, moving in with Bessie Chosak. The following fall he urges Katherine Dreier, a great patron of the avant-garde advised by Marcel Duchamp, to include him in her next Société Anonyme show, which she does, with *Super Table*. The exhibition is "an inspiration" to Davis, one that opens his eyes to the work of El Lissitzky in particular. At the end of the year, another great patron, Gertrude Whitney, advised by Juliana Force and knowing that Davis is broke, gives him a monthly stipend of $125. Freed of financial worries for a year, he is able to focus on the works that will become his breakthrough series, the egg-beater still lifes, and make him known as the egg-beater painter.[54]

We can draw a direct line forward in time from *Super Table* to the four egg-beater pictures, picking up *Percolator* (pl. 13) and *Matches* (pl. 12) along the way. The line begins under the table (not super- but sub-, always an interesting place to look) where a near-parallelogram settles awkwardly within a trapezoid. This is a spatial knot, a Lissitzky-like moment of undecidability or "reversibility" in an otherwise superlegible painting.[55] Does the parallelogram float in space or sit on the ground? Is it parallel to the picture plane or receding? Does it depict a carpet under the table or a sewing-machine treadle stuck in a fireplace? The blinding whiteness of this *sous-table* space, just where shadows (often good spatial clues) ought to lurk, does nothing to help us decide, nor do all the disconnected lines, straight, bent, and curved. This is spatial flux at its most glaring.

A similar parallelogram-in-trapezoid, more muted and well-behaved, defines the lower-right half of *Percolator*. Here the two unlike quadrilaterals are connected to each other in a legible box. This box then expands to fill the canvas in *Egg Beater No. 2*, opening to our view like a theater stage seen in one-point perspective—only to be rudely interrupted by a parallelogram that stretches across the canvas. The interruption will turn into full-blown destruction by 1940 with *Hot Still-Scape*, where color and pattern run amok and only the right stage wall of *Egg Beater No. 2* remains.

The stretched parallelogram of *Egg Beater No. 2* has its origins in another part of *Super Table*, this time above the table. There, an improbably folded letter or postcard bearing the image of a surrealist female nude (how Davis must have enjoyed reducing that movement to the status of a canceled postage stamp!) emerges from a backdrop of sinuous drapery. Here is another moment of acute (and obtuse) spatial undecidability, but rather than import it directly into the egg-beater pictures, Davis has taken up its iconographic suggestions instead. Approaching *Egg Beater No. 4* (pl. 17) with this tabletop object in mind, we begin to see scraps of envelopes with their cleverly overlapping folds everywhere. More important, we sense the kind of operational space that envelopes imply, a space of slicing open and unfolding, of looking around and into.

Davis's well-known recollection of the making of the egg-beater still lifes—"I nailed an electric fan, a rubber glove and an eggbeater to a table and used it as my exclusive subject matter for a year"[56]—is probably true, even if the nails seem excessive. But in setting off a futile hunt for reference (can you find the blue-gray handle in *Egg Beater No. 2?*) his statement has served to obscure, perhaps intentionally, just how much he was studying something else at the same time: *Super Table*. And what if anything did *Super Table* set up for scrutiny? It was a painting that Karen Wilkin judges one of "the most elegant and accomplished Cubist … still lifes … ever produced in the United States": *Red Still Life* of 1922 (fig. 10).[57]

Davis was a latecomer to the cubist party. Either he missed the analytic cubist paintings by Picasso and Braque at the Armory Show in 1913 or he was not ready to see

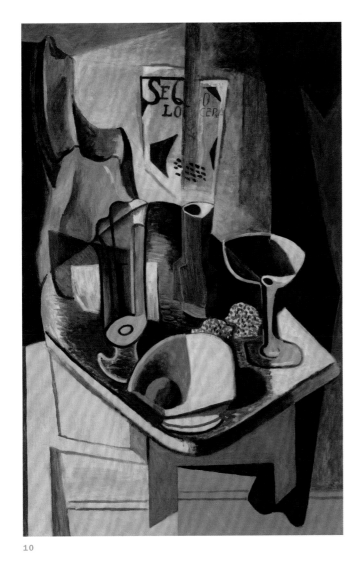

10

FIG. 9 *Super Table*, 1925, oil on canvas, Terra Foundation for American Art (pl. 11)

FIG. 10 *Red Still Life*, 1922, oil on canvas, Collection of Jan T. and Marica Vilcek, Promised gift to the Vilcek Foundation

them. As he told Phillips somewhat uncertainly in 1962, recalling the revelation of the Armory, "Cubism wasn't really developed at that time, at least in the show I don't think so." Rather, it was the "arbitrary" color of Vincent van Gogh and Paul Gauguin and the equally "arbitrary" drawing of Henri Matisse that bowled him over.[58] Michael Fitz-Gerald suggests that his real exposure to cubism did not come until 1921 and 1922, at exhibitions of modern art in Brooklyn and at the Metropolitan Museum, which stimulated in Davis a flurry of cubist paintings.[59]

Of these, *Red Still Life* is the most attentive. The palette of earths and grays, the black and white strokes on the tabletop that blend into one another, the rear edge of the table that both cuts through and defines the fluted glass carafe, and the motif itself, a café scene complete with poster on the rear window or wall—all these pay careful homage to Pablo Picasso and Georges Braque's analytic cubism of 1908 to 1912. Nor is Davis unaware of later developments: two piles of black and umber spots on the table recall the next, synthetic phase of cubism, in which Picasso played with pointillism, and the strong silhouettes and shadows along the right side show the influence of Juan Gris.[60]

Davis's cubist paintings of the early 1920s have not captured the interest of many commentators, but Davis himself kept going back to them. *Super Table* is a deliberate return to *Red Still Life*, starting with the impressive, almost identical size and tall shape of the two canvases.[61] Other similarities include the cocktail glass at right; the space under the table, shaped like an inverted, squared-off *U*; the tipped-up tabletop itself, rendered in glinting black and white; and the dark pile of drapery set off by a brighter background plane. And yet *Red Still Life* and *Super Table* are not considered related works in the catalogue raisonné, with some reason. Except for the cocktail glass, Davis has not imported any elements directly from one to the other. More important, the two are painted in diametrically opposed styles. *Super Table* replaces the murky analytic-cubist ambiguities of *Red Still Life* with the monumentality and clarity of purism, which was having its moment in 1925 at the Exposition des Arts Décoratifs in Paris. Invented by Fernand Léger and others, purism was a direct swipe at the fragmentation of cubism, a celebration of the mass-produced object in all of its machined integrity. Davis often mentioned Léger in his notes, and it seems likely that purism was on his punning mind, judging from two paintings of an Odol mouthwash bottle done the year before (pls. 8, 9) that prominently include the product's slogan: "It Purifies."

Super Table represents a pivot, a pregnant moment in Davis's career that looked both forward and backward. It prepared the breakthrough of the *Egg Beater* series by retrieving *Red Still Life*, with its almost fawning analytic cubism, only to attack it. This split attitude of one painting to a predecessor should feel familiar by now. It is the same dialectic of conservation and cancelation that we saw in the *Memo* game—recursion with a critical edge. Whether Davis knew about dialectics in 1922 is unclear; what is clear is that he had a naturally dialectical relationship to cubism. "I never did a Cubist picture," he told John Ashbery in a 1958 interview.[62] "I was a Cubist until somebody threw me a curve," he scrawled in a 1960s note.[63] The self-contradiction, bluster, and attempted humor betray anxiety. Here we approach another answer to the question of Davis's motives for recursion. Cubism was his anxious influence, the imitative crime he was often charged with, and so he needed to subject it, repeatedly, to a kind of purification, a trial by fire, which only meant imitating it all the more.

DAVIS ON CUBISM

The two statements just cited are, admittedly, late ones. What did Davis think about cubism when he met it? The first piece of evidence comes on the wrong side — the verso — of a rather ordinary painting of a Gloucester street scene.[64] It is 1918 and Picasso is already finished with cubism, at least as an all-absorbing pursuit, while Davis has not really started. He writes a statement of about 250 words on the back of this canvas and titles it "Man on an Ice Floe," a strange phrase that he must have ripped (I can think of no other explanation) from a newspaper account of a fishing accident that left a man stranded in freezing waters, not an uncommon occurrence. Davis begins by acknowledging "confusion" in front of "ultra-modern" paintings, and "being annoyed because this formal presentation is not obviously a chair or a landscape." (He is speaking about others here, but also, I suspect, about his own attitude not so long ago.) However, he answers, "this picture is not a landscape because its subject is not a landscape. It[s] subject was a mental concept derived from various sources." He concludes that cubism is "the bridge from percept to concept."[65] This mini-essay will become something of a talisman for him: he copies it over with some changes in September 1922, in about 1940, and again in the early 1950s.

Ironically, Davis did not know much about cubism at this time, in 1918, as his own confused attempts in the previous two years demonstrate. His first episode of real cubist painting, as we have seen, came in 1921 and 1922, after he saw some paintings firsthand, and with it came what FitzGerald calls a series of "combative ruminations on Picasso."[66]

These ruminations fill a 188-page sketchbook, written in a tight cursive hand between May 20, 1920, and November 28, 1922. They are indeed sometimes combative toward cubism, but sometimes celebratory. Davis's repeated charge is that cubism, beneath its apparent radicalism, is conservative. "Picasso is an old master Man [who] has invented movement — can an exhibition of stereopticon views hold the interest of a person who thinks in terms of electric wires…?"[67] (In other words, cubism is about as contemporary as a dusty nineteenth-century optical device.) Cubism is also "connected with the Old Masters" by virtue of its architectural effort to capture three dimensions.[68] And its tonality is petit bourgeois: "The latest work from Paris — Picasso, Braque, Gris, Metzinger, all show … a tendency … to the production of 'tonal quality' [and] 'rich color'; a genuine oil painting in other words, and what is more disagreeable than a genuine oil painting. Has the light gotten dimmer over there or what?"[69] Finally, the cubists share the faults of those younger old masters, the impressionists: "On their recording of many impressions and plane analysis they have many splendid works but all suffer from complexity." Davis concludes that "Impressionism is dead / Cubism is dead" and proposes instead, however vaguely, "a clear cut intellectual style."[70]

And yet cubism itself is intellectual for Davis, in two ways. First, it is logical: "Any painting no matter how well done … will look badly when juxtaposed to a Picasso. The reason being that Picasso's are logical in their own medium. In other words the space represented is that space inherent in the canvas."[71] Second, it is conceptual (and here is more of the 1918 note, recopied in September 1922): "Cubism is the bridge from percept to concept. A cubist picture is a concept in light and weight of a specific object in nature. From this it is only a step to the formulation of concepts of diverse phenomena into a single plastic unit."[72] But in other moods Davis can find the intellectualism of cubism

sterile and remote: "A painting by Picasso is a treatise *in* paint on the technique of painting but they are not works of art."[73]

Davis's opinions about other aspects of cubism swing wildly too. In the spring of 1921—the era of silent movies—he declares: "Words will have a place also (just as in movies, captions are necessary). The hint of 'Journal' in cubism should be carried on."[74] A year later: "Words in the picture won't do it. There are just two things that will do it and they are line and color."[75] In June of 1921 he asserts: "Cubism has freed drawing and it is now the artist's privilege to express himself in any terms he desires."[76] But five months later he praises cubism not for its total freedom but for its study of three-dimensionality: "Cubism is a rediscovery of the interest that lies in sculptural form."[77] And another five months later, "Picasso's work is good because it always has the surprises of nature in it."[78]

Why all the to-and-fro? In part, it is because Davis is not always talking about the same thing. His distaste for darkness and complexity would seem to be about analytic cubism; his celebration of simplicity and tangibility, about the next phase, synthetic, with its bigger simpler shapes. "Build the picture with your hands. Let each part be a something tangible—a shape—a color—a texture… This type of picture… has never been touched except by the modern masters, Picasso…"[79] And of course this is a notebook, not an essay. We should forgive its inconsistencies.

But something else lurks behind the vociferous vacillation, a worry that Davis owes cubism too much. He chides himself: "The principal thing is that we now copy Cezanne, Matisse & Picasso and as a result ignore our own abilities."[80] He brags defensively that his tobacco pictures, with their wit, simplicity, and realism, "will make all cubistic works look like mere studies which they are."[81] And yet only a few years later, feeling more secure, he expresses pride in his cubist apprenticeship. Accused by the critic Henry McBride in 1929 of copying Picasso, Davis answers not with denials but by proclaiming the importance of influence in eloquent terms:

I did not spring into the world fully equipped to paint the kind of pictures I want to paint. It was therefore necessary to ask people for advice. This resulted in my attending the school of Robert Henri… After leaving the direct influence of Mr. Henri I sought other sources… Chief among those consulted were Aubrey Beardsley, Toulouse-Lautrec, Fernand Leger and Picasso… [W]hy one should be penalized for a Picasso influence and not for a Rembrandt or a Renoir influence I can't understand … any more than I can understand how one is supposed to be devoid of influence. I never heard of or saw anyone who was. Picasso himself has as many influences as Carter [the king of patent medicines] has pills…"[82]

How indeed is one supposed to be devoid of influence? As Harold Bloom reminds us, influence is the very condition of ambitious artistic production, and it is only by the "strong misreading" of predecessors, by homage through desecration (sublation anyone?), that great artists can develop. The fact that Davis's attraction to cubism was from the start an argument, even a partial rejection, is the index of how important it was for him. "Freud's investigations of the mechanisms of defense and their ambivalent functionings provide the clearest analogues I have found for the revisionary ratios that govern intra-poetic relations," Bloom writes.[83] With Davis and cubism, it was ambivalence at first sight.

FIG. 11 *Landscape with
Saw*, 1922, oil and pencil
on canvas mounted on
board, Phyllis and Jerome
Lyle Rappaport

CUBISM WRAPPED AND DISSEMINATED

Davis made over two dozen cubist paintings from 1921 to 1922, moving generally from analytic to synthetic styles. Most of them are much smaller than *Red Still Life*, and it was to these that he returned from 1941 on. To get at the mechanics of these returns, let us look at a single group. I will choose my favorite, comprising the 1922 *Landscape with Saw*, the 1951–1952 *Rapt at Rappaport's* (pl. 55), and the 1953 *Semé* (pl. 57).

11

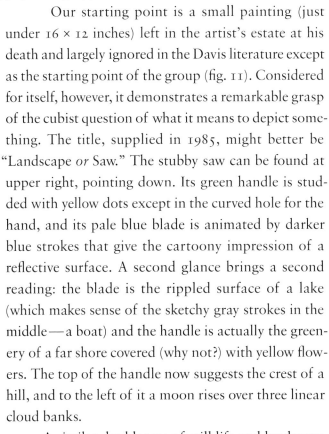

Our starting point is a small painting (just under 16 × 12 inches) left in the artist's estate at his death and largely ignored in the Davis literature except as the starting point of the group (fig. 11). Considered for itself, however, it demonstrates a remarkable grasp of the cubist question of what it means to depict something. The title, supplied in 1985, might better be "Landscape *or* Saw." The stubby saw can be found at upper right, pointing down. Its green handle is studded with yellow dots except in the curved hole for the hand, and its pale blue blade is animated by darker blue strokes that give the cartoony impression of a reflective surface. A second glance brings a second reading: the blade is the rippled surface of a lake (which makes sense of the sketchy gray strokes in the middle—a boat) and the handle is actually the greenery of a far shore covered (why not?) with yellow flowers. The top of the handle now suggests the crest of a hill, and to the left of it a moon rises over three linear cloud banks.

A similar doubleness of still life and landscape obtains on the left side of the image. In the still-life reading, a triangular gray box rests on a tipped-up yellow book whose title is partly obscured, and a stick with a knob is sandwiched between them. This could be a painter's mahlstick if not for the telltale white wisp rising from it (which might once have been more visible): it is a match that has just been extinguished. This ignites another reading of the box: a house with smoke (a swoosh of unpainted canvas) rising from a chimney. The letters *GAR* behind the house prop up the landscape reading once we know that the same lettering, as part of the word *GARAGE*, appeared in three earlier landscapes.[84]

It is a remarkable work of condensation, a double image: divided into two halves, each half supporting two readings. The two halves come together along a not-quite-vertical line, a shared contour that simultaneously defines both the upper-left shore of the distant lake/blade and the right-rear edge of the house/box. The ambiguous status of this line (whose contour is it, and where does it sit in space?) is underscored by that of the yellow plane behind the house, which seems to share the contour for a spell, comes in front of the green shore above the house, and tucks behind the lake below

12

it. This is a world of contradictory overlaps, a puzzling collage translated into paint. Davis describes this kind of "multi-planar" picture in the notebook with the cubist ruminations as "a series of superimposed major planes each one of which has its own detail," and he diagrams it with a sample still life (fig. 12).[85] The diagram is more telling than the text, for it demonstrates just the kind of contour-sharing that throws the spatial relationships of *Landscape with Saw* into doubt.

Davis has been looking closely. The device of a shared contour is fundamental to cubism going back to Picasso's *Demoiselles d'Avignon* of 1907 and *Three Women* of 1908; the gray triangular block/house nods to the monochrome cubic houses Braque painted in L'Estaque in 1908, which earned the movement its name; and the impossibly overlapping planes are straight out of synthetic cubism (from 1912 on). But more surprising is Davis's grasp of the polysemy of cubism, its exploration of the capacity of any one shape to signify differently depending on context. Davis does not discuss this in the notebook, but he comes close in the "Man on an Ice Floe" essay, with its description of cubism as "the expression of … diverse phenomena, sound, touch, light, etc., in a single plastic unit."[86] Significantly, in rewriting this passage for the notebook, he omitted the words "sound, touch, light, etc.," thereby turning our attention from multisensory experience to multiple meanings. If we understand "single plastic unit" not as the whole image but as part of it, a repeated morpheme, then we begin to approach cubism's semiotic territory.[87]

Landscape with Saw embodies two kinds of polysemy, which might be called vertical (having to do with substitution) and horizontal (having to do with association).[88] In the first case, the very same strokes of paint signify two things—a saw blade and a lake, or a box and a house. A classic example from Picasso can be found in one of his sketches for the squatting woman in *Les Demoiselles d'Avignon*, whose torso can also be read as a face. In the second case, the same shape (more or less) appearing in two different parts of the canvas signifies two things: see Picasso's use of similar almond-shaped forms to represent a lemon in one part of *Jars with Lemon*, 1907, and the mouth of a jar in another.[89] Likewise, in *Landscape with Saw* the box/house shape and the blade/lake shape have basically the same silhouette, just cut a little differently along the bottom and at upper right. (The similarity is underscored by the fact that their top contours are continuous, forming a line that slopes up and to the right.) Another example is the way the swoosh of smoke from the chimney almost matches the shape of the hole of the saw handle into which it obtrudes. Davis may be a little less exact than Picasso in his doublings across the canvas but he is just as interested in their potential to multiply meanings. In short, the painting is full of visual puns.

All this play of signification revolves around the point where the upward sloping line, the one from which the blade/lake and the box/house both hang, is crossed at its center by the nearly vertical line, the one that divides the blade/lake from the box/house by providing them with a shared contour. This crossing is the composition's geometric *origin* (where *x* and *y* axes cross), the spot where the conjoined twins of blade/lake and box/house meet, the zero point from which shape and meaning are generated.[90]

Fast forward almost thirty years to *Rapt at Rappaport's* (fig. 13). Davis noted in his desktop calendar on April 15, 1951, "Made enlargement in drawing of 12 × 16 of 1922 oil on 40 × 52 canvas to see whether its intrinsic interest would hold up."[91] To make the enlargement of *Landscape with Saw*, Davis used the traditional method of squaring for transfer: he drew a pencil grid (still visible) on the original painting as a guide. The photographs of the new work in progress prior to the application of color are telling (figs. 14A–D). In the first stage (A), the conjoined twins dominate, clear and sharp. (The only competition for our attention is the wisp of smoke from the match at left, now drawn firmly and darkly and given its own frame.) In the second stage (B), the attack begins: the right twin is overwritten by a pattern of ten curled rectangles derived from the ripples in the source painting, and the left one is obscured by a novel element, a large reversed S. Symbol and pattern proliferate in stage three (C): large polka dots (hearty descendants of the original yellow spots) cover the saw

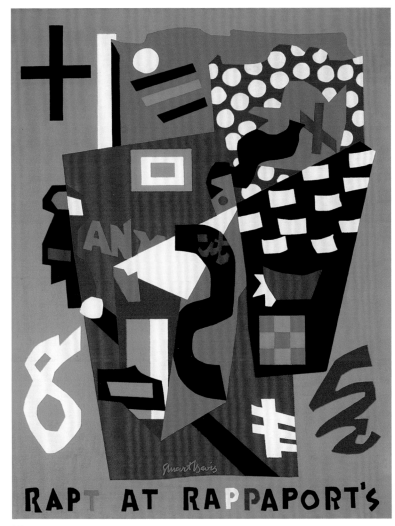

RAPT AT RAPPAPORT'S

13

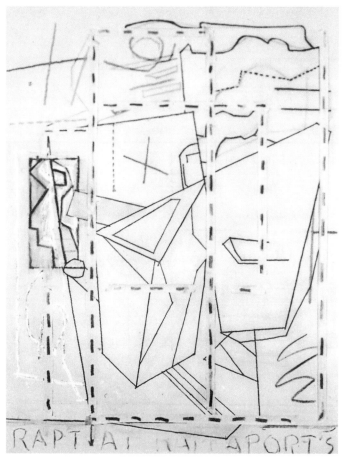

14A

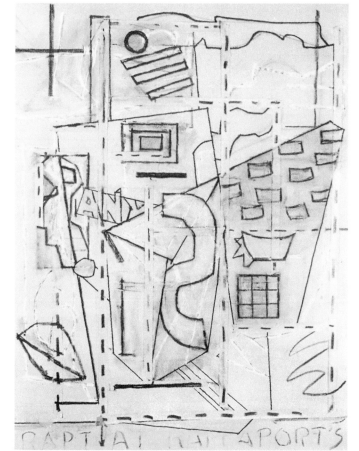

14B

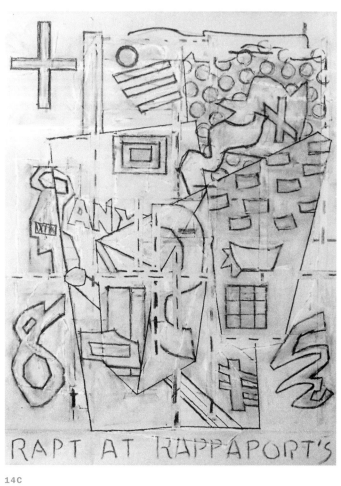

14C

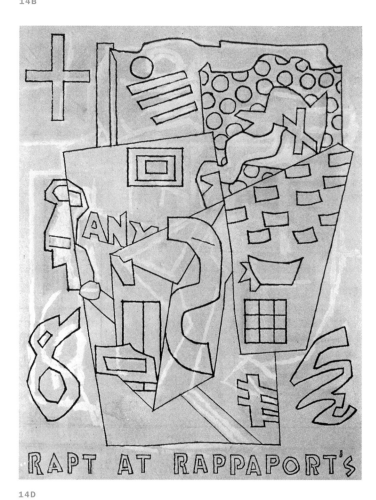

14D

FIGS. 14A–D Four photo-
graphs by Bernard Cole
of *Rapt at Rappaport's* in
progress, 1951–1952

handle; a squiggle grows at lower right; an upside-down ampersand appears at lower left; an *X* is inscribed within the handle of the former saw; and a cross (seemingly inspired by one of the crossings of the pencil grid, which of course is meant to assist in transfer, not to *be* transferred) bulks up in the top-left corner. The drawing gets cleaned up in stage four (D), but this does little to restore legibility or hierarchy.

What has been lost in all this is any sense of the neo-cubist visual punning that Davis wielded so brilliantly in *Landscape with Saw*. If we did not know that the earlier painting lay behind *Rapt at Rappaport's*, we could never figure out what if anything it depicted, and its title, which refers to a venerable toy store in Manhattan known for polka-dotted wrapping paper, does not help. All the elements of the earlier painting are present—transferred in loving detail, even to the point of preserving slight displacements where one corner or edge does not quite meet another—and some, such as the boat on the lake or the smoke from the match, have even been strengthened. And yet *none* of them are there. Instead of being drawn to the work of deciphering, we are overcome by a colorful blaze of shape and pattern, very much on the surface. With no depiction there can be no play with depiction. No pun.

Well, almost none. There are two major changes to the drawing, and they are both significant. One of them partly restores the subject, or a subject; the other denies the importance of subject. First, the left edge of the topmost shape (the one with the rising moon), which was originally a shadowy smudge, has been solidified into a white post or pole, which has the effect of turning that shape into a fluttering flag—an apt symbol for the painting as a whole, which is all heraldic pattern and surface incident. Second, the *GAR* inscription has become *ANY*, Davis's shorthand for his belief (whether we believe it or not) that choice of motif is unimportant. Davis's insistence on this word, which we have already seen at the bottom of *Memo*, dates back to the cubist notebook, where he asks, "Is the subject of a picture of any significance? No—since…it is possible to observe the phenomena of lighted form in space in any object."[92] Or again: "To-day one takes any subject and from it creates planar and color rhythms from the mind. The difficulty is that one still takes a 'subject.' As quickly as possible let us arrive at a genuine express of mental concepts."[93] As quickly as possible: the subjection of subject turned out to be a road that never quite ended. At the last moment, on the brink of pure abstraction, a flag gets run up the pole, starts to flutter.

All this raises the question that Davis asked himself as he was setting out to paint *Rapt*, namely, whether something of the "intrinsic interest" of the original painting would "hold up." If anything has held up, it can only be what has been more or less retained: not the visual puns of *Landscape with Saw*, therefore, and certainly not its muted cubist palette, but simply its skeleton, the drawing itself, that particular jigsaw puzzle with its crossing lines and shared contours that Davis reached back thirty years to retrieve.

In the passage from the notebook quoted earlier about cubism capturing the surprises of nature, Davis continued: "The value [of cubism] lies in the fact that…it makes drawing as subconscious as color. It is expression thro' shape."[94] In finally purifying cubism of its latent ties to nature, Davis liberated what was essential for him about it, namely, its expressive capacity as pure abstraction; but to do that he had to preserve the cubist drawing that had originated in nature or else he would be unable to surprise himself. When it comes to abstraction, Davis seems to say in *Rapt*, conscious invention

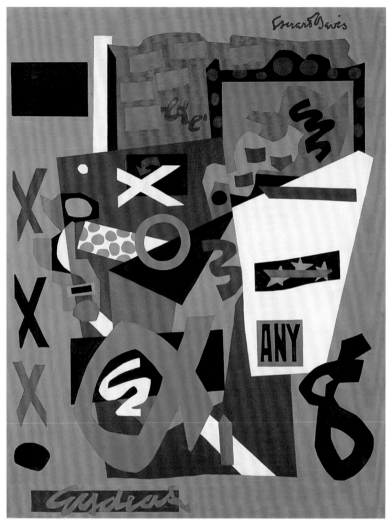

15

can never equal the shapes and contours discoverable in nature, even if those shapes must be divorced from their natural referent in order to be fully discovered. Here perhaps is definition of the "esthetic essence" that Davis invoked as one of the goals of his recursive plan in the July 1938 note: pure form. In *Rapt* Davis has not simplified *Landscape with Saw*, has certainly not removed the "details" that could "confuse" viewers (as he proposed to do in that note); and yet he has found the essence, or an essence, of the earlier painting—its abstract compositional relations, or what the French call *rapports*. (That is the very word that my automatic spell-check program keeps substituting as I try to type the title of the painting.)[95] *Rapt, rapport, Rappaport*. The words are concrete poetry, pure permutation, serial sound. But they have their meanings as well. *Rapt*, from the Latin, means to be seized or carried away. *Rapport* is from the Old French *raporter*, to bring or carry back.

We have arrived at a larger sense of Davis's motives in his cubist excursions and recursions. If the attempt to rework or sublate an anxious source was part of his motivation, an equal and more positive part lay in the extraction of a precious resource, abstraction. Davis's strong misreading of cubism was abstract in the most rigorous sense—not abstracting or abstracted like most American derivatives of cubism, but abstract, without reference, or nearly so, as close as Davis could bring himself to it. *Memo* is a Marxist abstraction; *Rapt* is a cubist abstraction.

On March 1, 1953, a little less than a year after he started *Rapt*, we find Davis, having taken up the 1922 painting again, considering a title: "Worked on / ~~Rapt #2~~ / ~~Eydeas~~ / Semé," his calendar notes (fig. 15).[96] Why settle on *Semé*? *Rapt #2* would have acknowledged the group relationship, and *Eydeas* (one of Davis's favorite puns, mixing *eye* and *ideas*) was probably already inscribed along the bottom of the painting, just as the words *Rapt at Rappaport's* had been in that work. We know that Davis had a fondness for French words (*pochade, école, concrète, allée,* and *midi* are titles still in his future), but *semé*, meaning sown or disseminated, would seem all wrong given what we have seen of his abandonment of the semiotic play and profusion of the 1922 original. What has happened, however, lies right before our eyes, right on the surface: the field of play has migrated from the depiction of things to the letters, words, and symbols sprinkled across the picture, cast abroad like seeds, following no evident rule except that of horror vacui.

This seeding of the image has its roots in the 1922 painting with its half-word (*GAR*) and its half-circle (the rising moon). In *Rapt*, both become whole. The moon is filled and a complete word is substituted (*ANY*), or almost complete: the *Y* is slightly

cropped, leaving the possibility that it might be an *X*, suggesting the beginning of *anxious* or *anxiety*. *Semé* goes further, subtracting the moon but adding three *X*'s, an *O*, two squiggles, and a loop, but who's counting? The blue loop dominates, looming closest: both bigger and thicker than the rest, it encompasses one of the white squiggles. And don't miss the newly added stars and stripe, whose reversed colors anticipate what Jasper Johns will soon do with the same flag.[97] The word *ANY* is kept on board too, now joined by *else*, another favorite in Davis's lexicon, with related connotations—or is it *été*, summer?[98] And yet this proliferation does not really constitute a renewal of semiotic play within the image proper, for the puns are verbal not visual. These words, together with the scattered symbols (and we know by now that *X* and *O* are not just shapes or letters for Davis), form a commentary that floats across the abstraction, about the abstraction. As Lane has observed, the importation of Davis's ideas about art via such keywords constitutes "an iconography of art theory" and is one way that his post-1950 paintings insist on their self-sufficient abstraction, their art-about-artness.[99] *Semé*'s reshaping of the former saw handle into what looks like a black-and-maroon polka-dotted picture frame seals this self-referential turn.

Before quitting *Semé*, let us note a final change. The background color, a grassier green than in *Rapt*, has crept from the edges of the image into the configuration itself, turning the swoosh of smoke, the right side of the house, and several smaller areas to background, to "lawn." The effect is both to flatten the image and to open it up, punching holes in it (as in a lawn before seeding). There is a new feeling of aeration or circulation, underscored by the addition of a symbolic element that escaped our inventory just now, a curving arrow near the center. Here, in the register of figure and ground, Davis succeeds in restoring a sense of lability to a composition that had become, in *Rapt*, too contracted, too tightly wrapped. The image has been expanded, opened up, *semé*.

CHAMPION

Comprising four finished paintings and an oil study based on a matchbook ad for spark plugs that caught Davis's eye in 1950, the *Champion* group is the only major non-recursive effort that he launched between 1939 and his death in 1964, the only effort that does not take off from earlier work.[100] At this pass, the question we posed at the outset about recursion seems more urgent in the negative: Why *didn't* he do it? Perhaps we can learn something about Davis's recursions by virtue of their absence in these works.

But first, let us take a third and final dip into the biography. With his retrospective opening at the Museum of Modern Art (MoMA) in October 1945, the fifty-two-year-old artist has finally made it. His conversation and writing embrace hipster slang and jive talk (often going embarrassingly overboard) thanks to a new friendship with the drummer George Wettling, who introduces Davis to jazz circles. The end of World War II no doubt contributes to the high spirits. And yet these years are as unproductive for Davis as the mid-1930s. He finishes only a handful of paintings in the second half of the 1940s, expending most of his energy on a titanic effort to rework the 1931 *House and Street* (pl. 30) into the 1945–1951 *Mellow Pad* (pl. 51). The result is a difficult masterpiece of modest size whose impacted densities and multiple layers reflect six years of struggle (and would, alas, take a separate essay to unpack): "I worked on it and I got stuck, and I'd come back to it."[101]

In the background of this struggle was Davis's drinking problem, which was only getting worse, or at least his body was no longer tolerating it. A hospitalization in 1949 seemed to help, and from mid-1950 on he managed to stay away from the bottle. His energy returned, and he experienced the creative revival that might have come four years earlier. In the fall of 1949 he took a break from *The Mellow Pad* to begin *Little Giant Still Life* (pl. 52), the first of the four paintings in the *Champion* group. By the following March it was finished, and the Virginia Museum of Fine Arts acquired it in May. Nine months might seem like a long time to work on a painting, but for Davis it was a breeze.

Even without these biographical prompts, the sense of release in the 1950 *Little Giant Still Life* is palpable. Lane writes of "a new breadth" in Davis's work, William C. Agee of "a new and brilliant style … more open, highly distilled and clarified."[102] Bright colors and bold letters fill the canvas like closeup images on a movie screen. Indeed, the Times Square marquee for *The Champion*, a 1949 boxing movie starring Kirk Douglas, might have influenced Davis's shaping of the lower contour of the painting's heroic word. (It is not clear if Davis saw the movie, but given his keen interest in boxing, he must have been aware of it, and the ads were hard to miss.)[103] Moviegoing is further suggested in the painting by the bright white expanse of the word's backdrop, the scarlet frame that surrounds it like a proscenium, the shape of the painting itself (unusually horizontal for Davis), and perhaps even the three vertical lines that score its surface like the occasional scratches in celluloid that streak across a projection.[104] That the title of the painting makes reference to another movie, *The Little Giant* of 1933, starring Edward G. Robinson as an uncouth beer baron who tries to break into high society by collecting bad cubist paintings, adds a hidden, humorous note to the filmic context.

It is hard to resist the conclusion that Davis's origin story for the painting is a bit of a cover. The Champion is not a matchbook or a sparkplug but Davis himself, the star, the winner. He has been liberated from alcohol, and from the struggle with *The Mellow Pad*, but also, at least temporarily, from recursiveness itself, with its constant resort from 1939 on to the squared grid, the careful transfer, the anxious origin. The *Champion* group is also a vacation from cubism in particular, for Picasso has been temporarily displaced in Davis's pantheon by Matisse, the Matisse of the cutouts. The prints based on the collages for Matisse's book *Jazz* had been shown at MoMA in October of 1948. *Little Giant Still Life* recalls the second page of *Jazz* with its bold capital letters (*CIRQUE*, see page 16, fig. 10) as well as the framing rectangles around several of the images in the book and its general mix of sharp and swirling forms. Davis's mature shapes always have a cutout look, but never more than in this painting, in which the curves are segmented, imitating and even exaggerating the action of scissors.

Davis adds words to the next painting in the *Champion* group. Painted just a year after *Little Giant Still Life*, *Visa* introduces "else" and "the amazing continuity" (pl. 53). In an artist's statement from November 3, 1952, Davis explains that "'else' … was in harmony with my thought … that all subject matter is equal," while "continuity" referred to "seeing the same thing in many of my paintings of completely different subject matter and style."[105] Is this really Davis talking? His words seem unusually bland and official, not unlike the unusually legible script in the painting, which comes as close as he ever got to a manifesto.[106] They have been removed in the third painting of the group, *Switch-ski's Syntax* of 1961 (pl. 80). The palette is sober and limited, and a canvas-spanning line of black paint on a strip of masking tape—an anomaly in Davis's finished

FIGS. 16A–C Details of loops, from *Switchski's Syntax* (A), 1961, casein and masking tape on canvas, Yale University Art Gallery (pl. 80); *Visa* (B), 1951, oil on canvas, The Museum of Modern Art (pl. 53); *Unfinished Business* (C), 1962, oil on canvas, Private collection (pl. 81)

paintings—brings the sweeping curves under control. Perhaps Davis had seen *The Champion* by 1961; it is not a comedy. No doubt he was aware of Matisse's death in 1954. In any case, the eager, almost heedless embrace of Matisse during the "vacation" of 1950 to 1951 is over.

And what about the three slashes, which, like the black bar, also cut across the word? If they evoke scratches in film, they also suggest bars on a window, hardly a figure of liberation. But their placement carefully marks the three syllables: *cham-pi-on*. The slashes both score and underscore the word, emphasizing its rhythm (like the scansion of poetry) even as they cancel it—a bit of dialectics writ large.

LOOPS AND LOOSE ENDS

A new, almost jaunty element in *Switchski's Syntax* has escaped our notice, a green and white loop presiding over the image (fig. 16A). It suggests a twist of rope, triggering memories of harbors, lines, and rigging, and also recalls the snipped figure eight, the broken infinity symbol, in *Memo*. Its visual precursors are the squared-off loop featured prominently in *Max #1* of 1949 (fig. 17), a much-abstracted harbor scene, and the smaller green loop at the upper left of *Visa* (fig. 16B), which stands out on a pale ground, balancing an X at lower right that was already present in *Little Giant Still Life*. These are not quite the tic-tac-toe symbols we are used to in Davis's work, for the X is too rangy and the loose ends of the loop make for a messy O at best. A similar loop, but more complicated, shows up in *Unfinished Business* of 1962 (pl. 81). Once again it is bicolored, this time green and black, with green still marking the loose ends (fig. 16C). Davis's symbols and squiggles are almost always a single color, so why two for the loop?

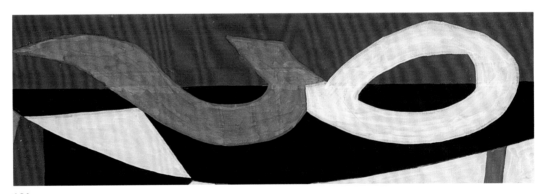

16A

16B

16C

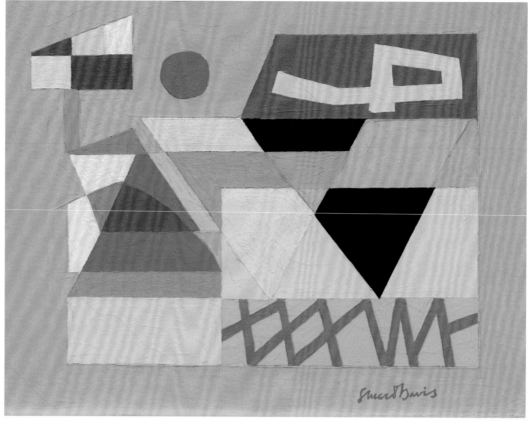

17

That the loop in *Unfinished Business* is cornered by an *X* and an *O* offers a hint. The loop is the combination of these two symbols. It is an *O* that ends in an *X*, with black indicating the *O* part, green the *X* part. *X* + *O* = [loop]. Davis at this point is, at least in part, a full-fledged "symbolicker," to borrow the term applied by Davis's friend, the cartoonist William Steig, to William Blake, another master at weaving together words and images.[107]

We are back to the question of contradiction and its resolution. Davis's work holds opposites in tension, just as Wallace Stevens did in "The Motive for Metaphor," a 1943 poem that seems appropriate to our subject. (We have been considering motives and motifs, after all, and figures of speech and sight: Stevens, like Davis, often made art his subject.) Stevens's poem contrasts a half-lit world "of things that would never be quite expressed" with "the weight of primary noon, the ABC of being." Thinking of Davis as pragmatic and vernacular, the lover of bright colors and strong shapes, we might put him in the latter camp, on the side of

The ruddy temper, the hammer
Of red and blue, the hard sound—
Steel against intimation—the sharp flash,
The vital, arrogant, fatal, dominant X.

But there are "intimations" in Davis's art as well, and "exhilarations of changes," and "half colors of quarter-things," and certainly "words without meaning"—all these being the poet's terms for that other camp, that of metaphor, which is always in migration,

slipping and sliding, moving and motive. The word *motive* has the long sound and endless circle of the *O*, which is where the poem begins; *X* is where it ends.

X can stand for death, for nothing, but it is also the classic algebraic symbol, the substitute for something, although Stevens does not tell us quite what. Harold Bloom, in the next breath after the passage cited earlier, rejects "the qualified Freudian optimism that happy substitution is possible, that a second chance can save us from the repetitive quest for our earliest attachments. Poets as poets cannot accept substitutions, and fight to the end to have their initial chance alone."[108] Davis embraced the "repetitive quest" as the means to confront and conquer his early attachment to cubism, to have his "chance alone." What made his approach original is that rather than return to the attachment itself, he returned to himself returning to it. (His recopying of the "Man on an Ice Floe" essay with changes seems an apt parallel for these pictorial recursions.) By defining himself rather than Picasso as predecessor, he put Picasso at a remove, kept him at bay. But deferral, of course, is no solution, and so his quest continued, as quests do, "to the end."

Davis's loop is the very figure of recursion. There is always a loose end or two in such a project, a bit of unfinished business, an incompletion that keeps things running—just as Davis's distinctive script runs through his work from its lyrical debut in *American Painting* of 1932 (pl. 37), with Duke Ellington's "It don't mean a thing if it ain't got that swing," to its spiky curtain call in the signature of *Fin* (pl. 84). *Cursive* and *recursion* share the Latin root *currere*, to run. Davis kept running and swinging. "I considered it complete," he told Phillips in 1962 about *Little Giant Still Life*, "but I still had an idea that I was going to do it over again, and I did it over again...because I felt that I could make certain changes—well, it was still a live thing, and it still is somehow."[109]

The wording of this statement says a lot about Davis's motives for recursion, at least as he finally understood them. His shares neither Ingres's belief in the possibility of perfection nor Rosso's faith in his materials and their vicissitudes. He embraces neither product nor process but something in between, a modest and incremental idea of improvement, a sense that "certain changes" might help. (His skepticism of grander notions of progress, no doubt a lingering effect of his disaffection with Marxist utopianism, is clear in the Phillips interview.)[110] He seems to accept the inevitability of the recursive drive itself, which he expresses in an appropriately Gertrude Steinian syntax: "I was going to do it over again, and I did it over again." The *over again*, twice repeated, reminds us of his fascination not with pure return or repetition (anathema to Davis) but with return as the exploration of other possibilities, untried variations, the *else*. Davis's recursions are permutations carried out in time as well as space. A chess player projects the game forward and back again, many times, before making a move. The carefree *any* is always accompanied by *anxt*.

Davis's loop of rope, an *O* twisting itself into an *X*, can also stand for the braiding or splicing of all the contradictions in his art—line and color, surface and depth, expansion and contraction, conservation and cancelation, influence and originality, past and present, representation and abstraction, observation and permutation, sense and nonsense (we could go on)—but it can never stand for their resolution or synthesis, their blending into a simple shape, a single color. Insofar as it is part of a figure eight, the loop is infinite. The rope keeps winding around the cleat.

Finally, the loop has a rapport with the spiral, that geometric figure often invoked to visualize Hegel's dialectic in its back-and-forth winding ascent to the far-off goal (in *The Phenomenology*, 1807) of Spirit in possession of itself, outside of time, no longer divided. Davis's loop is a but a single turn of the stair, a modest advance with no end in sight. His last painting, left on his easel at his death and still swaddled in masking tape, includes the word *fin*, possibly inspired by the last frame of a French movie he had been watching on TV. The word is often taken as a premonition of death, but who can say? Another possibility is that the word, like many of Davis's, like the painting itself, is just incomplete, unFINished.

I am indebted to Yve-Alain Bois, James Meyer, and Barbara Haskell for commenting in detail on the manuscript; to Nancy Troy for inviting me to present the ideas in a lecture at Stanford University; to Pamela Lee for suggesting "recursion" as a keyword; to Davida Fernandez-Barkan for a background paper on Davis's politics; to Sarah Humphreville and Paige Rozanski for all their research assistance; to Susan Felleman for answering questions about film history; to Ani Boyajian and Mark Rutkoski, authors of the indispensable catalogue raisonné; to Ed Shein for discussing *Unfinished Business*; to Earl Davis for directing me to the interview which begins the essay; to Julie Warnement for her keen copyediting; and above all to Sarah Boxer for countless suggestions that sharpened both my seeing and my writing.

1. Stuart Davis, interview with John Wingate, "Nightbeat," WOR TV, New York, October 10, 1957; audio cassette, from Estate of the Artist Archives, Fort Lee, NJ, and New York (hereafter cited as EAA). All rights reserved. © Estate of Stuart Davis / Licensed by VAGA, New York, NY.

2. See "Brief History of the Groundfishing Industry of New England: Period I, Sail to Steam, 1900–1920," *http://www. nefsc.noaa.gov/history/stories/ groundfish/grndfsh1.html* (accessed October 11, 2015).

3. Edward Tivnan, "John Wingate's Hard Fall: A Onetime Radio Host Ends Up Broke and Homeless," *New York Magazine* (March 13, 1989): 51–55.

4. Earl Davis, "Preface," in Ani Boyajian and Mark Rutkoski, eds., *Stuart Davis: A Catalogue Raisonné*, 3 vols. (New Haven, CT: Yale University Art Gallery; Yale University Press, 2007), 1: x (hereafter cited as CR). The twenty-three diagrams of Davis's "families" in the catalogue raisonné are invaluable maps of Davis's recursive practice.

5. Stuart Davis, quoted in Harlan Phillips, "Stuart Davis Reminisces: As Recorded in Talks with Dr. Harlan B. Phillips," May and June 1962, transcript, 41, Archives of American Art, Washington and New York (hereafter cited as AAA), 219. It is odd that Halpert would look for unconscious returns in Davis's work when there were so many conscious ones to be found.

6. The timing of the Wingate interview (1957) suggests that Davis was pushing back against fashion. Davis had no use for the discourse of originality and expressivity around abstract expressionism, which was at a peak of popularity in the United States in the wake of Pollock's death and was poised to conquer Europe with *The New American Painting*, an exhibition sent to eight countries the following year.

7. CR, 1: xi.

8. Rosalind Krauss, "You Irreplaceable You," in *Retaining the Original: Multiple Originals, Copies, and Reproductions*, National Gallery of Art, Studies in the History of Art, vol. 20 (Washington, 1989), 154.

9. Sharon Hecker, "Reflections on Repetition in Rosso's Art," in *Medardo Rosso: Second Impressions* (exh. cat., Fogg Art Museum of the Harvard University Art Museums, Cambridge, MA, 2003), 24. We can argue that the self-repetition began even earlier, in 1900, for after that year Rosso only modeled one new figure, the 1906 *Ecce Puer*.

10. Krauss 1989, 154, 157, 155.

11. Hecker, in Cambridge 2003, 56, 60.

12. Hecker, in Cambridge 2003, 49, 54. The Rodin theory fits Hecker's emphasis on Rosso's narcissism.

13. Stuart Davis Papers, July 25, 1938, Fogg Art Museum, Harvard University Art Museums, Gift of Mrs. Stuart Davis (hereafter cited as SDP, Harvard). All rights reserved by the President and Fellows of Harvard College.

14. When he lost federal support in August 1939, he later recalled, "The only possible security I could think of was to make more and better paintings." Phillips 1962, 279, AAA.

15. Davis, cited in Rudi Blesh, *Stuart Davis* (New York: Grove Press, 1960), 57.

16. Cited in John X. Christ, "Painting a Theoretical World: Stuart Davis and the Politics of Common Experience in the 1930s" (PhD dissertation, City University of New York, Queens College, 1997), 100.

17. His 1936 gouache showing a bloody figure being manhandled by two policemen, originally titled *Waterfront Incident*, is the exception that proves the rule.

18. Davis, quoted in John R. Lane, *Stuart Davis, Art and Art Theory* (exh. cat., Brooklyn Museum, New York, 1978), 34.

19. Stuart Davis Calendar, September 29, 1938, EAA. "It was a bleak time" writes T. J. Clark, "in which Marxist convictions were often found hard to sustain." T. J. Clark, "Clement Greenberg's Theory of Art," in Francis Frascina, ed., *Pollock and After: The Critical Debate* (New York: Harper and Row, 1985), 49.

20. In 1960, looking back on the late thirties in New York, the critic Clement Greenberg remarked: "Someday it will have to be told how 'anti-Stalinism,' which started out more or less as 'Trotskyism,' turned into art for art's sake, and thereby cleared the way, heroically, for what was to come." Although Davis had no apparent interest in Leon Trotsky, his ideas about the independence of art are Trotskyite, so the dictum applies to him well enough. Such was John R. Lane's judgment in his article "Stuart Davis and the Issue of Content in New York School Painting," *Arts Magazine* 52, no. 6 (February 1978): 154. The quotation is from Greenberg, "The Late Thirties in New York" [1957/1960], *Art and Culture* (Boston: Beacon Press, 1961), 230, emphasis added. (This sentence was added to the essay when Greenberg revised the 1957 essay for inclusion in the book.)

21. June 2 quotation cited in Lane, "Stuart Davis in the 1940s," in *Stuart Davis: American Painter* (exh. cat., Metropolitan Museum of Art, New York, 1991), 70. Second quotation from Davis, "Abstract Art in the American Scene," *Parnassus* 13, no. 3 (March 1941): 102, cited in Lane, "Stuart Davis in the 1940s," New York 1991, 71. In May of 1935, Davis had declared that "the abstract artist … has already learned to abandon the ivory tower in his objective approach to his materials." See the chronicle in this volume, April 1935 and note 161.

22. SDP, Harvard, July 25, 1938.

23. "Opinion under Postage: Abstraction" *New York Times*, August 20, 1939, sec. 9, quoted in the chronicle, August 1939. This was in response to the elitist declarations of Hilla Rebay, curator of the new Guggenheim Museum.

24. Greenberg 1961, 8: "Avant-Garde and Kitsch" [1939].

25. Stuart Davis, Autograph manuscript diary, February 9, 1922, MA 5062, 69, Department of Literary and Historical Manuscripts, The Morgan Library and Museum, New York (hereafter cited as SDD, The Morgan); reproduced in *Stuart Davis: Art and Theory, 1920–31* (exh. cat., The Pierpont Morgan Library, New York, 2002), 37.

26. The three 1939 gouaches related to *Shapes of Landscape Space* test different color schemes (CR 1247–1249). The two 1939 gouaches related to *Harbor Landscape* play with composition as well: *Composition* (pl. 43) and *Colors of Spring in the Harbor* (pl. 44).

27. "Schooner," in the Online Etymology Dictionary, *http:// www.etymonline.com/index.php? allowed_in_frame=0&search= schooner&searchmode=none* (accessed October 5, 2015).

28. Stuart Davis, *Stuart Davis* (New York: American Artists' Group, 1945); reprinted in Diane Kelder, ed., *Stuart Davis* (New York: Praeger, 1971), 25.

29. The chronology in the catalogue raisonné indicates that he continued going regularly until 1940 (CR, 1:129) but Barbara Haskell believes that he went only occasionally after 1934, probably to visit his mother (e-mail to the author, October 29, 2015).

30. *Swing Landscape* might possibly be regarded as Davis's first recursive work, but it is less an instance of reaching back to a single model than a more traditional case of combining sketches into a single large work.

31. Cooper, "Unfinished Business," catalog entry in *American Modernism: The Shein Collection* (exh. cat., National Gallery of Art, Washington, 2010), 38.

32. He recorded the drawing later that year in a larger gouache, *Configuration* (CR 541), which led to a 1952 painting (CR 1666), a 1955 mural (CR 1685), and the 1962 painting *Unfinished Business*.

33. The presence of these symbols *in* the image, rather than simply as marginal commentary, foreshadows Davis's habit of allowing his art theory to appear in his paintings as a subject.

34. See remarks at CR 519.

35. Lane 1978 (exh. cat.), 23.

36. He wrote that a picture should be built "in as certain a way as a mechanic puts an automobile together." SDD, The Morgan, May 27, 1922, 111. Earlier in the notebook, he outlined the steps in making a painting, from selecting the shape and color of canvas to laying out a palette, and added: "It would seem that this machine should work." June 1, 1921, 41.

37. On another page, Davis explained that any diagonal line implies the rectangle that it bisects: "You are drawing this … when you draw this." In other words, every diagonal is the resultant of horizontal and vertical vectors of given length. An autodidact who dropped out of high school, Davis seems to have been studying vectors, possibly with the aid of an important 1901 textbook that had just been reprinted in 1931: Edwin Bidwell Wilson, *Vector Analysis* (New Haven, CT: Yale University Press). The fact that two sentences later Davis used the word "resultant," albeit in a nonmathematical sense, supports this speculation. Furthermore, the surprisingly technical language that he used in the catalog of his 1931 solo exhibition at the Downtown Gallery — "the forms of the subject are analyzed in terms of angular variation from successive bases of directional radiation" — suggests a study of vectors.

38. For example, *Memo #2* is not part of the *Memo* group but rather part of the *Colonial Cubism* group.

39. SDD, The Morgan, March 12, 1921, 23.

40. Phillips 1962, 83–84, AAA.

41. "Memorandum," in *http://www.thefreedictionary.com/memorandum* (accessed October 5, 2015).

42. Does this mean we should backdate the onset of Davis's recursions from 1939 to 1935? Not really, for this is basically an act of copying and enlargement, something Davis often did with sketches; his recursions are not so faithful.

43. See sketchbook 9-21 (CR 313) and sketchbook 13-6 (CR 509).

44. See the three work-in-progress photographs in CR 1695.

45. On Davis's "bipartite" structures in general, see Karen Wilkin, "Multiple Views," in CR, 1:109–110.

46. Here I am thinking of Michael Fried's analysis of Pollock's painting *Cut-Out* as demonstrating that figuration or traditional drawing could only be brought into his allover mode in the negative, as a literal and material absence. *Three American Painters, Kenneth Noland, Jules Olitski, Frank Stella* (exh. cat., Fogg Art Museum, 1965), 17.

47. G. W. F. Hegel, *The Philosophy of History*, trans. J. Sibree (New York: Dover, 1956), 77. Michael Inwood, *A Hegel Dictionary* (Oxford: Blackwood, 1992), 284.

48. Lane mentions the "Marxist notion of non-linear progress" as important for vanguard painters in the 1940s but does not elaborate. Lane 1978 (exh. cat.), 66.

49. SDP, Harvard, August 7, 1937 (cited in Christ 1997, 102). See also SDP, Harvard, April 9, 1937, the page titled "Drawing and Dialectics" (quoted in Lane 1978 [exh. cat.], 39).

50. Phillips 1962, 125–126, AAA, emphasis added.

51. We can see a possible solution emerging in the paintings that followed, such as the 1956–1958 *Pochade* and the 1959 *Paris Bit*. In them, line and area are woven together, with areas of color seemingly laid over or under a master drawing, creating illusions of transparency. Yet I would argue (and I think Davis would realize) that that was just another, subtler way of separating line and area, not into zones (for example, upper right, lower left, as in *Memo*) but into apparent layers (under, over).

52. The two also shared an interest in dialectics, although they probably did not discover that. Mondrian's introduction of colored lines in 1941 was foreshadowed by his 1933 diamond painting with thick yellow lines.

53. Phillips 1962, 171–172, AAA. For other explorations of contradictory or dualistic compositional structures, see *Deuce*, 1951–1954, *Lesson One*, 1956, and *Pochade*, 1956–1958.

54. See the chronicle for 1925 and 1926, pages 163–164.

55. See Yve-Alain Bois, "El Lissitzky: Radical Reversibility," *Art in America* 76, no. 4 (April 1988): 160–181.

56. Davis 1945, reprinted in Kelder 1971, 26.

57. Wilkin, CR, 1:109.

58. Phillips 1962, 74–75, AAA. Matisse "took a single figure and bent it around in arbitrary ways to suit a sense of the whole structure of the canvas."

59. Michael FitzGerald, *Picasso and American Art* (exh. cat., Whitney Museum of American Art, New York, 2006), 73.

60. "Gris seems to have more vigor and design than any of the others." SDD, The Morgan, April 1922, 74.

61. *Red Still Life* is one of a quartet of cubist still lifes from 1922, the other three being *Still Life with "Dial," Brown Still Life*, and *Blue Still Life*. They are all very close in size (at 50 × 32 inches) and shape to *Super Table* (which is 48 × 34 inches). Davis made only two other paintings before 1925 that approached this size: *Multiple Views* of 1918, whose size was determined by the rules of a competition, and *Breakfast Table* of circa 1917.

62. Stuart Davis, quoted in John Ashbery, "Is Today's Artist with or against the Past? Stuart Davis," *Art News* 57, no. 4 (Summer 1958), 43.

63. SDP, Harvard, undated [November 1957].

64. In 1951 Davis added a couple of abstract elements to the painting (CR 1419) — a blue circle intersected by an irregular white pentagon — and the scripted words "Too Moons."

65. Transcribed in remarks at CR 1419. Davis elaborated the "percept to concept" idea as the latest step in the progress of art from "plot relationship of subject" (fourteenth century) to "plastic relationship of subject" (1870 to 1918) to "plastic expression of mental scope" (the present).

66. FitzGerald 2006, 73. He also suggests that Hamilton Easter Field (a collector of cubism who commissioned Picasso to make paintings for his Brooklyn library) "presumably gave Davis access" to the European modern art in his collection.

67. SDD, The Morgan, July 7, 1920, 5. This may reflect Davis's reading as much as his looking: in their 1912 book *Du Cubisme*, published in English the following year, Albert Gleizes and Jean Metzinger had popularized the idea (exaggerated if not mistaken) that cubism involved moving around an object to see it from multiple viewpoints.

68. SDD, The Morgan, March 12, 1921, 18.

69. SDD, The Morgan, April 1922, 80.

70. SDD, The Morgan, April 1922, 72.

71. SDD, The Morgan, December 4, 1920, 13. And on June 1, 1921, 42, Davis alludes to his formalist belief that the rectangularity of the canvas must be acknowledged: "Cubism is a recognition of the effect of one shape on another in both directions N. S. & E. & W."

72. SDD, The Morgan, September 1922, 143.

73. SDD, The Morgan, May 2, 1922, 95. He adds: "Matisse comes much nearer to it when he does his best things."

74. SDD, The Morgan, March 12, 1921, 19. "Journal" (newspaper) was one of the cubists' favorite words to include in their paintings and collages. Davis writes it with an upside-down capital *L*, his own conceit. While the cubists enjoyed cutting "Journal" into various pieces (jour, jou, urnal), Davis preferred inversions. In his calendar entries, he often writes one or more of the numbers of the date upside down.

75. SDD, The Morgan, April 1922, 84.

76. SDD, The Morgan, June 27, 1921, 42.

77. SDD, The Morgan, November 1921, 48.

78. SDD, The Morgan, April 26, 1922, 87. Years later Davis tells Phillips (1962, 88, AAA), in the course of criticizing abstract expressionism for its disconnection from observed reality: "So with the cubist angle, the cubist approach — just as Picasso himself, no matter what kind of work he did, his subject matter is always referent to something that you know about … My nature leads me to adhere to that kind of attitude."

79. SDD, The Morgan, May 1922, 105. The other artist he mentions here is George Grosz, perhaps because his biting depictions of Weimar society appealed to Davis's social conscience.

80. SDD, The Morgan, May 29, 1921, 40.

81. SDD, The Morgan, March 12, 1921, 37.

82. Kelder 1971, 110.

83. Harold Bloom, *The Anxiety of Influence: A Theory of Poetry*, 2nd ed. (New York: Oxford University Press, 1997), 8.

84. *Garage No. 2*, 1917; *Multiple Views*, 1918; and *Schooner and Garage*, 1922.

85. SDD, The Morgan, May 27, 1922, 110.

86. Transcribed in remarks at CR 1419.

87. The semiotic interpretation of cubism has been firmly established in numerous writings by Yve-Alain Bois and Rosalind Krauss.

88. See Roland Barthes, *Elements of Semiology* (New York: Noonday Press, 1988).

89. *Les Demoiselles d'Avignon*, 1907, Museum of Modern Art (MoMA); *Jars with Lemon*, 1907, Private collection.

90. Compare the similar radiating or pie-chart configuration of lines in Picasso's 1908 *Landscape*, MoMA.

91. Transcribed in remarks at CR 1665. See also Dorothy Gees Seckler, "Stuart Davis Paints a Picture," *Art News* 52, no. 4 (Summer 1953): 30–33, 73–74.

92. December 4, 1920, reproduced in New York 2002, 35 (see note 25 in this essay).

93. September 7, 1922, reproduced in New York 2002, 38.

94. SDD, The Morgan, June 1, 1921, 42.

95. Davis's treatment of the title in different colors along the bottom of the painting encourages "mistakes" in reading by making some of the letters much less evident, like the *t* in *rapt*.

96. Transcribed in remarks at CR 1672.

97. Davis mentions "the advertising copy of Campbell's soup" as a fit subject for painting in SDD, The Morgan, March 12, 1921, and of course his dots anticipate those of Roy Lichtenstein. No doubt the pop artists looked at his work, but Davis himself disclaimed the paternity.

98. Lane 1978 (exh. cat.), 72.

99. Lane 1978 (exh. cat.), 71.

100. The *Package Deal* group, which was also nonrecursive, was not launched by Davis but by *Fortune*, which commissioned him and six other artists to make still lifes from supermarket items. Interestingly, like the *Champion* group, it was also inspired by packaging. For Davis's assertion that "a book of paper matches" provided the motif, see remarks at CR 1663.

101. Transcribed in remarks at CR 1661. For more on the struggle, see William C. Agee, "1950–1955," in CR, 1:98.

102. Lane 1978 (exh. cat.), 76; Agee, CR, 1:98.

103. Agee (CR, 1:99) reproduces a 1949 photograph of Times Square at night showing the lighted marquee for the movie but does not suggest a specific visual connection.

104. For a similar effect, see Ed Ruscha's paintings from the early 1990s titled *The End*.

105. Transcribed in remarks at CR 1663. For more on Davis's use of "continuity" and his wordplay in general, see Lewis Kachur, "Stuart Davis's Word-Pictures," in New York 1991, 97–108 (see note 21 in this essay).

106. Compare his private notes on the word "else" from the previous year: "The Percept is a given which has an ELSE time dimension in it, which contains the System-Logic while simultaneously apprehending its Elseness, or likeness to what it is not." Quoted in Lane 1978 (exh. cat.), 72.

107. Sarah Boxer, obituary of William Steig, *New York Times*, November 29, 1997.

108. Bloom 1997, 8.

109. Phillips 1962, 130–131, AAA. The ampersand, another of Davis's favorite symbols, expresses this idea of endless continuation, not only in its meaning (*et cetera*) but also in its shape, which derives from the letters *ET* and also looks something like an infinity sign with two loose ends.

110. "I don't think that there are any great discoveries to be made." (Phillips 1962, 89, AAA). "Everything has happened already. The only thing you can do is make something that looks pretty good" (159).

PLATES

1 SWEET CAPORAL, 1921

oil and watercolor on lined cardboard, 51 × 47 cm (20 1/16 × 18 1/2 in.)
Museo Thyssen-Bornemisza

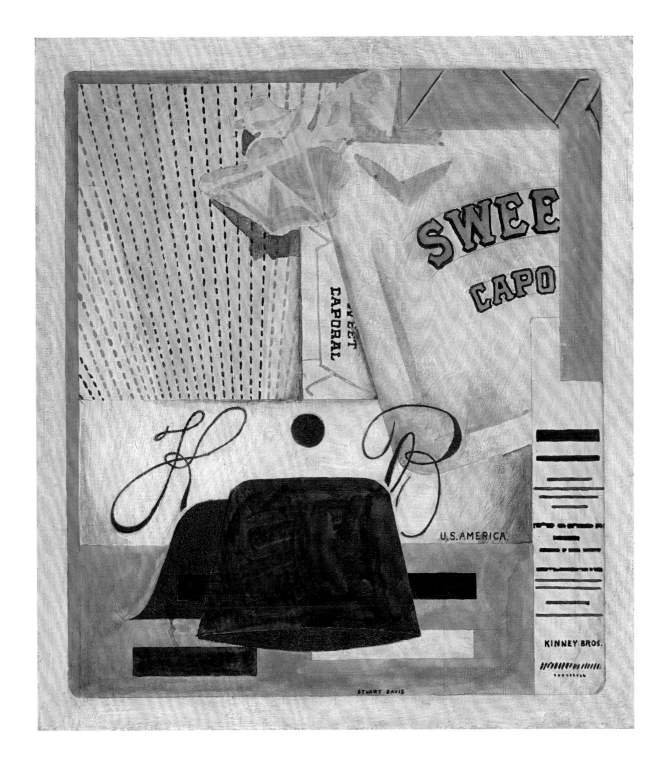

2 LUCKY STRIKE, 1921

oil on canvas, 84.5 × 45.7 cm (33 ¼ × 18 in.)
The Museum of Modern Art

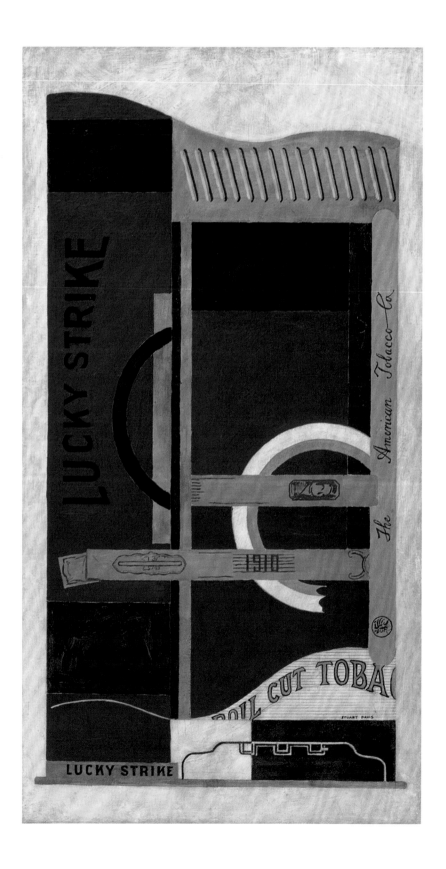

3 CIGARETTE PAPERS, 1921

oil, watercolor, ink, and pencil on canvas, 48.6 × 35.9 cm (19 ⅛ × 14 ⅛ in.)
The Menil Collection

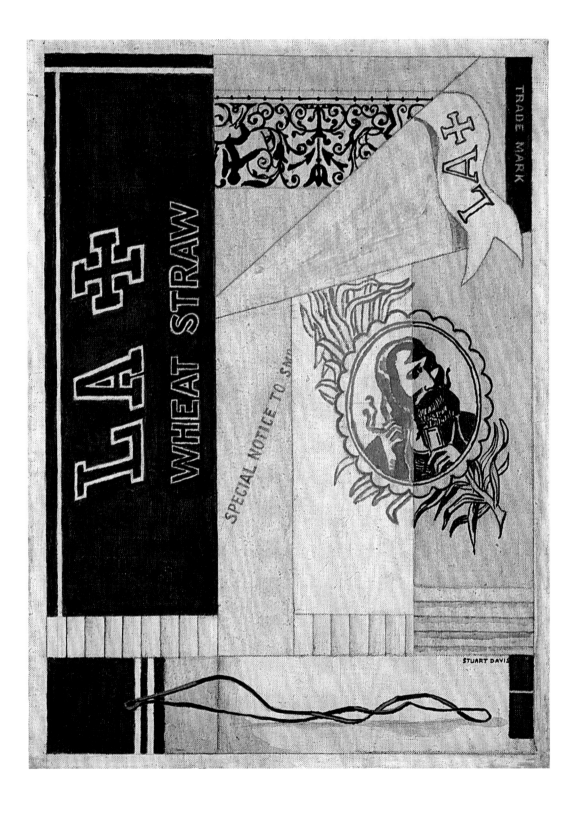

4 BULL DURHAM, 1921

oil and watercolor on canvas, 77 × 38.7 cm (30 ⁵/₁₆ × 15 ¼ in.)
The Baltimore Museum of Art

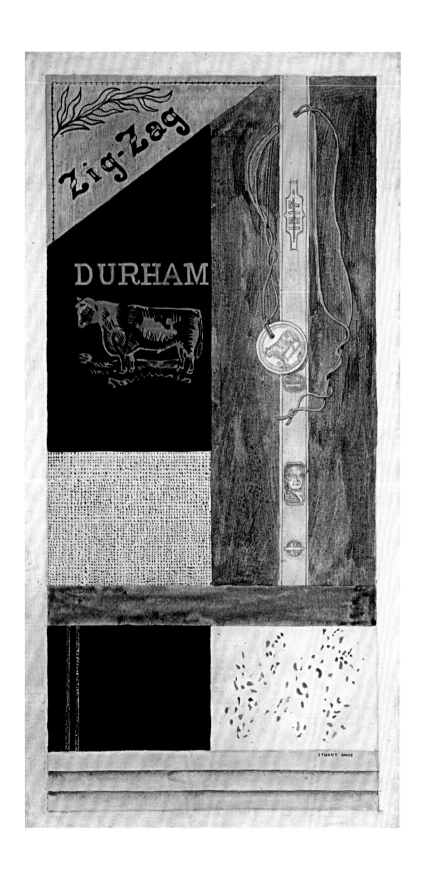

5 LANDSCAPE, GLOUCESTER, 1922 / 1951 / 1957

oil and wood on panel, 30.5 × 41 cm (12 × 16 ⅛ in.)
Ted and Mary Jo Shen

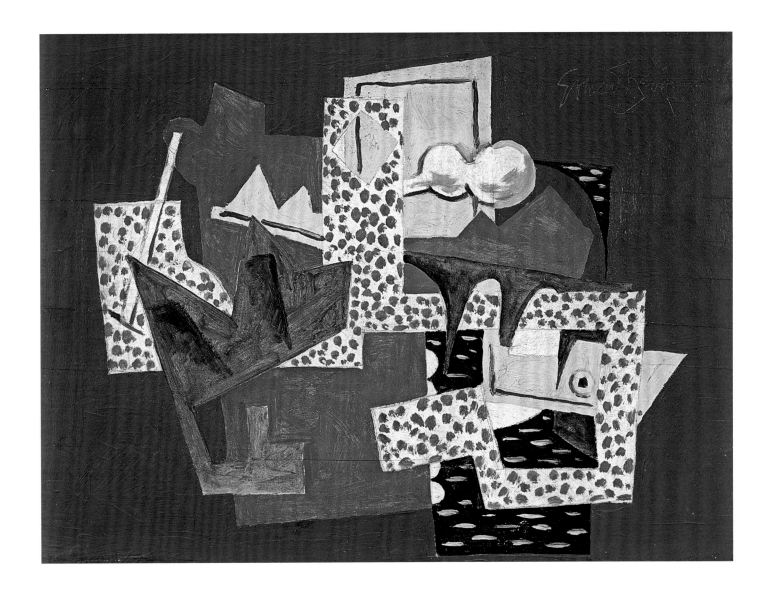

oil on cardboard, 62.2 × 47.3 cm (24 ½ × 18 ⅝ in.)
The Metropolitan Museum of Art

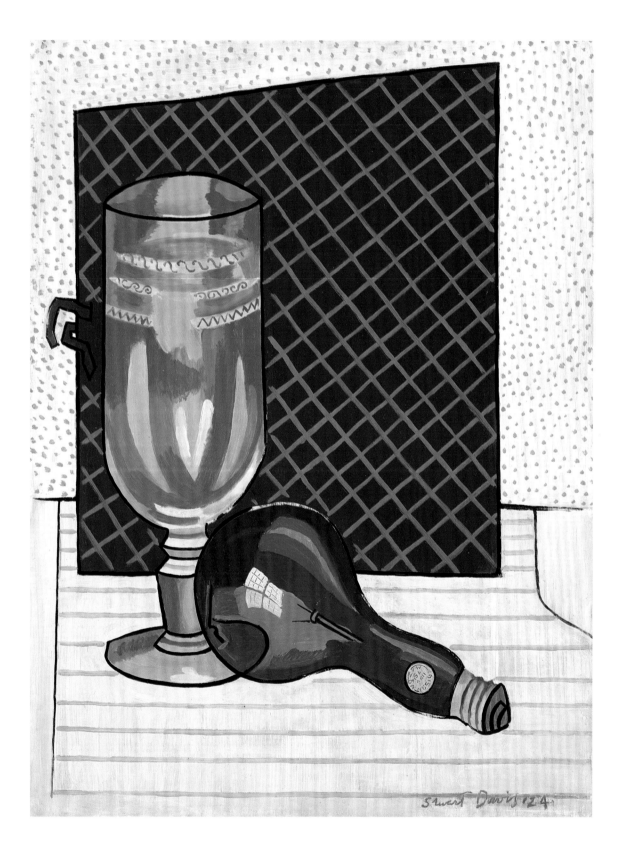

7 ELECTRIC BULB, 1924

oil on board, 61 × 45.7 cm (24 × 18 in.)
Dallas Museum of Art

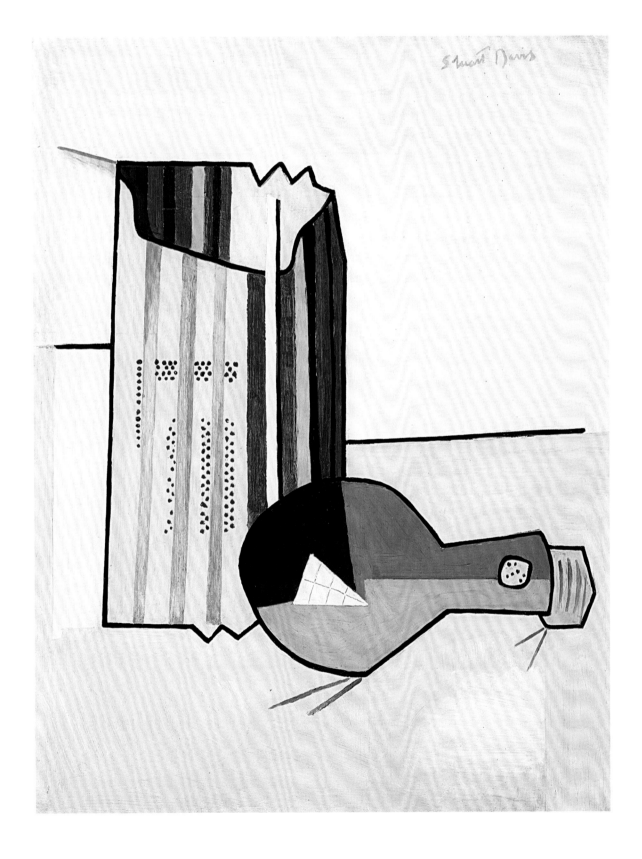

8 ODOL, 1924

oil on cardboard, 60.9 × 45.7 cm (24 × 18 in.)
The Museum of Modern Art

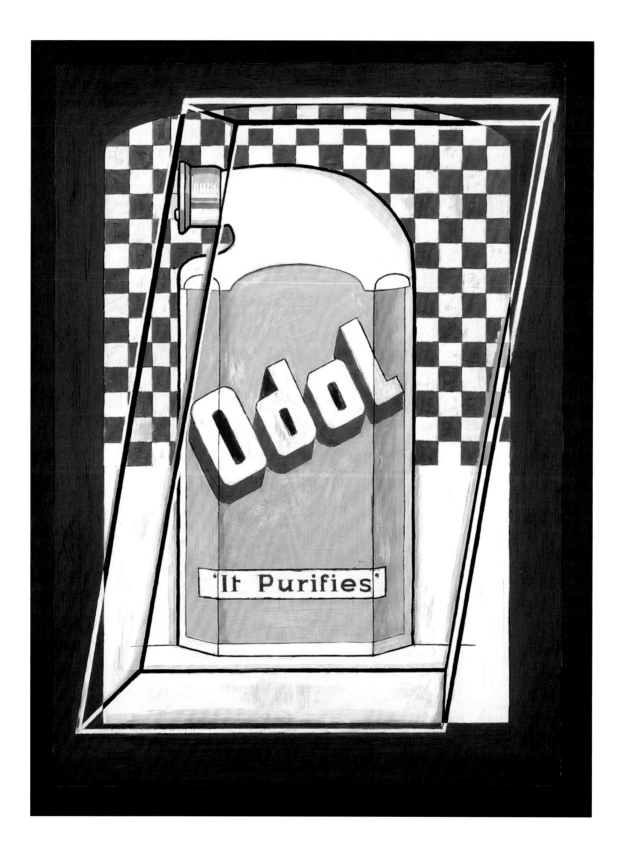

9 ODOL, 1924

oil on cardboard, 62.2 × 44.7 cm (24 ½ × 17 ⅝ in.)
Cincinnati Art Museum

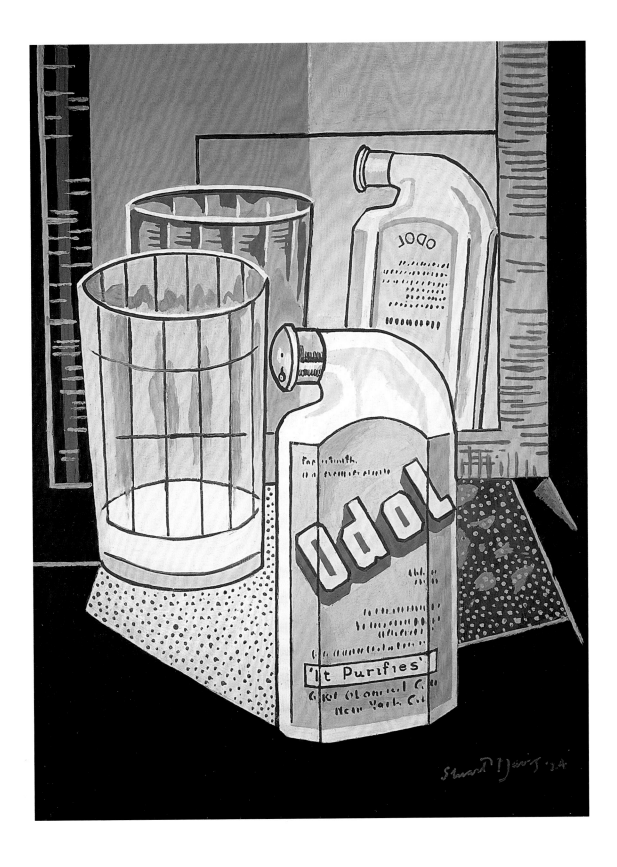

10 LUCKY STRIKE, 1924

oil on paperboard, 45.7 × 60.9 cm (18 × 24 in.)
Hirshhorn Museum and Sculpture Garden, Smithsonian Institution

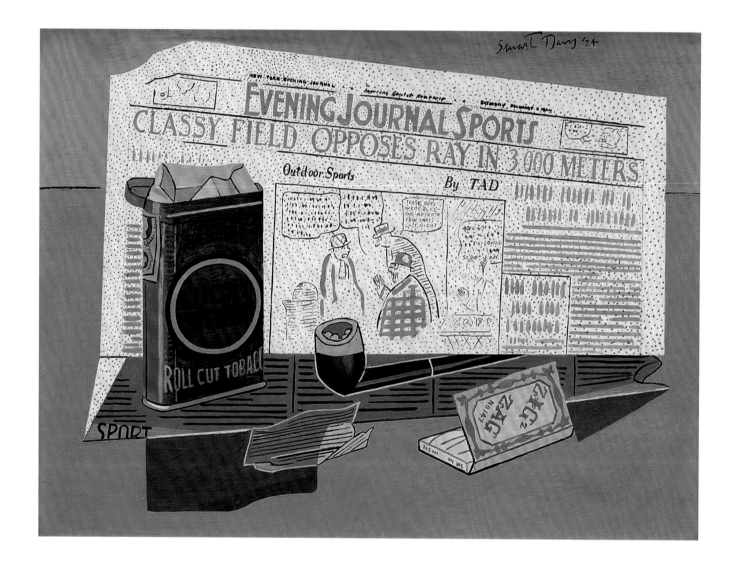

11 SUPER TABLE, 1925

oil on canvas, 122.2 × 86.7 cm (48 × 34 ⅛ in.)
Terra Foundation for American Art

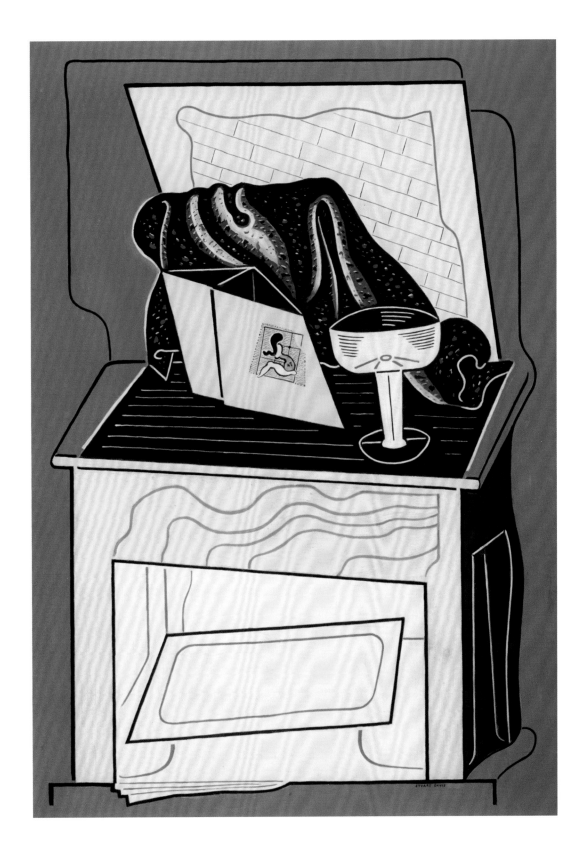

12 MATCHES, 1927

oil on canvas, 66 × 50.8 cm (26 × 20 in.)
The Chrysler Museum of Art

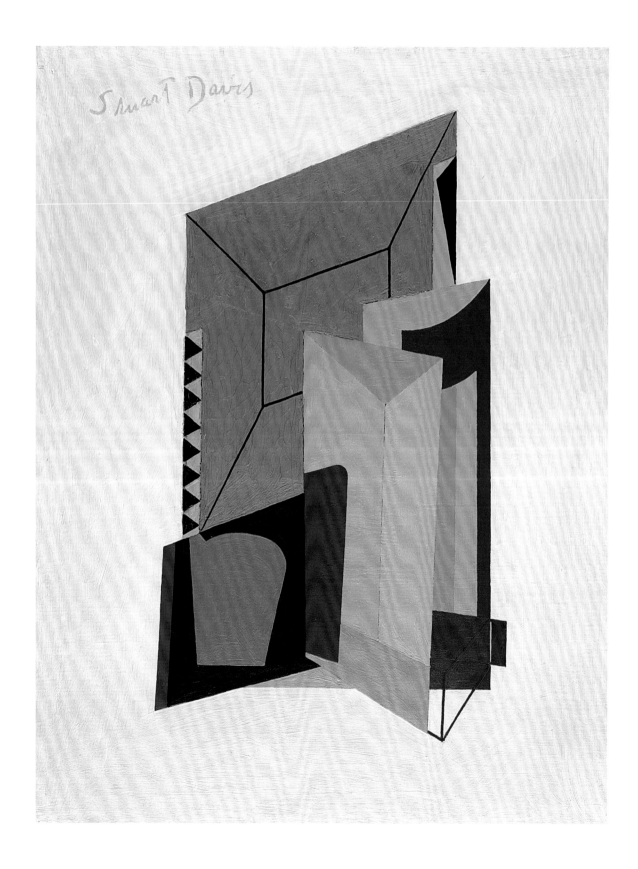

13 PERCOLATOR, 1927

oil on canvas, 91.4 × 73.7 cm (36 × 29 in.)
The Metropolitan Museum of Art

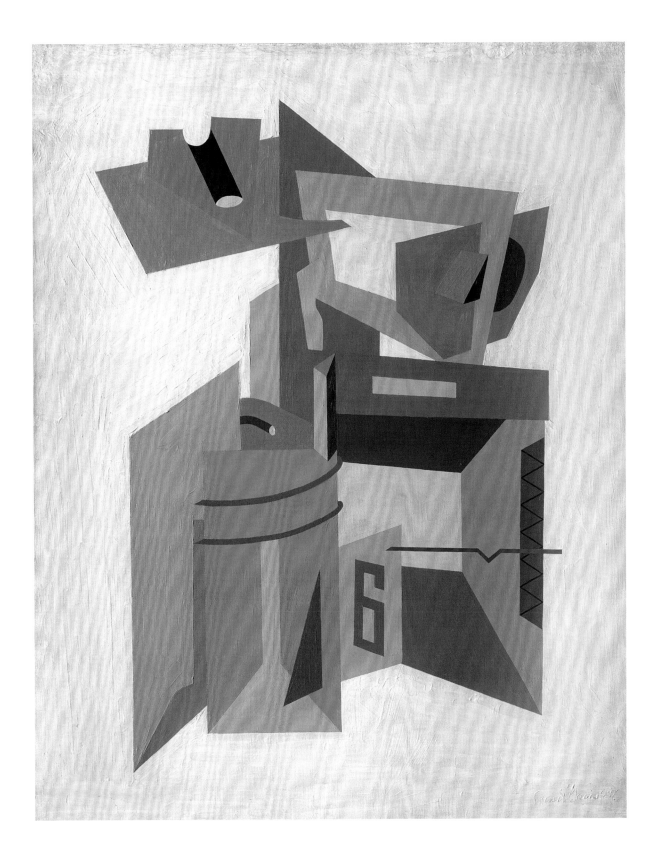

14 EGG BEATER NO. 1, 1927

oil on linen, 74 × 91.4 cm (29 ⅛ × 36 in.)
Whitney Museum of American Art

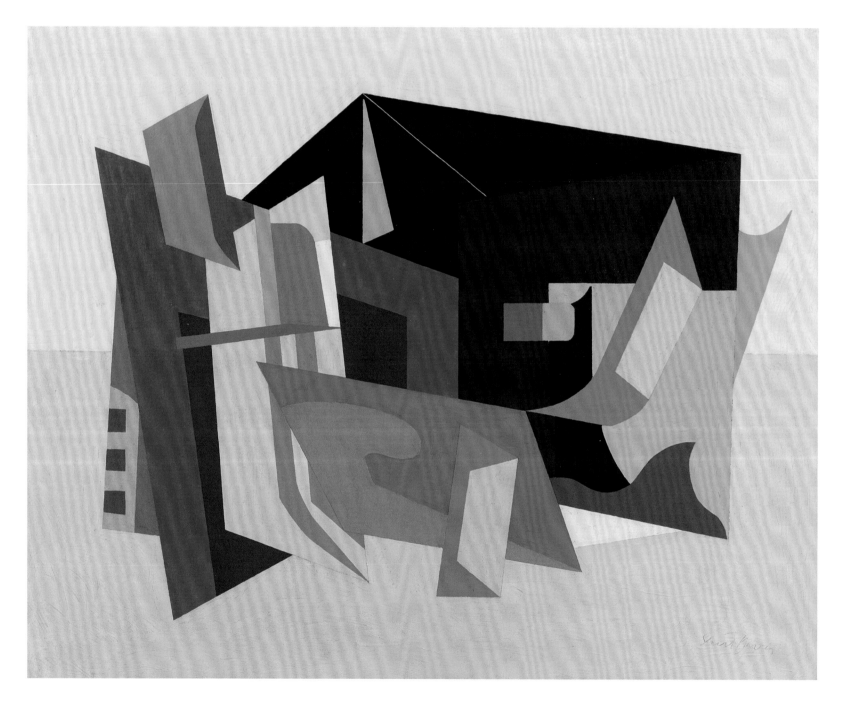

15 EGG BEATER NO. 2, 1928

oil on canvas, 74.3 × 92.1 cm (29 ¼ × 36 ¼ in.)
Amon Carter Museum of American Art

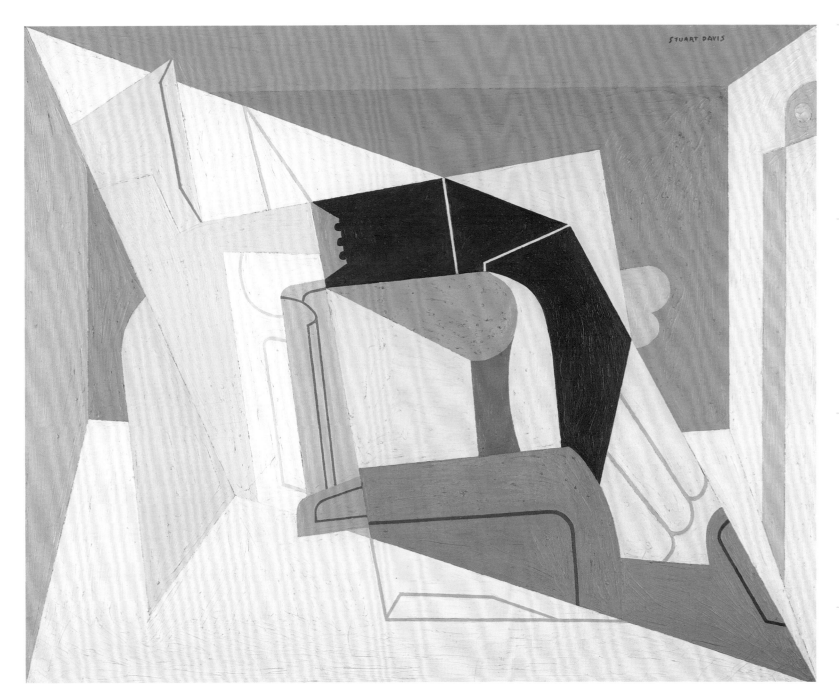

16 EGG BEATER NO. 3, 1928

oil on canvas, 63.8 × 99.4 cm (25 ⅛ × 39 ⅛ in.)
Museum of Fine Arts, Boston

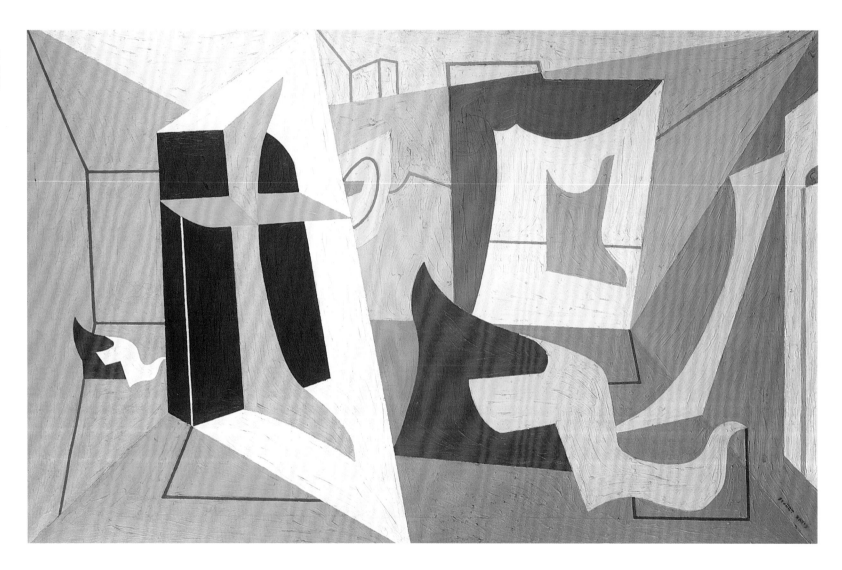

17 EGG BEATER NO. 4, 1928

oil on canvas, 68.9 × 97.2 cm (27 ⅛ × 38 ¼ in.)
The Phillips Collection

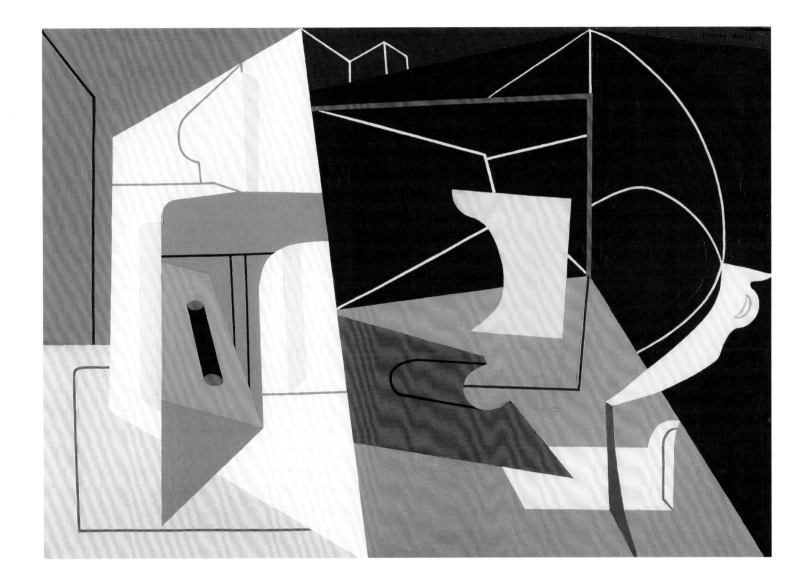

18 PLACE DES VOSGES NO. 2, 1928

oil on canvas, 65.3 × 92.3 cm (25 $^{11}/_{16}$ × 36 $^{5}/_{16}$ in.)

Herbert F. Johnson Museum of Art, Cornell University

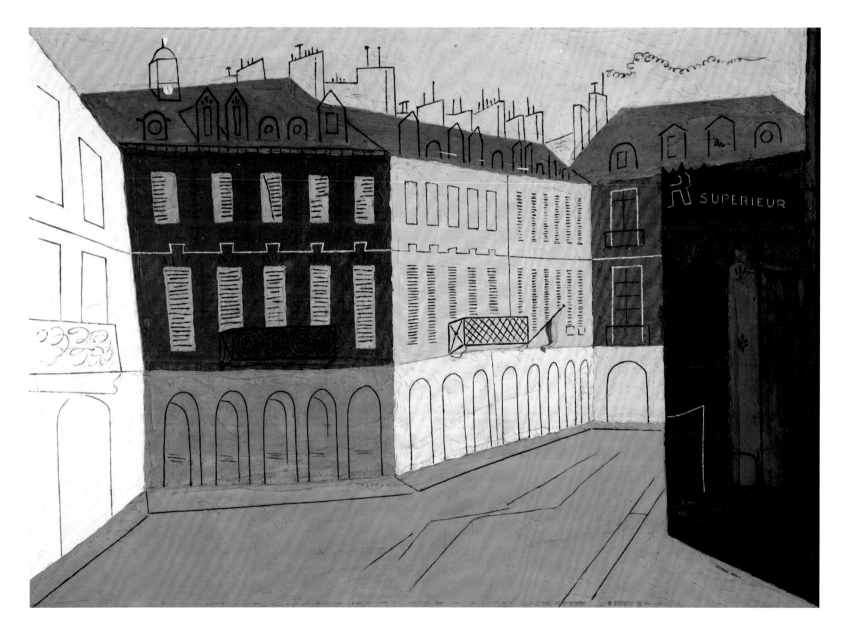

19 PLACE PASDELOUP, 1928

oil on canvas, 92.1 × 73 cm (36 ¼ × 28 ¾ in.)
Whitney Museum of American Art

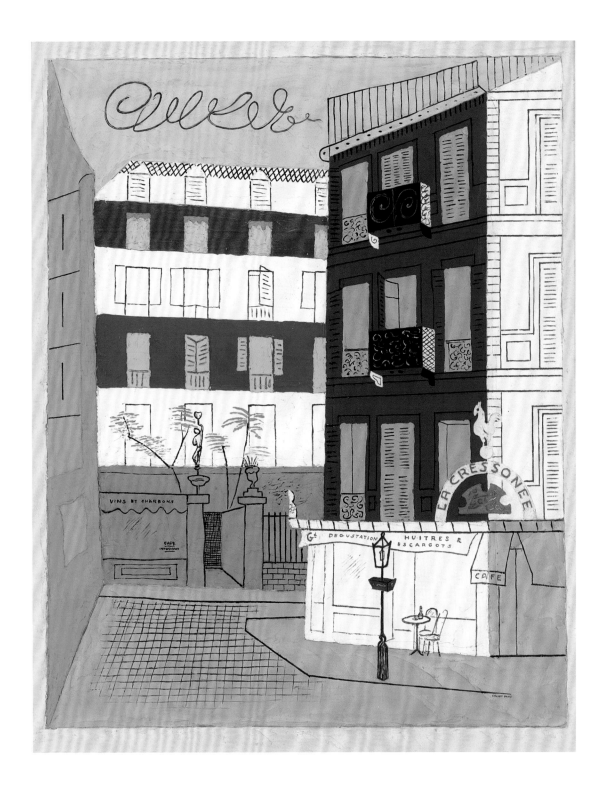

20 ADIT #1 (INDUSTRY), 1928

oil on canvas mounted on Masonite, 72.4 × 59.7 cm (28 ½ × 23 ½ in.)
The University of Arizona Museum of Art

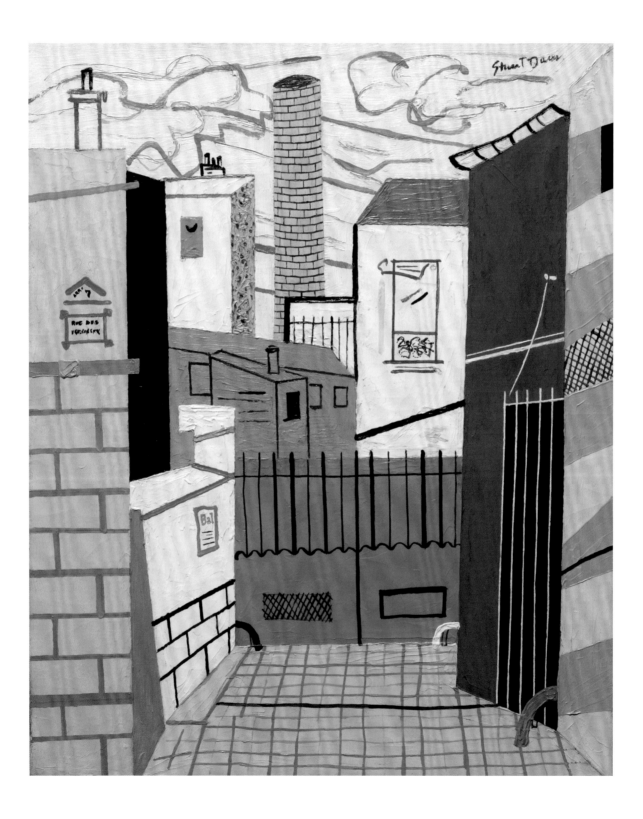

21 LAVOIR NO. 2, 1929

oil on canvas, 44.5 × 54.6 cm (17 ½ × 21 ½ in.)
Private collection

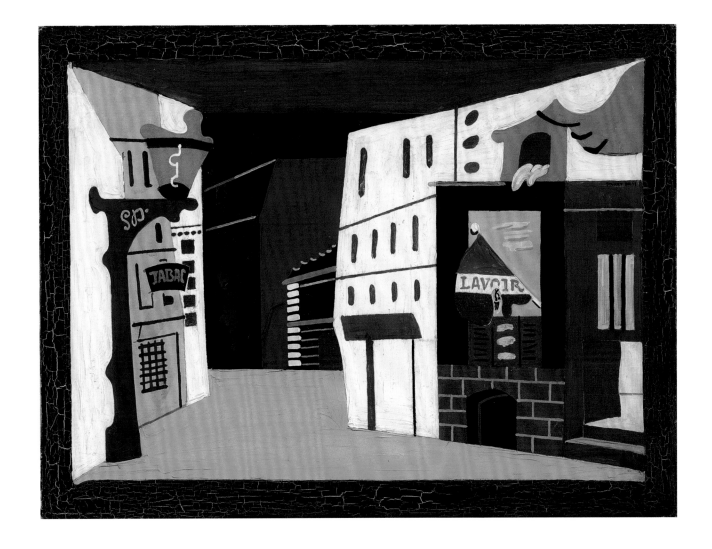

22 CAFÉ, PLACE DES VOSGES, 1929

oil on canvas, 73.7 × 92.7 cm (29 × 36 ½ in.)
Private collection

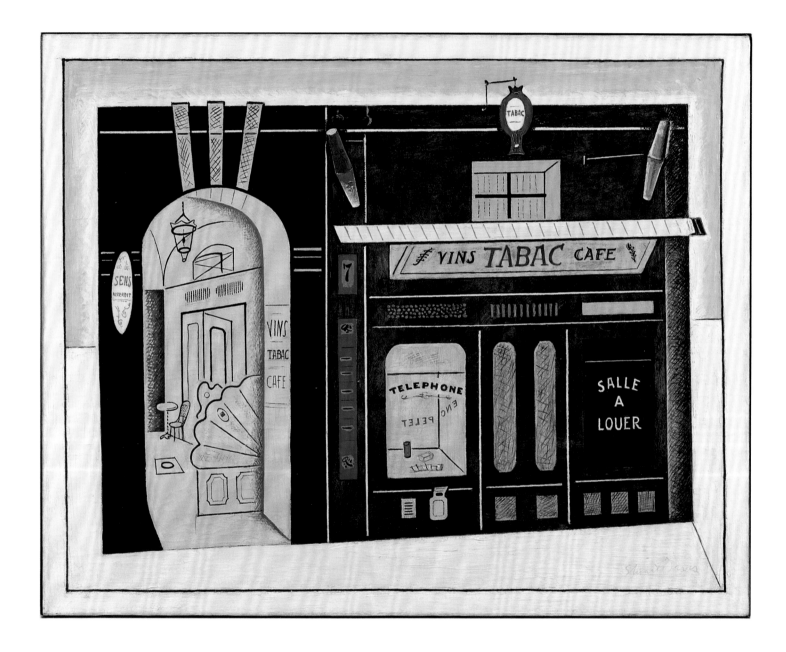

23 ARCH HOTEL, 1929

oil on canvas, 73 × 100.3 cm (28 ¾ × 39 ½ in.)
Sheldon Museum of Art, University of Nebraska – Lincoln

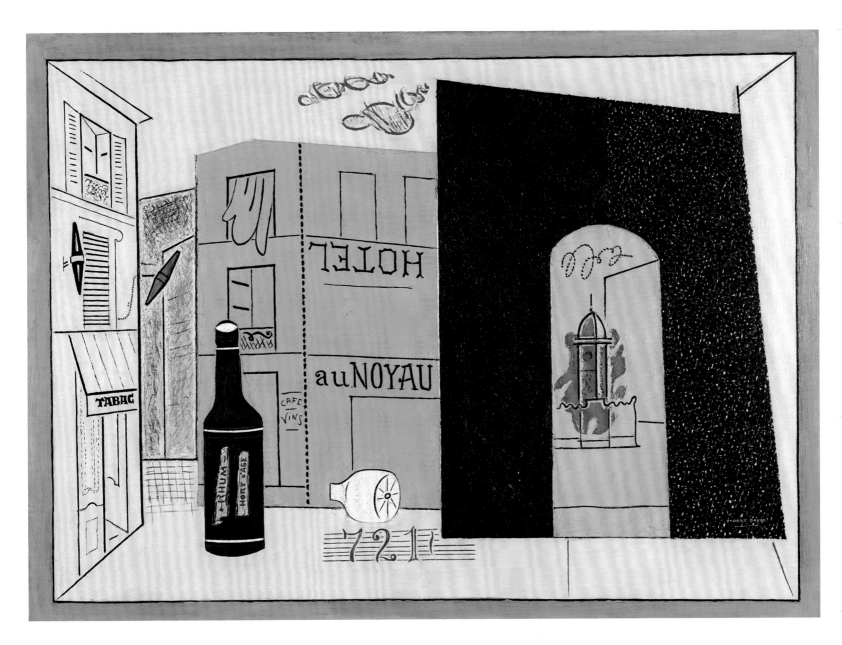

24 ARCADE, 1930

oil on canvas, 30.5 × 40.6 cm (12 × 16 in.)
Aaron I. Fleischman

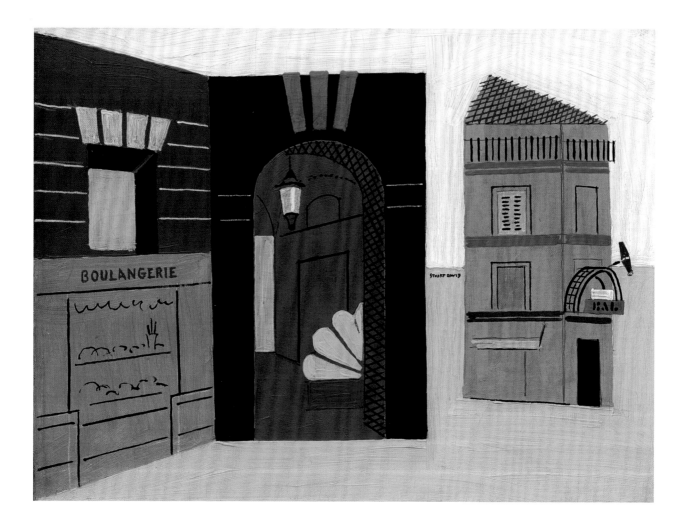

25 TOWN SQUARE, C. 1929

watercolor, gouache, ink, and pencil on paper, 39.4 × 58.1 cm (15 ½ × 22 ⅞ in.)
The Newark Museum

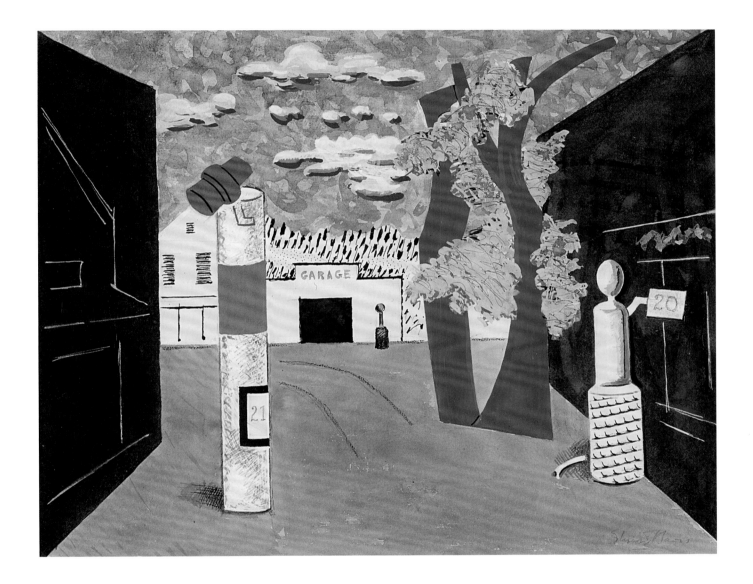

26 SUMMER LANDSCAPE, 1930

oil on canvas, 73.7 × 106.7 cm (29 × 42 in.)
Private collection of Pitt and Barbara Hyde

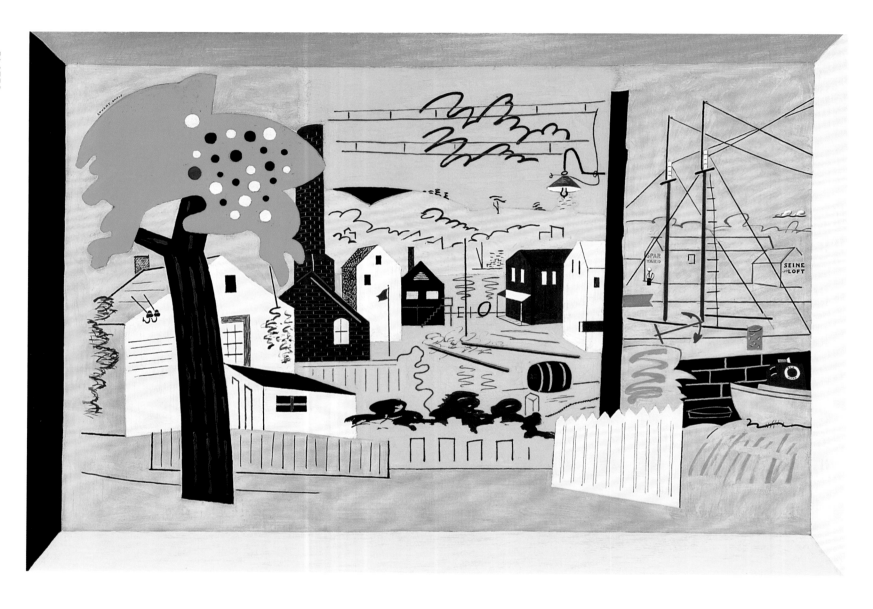

27 NEW YORK — PARIS NO. 2, 1931

oil on canvas, 76.8 × 102.2 cm (30 ¼ × 40 ¼ in.)
Portland Museum of Art

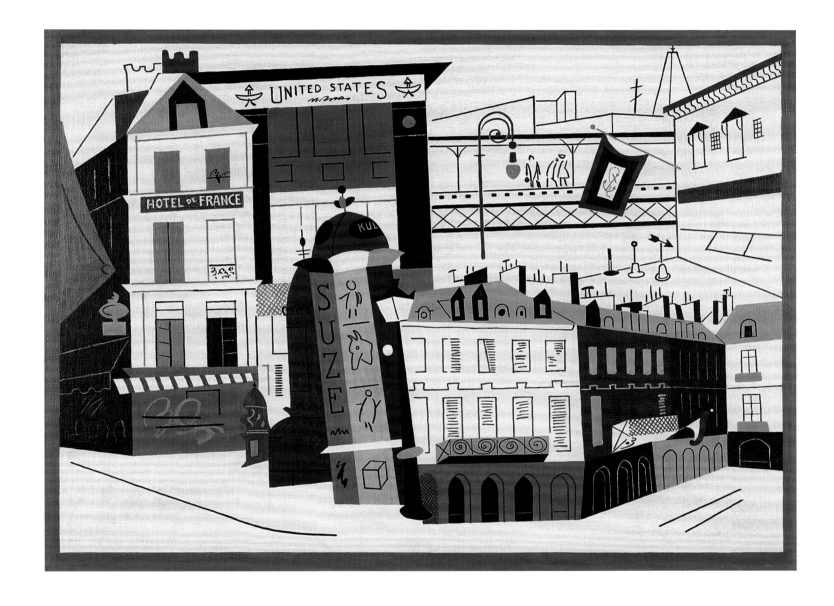

28 STILL LIFE: RADIO TUBE, 1931
oil on canvas, 127 × 81.9 cm (50 × 32 ¼ in.)
Rose Art Museum, Brandeis University

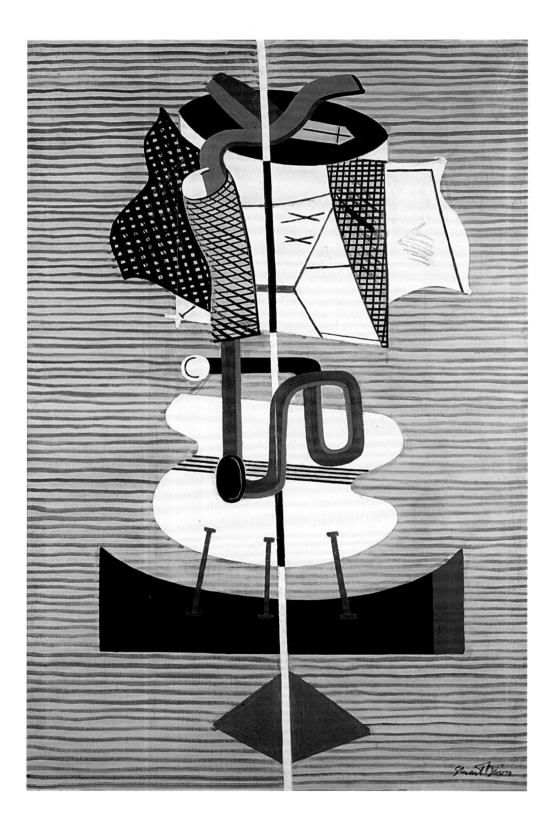

29 SALT SHAKER, 1931

oil on canvas, 126.7 × 81.3 cm (49 ⅞ × 32 in.)
The Museum of Modern Art

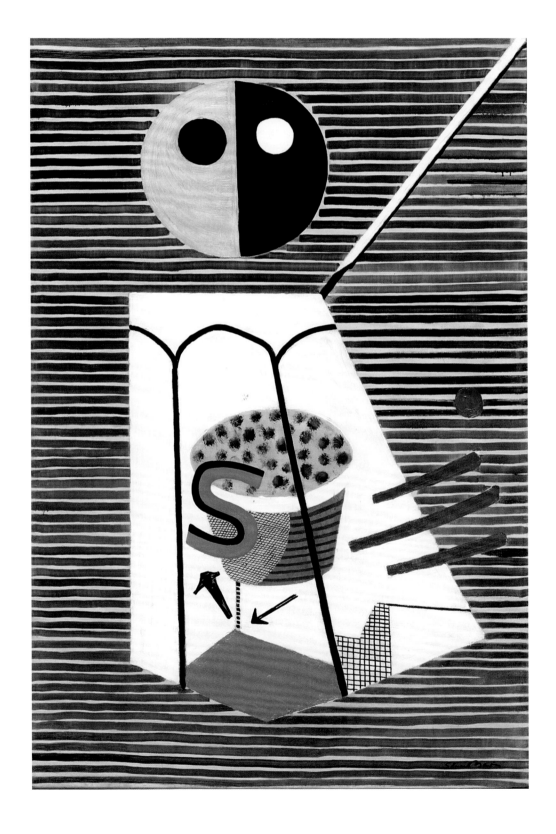

30 HOUSE AND STREET, 1931

oil on canvas, 66 × 107.9 cm (26 × 42 ½ in.)
Whitney Museum of American Art

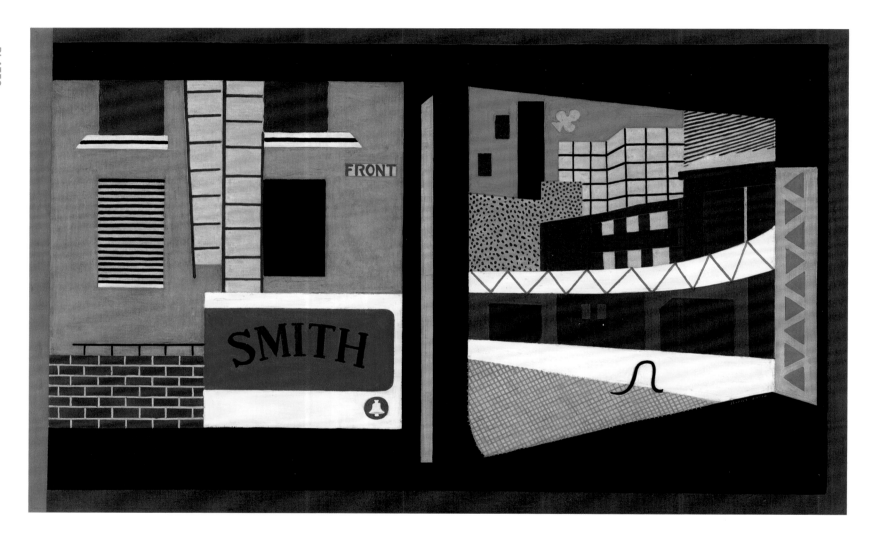

31 LANDSCAPE WITH GARAGE LIGHTS, 1931–1932
oil on canvas, 81.3 × 106.7 cm (32 × 42 in.)
Memorial Art Gallery of the University of Rochester

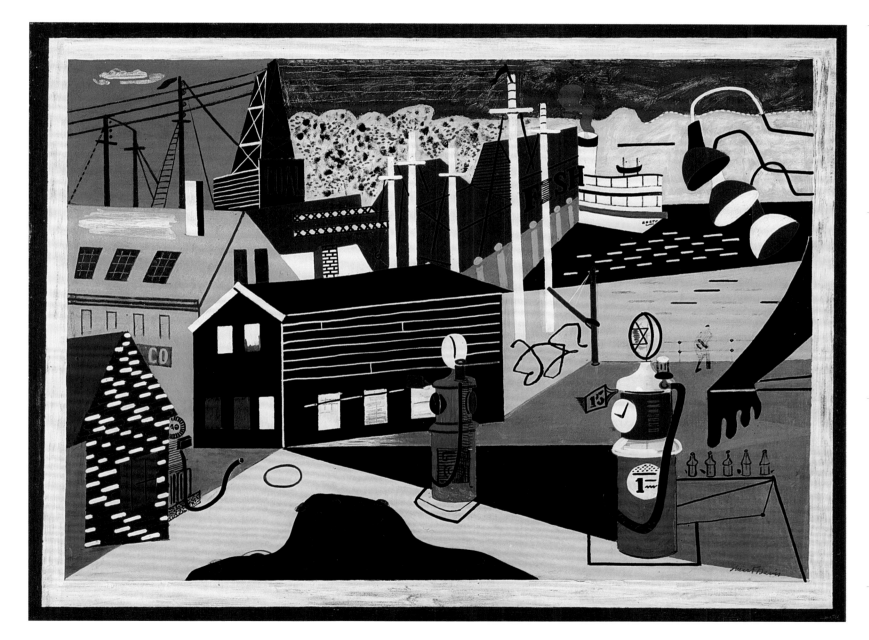

32 NEW YORK MURAL, 1932

oil on canvas, 213.4 × 121.9 cm (84 × 48 in.)
Norton Museum of Art

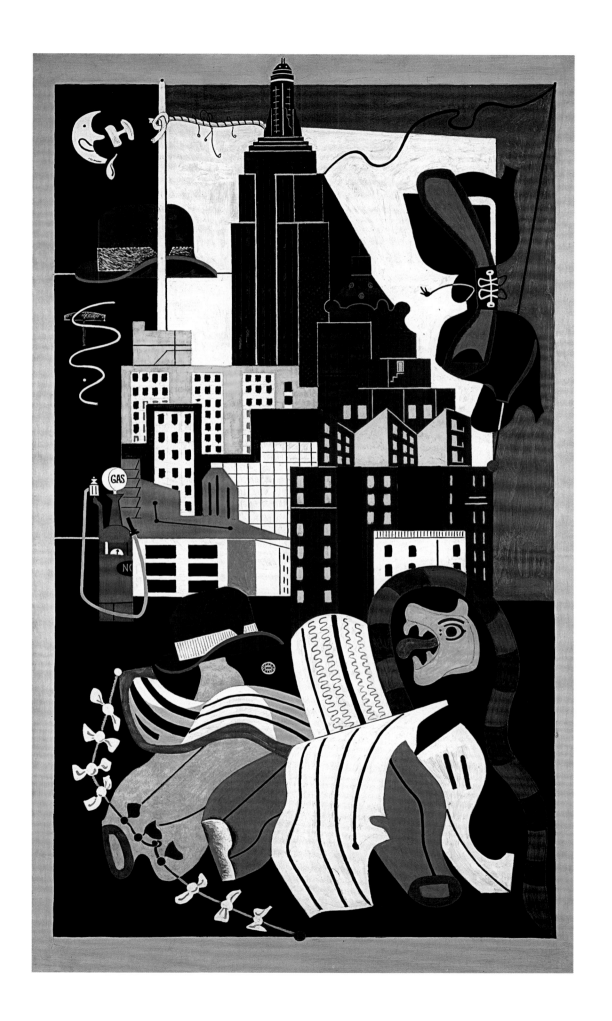

1930 - 1939

33 RED CART, 1932

oil on canvas, 81.9 × 127 cm (32 ¼ × 50 in.)
Addison Gallery of American Art, Phillips Academy

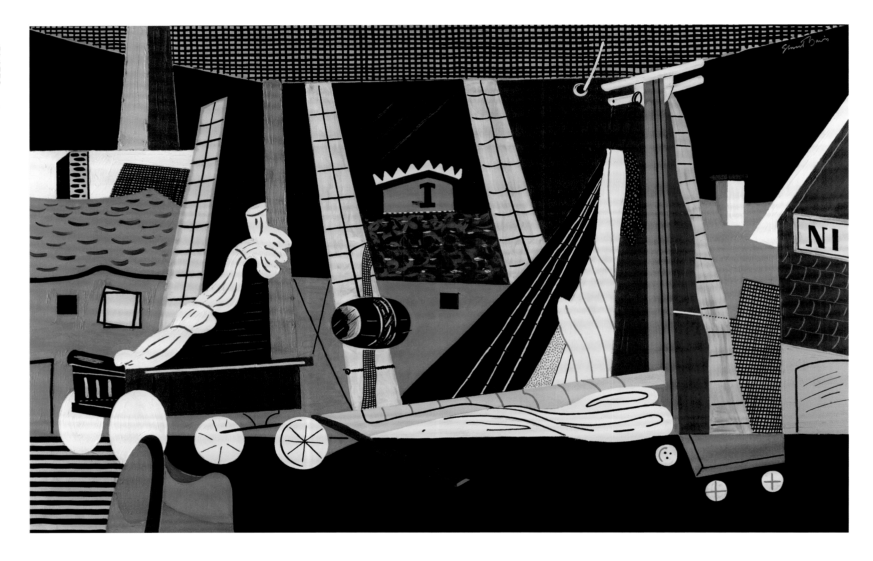

34 STUDY FOR MEN WITHOUT WOMEN,
RADIO CITY MUSIC HALL MEN'S LOUNGE MURAL, 1932

gouache and pencil on paper, 27.3 × 42.6 cm (10¾ × 16¾ in.)
Currier Museum of Art

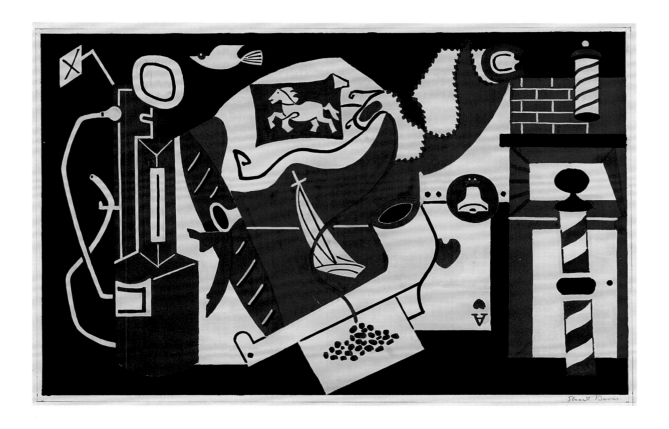

35 MURAL (RADIO CITY MEN'S LOUNGE MURAL: MEN WITHOUT WOMEN), 1932

oil on canvas, 327.2 × 518 cm
(128 ⅞ × 203 ⅞ in.)
The Museum of Modern Art

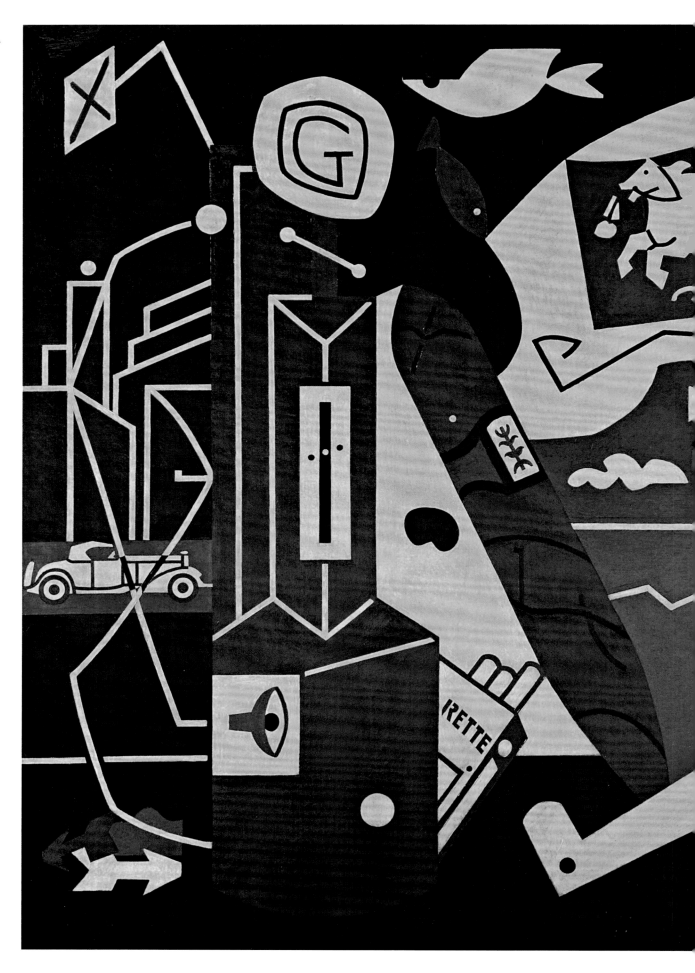

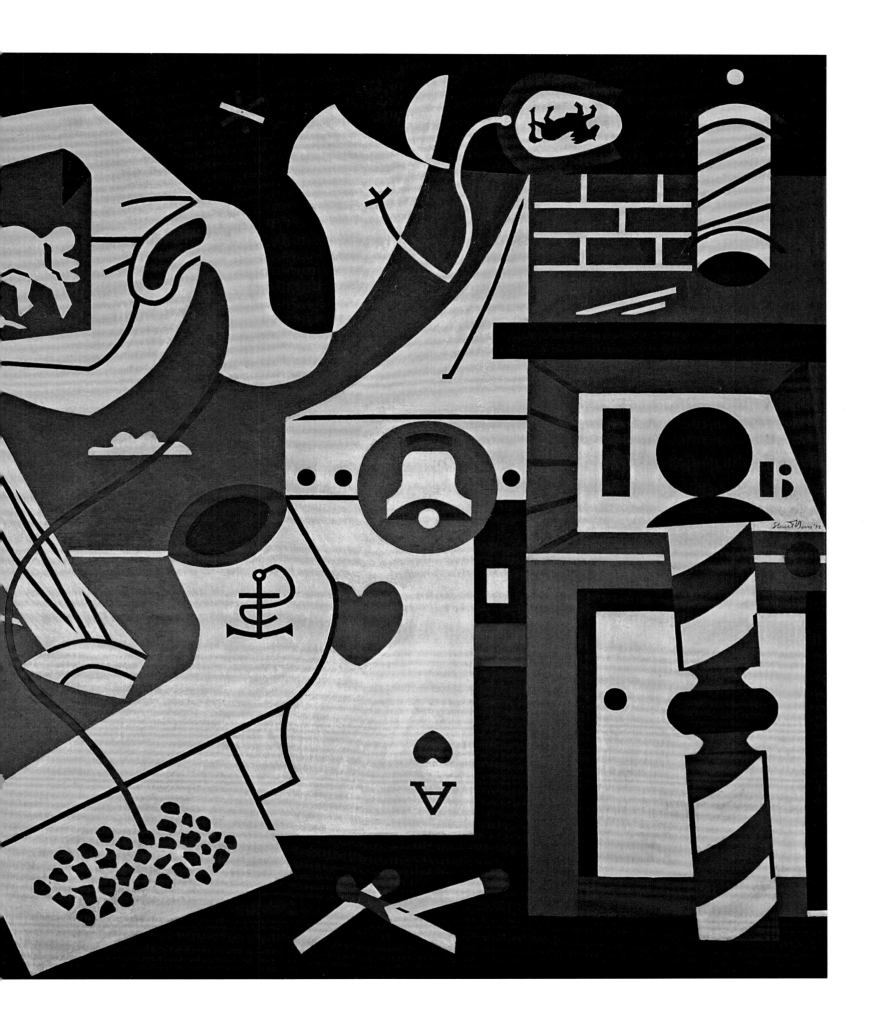

36 LANDSCAPE, 1932 / 1935

oil on canvas, 82.6 × 74.3 cm (32 ½ × 29 ¼ in.)
Brooklyn Museum

37 AMERICAN PAINTING, 1932/1942–1954
oil on canvas, 101.6 × 127.6 cm (40 × 50¼ in.)
Joslyn Art Museum

38 MEN AND MACHINE, 1934

oil on canvas, 81.3 × 101.6 cm (32 × 40 in.)
The Metropolitan Museum of Art

39 ARTISTS AGAINST WAR AND FASCISM, 1936

gouache and pencil on paper, 29.5 × 39.4 cm (11 ⅝ × 15 ½ in.)
Collection of Fayez Sarofim

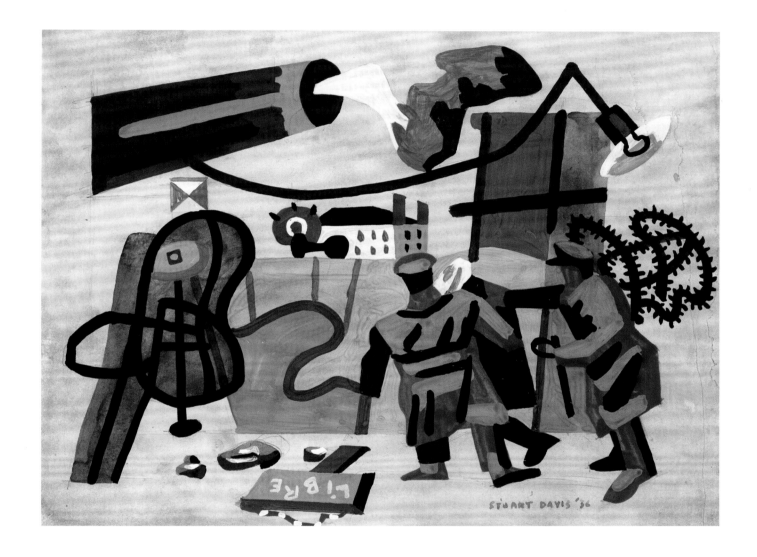

40 SWING LANDSCAPE, 1938

oil on canvas, 220.4 × 439.7 cm (86 ¾ × 173 ⅛ in.)
Indiana University Art Museum

oil on canvas, 213.4 × 335.3 cm (84 × 132 in.)
The Metropolitan Museum of Art

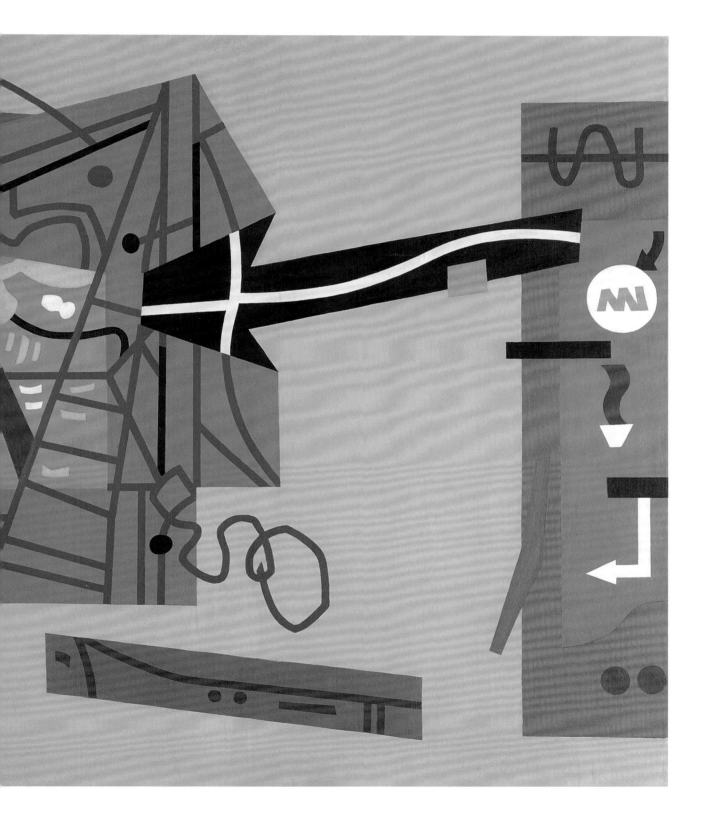

42 SHAPES OF LANDSCAPE SPACE, 1939
oil on canvas, 91.4 × 71.1 cm (36 × 28 in.)
Neuberger Museum of Art

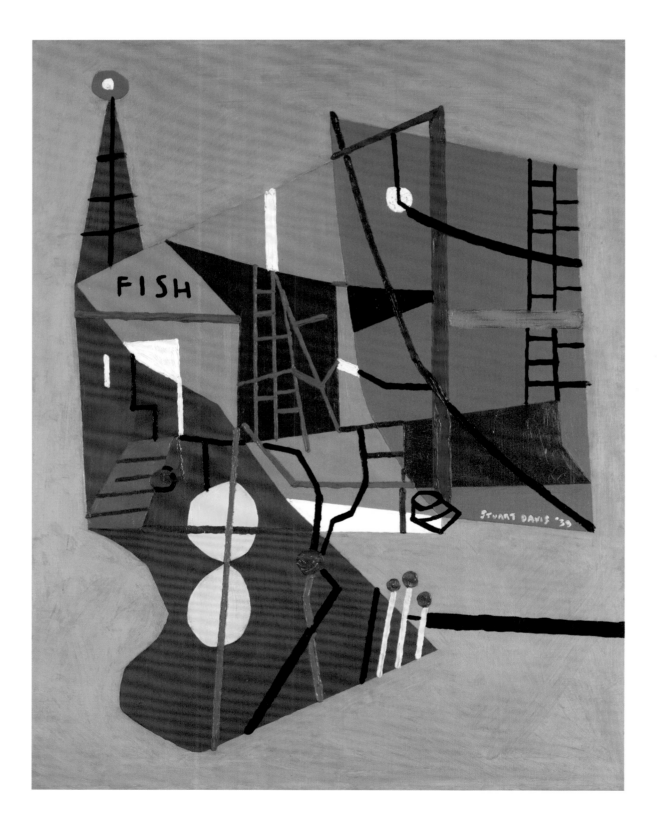

gouache on paper, 29.5 × 39.1 cm (11 ⅝ × 15 ⅜ in.)
Seattle Art Museum

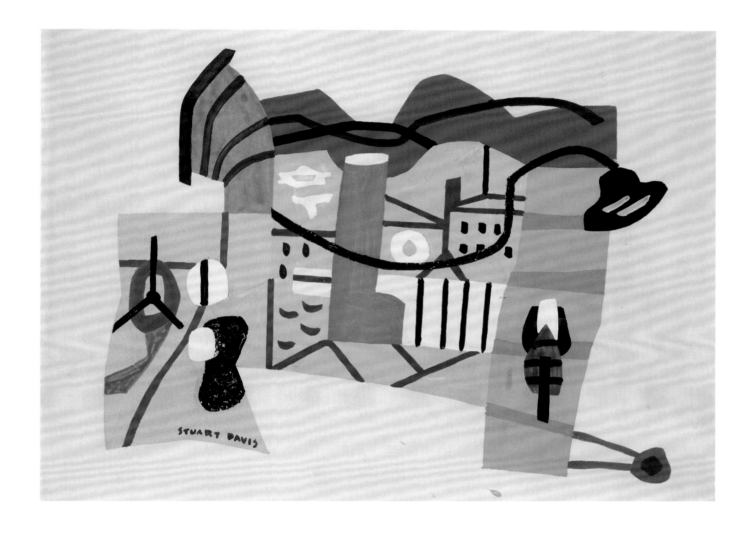

44 COLORS OF SPRING IN THE HARBOR, 1939
gouache on watercolor board, 30.5 × 40.6 cm (12 × 16 in.)
Munson Williams Proctor Arts Institute, Museum of Art

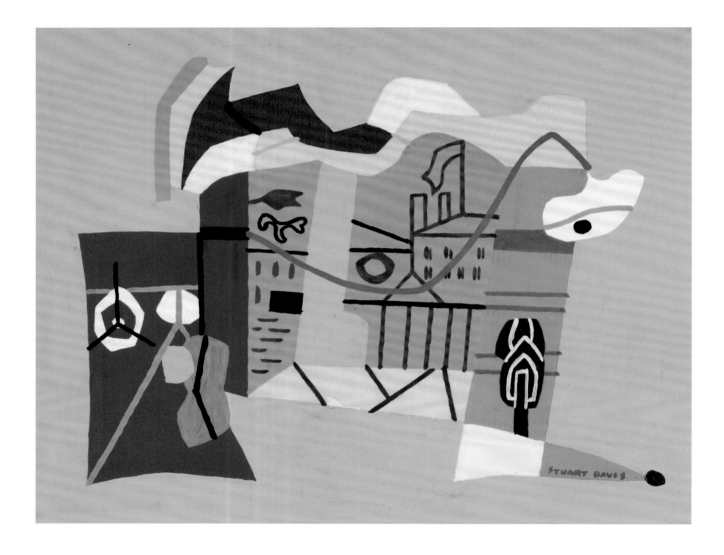

45 SHAPES OF LANDSCAPE SPACE #3, 1940

oil on canvas, 39.4 × 49.5 cm (15 ½ × 19 ½ in.)
The Columbus Museum

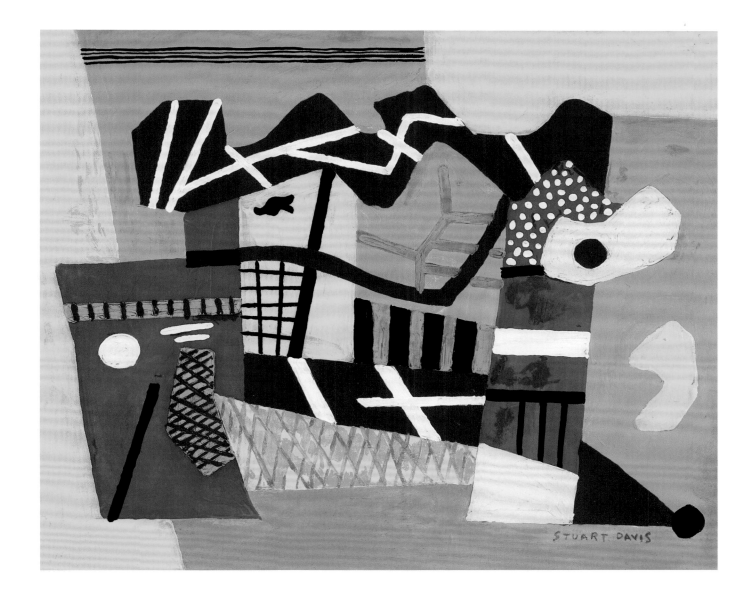

46 LANDSCAPE WITH CLAY PIPE, 1941

oil on canvas, 30.5 × 45.7 cm (12 × 18 in.)
Brooklyn Museum

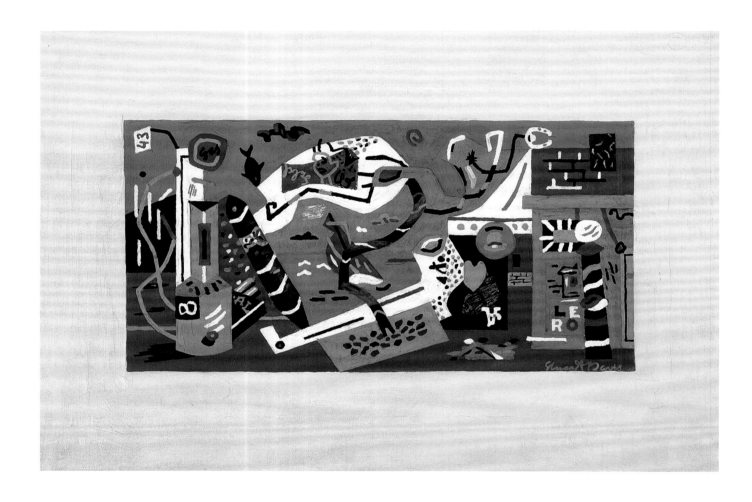

47 REPORT FROM ROCKPORT, 1940
oil on canvas, 61 × 76.2 cm (24 × 30 in.)
The Metropolitan Museum of Art

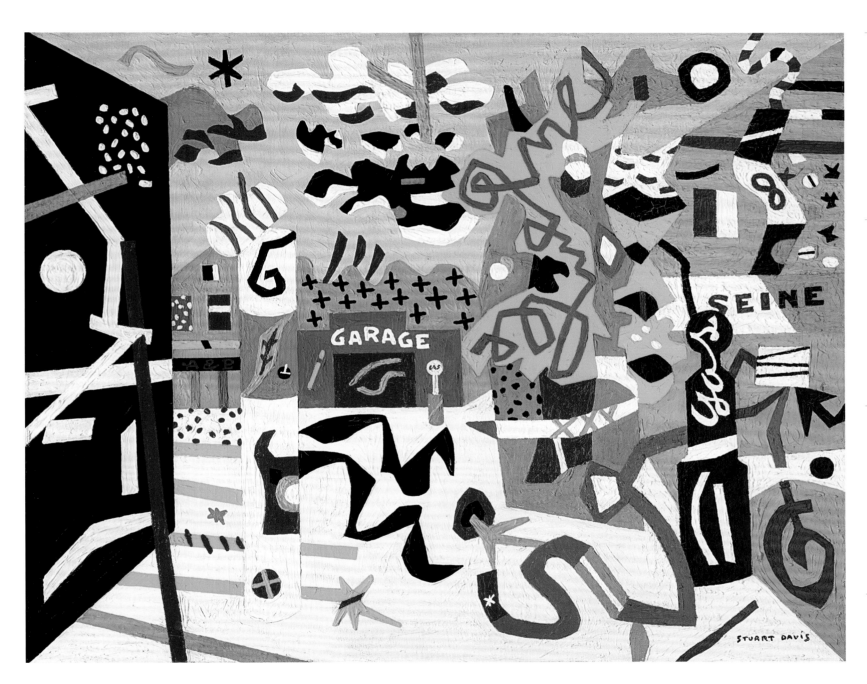

48 ARBORETUM BY FLASHBULB, 1942

oil on canvas, 45.7 × 91.4 cm (18 × 36 in.)
The Metropolitan Museum of Art

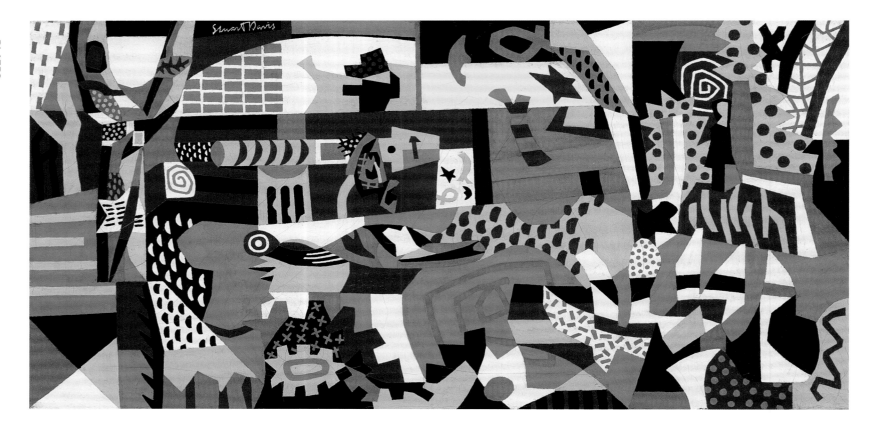

49 ULTRA – MARINE, 1943 / 1952
oil on canvas, 50.8 × 101.9 cm (20 × 40 ⅛ in.)
Pennsylvania Academy of the Fine Arts

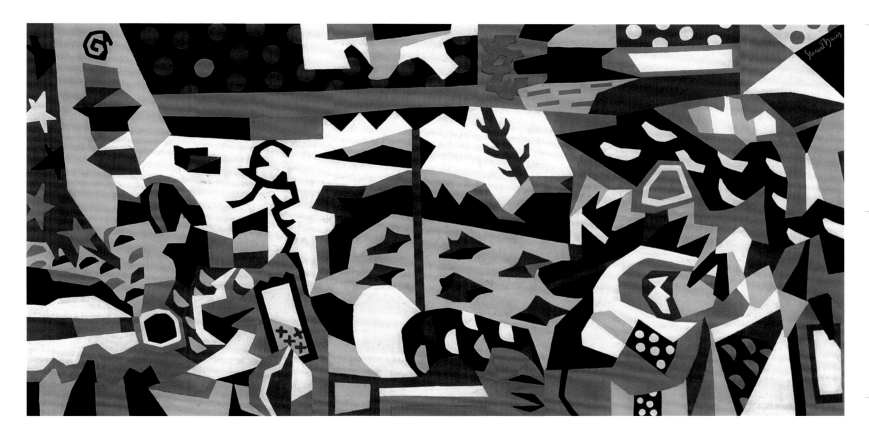

50 FOR INTERNAL USE ONLY, 1944 – 1945
oil on canvas, 114.3 × 71.1 cm (45 × 28 in.)
Reynolda House Museum of American Art

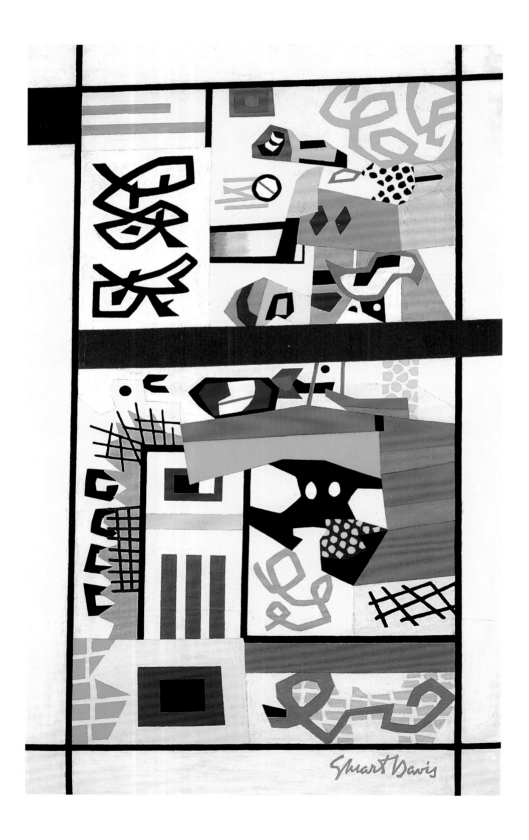

51 THE MELLOW PAD, 1945–1951

oil on canvas, 66.7 × 107 cm (26 ¼ × 42 ⅛ in.)
Brooklyn Museum

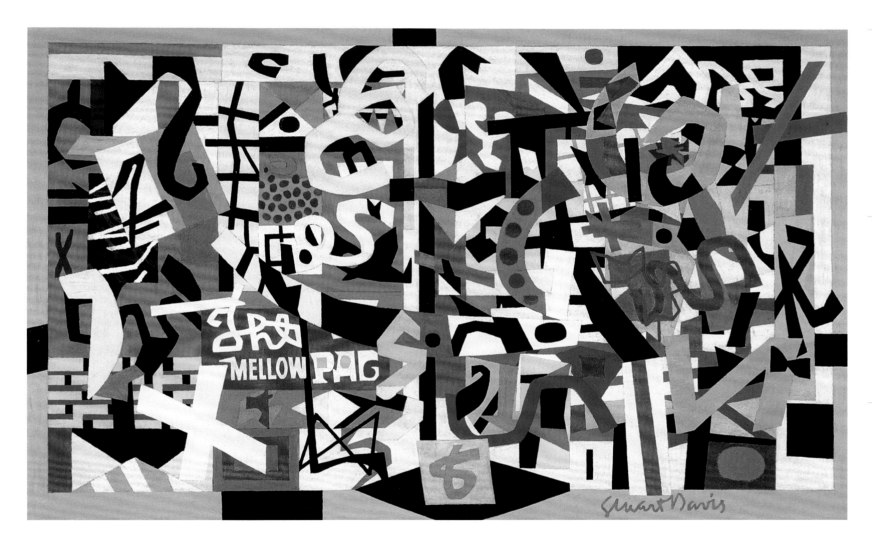

52 LITTLE GIANT STILL LIFE, 1950
oil on canvas, 83.8 × 109.2 cm (33 × 43 in.)
Virginia Museum of Fine Arts

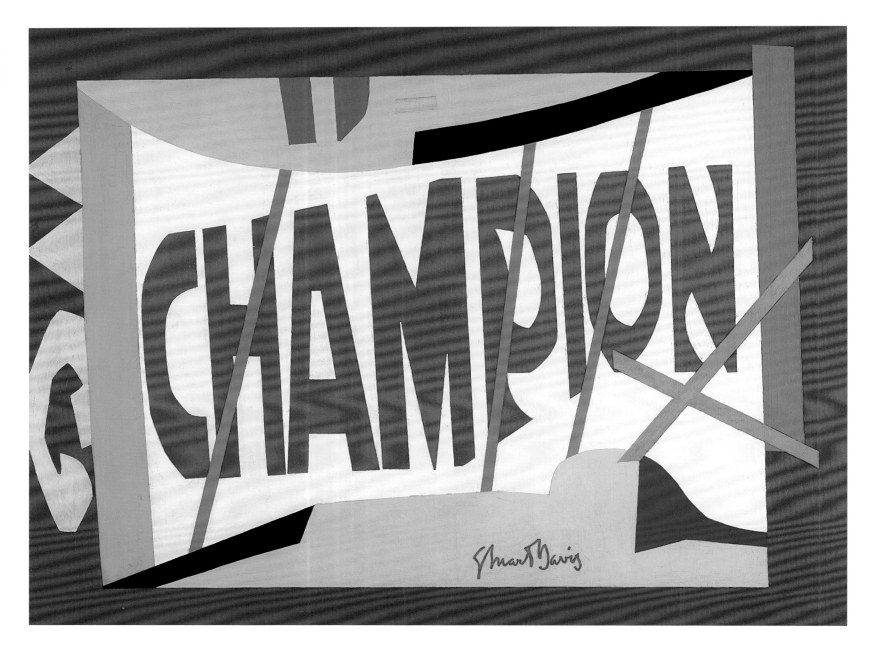

53 VISA, 1951
 oil on canvas, 101.6 × 132.1 cm (40 × 52 in.)
 The Museum of Modern Art

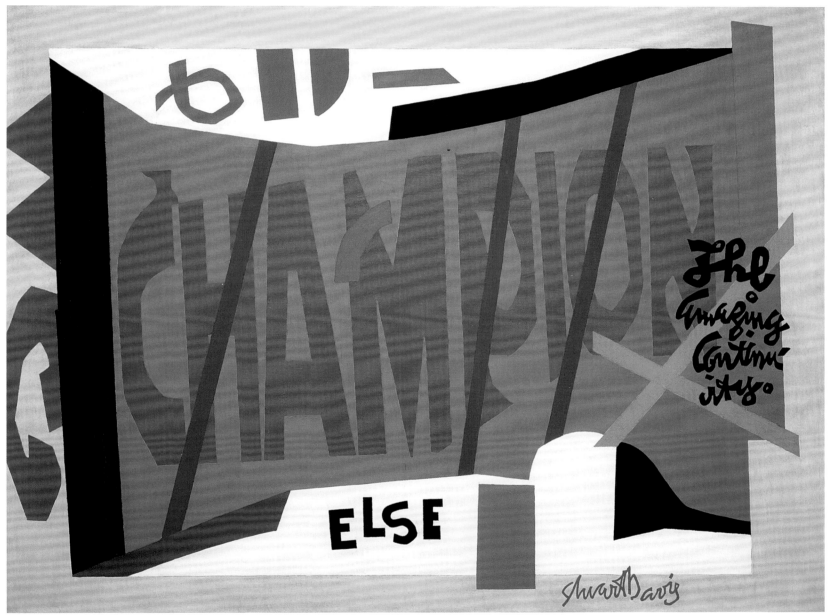

54 LITTLE GIANT STILL LIFE (BLACK AND WHITE VERSION), 1953

casein and pencil on canvas, 83.5 × 109.2 cm (32 ⅞ × 43 in.)
Private collection

oil on canvas, 132.1 × 101.6 cm (52 × 40 in.)
Hirshhorn Museum and Sculpture Garden, Smithsonian Institution

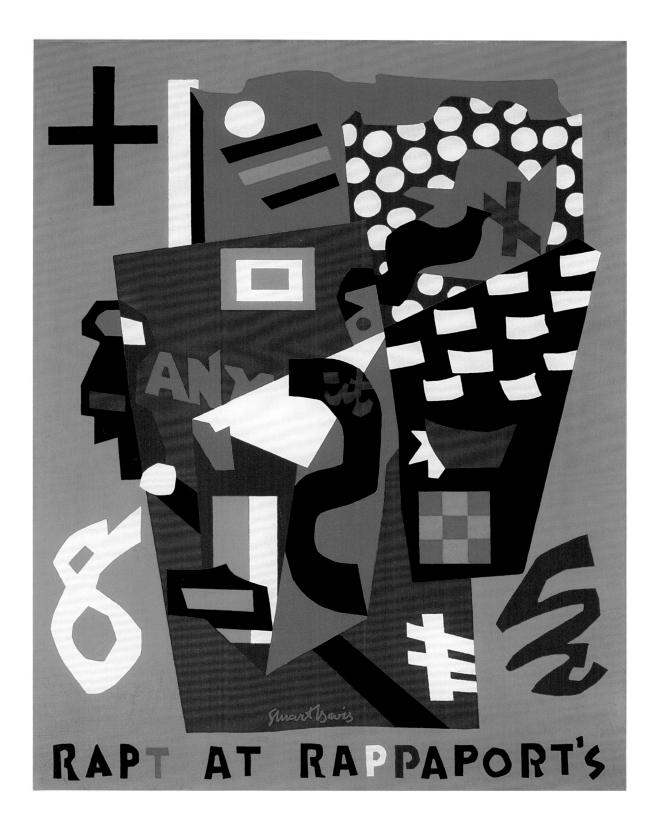

56 OWH! IN SAO PÃO, 1951

oil on canvas, 132.7 × 106.1 cm (52 ¼ × 41 ¾ in.)
Whitney Museum of American Art

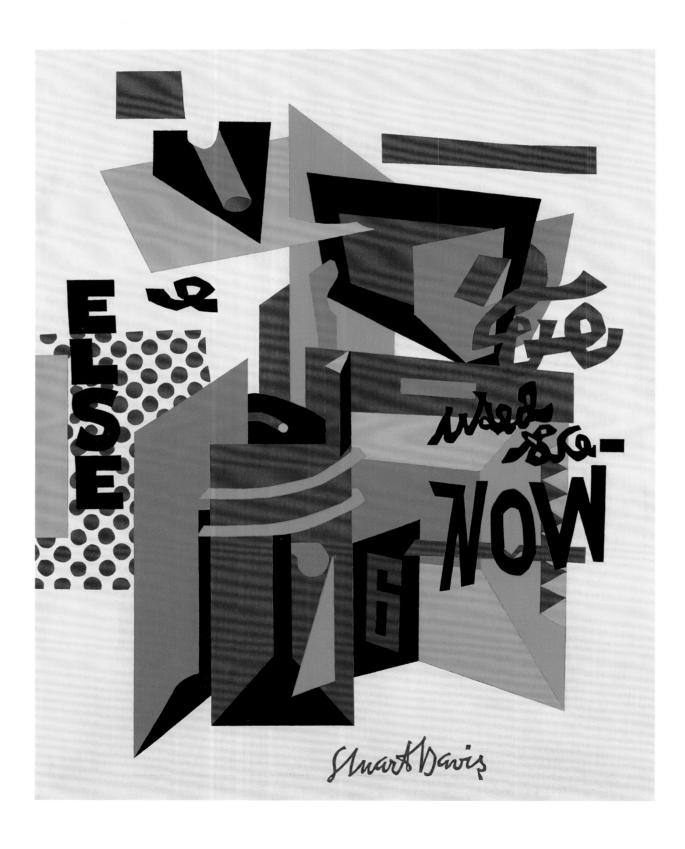

57 SEMÉ, 1953

oil on canvas, 132.1 × 101.6 cm (52 × 40 in.)
The Metropolitan Museum of Art

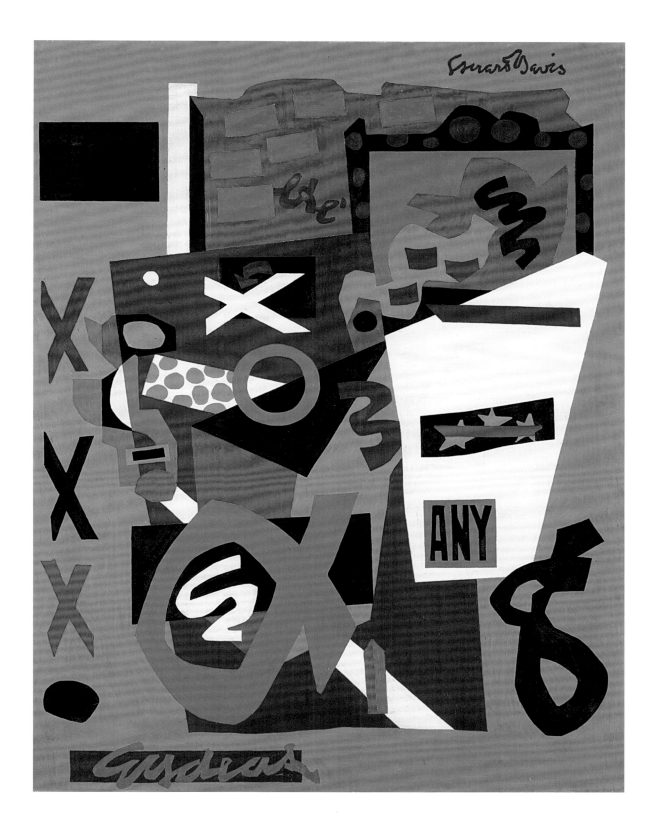

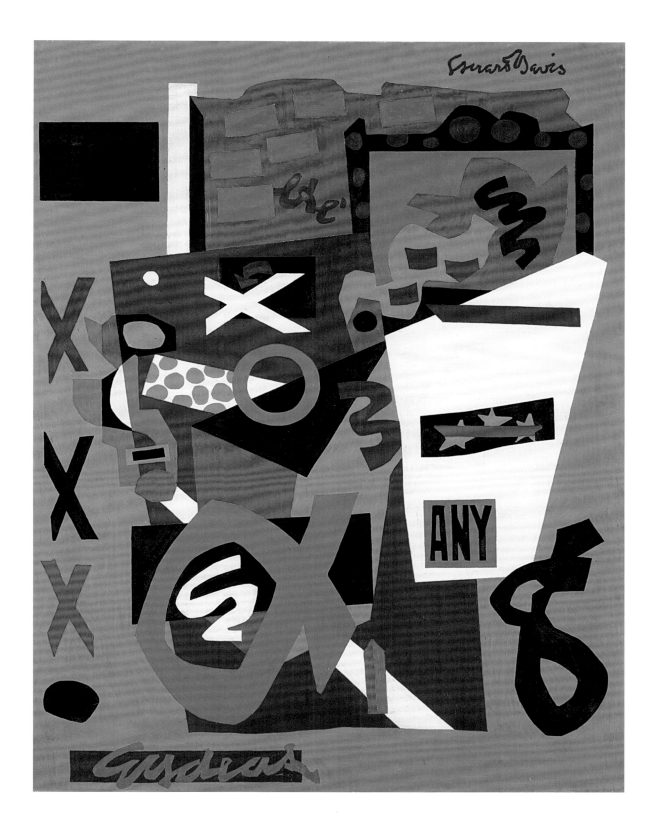

58 MEDIUM STILL LIFE, 1953

oil on canvas, 114.3 × 91.4 cm (45 × 36 in.)
Museum of Fine Arts, Boston

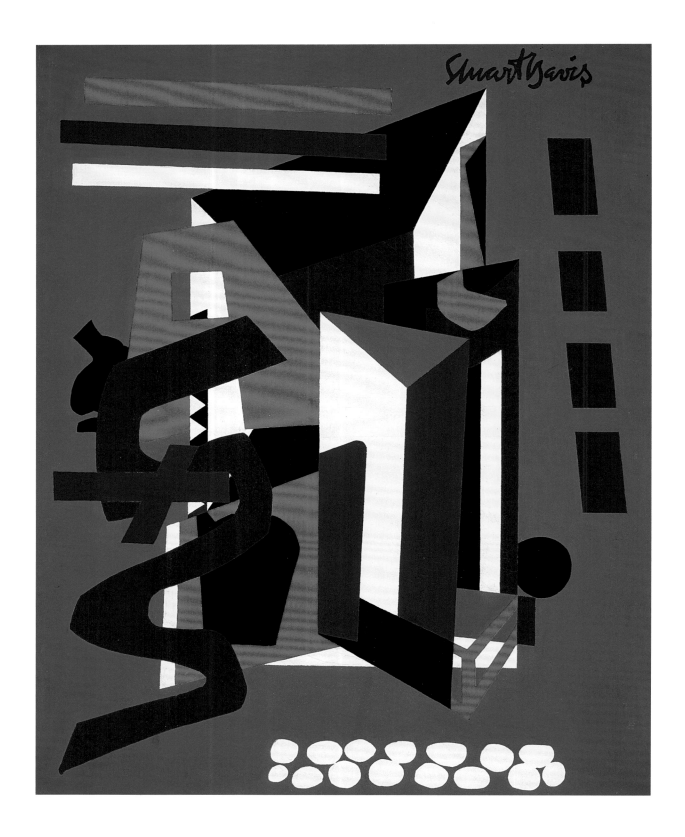

oil on canvas, 142.2 × 114.3 cm (56 × 45 in.)
Philadelphia Museum of Art

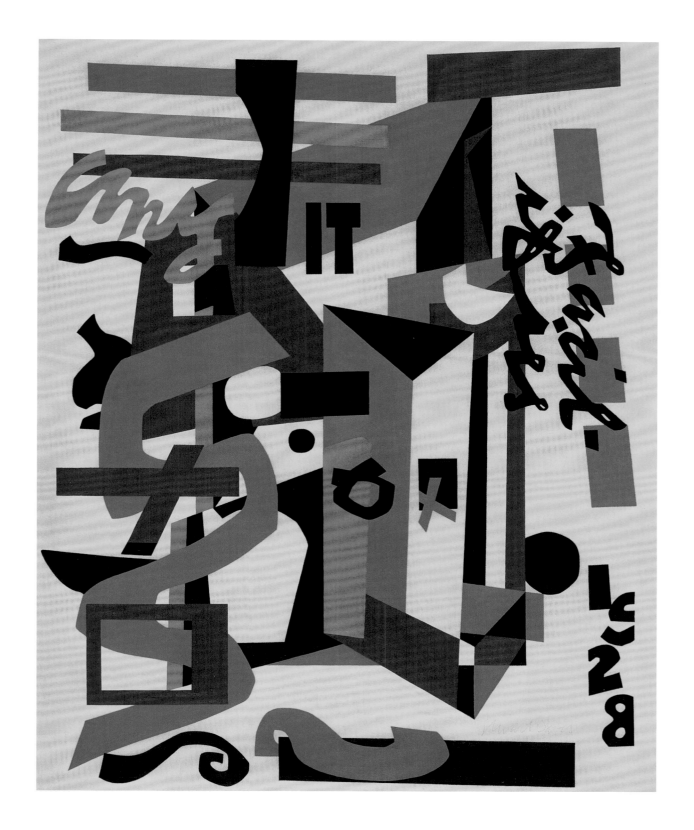

60 TOURNOS, 1954

oil on canvas, 91.1 × 71.1 cm (35 ⅞ × 28 in.)
Munson Williams Proctor Arts Institute, Museum of Art

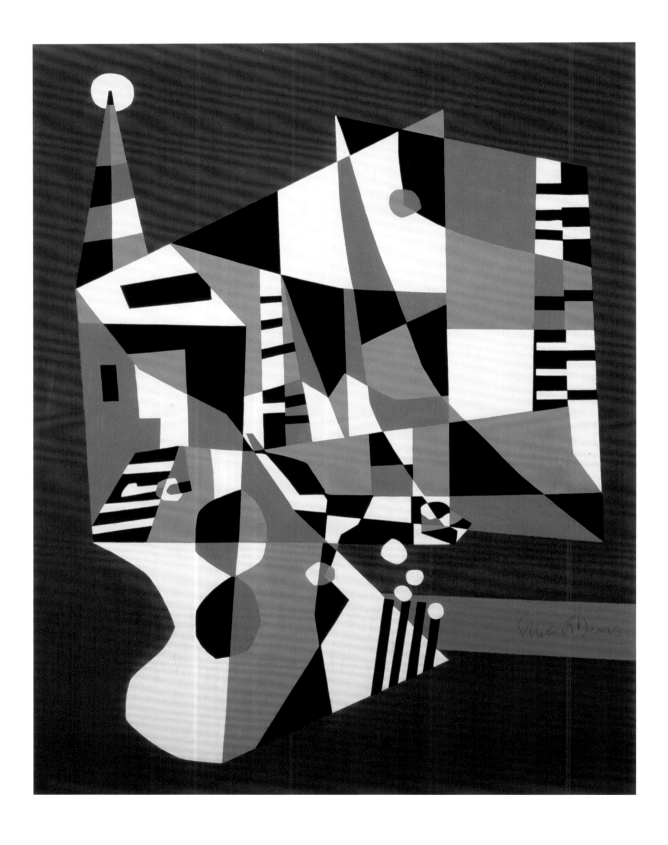

oil on canvas, 71.1 × 92.1 cm (28 × 36¼ in.)
Wadsworth Atheneum Museum of Art

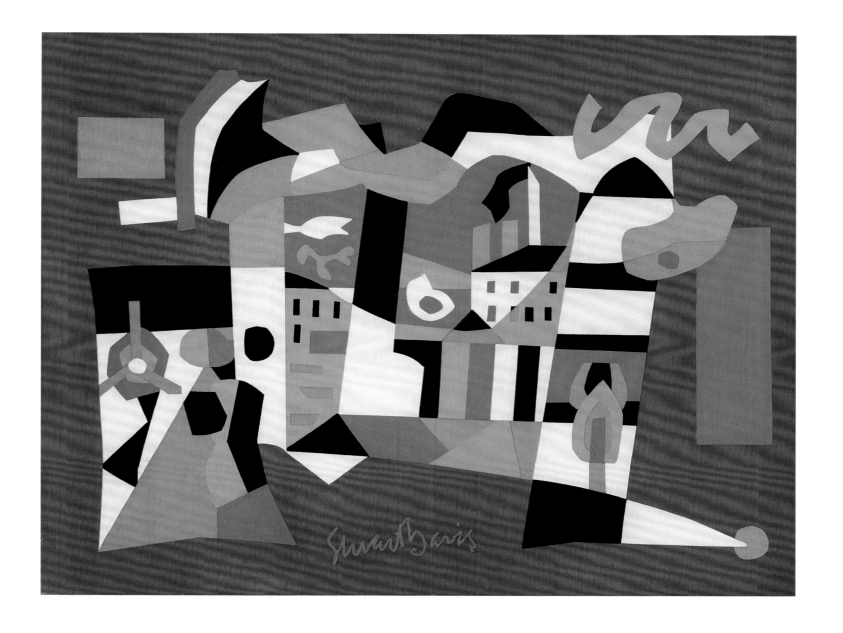

62 COLONIAL CUBISM, 1954

oil on canvas, 114.6 × 153 cm (45 ⅛ × 60 ¼ in.)
Walker Art Center

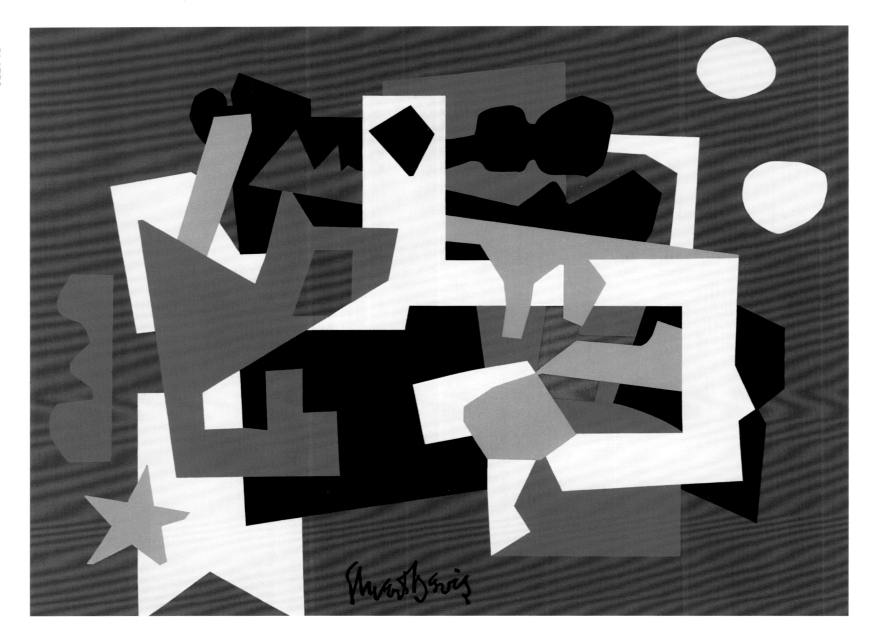

63 READY-TO-WEAR, 1955

oil on canvas, 142.6 × 106.7 cm (56 ⅛ × 42 in.)
The Art Institute of Chicago

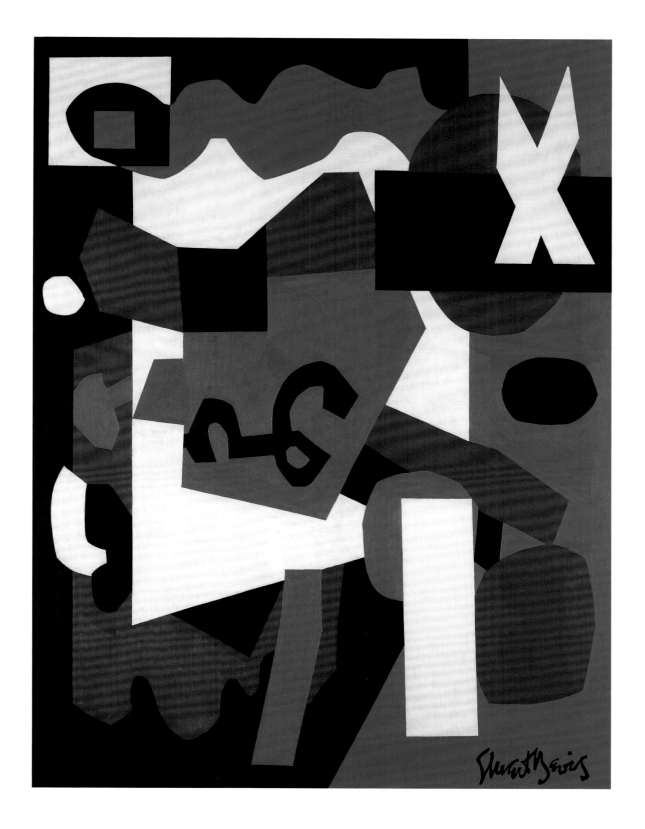

64 DETAIL STUDY FOR "CLICHÉ," 1955
gouache and pencil on paper, 32.4 × 38.1 cm (12 ¾ × 15 in.)
Private collection

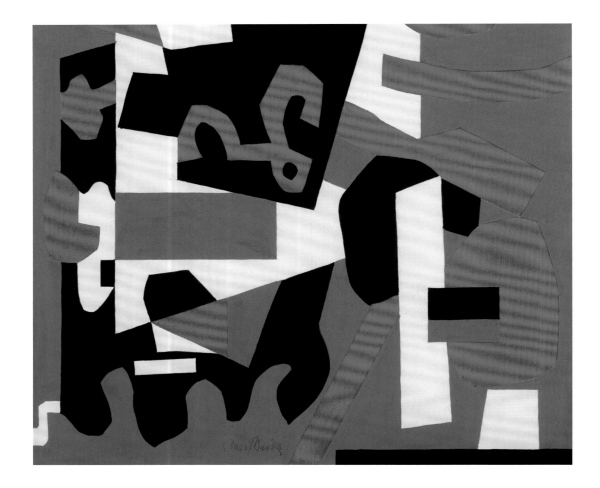

65 CLICHÉ, 1955

oil on canvas, 142.8 × 106.6 cm (56 ¼ × 42 in.)
Solomon R. Guggenheim Museum

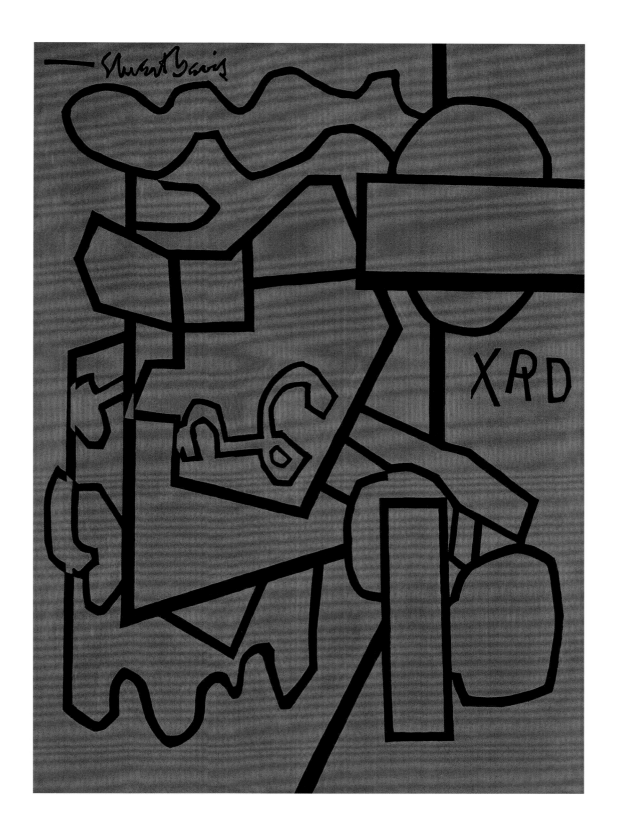

66 STELE, 1956

oil on canvas, 132.7 × 101.9 cm (52 ¼ × 40 ⅛ in.)
Milwaukee Art Museum

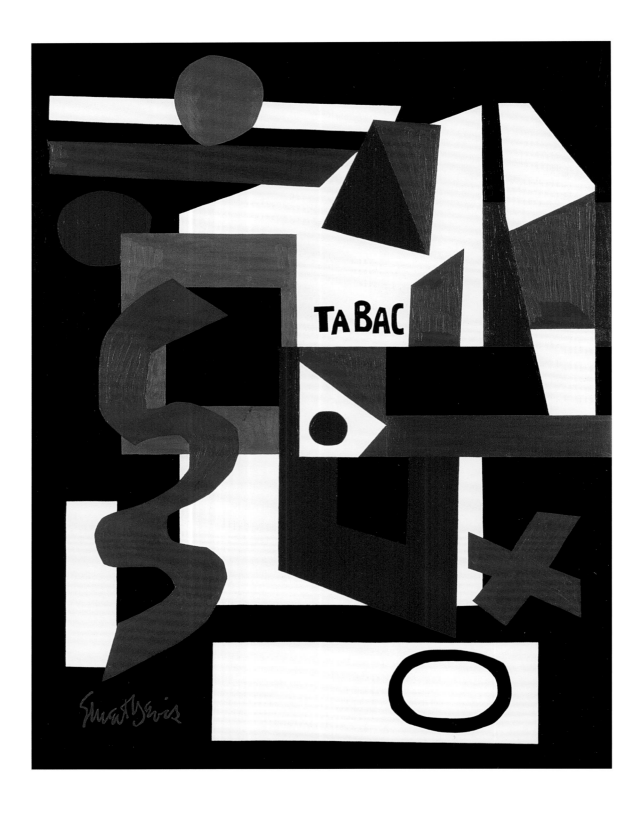

67 TROPES DE TEENS, 1956

oil on canvas, 114.9 × 153 cm (45 ¼ × 60 ¼ in.)
Hirshhorn Museum and Sculpture Garden, Smithsonian Institution

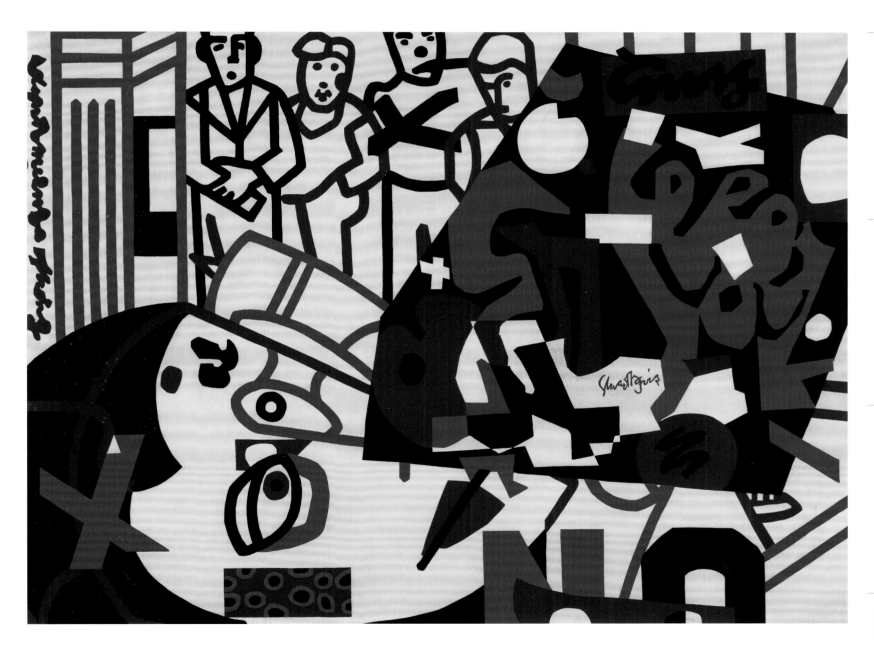

68 MEMO #2, 1956
oil on canvas, 61 × 81.3 cm (24 × 32 in.)
Private collection

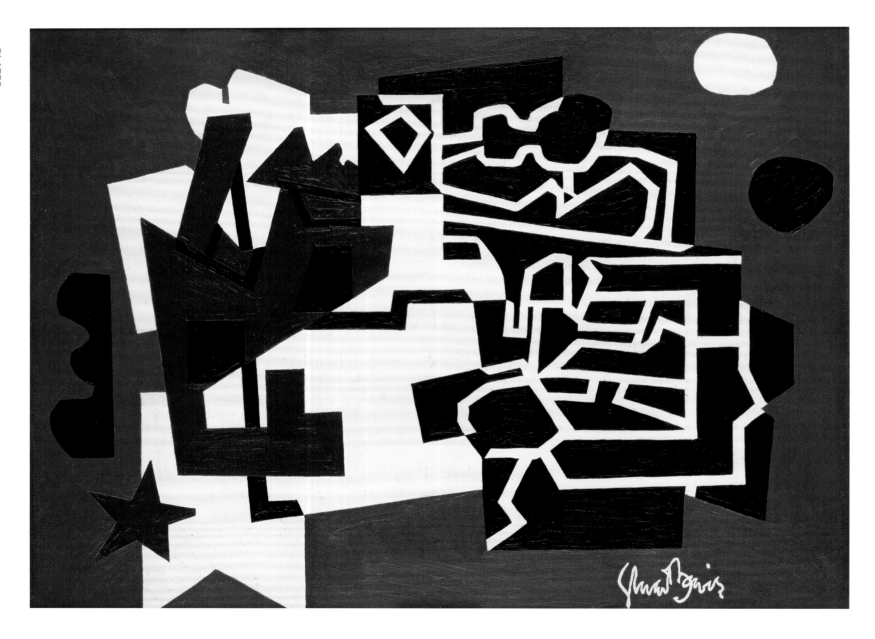

69 MEMO, 1956

oil on linen, 91.4 × 71.8 cm (36 × 28 ¼ in.)
Smithsonian American Art Museum

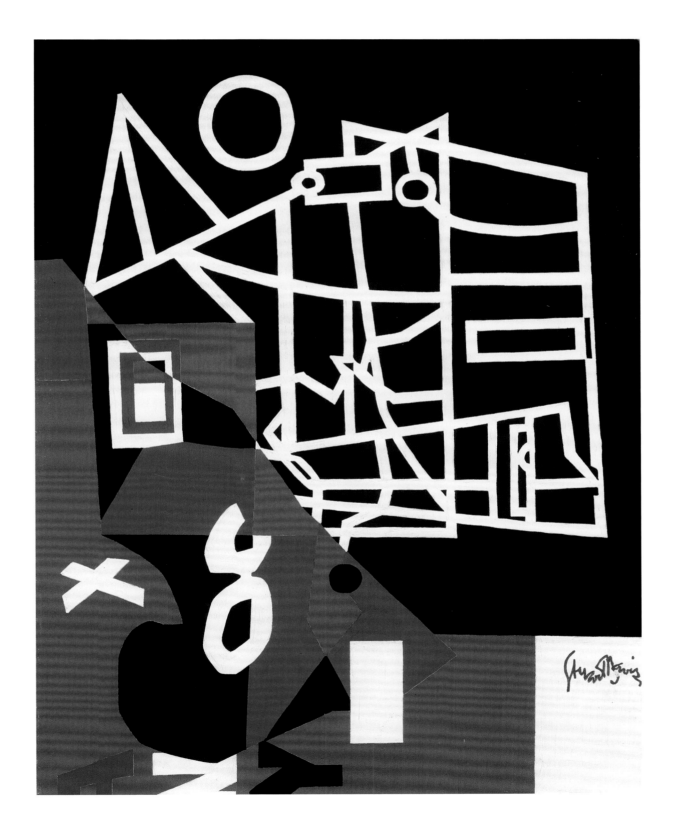

70 PACKAGE DEAL, 1956
gouache and pencil on paper, 54.6 × 47.3 cm (21 ½ × 18 ⅝ in.)
Lawrence B. Benenson Collection

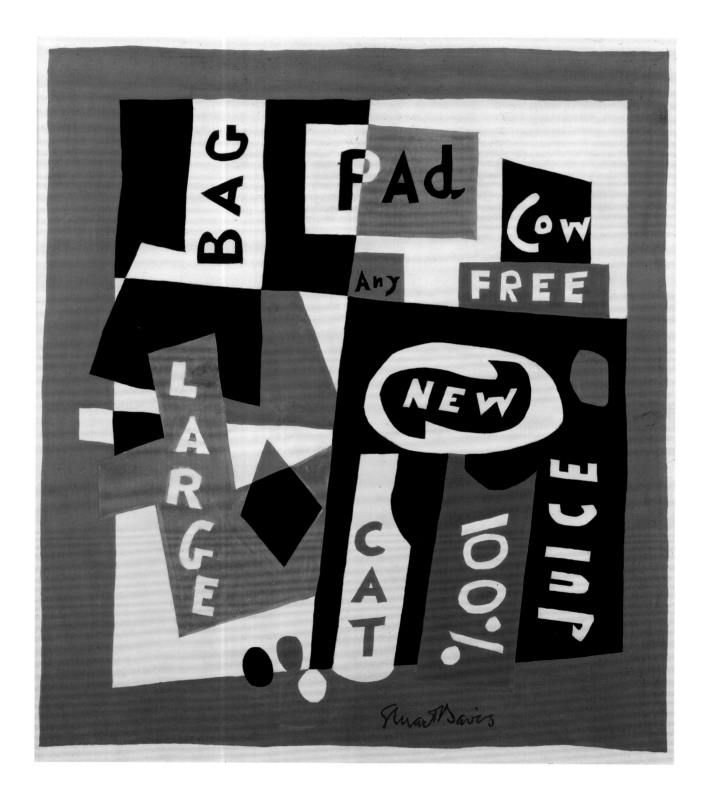

71 DETAIL STUDY #1 FOR "PACKAGE DEAL," 1956

gouache and pencil on paper, 41.3 × 33.3 cm (16 ¼ × 13 ⅛ in.)
The Art Institute of Chicago

72 STUDIES FOR "PACKAGE DEAL," 1956

Los Angeles County Museum of Art (studies 1–27)
Estate of the Artist (study 28)
(top to bottom, left to right)

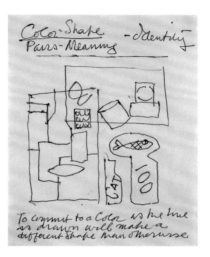

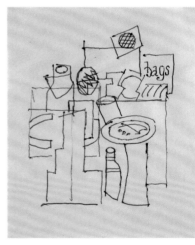
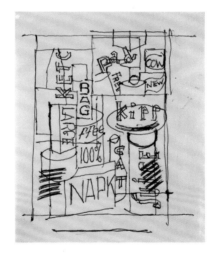

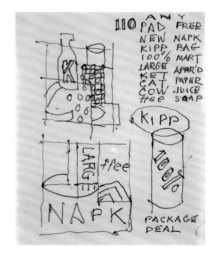
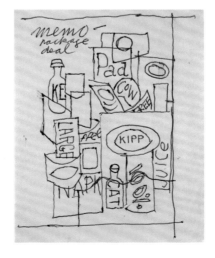

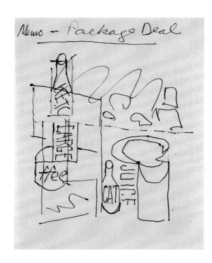

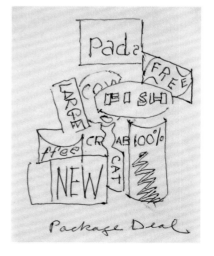

 + ②

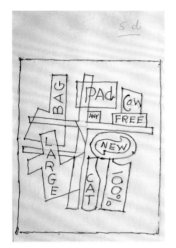

5 d

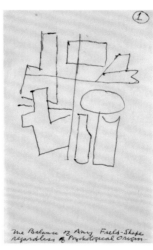 ①

The Balance of Any Field-Shape
regardless of Psychological Origin

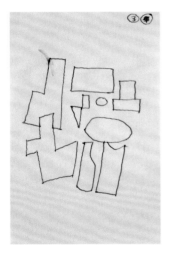 ③ ④

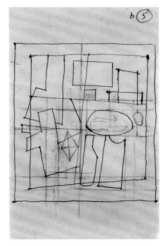 b ⑤

 ② ③

 ④

⑤ c

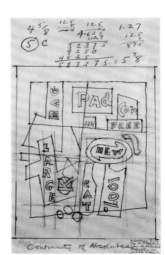

Continuity of Absolutes

1950 – 1964

133

73 PREMIÈRE, 1957
oil on canvas, 147.3 × 127 cm (58 × 50 in.)
Los Angeles County Museum of Art

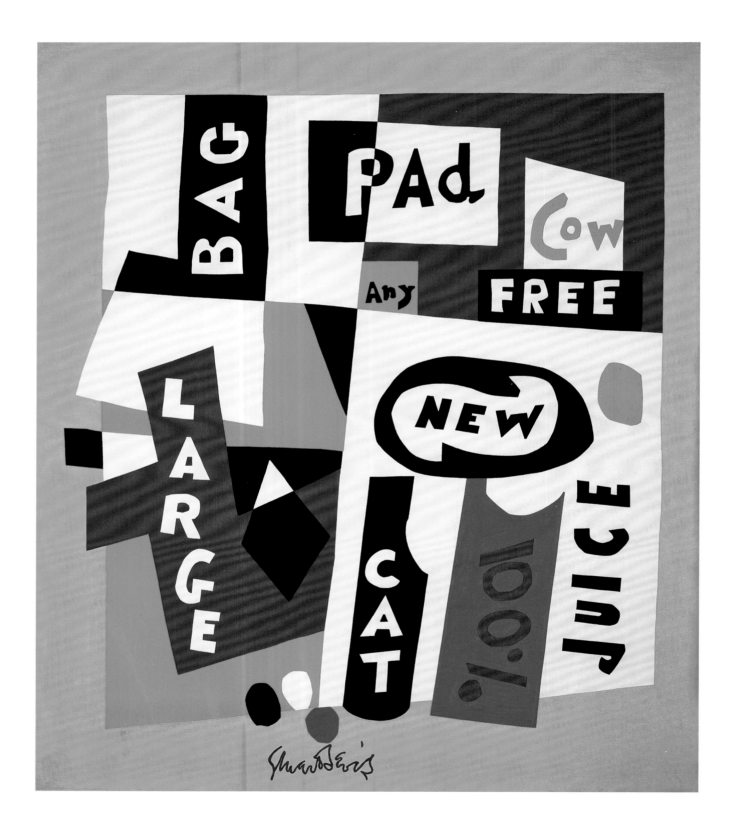

oil on canvas, 144.8 × 114.3 cm (57 × 45 in.)
Smithsonian American Art Museum

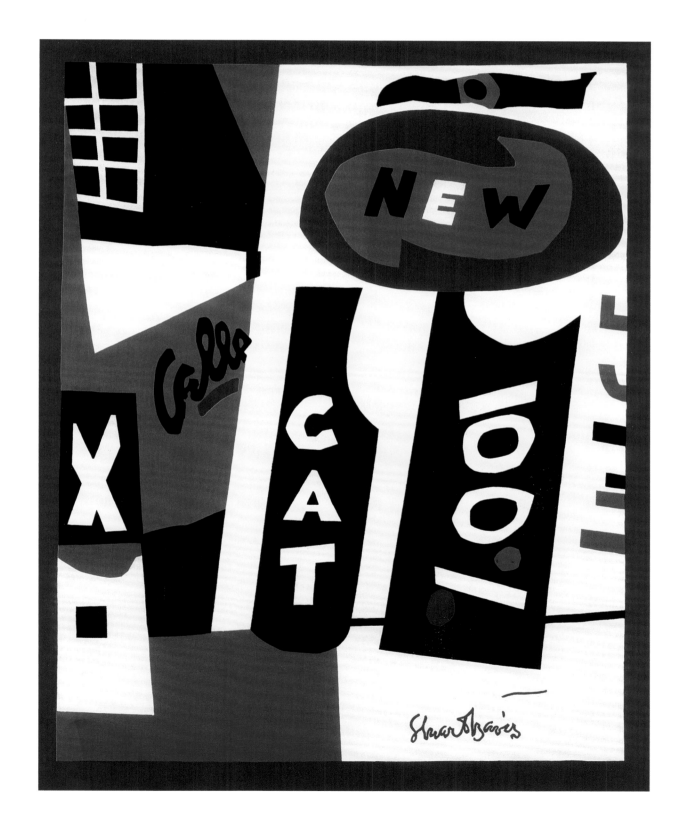

75 POCHADE, 1956–1958

oil on canvas, 132.1 × 152.4 cm (52 × 60 in.)
Museo Thyssen-Bornemisza

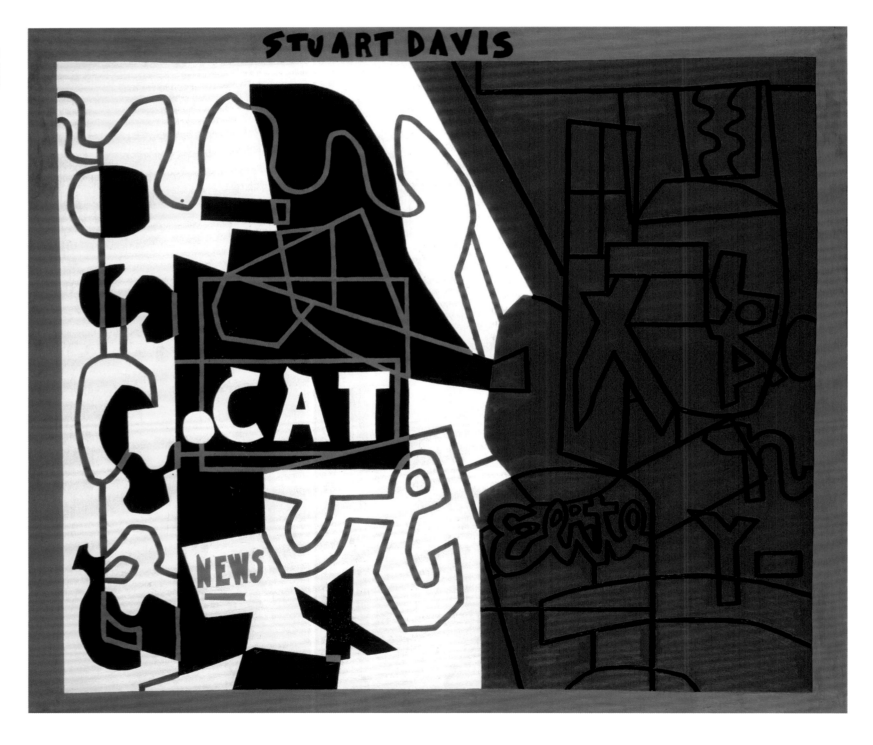

76 UNTITLED (BLACK AND WHITE VARIATION ON "POCHADE"), C. 1956–1958
casein on canvas, 114.3 × 142.2 cm (45 × 56 in.)
Estate of the Artist

77 STUDY FOR "THE PARIS BIT," 1951/1957–1960

oil on canvas, 71.1 × 91.4 cm (28 × 36 in.)
Private collection

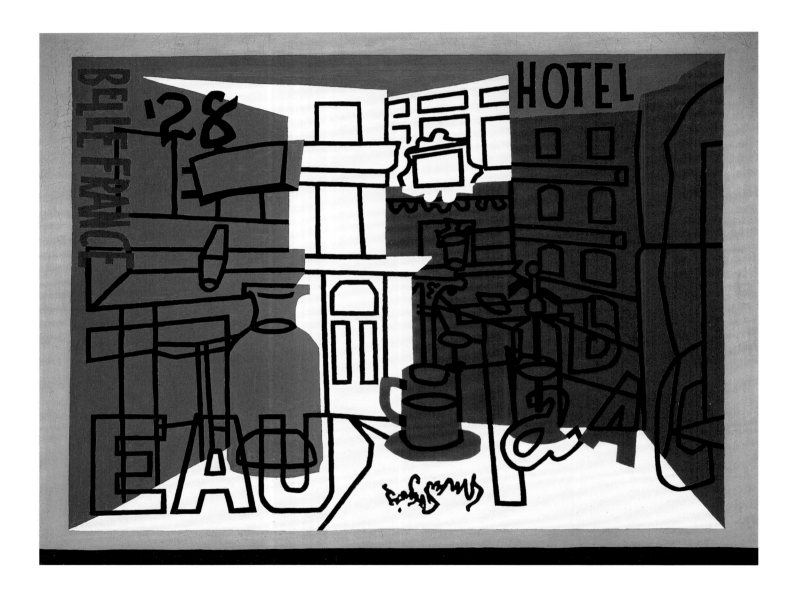

oil on canvas, 116.8 × 152.4 cm (46 × 60 in.)
Whitney Museum of American Art

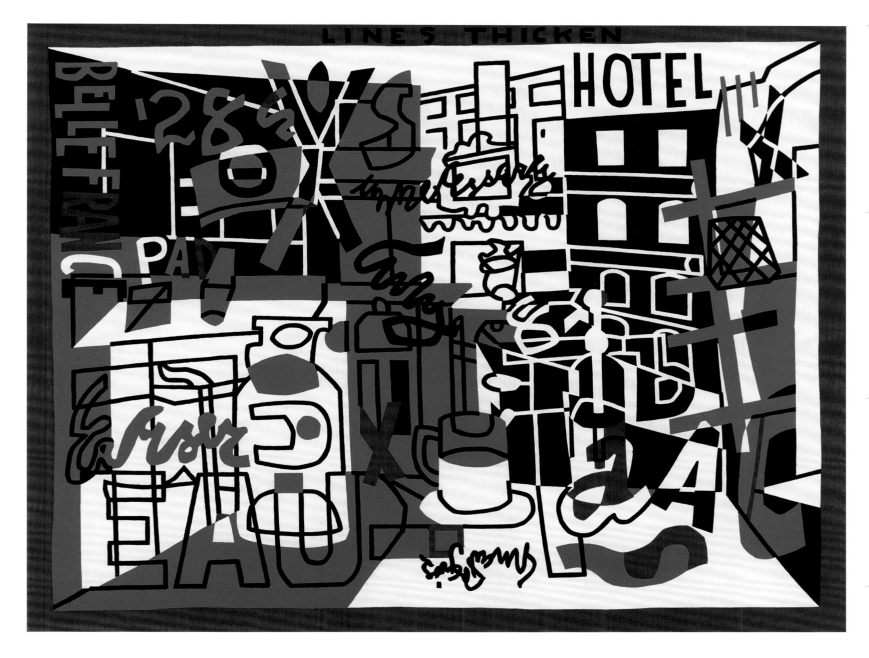

79 STANDARD BRAND, 1961

oil on canvas, 152.4 × 116.8 cm (60 × 46 in.)
The Detroit Institute of Arts

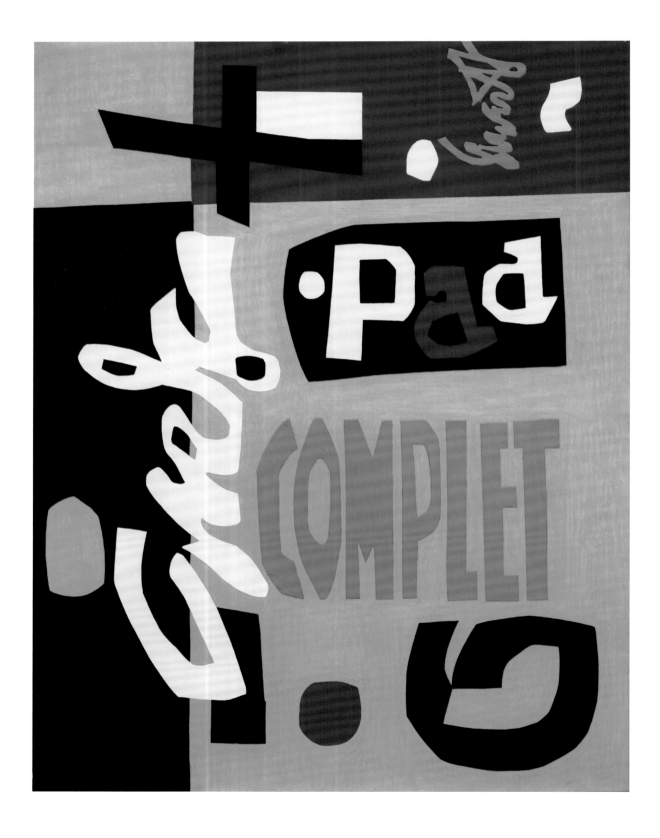

casein and masking tape on canvas, 106.7 × 142.2 cm (42 × 56 in.)
Yale University Art Gallery

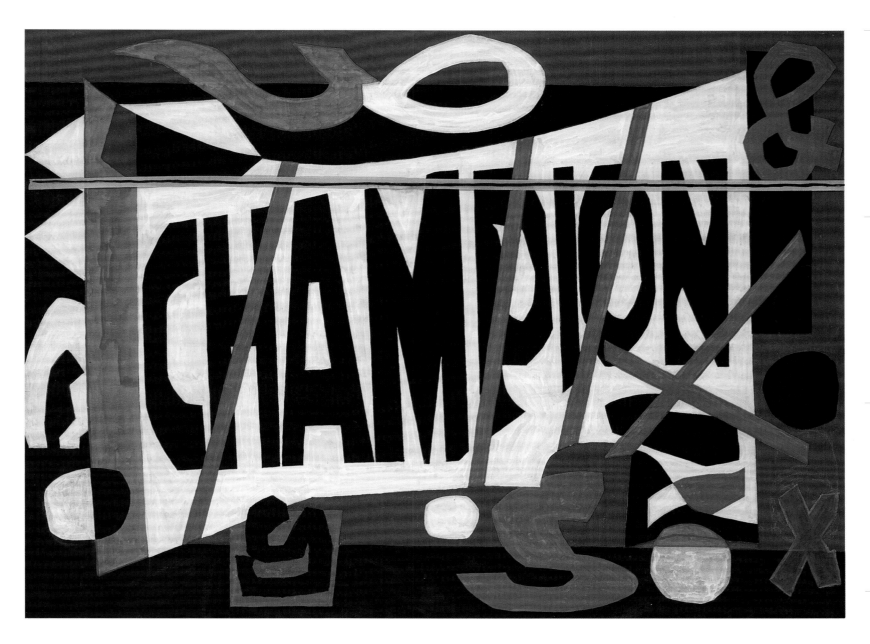

81 UNFINISHED BUSINESS, 1962

oil on canvas, 91.5 × 114.3 cm (36 × 45 in.)
Private collection

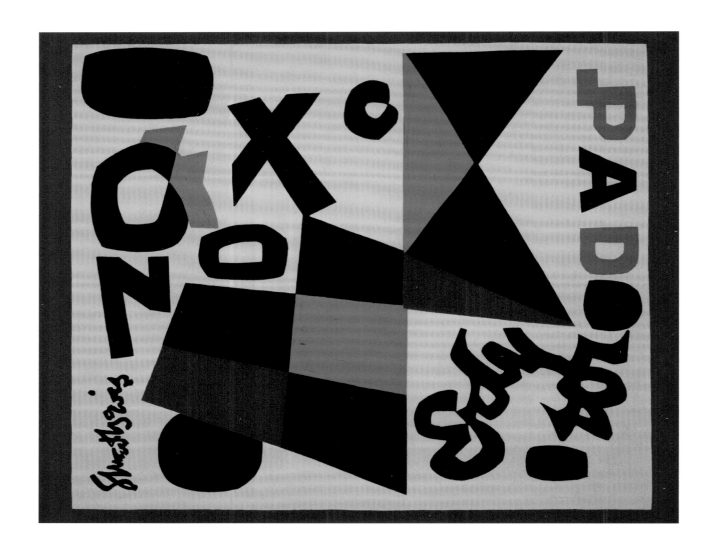

82 CONTRANUITIES, 1963

oil on canvas, 172.7 × 127 cm (68 × 50 in.)
Private collection

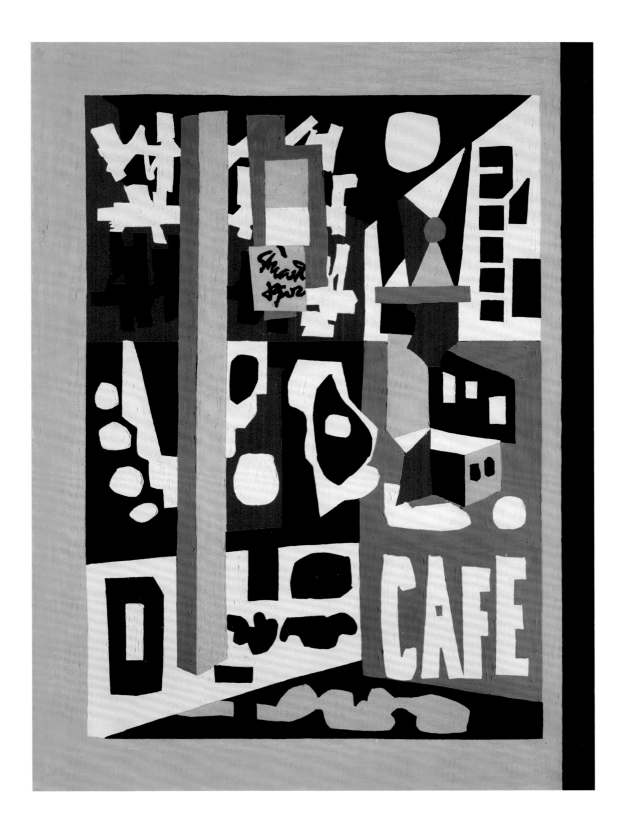

83 BLIPS AND IFS, 1963–1964
oil on canvas, 180.7 × 134.9 cm (71 ⅛ × 53 ⅛ in.)
Amon Carter Museum of American Art

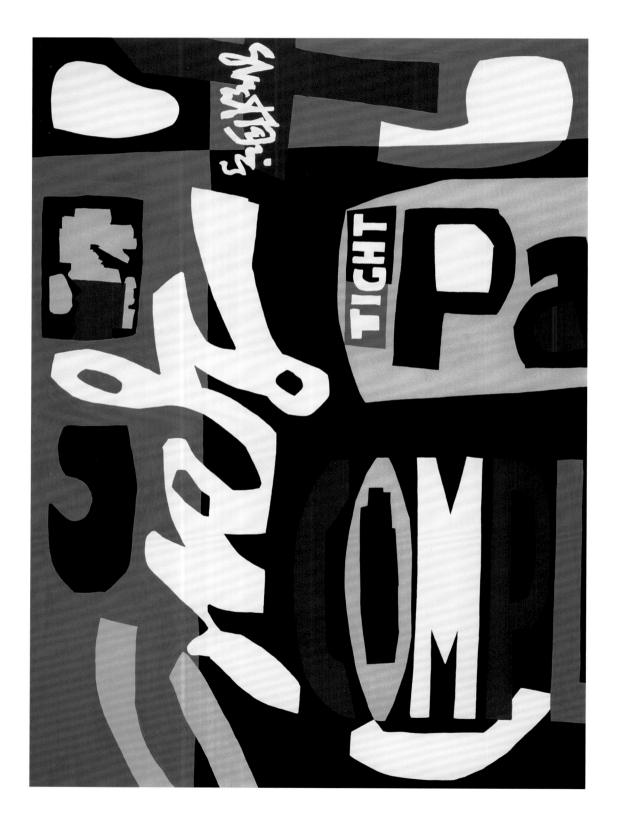

84 FIN, 1962–1964

casein and masking tape on canvas, 136.8 × 101 cm (53 ⅞ × 39 ¾ in.)
Private collection

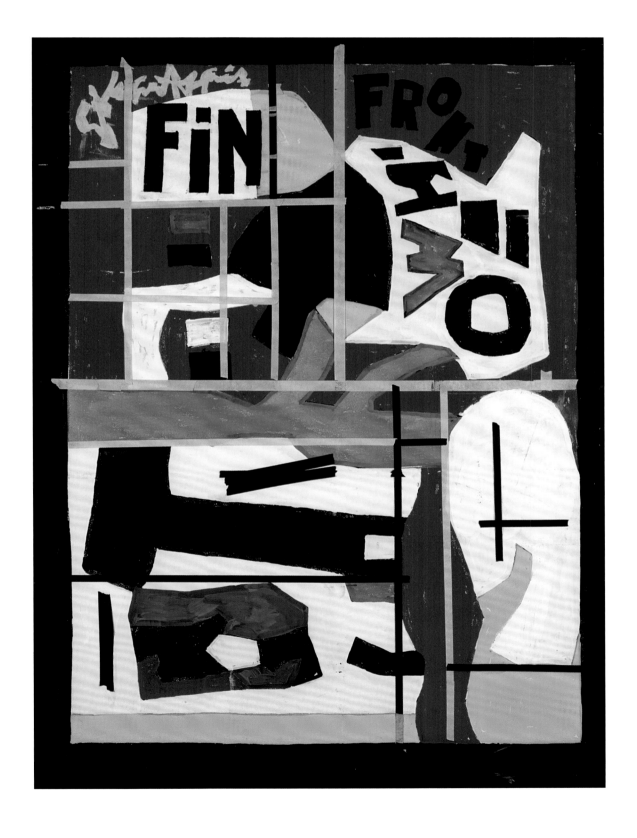

STUART DAVIS A Chronicle

BARBARA HASKELL

Stuart Davis as a toddler, c. 1894, Estate of the Artist Archives

1892

December 7. Edward Stuart ("Stuart") Davis is born in Philadelphia in the family home at 911 Franklin Street, the first child of artists Edward ("Ed") Wyatt and Helen Stuart Foulke Davis, both of whom studied at the Pennsylvania Academy of Art.[1] They married in 1889, the year Ed began working as an illustrator at the *Philadelphia Inquirer*, where he met other former academy students William Glackens, Everett Shinn, John Sloan, and George Luks, who would go on to form the nucleus of the group known as The Eight. Growing up in this milieu would leave a lasting mark on Stuart's aesthetic values.

1893

March. Ed participates in founding the Philadelphia Charcoal Club, which meets informally in the evening for seven months in Sloan's studio to draw from the model and sketch. There are no instructors, but Robert Henri, recently returned from three years in Europe, is the de facto leader. His impassioned advocacy of painting encourages the club's core members to shift their focus from illustration to the fine arts.

Fall. Henri begins hosting open houses every Tuesday evening in his studio at 806 Walnut Street, where he leads free-flowing conversations about painting, literature, music, politics, and ethics. Ed, considered the "most worldly and cavalier member of the newspaper crowd," does not attend these sessions as regularly as some, but his involvement is sufficient for Sloan to identify him later with "the old '806' days."[2]

1895

Ed joins the *Philadelphia Press* as assistant art director. Two years later, he is promoted to art director.[3] Fascinated with cameras and half-tone printing, he pioneers the use of photographs to report news events. This technology eventually leads newspapers to replace illustrators with photographers and results in the exodus of Ed's colleagues to New York to find work illustrating magazines and books.

1899

September. Stuart is enrolled in a private German kinder-garten. Almost seven, he is nearly two years older than most of his fellow students. At the end of the term, he performs on stage in black face singing the song "Coon, Coon, Coon," acknowledging later "in this day and age of social consciousness you wouldn't dare to mention" it.[4] He ulti-mately traces his "love of negro music" back to this perfor-mance and, more generally, to the African American songs his father routinely sang to him and to those heard at the blackface vaudeville shows the two attended together, including those of Bert Williams and George Walker.[5]

1900

Fall. Stuart enters first grade in a private Quaker grammar school.

1901

Ed is appointed art editor and cartoonist for the *Newark Evening News*, and the family moves to East Orange, New

Jersey, a lower middle-class suburban community bordering Newark that Stuart will recall as having an old-fashioned, comforting quality. For the next seven years, the family lives in East Orange, after which it moves frequently, owing in large part to fluctuations in Ed's career.

September. Stuart enters second grade in East Orange's public elementary Nassau School. He remains there for the next four years, serving as class president in his final year.

1905

Summer. Ed takes a job as illustrator for *Leslie's Weekly*, commuting daily between East Orange and New York City. A year later, he joins the art department of the satirical magazine *Judge*. By then, his former newspaper colleagues are all pursuing painting careers in New York under the guidance of Henri, who relocated to the city in 1900 and is teaching at the New York School of Art.

Edward Davis, "The Autumn Trek to Washington," cover illustration for *Leslie's Weekly*, September 21, 1905, courtesy of the Library of Congress, (DLC) sf 89091374

Stuart and Wyatt Davis, c. 1910, Estate of the Artist Archives

1906

February 14. Helen gives birth to John Wyatt ("Wyatt") Davis, thirteen years Stuart's junior.

November. Ed resigns from *Judge* to start a company to manufacture Gumlax, a laxative chewing gum. By spring 1907, he has backers and is producing the gum and selling it in stores.

1908

Summer. The family rents a cottage in Avon, a seaside resort on the New Jersey shore. They continue to summer there or in adjacent Belmar through 1913. Stuart begins a lifelong correspondence with his maternal cousin, Hazel Foulke, an aspiring artist living in Philadelphia with whom he shares details about his life and evolving attitudes about art.

September. Stuart enrolls in ninth grade in East Orange High School, where he competes on the football and track teams, but shows little aptitude for academics.[6] In the spring, he convinces his parents to let him drop out of high school at the end of the semester and enroll in art school in the fall.

1909

January. Henri resigns from the New York School of Art and founds the Henri Art School in the Lincoln Arcade Building at 66th Street and Broadway.

February. Ed abandons his Gumlax venture after failing to secure money to mass-produce and market the gum. The family moves to the top floor of a boarding house at 49–51 James Street in Newark, adjacent to a saloon.

Spring. Ed finds a job in the advertising department of the daily newspaper the *New York American*.

November. Encouraged by Sloan, who has remained a close family friend, Stuart enrolls in the Henri School. The aesthetic principles he encounters there will be central to his outlook for the rest of his life. Henri's insistence that "art cannot be separated from life… we value art… because of its revelation of a life's experience" electrifies Stuart, who paints from 9:30 a.m. until 2:30 a.m. in the school's studio, returning to Newark only to sleep.[7] As he later recalls:

The Henri School was regarded as radical and revolutionary in its methods, and it was. All the usual art school routine was repudiated. Individuality of expression was the keynote, and Henri's broad point of view in his criticisms was very effective in evoking it. Art was not a matter of rules and techniques, or the search for an absolute ideal of beauty. It was the expression of ideas and emotions about the life of the time… We were encouraged to make sketches of everyday life in the streets, the theater, the restaurant, and everywhere else. These were transformed into paintings in the school studios. On Saturday mornings they were all hung on the wall at the Composition Class. Henri talked about them, about music, literature, and life in general, in a very stimulating manner, and his lectures constituted a liberal education… [The school] took art off the academic pedestal and, by affirming its origin in life of the day, developed a critical sense toward social values in the student.[8]

While enrolled at the Henri School, Stuart encounters another key influence: saloons and the new American-born strains of music being performed within. Younger than the school's other students, Stuart uses his consumption "of a large quantity" of alcohol to gain acceptance.[9] His two closest friends in this pursuit are Henry Glintenkamp and Glenn O. Coleman, five and eight years his senior respectively, who join him in patronizing various saloons that provide free counter-food for the price of a drink. Heeley's Saloon, across the street from the school, and the saloon in the Lincoln Arcade, whose back room features a live piano

player, are particular favorites. Here, and in the African American saloons in the red-light districts along Palisades Avenue in Hoboken and Arlington Street in Newark, Stuart hears ragtime. The music, which he later calls the "great American art expression," makes a lifelong impression on him: "For me—I had jazz all my life—I almost breathed it like air."[10] Describing it as an "integral part of my mood and my attitude toward things," he notes that all his paintings derived in part from the influence of the "anonymous giants of jazz" he heard on Arlington Street and in various other dives.[11]

Coleman, Henry Glintenkamp, and myself toured extensively in the metropolitan environs. Chinatown; the Bowery; the burlesque shows; the Brooklyn Bridge; McSorley's Saloon on East 7th Street; the Music Halls of Hoboken; the Negro Saloons; riding on the canal boats under the Public Market... Coleman and I were particularly hep to the jive, for that period, and spent much time listening to the Negro piano players in Newark dives. About the only thing then available on phonograph records was the Anvil Chorus. Our musical souls craved something a bit more on the solid side and it was necessary to go to the source to dig it. These saloons catered to the poorest negroes, and outside of beer, a favorite drink was a glass of gin with a cherry in it which sold for five cents. The pianists were unpaid, playing for love of art alone. In one place the piano was covered on top and sides with barbed wire to discourage lounging and leaning on it, and to give the performer more scope while at work. But the big point with us was that in all of these places you could hear the blues, or tin-pan alley tunes turned into real music, for the cost of a five cent beer.[12]

Fifty years later, Stuart Davis recalls the ethos of Newark's jazz saloons.

[T]hey didn't keep white people out as they did in Harlem... Over in Newark it was just the saloons of the neighborhood. It was this one street—Arlington Street, and they were all poor people. It was no night club, or anything like that. They always had a piano player, sometimes even a band, a small band—three or four pieces, and if they ever got paid, I never heard anything about it. They used to get beer, maybe gin, free, but they were all poor guys, and where they all came from God only knows!... James P. Johnson explained that Newark and Jersey City were stopping off places for musicians and pimps with their girls who wanted to make it in New York, but stopped off and stayed over in Newark and Jersey City because it was too crowded in New York and there weren't any opportunities.[13]

1910

April 1. Henri, Sloan, and Walt Kuhn organize the *Independent Artists Exhibition*, the first nonjuried, no-prize show in the United States. Held in an empty house on West 35th Street in New York, it includes 103 artists, whose works are hung alphabetically. With little more than five months of formal training, Davis is confident enough of his urban realist paintings to enter the show.

September. Ed takes a job in the advertising department of the daily newspaper the *Globe*, selling ads for its food section. The family moves into an apartment on Cathedral Parkway near 110th Street in Manhattan.

Fall. Henri becomes enamored of the pseudoscientific color theories of Hardesty Maratta, frequently inviting the painter to the school to demonstrate his color charts. Davis does not adopt the Maratta system and later asserts that "any color system that is not based on the visual effect of color is of no use in painting however true it may be from the standpoint of logic."[14] Nevertheless, the widespread acceptance of the system's implicit faith in quantifiable rules for making art lays the groundwork for Davis's own efforts to uncover objective compositional principles.

December. The Davis family moves back to Newark, into a boarding house at 60 James Street across the street from their previous residence. The apartment is difficult to heat, and on at least one occasion the family is forced to wait out the cold in a hotel. Ed and Stuart commute daily to New York.

1911

February. John Cotton Dana, director of the Newark Library and Art Museum, includes Davis's work in a group show, *City Landscapes*, the artist's first museum exhibition.

Summer. The family's finances improve significantly, owing to Ed's procurement of the Borden Milk advertising account for the *Globe*, which allows the family to spend the summer in Belmar in what Stuart calls a "very fine" six-bedroom house with a parlor, library, dining room, and a maid.[15] At the end of the summer, the family relocates to the Gerard Hotel in New York City to await completion of an upscale house at 153 South Arlington Avenue, East Orange, into which they move in November.

City Snow Scene, 1911, oil on canvas, Private collection

Fall. Davis rents a studio with Glintenkamp on the top floor of Hoboken's Terminal Building, a former office building located on Hudson Street near the railroad station. Together with Coleman, they spend their free time in the seedy cafés, pool halls, and saloons that cater to sailors in port.

November. Henri and Sloan include Davis's work in the first of four shows held over the next three years at the MacDowell Club, which had recently introduced a policy to allow self-organized groups of artists to exhibit their work in the club's galleries at little expense. By now, Davis has fully adopted the "free brushwork and broad interpretation" of form that decades later he remembers as being the keynote of Henri's teaching.[16] Critic Joseph Chamberlain notices the "pathos and power" Davis achieves through stage-like compositional space, brushy paint handling, and psychologically charged subject matter, a quality especially noticeable in Davis's watercolors following his purchase the next year of a book of Toulouse-Lautrec's drawings of the theaters, brothels, and bohemian cabarets in Paris.[17]

December. Henri's obsession with the Maratta palette leads him to mandate that it be taught to all students at his school. When the faculty rebels, Henri turns over the school's management to Homer Boss and begins teaching exclusively at the Ferrer School. For the next three years, he works on writing a book on Maratta's color theories with Sloan and painter-illustrator Charles Winter.

1912

Winter. Davis leaves the Henri School. Never as personally close to the charismatic teacher as he is to Sloan, Davis does not see Henri for a year. His departure does not diminish his friendship with Sloan, whom he later says he knew "as well as my own father."[18]

Fall. The socialist magazine *The Masses*, which publishes the illustrations of Sloan, Winter, and others in Henri's circle, loses its backing. Rather than let the journal die, the staff decides to transform it into a cooperative. No one is paid, and decisions about content, including the captioning of drawings, are made collectively at monthly editorial meetings. Max Eastman is enlisted as editor in chief and moves the journal's office from New York's jewelry district to Greenwich Village. Sloan, the journal's de facto art editor, recruits Davis, Coleman, and Glintenkamp as illustrators, which thrusts Davis into the center of the intellectual and artistic community of the Village, where he becomes a habitué of its two most popular hangouts, Polly Holliday's Greenwich Village Inn and Romany Marie's Tavern. As Davis will recall of the latter: "From astoundingly different backgrounds, each of us was accepted by Marie with that rare gift of individuality... She operated at some kind of universal, human level. She could take on anybody, talk to them all night, and they'd feel they had a friend."[19]

Henry Glintenkamp, Glenn O. Coleman, and Stuart Davis, c. 1913, Estate of the Artist Archives

1913

February 17. Through the efforts of Henri and Sloan, five of Davis's watercolors are included in the *International Exhibition of Modern Art*, or Armory Show, which Davis later describes as "the greatest single influence I have experienced... All my immediately subsequent efforts went toward

incorporating Armory Show ideas into my work."[20] Although Davis was familiar with the simplified forms of modern art through discussions at the Henri School and through his exposure to Aubrey Beardsley's illustrations and the posters of Will H. Bradley and Edward Penfield that his father's colleagues, especially Sloan, had emulated in the 1890s, the Armory Show is a revelation. He later calls it "a World's Fair of ideas, a complete bombshell … it opened up a whole panorama of possibilities that had no counterpart in American art."[21] "[T]he possibility of using colors, shapes, which one hadn't regarded as legitimate before" is inspiring, but what impresses him the most is the artists' emphasis on formal properties over subject matter.[22] Excited by the idea of an autonomous picture, whose emotional force is independent of subject matter, he commits himself to modernism.

In Gauguin, van Gogh and Matisse… I sensed an objective order which was lacking in my own work and which was present here without relation to any particular subject matter. It gave me the same excitement I got from the numerical precision of the Negro piano players in the Newark saloons. I resolved that I would quite definitely have to become a "modern" artist. It took an awful long time. I soon learned to think of color more or less objectively so that I could paint a green tree red without batting an eye. Purple or green faces didn't bother me at all, and I even learned to sew buttons and glue excelsior on the canvas without feeling any sense of guilt.

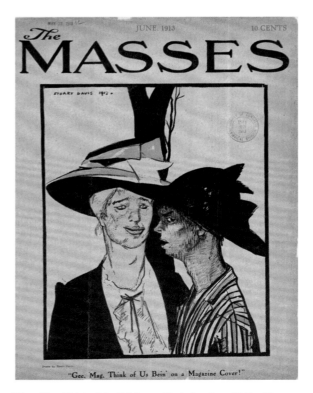

"'Gee, Mag, Think of Us Bein' on a Magazine Cover!'" *The Masses*, June 1913

But the ability to think about positional relationships objectively in terms of what they were, instead of what they represented, took many years.[23]

Some felt they could jump right in and paint a cubist picture. I couldn't. I could only keep looking at a manageable hunk of the world and keep trying to twist and shape it my way. I wanted something solid, so I picked out *things* instead of *manners*.[24]

March. Davis's enthusiasm for the Armory Show notwithstanding, his drawings for *The Masses* remain illustrational. The first example of his work to appear in the journal depicts two society women pausing before a sign in the Metropolitan Museum of Art directing visitors to the Morgan collection, accompanied by the caption, "Oh, I think Mr. Morgan paints awfully well, don't you?"[25]

April. Davis's illustration of two lower-class homely women causes an uproar at *The Masses* monthly editorial meeting, with several editors claiming it is too ugly to print and threatening to quit if it is. Davis describes the meeting as "a very stormy session where everybody got personal and started saying nasty things about each other."[26] Only after Sloan suggests that the drawing be used on the cover with the caption "Gee, Mag, Think of Us Bein' on a Magazine Cover" is it accepted. The *Evening Mail* calls it "the best magazine cover of the year" and *Harper's Weekly* and the *Globe* laud it as a parody of the "pretty girl picture" on most magazine covers.[27] Thereafter, Davis's illustrations are featured regularly in *The Masses*, even as the artist himself remains somewhat detached from the socialist cause, later admitting that he accepted socialism "without any real feeling about it," and instead found in modern art "what other people found in political and social reform."[28]

Late June. The notoriety over Davis's "Gee, Mag" cover leads Norman Hapgood, editor of *Harper's Weekly*, to hire the artist to produce six full-page illustrations for the magazine's August and September issues. With the fifty dollars Davis receives per drawing, he rents a beachfront studio with Coleman in Provincetown, Massachusetts, a summer retreat for many of the intellectuals and artists in Greenwich Village. His mother and brother join him for the summer.

At that time, Provincetown still retained a considerable vestige of its sea-faring past. On clear days the air and water had a brilliance of light greater than I had ever seen, and while this tended to destroy local color, it stimulated the desire to invent high intensity color-intervals. The presence of artists and writers, not too many, added intellectual stimulus to the natural charm of the place.[29]

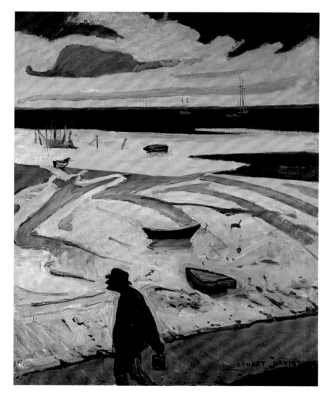

Ebb Tide—Provincetown, 1913, oil on canvas, Myron Kunin Collection of American Art

Stuart Davis, c. 1914, Estate of the Artist Archives

In his depictions of Provincetown subjects, Davis tentatively experiments with the flattened forms and saturated palettes he admires in the work of Van Gogh and Gauguin.

September. Davis takes a studio with Coleman and Glintenkamp in the Miller Building, across from the Lincoln Arcade, returning to his family's home in East Orange only to sleep. The trio throws parties in the studio at which everyone consumes large quantities of beer and cheap peach brandy, which they purchase for a quarter per pint. In February, Davis leaves the studio, citing the difficulties of getting along with his two friends in such close quarters.

1914

Spring. Michael Breener and Robert J. Coady open the Washington Square Gallery, where they exhibit the work of Pablo Picasso and other European modernists. The gallery's location in Greenwich Village makes it convenient for Davis to visit, in contrast to Alfred Stieglitz's more uptown gallery at 291 5th Avenue, between 30th and 31st Streets, whose exhibitions of American and European modernists Davis seems not to have viewed.

June. Davis summers again in Provincetown, renting a room in Polly Holliday's boarding house, where his fellow boarder is artist Charles Demuth, whose exhibition of fauvist watercolors that fall establishes him as a modernist. The two remain friends after the summer, and Davis later credits the older artist's "superior knowledge of what it was all about" as important to his own aesthetic development.[30]

Fall. With *Harper's Weekly* having ended its ill-fated effort to modernize and no longer commissioning vanguard artists, Davis sells a few illustrations to periodicals such as *Judge*, the *World*, the *Bookman*, the *Globe*, and the *New York Sunday Call* over the next two years, but his income is otherwise limited. Polly Holliday hires him to paint a sign for her restaurant and Romany Marie buys paintings when Davis is without money, which is often. Looking back over this period, Davis says, "I really don't know how I lived. Occasionally I had to go back to my parents."[31] He recalls walking fifteen miles from East Orange to Manhattan one New Year's Eve: "Demuth was there. He loaned me the money to go home."[32]

October. Polly Holliday hangs three of Davis's drawings in the dining room of her Greenwich Village Inn. In an unsigned review in the *Sun*, critic Henry McBride dismisses them as "so slight that Mr. Davis's philosophy of life cannot be deciphered at present."[33]

April. Davis typically exploits comic stereotypes for humorous effect in his *Masses* illustrations. His exaggerated treatment of the facial features and gestures of African Americans outrages one reader, who protests that Davis's caricatures "depress the negroes themselves and confirm the whites in their contemptuous and scornful attitude."[34] Eastman reprints the letter in the magazine's May issue along with his reply: "Stuart Davis portrays the colored people he sees with exactly the same cruelty of truth with which he portrays the whites."[35]

June. Juliana Force, director of the Whitney Studio, established by heiress and sculptress Gertrude Vanderbilt Whitney the previous December at 8 West 8th Street in Greenwich Village, includes Davis's work in a group show on the recommendation of Sloan. In December, she invites him to exhibit again.

Summer. Sloan and his wife, Dolly, lease the Red Cottage in the Rocky Neck area of Gloucester, Massachusetts, an artists' colony thirty miles north of Boston on Cape Ann, where they summered the previous year. To save on expenses, they invite artist-friends to join them: Charles Winter and his wife, Alice; Randall and Florence Davey; Agnes Richmond and her husband, Paul Cornoyer; Katherine Groschle;

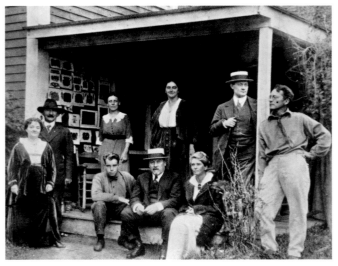

Stuart Davis, seated at left with Paul Cornoyer and Agnes Richmond; standing from left, Dolly Sloan, F. Carl Smith, Alice Winter, Katherine Groschle, Paul Tietjens, and John Sloan at the Red Cottage, Gloucester, 1915, photograph by Charles Allen Winter

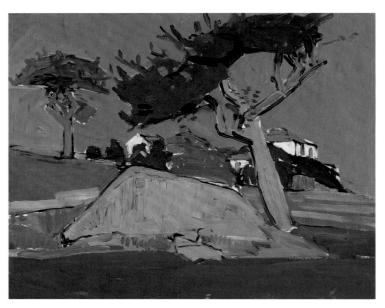

Hillside Near Gloucester, c. 1915, oil on canvas, Museum of Fine Arts, Boston, A. Shuman Collection—Abraham Shuman Fund

Paul Tietjens; and Stuart, Wyatt, and Helen Davis. Stuart describes his social life that summer as filled with "many parties and lots of liquor, lobsters and auto rides," but he also characterizes Gloucester as "the place I had been looking for."[36]

It had the brilliant light of Provincetown, but with the important additions of topographical severity and the architectural beauties of the Gloucester schooner... I went to Gloucester every year, with few exceptions, until 1934, and often stayed late into the Fall. I wandered over the rocks, moors, and docks, with a sketching easel, large canvases, and a pack on my back, looking for things to paint.[37]

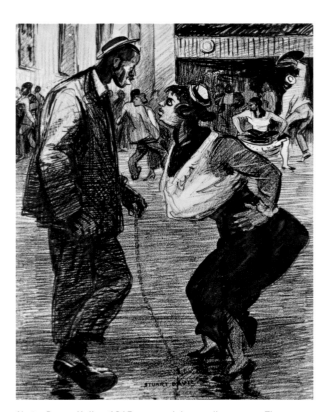

Negro Dance Hall, c. 1915, crayon, ink, pencil on paper, The Newark Museum, New Jersey, Gift of Mrs. Stuart Davis, 1972.72.144

Mid-October. Davis moves with his family to 85 Hawthorne Street in East Orange, where he lives until 1918.

Fall. Having learned to play chess from Winter over the summer, Davis becomes an avid competitor, playing every Saturday with him and Denys Wortman, a successful newspaper cartoonist, at the Marshall Chess Club on 10th Street in the Village, and participating in tournaments of simultaneous chess in which one player competes against multiple players concurrently. The same instinct for order and organization that Davis will call upon for his art makes him a skilled chess player; he remains immersed in the game until 1928, when he goes to Paris.

1916

March. Tensions develop at *The Masses* over what some staff members, led by Davis, Coleman, and Glintenkamp, perceive as Eastman's arrogation of decision-making. As Davis later describes it, Eastman "began to develop the idea that a more conventional editorial procedure was mandatory. Pictures and articles must be edited at his discretion."[38] Speaking on behalf of the dissidents at the monthly editorial meeting, Sloan makes a motion to eliminate the position of editor in chief. The ensuing mayhem leads to a special session at which Eastman is reelected editor and Art Young makes his now-famous remark that ultimately lends the Ashcan group its name: "[Men like Sloan and Davis] want to run pictures of ash cans and girls hitching up their skirts in Horatio Street—regardless of ideas—and without title… For my part, I do not want to be connected with a publication that does not try to point the way out of a sordid materialistic world."[39] Managing Editor Floyd Dell's motion to expel the dissenters from the editorial board is defeated, but Sloan, Davis, Coleman, and the writer Robert ("Bob") Carlton Brown resign from the magazine the next day.

Spring. One night after seeing a ballet in New York, Davis returns to New Jersey by train with Glintenkamp and Gar Sparks, the artist-proprietor of Newark's chain restaurant Nedick's who became one of Davis's close friends after the two had met in an African American saloon on Arlington Street in 1912. The three friends create a proto-Dada, single-issue broadsheet they call *The BLA!*, consisting exclusively of words, musical notes, and pictures they draw on the cover of the ballet's program.[40]

Summer. Stuart and his family again join the Sloans and friends at the Red Cottage in Gloucester. He experiments with cubist simultaneity in his art this season, but instead

of presenting a single object from various perspectives, he juxtaposes multiple scenes side by side in a manner much like that of contemporary illustrators. He describes the origins of the technique:

W. E. Hill, *Life Sketches*, from "Arcade Archives," *Arcade, the Comics Revue* no. 2 (Summer 1975), 3

Forty Inns on the Lincoln Highway, 1916, crayon, pencil, ink on paper, The Museum of Modern Art, New York, The John S. Newberry Collection

In all of this tramping around the landscape with a cumbersome equipment, I found that on many days nothing of interest was to be found that seemed worth painting…

[T]he discovery itself, that fluctuations in objective visual interest existed, led me to experiment in ways to find interest in subject matter which seemed to have none. These experiments took the form of painting several different scenes on the canvas at the same time. The composition was made of juxtaposed scenes, observed from a single point of observation. Not only what was directly in front, but to the side, and even in back of the observer. In this way I escaped the banality of appearance on a bad day by bringing into focus a number of points of interest instead of one…

The problem of composing several different views into simultaneous presentation involved distortions and arbitrary decisions about position, size, and shape. The process demanded active use of the memory and imagination, and also developed awareness of the objective reality and importance of the actual areas on the canvas. It started speculation about the general structural laws of composition [which]… were the beginning of my conception of a picture as an independent object with a reality of its own apart from its subject matter.[41]

September. Davis begins teaching an evening art class for high school students at East Orange High School.

December. The first issue of Robert Coady's avant-garde art journal the *Soil* appears, exhorting American artists to broaden their subject matter to include popular culture, industry, and technology. "There is an American Art," Coady writes, "Young, robust, energetic, naïve, immature, daring, and big spirited. Active in every conceivable field."[42] He enumerates where it can be found:

The Panama Canal, the Sky-scraper and Colonial Architecture. The East River, the Battery and the "Fish Theatre." The Tug Boat and the Steam-shovel. The Steam Lighter. The Steel Plants, the Washing Plants and the Electrical Shops. The Bridges, the Docks, the Cutouts, the Viaducts… Wright's and Curtiss's Aeroplanes and Aeronauts. The Sail Boats, the Ore Cars… Music and Dances. Jack Johnson, Charlie Chaplin… Bert. Williams, Rag-time… Syncopation and the Cake-walk… the Sporting Pages, Krazy Kat, Tom Powers. Old John Brown. Nick Carter… Walt Whitman and Poe… The Electric Signs and the Railroad Signals… Madison Square Garden on a fight night… Dialects and Slang… The Cranes, the Plows, the Drills, the Motors, the Thrashers, the Derricks, Steam Hammers, Stone Crushers, Steam Rollers, Grain Elevators, Trench Excavators, Blast Furnaces—This is American Art.

It is not a refined granulation nor a delicate disease—it is not an ism. It is not an illustration to a theory, it is an expression of life—a complicated life—American life.[43]

Excited by what he describes as Coady's "broader thinking about art in the whole community, about art as being in technology, machinery and all that," Davis eagerly awaits each issue of the magazine.[44]

1917

January. In order "to fill up the space of not having any place to show our work," Davis, Brown, and Glintenkamp found *Spawn*, a portfolio of reproductions of verses and drawings on sheets of unbound paper.[45] Funded by each contributing artist or writer, it folds after three issues.

April 10. Davis exhibits two works in the *First Annual Exhibition of the Society of Independent Artists*, a nonjuried exhibition open to anyone who pays the six dollar membership and entry fee. He gives little attention at the time to the controversy surrounding the society's refusal to include a urinal placed on its back that Marcel Duchamp elevates to the status of art by titling it *Fountain* and signing it with the pseudonym R. Mutt. Years later, the implications of Duchamp's act register with Davis: "Duchamp's suggestion worked slowly. Unesthetic material, absurd material, non-arty material—ten years later I could take a 'worthless' eggbeater, and the change to the new association would inspire me."[46]

May 18. Following the United States' declaration of war against Germany four months earlier, Congress enacts the Selective Service Act, requiring all men between the ages of twenty-one and thirty to register for military service. In contrast to a number of his former *Masses* colleagues, including Glintenkamp, Maurice Becker, and Brown, who ultimately leave the country to avoid being drafted, Davis registers in Gloucester in June. After taking a physical exam that finds him unfit for military service on the basis of a heart condition, he is discharged on August 20.[47] He describes his attitude toward the war as "passive, apathetic and casual."[48] As he tells Hazel, "I have not the slightest interest in what I or anybody does. Let the other people act."[49]

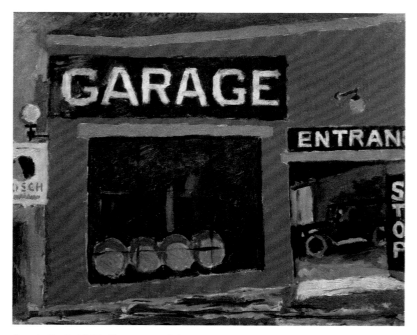

Garage No. 2, 1917, oil on canvas, Private collection

Summer. Stuart rooms with his paternal uncle Branch in a private house in Gloucester on Church Street and paints in a rented studio at 21 Wonson Street.[50] By this time, he has tired of "wander[ing] over the rocks with a sketching easel, large canvases and a pack... looking for things to paint" and instead sketches outdoors in a small sketchbook, returning to his studio to compose his paintings:

In abandoning the weighty apparatus of the outdoor painter I did not abandon nature as subject matter. My studio pictures were all made from drawings made directly from nature. As I had learned in painting out-of-doors to use a conceptual instead of an optical perspective, so in my studio composi- tions I brought drawings of different places and of different things into a single focus. The necessity to select and define the spatial limits of these separate drawings, in relation to the unity of the whole picture, developed an objective attitude toward positional relations. Having already achieved this to a degree in relations of color, the two had to be integrated and thought about simultaneously. The abstract kick was on, and a different set of headaches made their appearance.[51]

August. Acting on the authority of the recently passed federal Espionage Act, the post office declares a Glinten- kamp illustration in *The Masses* treasonable and refuses to mail the magazine. The editors go to court but lose the case. Without access to the mail, *The Masses* folds in December; about the magazine's pacifist stance Davis later says, "I just don't remember about it because actually I guess I wasn't interested."[52]

December. Polly Holliday hosts Davis's first solo exhibition in her newly opened Sheridan Square Gallery, above her Greenwich Village Inn. Although confident that his exhib- ited drawings and watercolors are "the equal of any ever made in this country," he sells only one.[53] The *New York Evening World* decries them as "screaming with degeneracy," singling out *Negro Saloon* as presenting a "horrid truth... quite inexcusable in a picture."[54]

1918

February 1. Force invites Davis and nineteen other artists to paint in situ in the Whitney Studio for three days, each on a randomly assigned, framed canvas, adjourning only for meals and to sleep. Working from sketches he brought with him, Davis creates *Multiple Views*, continuing his practice of juxtaposing disparate scenes of Gloucester into a single composition. Immediately following the three-day session, Force exhibits the finished works in the *Exhibition of Indigenous Paintings*. As a participant in the show, Davis becomes a charter member of the Whitney Studio Club, an exhibition and meeting space for artists on West 4th Street, four blocks south of the Whitney Studio.

Summer. Staying with the Sloans and friends at what will be his final summer at the Red Cottage, Davis writes a text entitled "Man on an Ice Floe" on the back of a painting depicting a Gloucester street scene. In this text, Davis defines the entire scope of an artist's consciousness as the subject of modern art.

Ultra-modern expression takes the whole scope of many consciousness[es] as its field... this picture is not a land- scape because its subject is not a landscape. It[s] subject was a mental concept derived from various sources and expressed in terms of weight and light which is the language of all visual art.
 Cubism is the bridge from percept to concept... It is from that only a step to the expression of a concept of diverse phenomena, sound, touch, light, etc., in a single plastic unit. 14th century demanded plot relationship of subject. 1870 to 1918 demanded plastic relationship of subject. 1918 — demands plastic expression of mental scope.[55]

Davis returns to the idea two years later: "A realistic picture gives an opportunity for the complete expression of one phase of an object whereas an aggregation of symbols may express many phases, incongruity or in other words a greater sense of life."[56]

June. As a result of the growing visibility Davis's art gains through group exhibitions, primarily at venues connected to Sloan and Henri — the Whitney Studio, the Whitney Studio Club, the Society of Independent Artists, the MacDowell Club, and the Liberal Club — the *Newark Morning Ledger* boasts that the "young painter of East Orange" is "fast gaining an enviable reputation."[57]

August. As a substitute for military service, Davis takes a job in the army's intelligence department for twenty-five dollars a week drawing maps and graphs of Europe, the Middle East, and Central America in anticipation of the new borders that will be redrawn in the postwar settlement. His hours are short, but the strain on his eyes makes sleeping at night difficult. Initially, he works in the Geographic Society Building at 156th Street and Broadway, then transfers to Columbia University's library. He commutes from East Orange until mid-August, when he moves into a room at 86 Greenwich Avenue across from the former *Masses* office and near Coleman, for whom he gets a job in his department. Davis works for the department until November, when Germany signs the armistice with the Allied powers, ending World War I.

Tobacco Fields, 1919, oil on canvas, Private collection

Summer. John and Dolly Sloan spend the first of what will be every subsequent summer in Santa Fe, New Mexico. With the Red Cottage no longer an option, Davis vacations in a farmhouse in rural Tioga, Pennsylvania, with his brother and mother. He paints the area's agricultural landscape, using thickly textured paint in the spirit of Van Gogh.

August. Following the worldwide influenza pandemic the year before, a second, more virulent strain of the disease breaks out. Showing symptoms, Davis returns to East Orange's Hotel Clinton, where his parents now live, to recover. By autumn, he is well enough to travel to Gloucester.

Late October. Davis returns to New York from Gloucester and moves into a room at 36 Perry Street.

December. Even as he continues to recover from the flu, Davis decides to join Coleman in Cuba, where the latter is vacationing. He sails on December 26 in a second-class compartment and arrives five days later at the dock in Havana, where Coleman meets him. The mandatory inoculation he receives makes him sick for the first two weeks, exacerbating his initial dislike of the city, which he finds dirty and without character. Yet by early January, when he and Coleman find a room in a private house, he begins to feel "almost as much at home as I do on Rocky Neck Avenue."[58] He writes daily to his parents, who send him twenty-five dollars a week for expenses. Still, with prices double what they are in the United States, he advises Hazel to tell her friends to choose Puerto Rico or Jamaica as a vacation destination over Cuba. Looking back on his trip, he recalls the country as interesting for its novelty, but not a place he wants to revisit.

January. Prohibition formally begins. The nationwide ban on the sale, transport, and manufacture of alcoholic beverages will make little impact on the alcohol consumption of Davis and his friends, who have no difficulty obtaining liquor in the myriad speakeasies that spring up or at their more familiar haunts, such as McSorley's Ale House.

February 1. Likely having contracted a venereal disease from his frequent visits to Havana's brothels, Coleman becomes too ill to remain in Cuba; he and Davis return to the United States, where Davis paints most of his Cuban watercolors.

May. Davis begins the first of many journals that record his private ruminations about the meaning and formal properties of art. In the initial journal, he establishes the principle that painting must diminish the illusion of three-dimensional space: "My purpose in making a picture is to create an ensemble which by itself will create a direct impression on the spectator without taking him 'into' the picture… [My aim is to]… have what the picture 'is' on the canvas and no place else."[59] He recognizes early on that advertisements and commercial labels possess the impact and "high visibility" he wants for his art and he exhorts himself to use "letters, numbers, canned goods labels, tobacco labels" as subject matter in an effort to "copy the nature of the present days," singling out in particular "tobacco cans and bags and tomatoe [*sic*] can labels."[60] Two years later, he confidently concludes: "I set out to learn abstract painting and I have learnt it and probably know its mechanism as few do in the whole world."[61] Davis continues his journal writing through 1923, stops, then resumes in 1932.

Summer. The Davis family shares a house in Gloucester with Whitney Studio Club artists Teresa Bernstein and her husband, William Meyerowitz, on the corner of Rocky Neck Avenue and Eastern Point Road. The house is a meeting place for a wide community of artists, among them Ukrainian futurist David Burliuk and Marsden Hartley, who is painting synthetic cubist still lifes at the time. He recommends Davis to Stieglitz in October, writing that the younger artist is doing "some nice work here and bids fair to become a new serious American painter."[62] Davis and his family summer in the Bernstein-Meyerowitz house through 1923.

Mutual friends show Davis's *Gloucester Terraces* to William Carlos Williams, who is struck by how conceptually related the drawing is to his poetry. He travels to Gloucester with his wife, Floss, to ask Davis's permission to use it as the frontispiece for his forthcoming book of poems, *Kora in Hell*. As Williams later recalls, Davis's work was "as close as

possible to my idea of the Improvisations. It was, graphi-cally, exactly what I was trying to do in words, put the Improvisations down as a unit on the page."[63] Davis's view of Williams's poetry is no less admiring. Writing to Williams upon the book's publication, Davis exudes: "It opens a field of possibilities. To me it suggests a develop-ment toward word against word without any impediments of story, poetic beauty or anything at all except word clash and sequence."[64]

August. Scofield Thayer, co-owner and editor since November 1919 of the vanguard literary journal *The Dial*, publishes four of Davis's whimsical line drawings of writers and composers; in 1922 two more follow.[65]

1921

Winter. Davis creates the first of his tobacco still lifes (pls. 1–4), using the commercial packaging of cigarette products as source material. He explains his choice of subject matter in his journal.

I want to paint a series of pictures the subject matter of which will be popular… By "popular" pictures, I mean those phases of the modern life which I am capable of under-standing. One of these things is the beauty of packing. Where a few decades ago everything was packed in barrels and boxes they now are packed singly or in dozen or half dozen lots as the control over distribution increases. This symbolizes a very high civilization in relation to other civilizations. The newspaper and magazines are of enormous interest to me conceived as a whole… My ten years of work have given me the power of expression and freed me from the tyranny of nature and I feel that the next few years should enable me to do some really original, American work… I feel that my tobacco pictures are… in some way direct descendants of Whitman our one big artist. I too feel the thing Whitman felt—and I too will express it in pictures—America—the wonderful place we live in… I want direct simple pictures of classic beauty expressing the immediate life of the day.[66]

April 25 – May 15. The Whitney Studio Club exhibits fifteen of Davis's works, including three of his tobacco still lifes, in a three-person show with Joaquín Torres-Garcia and Stanis-laus Szukalski. The first major presentation of Davis's work, the show wins over McBride, who sees the artist's originality as evidence that he has not been "consulting others as to what he should paint. Most evidently he has been working his own sweet will."[67] The critic lauds Davis as "one of the most considerable 'modernists' in the city," noting that

"lucky will be the collectors who snap up [his pictures] before Mr. Davis gets too famous."[68] McBride remains an ardent supporter of Davis's work through the next decade, when Davis accuses him at a public panel at the Museum of Modern Art (MoMA) of being a cultural chauvinist, leading the critic to stop reviewing Davis's shows.

May. Sparks, now manager of Newark's Nut House, commissions Davis to paint the soda fountain's menu on two walls. Davis's typographically diverse lettering suggests the influence of Guillaume Apollinaire's image-poems, which Davis described in his journal just two months earlier: "Words will have a place also… As in Apollinaire poetry encroaches on painting so let painting encroach on poetry."[69]

Mural, Gar Sparks's Nut House, Newark, New Jersey, 1921, commercial paint on wall, destroyed, photograph from Estate of the Artist Archives

1922

Stuart lives with his parents, his brother, Wyatt, and his uncle Branch at 356 West 22nd Street in a narrow two-story house, whose living quarters on the second floor are divided into three rooms. Stuart uses the front room as a studio and sleeps with Branch and Wyatt in the middle room; his parents sleep in the back room, separated from the others by a sliding door. Stuart describes the lack of privacy as not mattering, as no one is there much. They mostly eat out, usually at Longchamps on 5th Avenue.

At the Whitney Studio Club, Davis meets the painter and later precisionist artist Niles Spencer, who becomes one of his closest lifelong friends.

February 5. Davis writes to McBride suggesting that the critic alert his readers to the idea that worthwhile art is being created in America.

Somebody made the statement to me the other day that art was being done in America. The idea had never occurred to me before and the statement made very little impression on me at the time. Thinking it over, however, I found myself accepting this all but incredible discovery… A regular vampire of an idea. The knowledge that right now, around us, in New York city [*sic*], as well as elsewhere, artists are creating worthwhile things gives one a sense of comfort hitherto unexperienced. It struck me that other people might be interested in knowing what I had learned.

 My purpose in writing this letter was to ask you whether the idea appealed to you sufficiently to expound it to your customers. Some of them might be interested to know that America was a safe place to be in after all. If you could write an article with this idea as a basis I think it would do a lot of good.[70]

McBride prints Davis's letter along with his endorsement of its contents.

Before the war I used to spend as much time in Europe as I could afford and was frequently told by English and French friends "Why, we should never take you for an American!" This was meant as a compliment and was accepted as such. My stock reply to this compliment was, "I am not one. I am an exile in America and only begin to live when I get abroad," which went great, as you may well believe. However, when the war broke out something happened to me that happened to many others of the hyphenated and I took out spiritual naturalization papers to the land of my birth.

 Whatever was to be the final outcome of the war I saw at once in 1914 that the supply of mysterious ether that had hitherto sustained artists in Europe upon a high plane would be exhausted; that Europe, as far as you and I, Stuart, was concerned, was finished. I believe that the dominating country in the world has the chance for the greatest expression in art, and although I was forced to take immediate passage back to this country I realized instantly upon landing that the scepter of power had beat me to New York. This city had taken on the indescribable air of a world capital.[71]

Spring. Still working through the lessons of French modernism, Davis paints a series of monumental still lifes indebted to synthetic cubism.

June. Davis is elected a director of the Society of Independent Artists after being nominated by Sloan, the organization's president since 1918. Davis remains on the board until

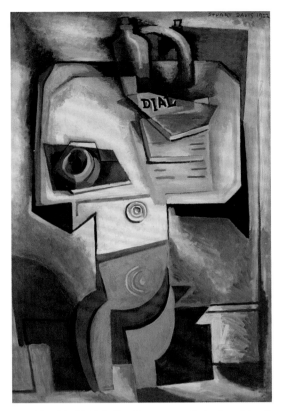

Still Life with "Dial," 1922, oil on canvas, Collection of Jan T. and Marica Vilcek, Promised gift to the Vilcek Foundation

the 1930s when he resigns "owing to boredom and the monotony of it and the continuous disputes as to whether the pictures should be hung alphabetically, or visually, or interestingly."[72]

Summer. Davis rents a studio at 4 Eastern Point Road in Gloucester, returning to the Bernstein-Meyerowitz house in the evening for meals and to sleep. In September, he holds an exhibit in his studio of his summer's output. Portending his political activism on behalf of artists in the 1930s, he helps found the Gloucester Society of Artists, open to anyone who wants to join. Despite his role in its formation, he exhibits with the society only three summers, from 1924 to 1926.

Fall. Davis partners with Harry Kemp and Ralph deGolier to create theater productions to sell to motion picture houses for presentation between film screenings. Their first project is *The Puritans*, a Dutch play Kemp translates into English with music by deGolier and costumes and sets by Davis. By December, the trio has several other productions in process; none sell.

November 19. Davis meets Elliot Paul on an assignment to draw the novelist's portrait for the *New York Tribune*. Paul will be an important contact for Davis during his 1928–1929 sojourn in Paris.

Winter. Davis begins visiting the Metropolitan Museum of Art weekly. Studying its collection of Greek vases dating to the sixth century BC leads him to conclude that "the appreciation of art seems to me to be simply a matter of desire for order as a relief from the apparent and possible chaos of everyday affairs."[73]

1923

The *Sun* acquires the *Globe*, leaving Stuart's father without a job. Ed buys an interest in the nearly defunct A.R. Elliott Advertising Company, taking with him the highly lucrative Borden Milk account he has managed at the *Globe* since 1911.

May. The Whitney Studio Club mounts a survey exhibition of Picasso's work that includes his synthetic cubist pochoir prints and paintings; Force buys and installs one in her apartment on the club's top floor. Four years later, Davis adopts Picasso's vocabulary of flat, crisply demarcated planes in his own work.

Summer. At Sloan's urging, Davis ventures to Santa Fe for the summer, accompanied by his brother, Wyatt. They stay in Sloan's studio until they find a room in a local house and Sloan arranges a studio for Davis in the Palace of the Governors. Most of the summer, however, they spend outdoors, traveling to sites outside Santa Fe in Sloan's car or by taxi.

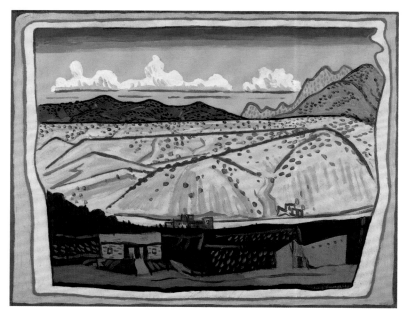

New Mexican Landscape, 1923, oil on canvas, Amon Carter Museum of American Art, Fort Worth, 1972.49

Untitled, 1923, ink, opaque watercolor, wax crayon on paper, Whitney Museum of American Art, New York, Purchase, with funds from the Drawing Committee, 96.167

Davis finds the Native American dances fascinating and the desert scenery "the most marvellous landscape you can imagine… must be seen to be appreciated," a view that takes on more complexity in Davis's later recollections.[74]

[I] did not do much work because the place itself was so interesting. I don't think you could do much work there except in a literal way, because the place is always there in such a dominating way. You always have to look at it… Forms made to order, to imitate. Colors—but I never went there again.[75]

Davis paints a few still lifes of familiar household objects— an egg beater, a light bulb, a saw—but the majority of his works are landscape images whose two-dimensionality he fosters by applying dashes, dots, speckles, and spots to delineated areas of color and by enclosing the scenes in undulating painted borders, a technique introduced earlier in his tobacco pictures, albeit with geometric edges. By 1928, painted borders are commonplace in his work.

September. Wyatt returns to New York for the fall semester; Stuart remains in Santa Fe until October 14, when he goes to Gloucester. There, he begins a series of witty satirical illustrations of suave urbanites, which he hopes to sell to literary magazines.

1924

Davis creates a series of still lifes of commercial domestic products—light bulbs, drinking glasses, bottles of Odol mouthwash—each carefully demarcated and set within a shallow stage-like space (pls. 6–9). Guided by his intuition that pictorial order is a prerequisite for the appreciation of art, he wants them to read as "ONE thing and not TWO things," to "have unity, singleness of idea."[76] For the next decade, he creates work that fulfills his prescription that "there must be a unit of area that dominates all the areas, so that viewers looking at the picture will instinctively feel a simple order."[77]

Summer. Bernstein and Meyerowitz, whose rented house the Davis family has been sharing every summer since 1920, purchase a home in Gloucester at 44 Mount Pleasant Avenue. The Davis family rents one nearby, at 134 Mount Pleasant Avenue.

1925

February 7. John Cotton Dana mounts Davis's first one-person exhibition at the Newark Museum and Public Library. The critic for the *World* heralds it as emblematic of new tendencies in American art.

[The] exhibition is a cross section of the history of American art in the past twelve years… The work is modern, full of the arbitrary handling of form and color which one expects of modernism, and yet there is in it a remarkably good commentary on the American scene of the past decade. Flappers, jazz bands, dance halls, gasoline pumps, tin roofs, cross word puzzles, and the many worries and enthusiasms of contemporary America jostle with cubistic truculence across the canvas of Stuart Davis.[78]

The exhibition inaugurates a lifelong friendship between Davis and Holger ("Eddie") Cahill, Dana's assistant and Sloan's close friend.

Summer. The Davis family purchases a house at 51 Mount Pleasant Avenue in Gloucester, across the street from Bernstein and Meyerowitz and near the home of Charles and Alice Winter. In the paintings Davis executes at the new house, he works to further reduce illusionistic spatial recession.

I had come to feel that what was interesting in a subject or what had really caused our response to it could be best expressed in a picture if these geometrical planes were arranged in direct relationship to the canvas as a flat surface. I felt that a subject had its emotional reality fundamentally through our awareness of such planes and their spatial relationships.[79]

November 15. The Société Anonyme, which Katherine Dreier, Man Ray, and Duchamp founded in 1920 to promote modern art through exhibitions, publications, and lectures, opens a one-person exhibition of Fernand Léger's work in rented space in the Anderson Galleries on Park Avenue. The show offers Davis his first in-depth view of the artist he later calls "the most American painter painting today" and venerates for having come "to grips with the subject matter of contemporary life in its industrial aspects."[80]

Late Fall. One night at Romany Marie's, Davis meets Bessie Chosak, fourteen years his junior and the only American-born child of Russian Jewish immigrants living in Brooklyn Heights.[81] Both of her parents are professional musicians. Funny, smart, and an accomplished pianist, she makes an immediate impression on Stuart, who tells Wyatt later that evening that he is in love. Stuart's mother, described by Romany Marie as having "a love [for Stuart] that sometimes was too close for comfort. Too possessive," attempts to break up the relationship without success.[82] Stuart and Bessie move in together, taking an eight-by-eleven-foot room with a single-burner alcohol stove at 67 7th Avenue, between 14th and 15th Streets. Helen's continued hostility toward Bessie most likely accounts for his never mentioning her name in letters to his parents.

Portrait of Bessie Chosak, 1927, ink, pencil on paper, Estate of the Artist

September 25. Davis petitions Dreier to include his work in the Société Anonyme's forthcoming *International Exhibition of Modern Art* at the Brooklyn Museum: "Burliuk saw my work and said I should be in the show. I would like very much to be a member of the Société and will do anything you may suggest to make it possible."[83] Dreier, who has followed Davis's work for years, includes *Super Table* (pl. 11) in the exhibition. Finding it "an inspiration," Davis later tells Dreier that the exhibition "has given me fresh impulse" and that the catalog is even more informative "owing to the understanding that comes with familiarity."[84] He expresses interest in seeing more reproductions of works by the Russian constructivists, El Lissitzky in particular.

October. Valentine Dudensing, whose gallery is renowned for its exhibitions of vanguard French art, especially that of Picasso and Henri Matisse, includes Davis's *Early American Landscape* in a group show, *Selection of Important Works of the Best Young American Art.*

November. Edith Halpert — whose husband, the painter and Whitney Studio Club member Samuel Halpert, Davis knows — opens Our Gallery with Berthe ("Bee") Goldsmith, the sister of artist Leon Kroll, as a silent partner. Halpert renames it the Downtown Gallery a few months before opening Davis's first solo show there the following year.

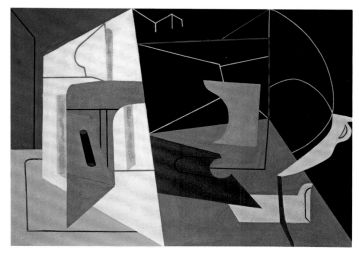

Egg Beater No. 4, 1928, gouache on illustration board, Ted and Mary Jo Shen

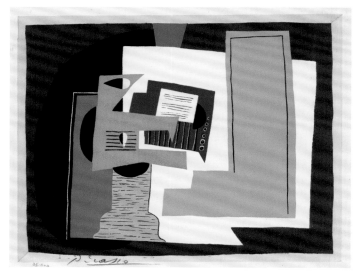

Pablo Picasso, *Still Life — Horizontal*, c. 1920, stencil, The Museum of Modern Art, New York, Lillie P. Bliss Collection, 1934

El Lissitzky, *Proun 99*, c. 1923–1925, water soluble and metallic paint on wood, Yale University Art Gallery, Gift of Collection Société Anonyme

December. Describing himself as "dead broke… [with] no place to work," Davis has been storing his paintings in Joseph Pollet's studio on the top floor of the Whitney Studio Club.[85] When Force hears about his situation, she mounts a show of these works in hopes of generating some income for him. Five paintings in the show sell, but with the exception of McBride, who applauds Davis for giving his "quotations" of Georges Braque and Picasso "a humorous twist foreign to the originals," critical response is negative.[86] The diversity of the work puzzles critics. One denounces his paintings as "laboratory work," reprocessing ideas already expressed by other artists, while another concludes that the lack of clarity in his work "probably is quite negligible to Mr. Davis, since he is still in the throes of theory and undecided himself as to his aesthetic credo of procedure."[87] Despite such assessments, Force and Gertrude Whitney commit to providing Davis with a stipend of $125 a month for a year, which dramatically changes his life. As he puts it: "[N]ot buying any stocks and bonds but I eat regularly."[88]

1927

With his newfound financial freedom, Davis spends the year painting still lifes, initially of a percolator, then matchbooks, and finally of an electric fan, a rubber glove, and an egg beater (pls. 12–14). Likening himself to "Monet with his haystack," he studies this latter arrangement for so many months that the objects in it lose their associative meanings and become angled geometric shapes.[89] Years later, Davis characterizes the breakthrough he made:

In paintings [from 1924 and 1925] the major relationships — the larger generalizations — were established, but the minor features were still imitative. In the eggbeater series, on the other hand, I made an effort to use the same method throughout. This I felt would give the picture a more objective coherence. The result was the elimination of a number of particularized optical truths which I had formerly concerned myself with. In effecting this elimination, however, the subject was not repudiated in favor of some ideal order; but this approach was regarded as a more intense means of equating the sensible material one responds to in various subjects. My aim was not to establish a self-sufficient system to take the place of the immediate and the accidental, but... to strip a subject down to the real physical source of its stimulus.[90]

Spring. As Davis begins work on his geometric still lifes, Jean Heap, coeditor of the *Little Review*, opens the *Machine Age Exposition*, which juxtaposes actual machines and photographs of industrial structures with fine art, including Léger's *La Ville*, as well as Duchamp's *Chocolate Grinder* and Louis Lozowick's *Machine Ornament* whose vocabulary of abstract geometric planes floating against neutral backgrounds parallels Davis's approach.

Mid-October. Davis and Bessie move into what he calls a "human sized" apartment — with a bath and kitchenette — in the same building on 7th Avenue in which they have been living.[91] His parents move with Wyatt and Branch into an apartment in the Chelsea Hotel at 222 West 23rd Street.

November 26. The Downtown Gallery opens simultaneous solo exhibitions of the work of Davis and Frank Osborn. The inclusion of Davis's recent geometric still lifes, among them *Egg Beater No. 1* (pl. 14), announces the radical direction his art has taken since his Whitney Studio Club show the year prior. He describes his new approach in a letter to Halpert:

In the first place my purpose is to make Realistic pictures. I insist upon this definition... A picture is always a three dimensional illusion regardless of subject matter... People must be made to realize that in looking at Abstractions they are looking at pictures as objective and as realistic in intent as those commonly accepted as such. I think this point is important and not generally understood... The type of subject I am now interested in representing is characterized by simple geometrical solids. That many of the younger artists are similarly interested in various ways probably indicates that this type of form has greater contemporary aesthetic utility than other types.[92]

Stuart and Bessie Davis, 1926, Estate of the Artist Archives

1928

April. The Valentine Gallery hosts a two-person exhibition of Davis's and Coleman's work that includes the three egg-beater still lifes Davis has completed since his Downtown Gallery show. Again, he authors a manifesto, available on request, for those who might find his work incomprehensible.

Three-dimensional space is something which everyone can understand because it is an important part of every one's daily experience. When you cross the street you must immediately exercise this three-dimensional sense or you will be run over by an automobile. Therefore, people cannot logically say that they do not understand this painting because it is abstract. They can say without contradiction that they do not like it, that the subject is uninteresting or repulsive to them, but never that it is unintelligible.[93]

April 29. Force invites Davis to participate in the Whitney Studio Club Annual. He removes *Egg Beater No. 4* (pl. 17) from the Valentine Gallery a few days before that show closes and sends it to the club.

The only trouble was that I hadn't marked which was top and they hung it on its side between two windows. It just fitted that way but you couldn't turn it right side up and still get it in the same space. I had what I thought then was a pretty novel idea. I went back to the studio and brought in another picture that would fit… But Mrs. Force was a strong character. She liked that eggbeater on its side and that's the way it stayed all through the show.[94]

According to a newspaper report of the incident, the painting Davis unsuccessfully tried to substitute for *Egg Beater No. 4* was *Early American Landscape*. Force buys it and *New Mexican Landscape* in May on behalf of Gertrude Whitney for $900 in order to finance a trip to Paris for Davis. In exchange, he promises to give Whitney one of the pictures he makes abroad upon his return. As Davis later recalls:

I guess [Force] was sorry for me because I was about the only one in the Club who hadn't been to France and she thought it would be good for me. I didn't ask her for the money but I accepted it gratefully and was on the next boat over… It was a very profitable experience.[95]

June. Davis and Bessie sail to Le Havre, France, with two of his egg-beater paintings and travel to Paris by train. A month after their arrival, Force arranges for them to rent Jan Matulka's vacant apartment at 50 rue Vercingétorix for seven dollars a month. The apartment is a fair-sized, well-lit room with a sleeping balcony, but lacks gas, water, and a toilet, deficiencies they overcome by using a coal stove for heat, hauling water up in buckets, and using the toilet in the alley. The lack of amenities does not mar Davis's enthusiasm for Paris.

Everything about the place struck me as being just about right. I had the feeling that this was the best place in the world for an artist to live and work; and at the time it was. The prevalence of the sidewalk café was an important factor. It provided easy access to one's friends and gave extra pleasure to long walks through various parts of the city… It reminded me of Philadelphia. I remember Philadelphia only as a child… an old fashioned place. Paris was old fashioned, but modern as well. That was the wonderful part of it… There was so much of the past and the immediate present brought together on one plane that nothing seemed left to be desired. There was a timelessness about the place that was conducive to the kind of contemplation essential to art. And the scale of the architecture was human.[96]

Davis writes to his parents:

Paris is the place for artists. Here, an artist is accepted as a respectable member of the community whether he is good or bad. In the swellest cafés one can sit all afternoon with a 6 cent glass of coffee without anything being thought of it. At the next table people may be drinking champagne cocktails in dress suits. That is how different it is from N.Y.[97]

By the time Davis and Bessie arrive in Paris, so many Americans are living there that one American journal calls it the "capital of America."[98] Unable to speak French, the couple socializes exclusively with Americans, most of whom live in Montparnasse. Man Ray and Gerald Murphy, the two artists whose work Davis's most resembles, keep their distance from this group, but Davis has plenty of other companions: Elliot Paul, who gives him a tour of the sights immediately upon his arrival, John Graham, Hartley, Alexander Calder, Paul Gaulois, and a host of Whitney Studio Club members, including Kroll, Yasuo Kuniyoshi and his wife, Katherine Schmidt, and Adolf Dehn. As Davis tells Hazel, "Owing to this fact of the café—I have met everybody I ever knew in N.Y. and a lot of others besides."[99] With the arrival a few months later of Spencer and former *Masses* writer Brown and his wife, Rose, Davis gains drinking companions. "We used to go out and drink beer by the gallon," he later says, an assessment confirmed by Brown's affectionate memory of the "beer to urinal stream… poured out with the big quart bottles there in the Vercingétorix."[100]

Stuart Davis with *Porte de Saint-Martin*, Paris, 1928, photograph by Thérèse Bonney

September. Davis meets Léger through Graham, who serves as translator for the several studio visits the artists exchange. In a letter to his parents, Davis quotes the French painter as saying he liked the two egg-beater paintings and thought

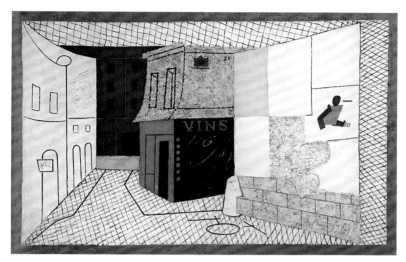

Rue des Rats No. 1, 1928, oil and sand on canvas, Myron Kunin Collection of American Art

they "showed a concept of space similar to his latest development. Said it was interesting that 2 people who did not know each other should arrive at similar ideas."[101]

October. Despite the favorable exchange rate, Davis's funds dwindle to seventy-five dollars. His appeal to his parents that his "original funds are horribly wounded… whatever you can afford to put into this project will not be wasted" yields some additional money but does not alleviate his worry about how much longer he will be able to stay in Paris.[102]

Fall. Elliot Paul writes a cover article on Davis for the literary journal *transition*, in which he salutes Davis for showing the common sense to be influenced by "important contemporaries rather than by his second-rate predecessors" and for accepting the attendant "neglect, nonsense and misunderstanding which has fallen to his lot."[103] That November, he introduces Davis to Gertrude Stein, who later tells Paul she is interested in buying one of the artist's paintings.

In painting Paris, Davis replaces the severe geometries of his *Egg Beater* series with more realistic depictions of what he will describe as the "actuality" of the Parisian streets, which he explores daily.[104] He retains his commitment to geometry and angular variation by presenting building facades as flat planes set at angles to one another and by using textured paint to reinforce the paintings' surfaces, but his Paris pictures differ from his previous work in their more pronounced realism and lyric delicacy, which the artist achieves through a confectionary palette and whimsical calligraphy (pls. 18–24). Nearly twenty years later, critic Clement Greenberg calls Davis's Paris pictures the best of his career.[105]

January. Being in Paris sours Davis on Halpert. When she proposes hosting an exhibition in the spring, he tells his parents he will let her have watercolors and lithographs but not oils, as "her gallery is not the place" for them.[106] A few months later, bereft of other options, he reconciles himself to exhibiting his paintings with her again.

March. Spencer introduces Davis to Hilaire Hiler, a wealthy American expatriate painter and amateur musician who runs several nightclubs in Paris; the most well-known is the Jockey Club, an after-hours jazz hangout on boulevard Montparnasse on the Left Bank. Hiler plays Davis the first recording he has ever heard of Earl Hines, the seminal African American jazz pianist and bandleader, after whom Davis will one day name his son.

April. In Europe to dedicate the *Columbus Memorial* that Whitney carved for the city of Huelva, Spain, Force gives Davis an additional $500.

May 1. Force's additional money helps, but with Davis's finances still "missing on all cylinders [*sic*]," he invites Stein to his studio in the hope that she will buy something.[107] When she fails to visit, he writes again, offering to sell her an egg-beater painting at any price. She declines this offer as well as Davis's request that she write the foreword for his upcoming Downtown Gallery show.

May 29. Davis and Bessie marry, with the Browns hosting a celebratory dinner in their apartment at the Palais Royal.

July 15. The newlyweds sail back to New York, optimistic that Davis can make enough money from his Downtown Gallery show to finance their return to Paris. Once home, Davis gives *Egg Beater No. 1* and *Place Pasdeloup* (pl. 19) to Gertrude Whitney in repayment for the money she and Force gave him for the trip. Davis's first impressions of the city are negative.

On my arrival in New York I was appalled and depressed by its giantism [*sic*]. Everything in Paris was human size, here everything was inhuman. It was difficult to think either of art or oneself as having any significance whatever in the face of this frenetic commercial engine. I thought, "Hell, you can't do any painting here."[108]

Davis retreats to his family's house in Gloucester, where he spends the rest of the summer painting watercolors of the town's harbor with the same calligraphic playfulness and

lyricism he employed in his Paris pictures. Bessie remains in New York, working in her brother's pharmacy. In subsequent summers, she works as a cashier in a movie theater instead of joining her husband in Gloucester.

Fall. Back in New York, Stuart's affection for the city revives. Being abroad made him realize, as cultural critic Malcolm Cowley expresses it, that "America is just as god-damned good as Europe."[109] Davis later calls his Parisian sojourn the "one outstanding event" of his artistic life because it dispelled all sense of inferiority he had in relation to European artists.[110]

Stuart meets Arshile Gorky through his brother, Wyatt, and Wyatt's new wife, Mariam Hapetian, a former Denishawn dancer who shares Gorky's Armenian roots. With Graham, who is also back from Paris, the three painters become a trio Willem de Kooning dubs "the Three Musketeers."[111] More aesthetically vanguard than other American artists, they become magnets for a group of younger talents, among them de Kooning, Burliuk, David Smith, and Misha Reznikoff, a Ukrainian-born friend of Gorky and de Kooning then married to Rose ("Roselle") Springer, who will later be Davis's second wife.[112] Except for Gorky, all are heavy drinkers who frequently "used to get loaded," as Reznikoff later puts it.[113] Their hangouts are Ticino's restaurant on Thompson Street, Stewart's Café on 6th Avenue, Romany Marie's, and the Jumble Shop, a tearoom on 8th Street and MacDougal with a bar in the back.

October 29. The stock market crashes, wiping out thousands of investors and ushering in the Great Depression.

November 25. The Whitney Studio Galleries exhibits nine of Davis's Gloucester watercolors in a small room on its second floor. In an otherwise complimentary review of the show, McBride calls Davis's style "French" and suggests that if Picasso had not lived, Davis would be forced to invent a style of his own, a charge Davis refutes in the February 1930 issue of *Creative Art*.[114]

I did not spring into the world fully equipped to paint the kind of pictures I want to paint. It was therefore necessary to ask people for advice. This resulted in my attending the school of Robert Henri where I received encouragement and a vague idea of what it was all about. After leaving the direct influence of Mr. Henri I sought other sources of information and as the artists whose work I admired were not personally available I tried to find out what they were thinking about by looking at their pictures. Chief among those consulted were Aubrey Beardsley, Toulouse-Lautrec, Fernand Leger and

Picasso… why one should be penalized for a Picasso influence and not for a Rembrandt or a Renoir influence I can't understand…

In view of all this I insist that I am as American as any other American painter. I was born here as were my parents and their parents before, which fact makes me an American whether I want to be or not. While I admit the foreign influence I strongly deny speaking their language… Over here we are racially English-American, Irish-American, German-American, French, Italian, Russian or Jewish-American and artistically we are Rembrandt-American, Renoir-American and Picasso-American. But since we live here and paint here we are first of all, American.[115]

Fifteen years later, Davis feels compelled to repeat the idea:

I am American, born in Philadelphia of American stock. I studied art in America. I paint what I see in America, in other words, I paint the American scene… I don't want people to copy Matisse or Picasso, although it is entirely proper to admit their influence. I don't make paintings like theirs. I make paintings like mine. I want to paint and do paint particular aspects of this country which interest me. But I use, as a great many others do, some of the methods of modern French painting which I consider to have universal validity… Why should an American artist today be expected to be oblivious to European thought when Europe is a hundred times closer to us than it ever was before?[116]

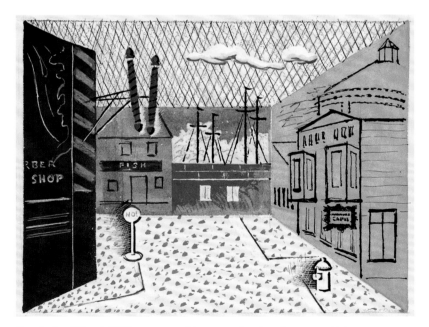

New England Street, 1929, opaque and transparent watercolor, pen and ink, wax crayon, graphite pencil on paper, Whitney Museum of American Art, New York, Gift of Gertrude Vanderbilt Whitney, 31.421

1930 – 1939

Mid-January. A fire breaks out on the floor below the apartment where Davis and Bessie have lived since returning to New York from Paris. In putting it out, firemen chop holes in the floor and walls of their apartment, which becomes inundated with rats.

January 21. *Hotels and Cafés*, Davis's show of his Parisian paintings, opens at the Downtown Gallery, winning "panegyrics from the critics," according to *Art Digest*.[117] Only Lloyd Goodrich, a contributing editor to *Arts*, interjects a negative note.

Mr. Davis's style is admirably logical and consistent, and there is something engaging in its severe purity… But the language in which he has chosen to express himself seems unnecessarily limited, a little like a framework on which a more solid structure could be erected, for although he suggests three-dimensional form he does not always actually create it in a way that is convincing to our senses.[118]

February 3. Anxious to escape their rat-infested apartment, Davis and Bessie move into a sixty-dollar-a-month two-room apartment with a kitchenette on the second floor of 8 St. Luke's Place next door to New York mayor Jimmy Walker. They rent out the smaller of their two rooms and eat out every night, usually at Ticino's.

Summer. Stuart joins Helen and Wyatt in Gloucester. Whereas Paris's layered history satisfied his desire to simultaneously portray past and present, he now returns to the approach he pursued in 1918 in his multiple views of Gloucester by bringing together in a single composition scenes observed in different times and in different places.

Fall. Davis and Bessie move into a tenement apartment— "a closet," Davis calls it, at 166 2nd Avenue on the Lower East Side across from St. Mark's Church—where they live for the next two years.[119] That October, Halpert contracts to pay Davis fifty dollars a week in exchange for all the watercolors and all but one of the oils he makes each year, with Davis to receive a commission on any work Halpert sells. At the end of two years, Halpert renews the contract. The arrangement funds the couple's living expenses, but it effectively means that Halpert purchases almost all of Davis's art at a greatly reduced price.

October. The Valentine Gallery holds an exhibition of Joan Miró's surrealist paintings. Davis encountered surrealism in Paris in galleries and in the studio of Gaulois, whose work he saw again in MoMA's April survey of artists under the

age of thirty-five. While Davis disapproves of Miró's and Gaulois's embrace of dreams and the unconscious, their technique of placing unrelated images side by side resonates with his conviction that memories and associations inform the artist's mental concept of a subject. Putting his theory into practice, he juxtaposes images of New York and Paris against neutral, indeterminate backgrounds in disregard of spatial and temporal congruence.

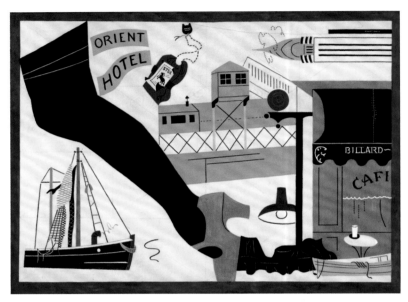

New York—Paris No. 1, 1931, oil on canvas, University of Iowa Museum of Art, Iowa City, University acquisition, 1955.5

1931

March 31. The Downtown Gallery opens an exhibition of Davis's recent work, accompanied by excerpts from his letters to Halpert stating his theory that people perceive objects as angular relationships and that artists must therefore depict them as such. Critics find the theory puzzling, with Murdock Pemberton in the *New Yorker* "beg[ging]" his readers to "look at his pictures before you appraise his ability to express himself in words."[120] McBride applauds the artist's work for embodying a "healthy, wholesome, and typically American" sense of fun but laments that Davis "is not so funny when he starts to explain his art."[121] He closes by modifying his earlier criticism of Davis's appropriation of French styles:

The only thing wrong about Stuart Davis is that he picked the language [of French modernism] up when out scouting. I love scouts and approve of scouting, but somehow—deep down in my heart—I should have preferred Stuart Davis to have invented the kind of talk he now hands out. But we can't have everything and next to the invention of a language, there is the speaking it nicely—and that Stuart Davis surely does.[122]

September. *Creative Art* publishes Davis's "Self-Interview," in which he describes the impact of his trip to Paris and proposes simultaneity and speed as the salient characteristics of modernity.

Q: What was [the] particular value [of your trip to Europe]?

A: It enabled me to spike the disheartening rumor that there were hundreds of talented young modern artists in Paris who completely outclassed their American equivalents. It demonstrated to me that work being done here was comparable in every way with the best of the work over there by contemporary artists. It proved to me that one might go on working in New York without laboring under an impossible artistic handicap. It allowed me to observe the enormous vitality of the American atmosphere as compared to Europe and made me regard the necessity of working in New York a positive advantage.

Q: Could you name some of the important positive factors that contribute to the vitality of the American atmosphere you spoke about?

A: The movies and the radio.

Q: Why?

A: Because they allow us to experience hundreds of diverse scenes, sounds and ideas in a juxtaposition that has never before been possible. Regardless of their significance they force a new sense of reality and this must, of course, be reflected in art.[123]

To accompany the article, the magazine allows Davis to choose someone to write a critical appraisal of his art. He selects Gorky, despite the Armenian's lack of proficiency in English. The article takes Gorky a long time to write. Davis later remembers thinking after it comes out that Gorky "laid it on thick—at that time too thick. The phrase 'mountain-like' as applied to me was particularly embarrassing, and various persons of my acquaintance in Cafeteria Society lost no time in making the most of it."[124]

September 28. Davis begins teaching a semiweekly evening class at the Art Students League, but with few people able to afford tuition owing to the worsening Depression, he never has more than eight students. The school drops his contract in June.

November 18. The Whitney Museum of American Art, founded by Gertrude Vanderbilt Whitney the year prior, opens with a show of work from its collection, including *Egg Beater No. 1*.

December 28. Calls for art that expresses American national identity mount in the wake of the crisis in national confidence that accompanies the Depression. Cognizant of this nationalist emphasis, Graham emphasizes the American quality of his, Davis's, and Gorky's work in a letter to wealthy philanthropist Duncan Phillips, cofounder and director of the Phillips Memorial Gallery.

Stuart Davis, Gorky and myself have formed a group and something original, purely American is coming out from under our brushes. It is not the subject matter that makes painting American or French, but the quality, certain quality which makes painting assume one or the other nationality… Schools of art are not made but are the product of surroundings and time.[125]

1932

January. In a letter to his cousin Hazel, Davis describes his December exhibition at the Crillon Gallery in Philadelphia as "a flop," most likely owing to the collapse of the art market.[126] He laments, "I haven't sold anything for so long I forget what it feels like."[127]

February. Davis creates *American Painting* for the Whitney Museum's first painting annual, paying subtle homage to de Kooning, Gorky, Graham, and himself by including four figurative images in the painting, along with the phrase "it don't mean a thing if it ain't got that swing," a quote from Duke Ellington's hit record of that name, released eight months earlier. While Davis has often included words in his paintings, never before has he used them so blatantly as independent subjects.

Photograph of *American Painting* (original state), 1932, Estate of the Artist Archives

March. In an effort to emphasize Davis's subject matter as uniquely American, the Downtown Gallery titles its show of his most recent New York and Gloucester paintings *Stuart Davis: American Scene*. The strategy works: *New York Times* critic Edward Alden Jewell notes affirmatively that Davis has "graduated from the School of Paris," and McBride expresses relief that the artist "seems at last to have recovered from his European trip. He sounds once more the American note."[128] Despite plaudits, nothing sells.

Spring. Following protests by American artists over the selection of Diego Rivera by John D. Rockefeller, Jr., to paint the mural for the lobby of the RCA Building in Rockefeller Center, MoMA invites sixty-five American artists, Davis included, to create mural designs on the theme of postwar life to be exhibited at the museum in May in the explicit hope, articulated by MoMA advisory curator Lincoln Kirstein, of stimulating mural commissions for American artists. Following Kirstein's instructions that each artist design a set of three small studies and a large-scale painting based on one of them, Davis creates the triptych *Abstract Visions of New York* and *New York Mural* (pl. 32).

Donald Deskey wins the competition to design the interior of Rockefeller Center's Radio City Music Hall. Halpert, who has hired Deskey for several previous projects, including the 1929 expansion of her gallery, offers him advice about which artists should decorate the hall. Through her, Davis is commissioned to paint the mural for the men's lounge.

June. Halpert cuts her payments to Davis owing to the declining art market. Notwithstanding her recommendation of him for the Radio City Music Hall commission, tensions between them build. When Hazel inquires about purchasing a painting, Davis suggests she buy it from him directly, otherwise he "wouldn't get a nickel."[129]

June 13. Bessie disappears. Davis searches for her frantically for two days, finally locating her at her parents' apartment in Brooklyn, where she has gone after developing an infection from an abortion she has kept secret from him. She dies on June 15. Davis puts the couple's belongings in storage and moves into the Chelsea Hotel, but even being surrounded by family does little to mitigate his emotional paralysis. For weeks, he weeps uncontrollably and sits for hours at a time without talking. In an effort to take his mind off Bessie's death, Wyatt's wife Mariam brings assorted tobacco products to the apartment, hoping to inspire him to start sketching the Radio City Music Hall mural. The strategy succeeds: in mid-July, he finishes his design and submits it to Deskey for approval.

Late July. Still depressed over Bessie's death, Davis goes to Gloucester, where he draws, makes watercolors and modestly sized paintings, and awaits Deskey's response to his mural design.

September. With no word from Deskey, Davis writes to Halpert: "The fact that Deskey doesn't say anything causes me to imagine that [the mural designs] make him nervous or that he just can't believe that they're alright… [I] hope to God [he] let[s] me do it."[130] Finally, in October, Deskey approves the mural, and Davis begins painting it in Gloucester in an office building downtown.

I have a studio in town which is just large enough to accommodate the main-sail I am painting on. It is 11 × 17 feet which doesn't sound big, but measure it off and see what it looks like. I will be here all October. It has to be done by Nov. 1 or I lose $1,000 a day in publicity money. I hope everything comes out alright and that I will once again be in position to quaff the tasty and stupifying [sic] McSorley's ale.[131]

December 27. Radio City opens while Davis is still in Gloucester. He receives $700 for his mural, plus materials. An adman invents its title, *Radio City Men's Lounge Mural: Men without Women*, which Davis dislikes. Decades later, after the mural is removed from Radio City, he retitles it *Mural* (pl. 35).

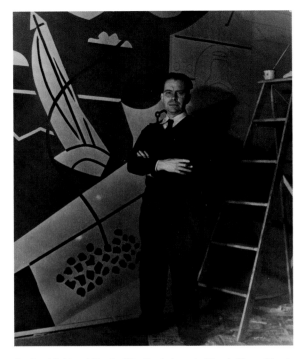

Davis with *Mural (Radio City Men's Lounge Mural: Men without Women)* in progress, 1932, Estate of the Artist Archives

1933

January. Emotionally and physically exhausted from the pressure of completing the Radio City mural on time and still reeling from Bessie's unexpected death, Davis returns to New York and hospitalizes himself. After his release, he moves into a fourth-floor attic apartment at 236 West 14th Street next door to Franz Kline, whose later abstract expressionist work he will deem "important and stimulating."[132]

For the next six months, Davis's only income is the seventy dollars a month he earns teaching art five days a week to four of his former Art Students League pupils. "Hoping for a miracle to restore a degree of good humor," he goes to McSorley's, Romany Marie's, or the nearby speakeasy on Christopher Street after class most afternoons and stays until two or three in the morning, drinking heavily and getting up only in time for class the next day.[133]

February. With national unemployment close to 25 percent, Davis, like other artists, sees collective action as the only way to attain economic security. He joins the Communist-affiliated John Reed Club and helps found its subsidiary, the Unemployed Artists Group, to petition the federal government for relief work for artists. As he later says, "I had no family, no wife, no nothing. I just lived in a small room and so it was proper for me to go in it, and there wasn't

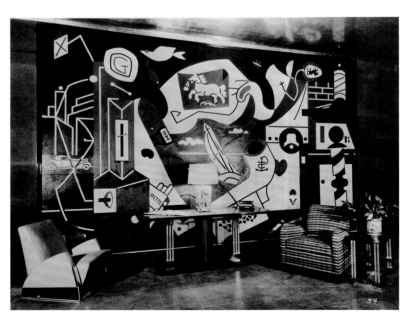

Mural (Radio City Men's Lounge Mural: Men without Women) in situ, 1932, Estate of the Artist Archives

anything else for me to do."[134] During the next six years Davis throws himself into political activism. He later describes this period as "meetings, articles, picket lines, internal squabbles. Everything was hectic. Lots of work done, but little painting."[135] To compensate, he sketches and writes extensively in his journals. By 1940, he will have filled sixteen sketchbooks with drawings and will have consolidated his theories about abstract art in the hope of publishing a book on the subject.

July. With the departure of his students for the summer and the loss of his income to pay rent, Davis makes plans to vacate his apartment, but not before throwing a party to which everyone brings liquor. The following day, he moves out with Gorky's help and then goes drinking with the expressionist painter Hans Burkhardt until three in the morning, when his father picks him up and drives him to Gloucester. Davis completes only small paintings this summer.

Late summer. Davis's father has a stroke, which paralyzes the right side of his body and affects his ability to talk. Ed and Helen's marriage has been strained for decades over his intimacy with other women and her incessant demands for affluence. She now flees to Florida with another man, leaving Mariam and Wyatt, currently unemployed, to care for Ed in the family's Chelsea Hotel apartment with their daughter, Joan, until they are all evicted for failure to pay rent. Wyatt moves Ed to the Charity Hospital for the Elderly on Welfare Island, where he remains for three years, unable to walk.[136] At the end of the year, the family is forced to give up its Gloucester house for failing to pay taxes. Davis later characterizes this period as a time when "everything went to hell."[137]

September. Desperate to return to New York, but lacking money, Davis beseeches Halpert for help.

I am stranded in Gloucester. Can you help me to overcome this unfortunate situation?... I have every respect for the fact that your gallery is doing very little business and that it is impossible for you to make any payments. However if you can develop some dough it is a matter of the first importance to me![138]

Halpert replies that she cannot send money because she needs to pay her gallery mortgage.

Fall. Samuel ("Sam") Kootz, author of *Modern American Painters* (1930), opens an industrial design business and invites Davis to design mirrors, shower curtains, and fabrics on a contingency basis. Over the next year, Davis makes

thirty-two designs for him, a task that consumes much of his time. Indeed, writing in November 1934, Davis tells the John Simon Guggenheim Memorial Foundation, in his application for a 1935 fellowship, that he has painted very little "[i]n the last year [because I] have had to devote my time to textile designing in an effort to make a living."[139]

December. The Roosevelt administration launches the federal Public Works of Art Project (PWAP) and names Force its regional director in New York. "[A]mazed that such a thing could exist" after hearing about it on the radio, Davis anxiously awaits Kootz's first check so that he can return to New York.[140] He finally arrives in the city on Christmas Day and makes "a bee-line for McSorley's Saloon."[141] Finding it closed, "which made me feel very bad," he goes to Romany Marie's, where he stays up until dawn talking with Romany.[142] That morning, he enrolls in the PWAP and moves into a twenty-five-dollar-a-week room above Romany's restaurant.

1934

January 7. The Unemployed Artists Group, a de facto trade union for artists, protests outside the Whitney Museum, demanding an increase in the number of artists employed on the PWAP and an end to Force's use of merit over need as a selection criterion. Over the next two months, the frequency of demonstrations grows to one per week. On March 27, after protesters breach security and forcibly enter the building, Force closes the museum, fearing that its collection is at risk.

February. Davis moves with Wyatt and his family into the top floor of a building near 14th Street and 8th Avenue. The apartment consists of two rooms in the front, a sky-lit room in the center, and two small rooms in the back that Stuart uses as a bedroom and studio. He drinks heavily and comes home late.

At that time I was still going to speakeasies... I went to wherever you could get it... I don't mean to emphasize it, but I used to come home late, stay out late, or I went to Romany Marie's... I used to sit around there until two, or three o'clock in the morning and come home, and then I'd realize that I had to make one of these paintings by a certain time. I know I had a phonograph, a hand wound phonograph, and I used to play records after I got home. They were asleep, the baby was asleep, but it wasn't too brutal. My brother used to come out, and one night I said, "I've got to get this drawing on that

canvas by tomorrow morning so I can get on with it." He projected the drawing through a camera in reverse, so that it was enlarged on the canvas I had. I drew it on the canvas, and got the thing started with his assistance.[143]

To better communicate their mission, the Unemployed Artists Group changes its name to the Artists Union.[144] Davis is one of the group's most active members, becoming its vice president in July 1935. As he later says, "I have a sense of organization and structure which is basically a quantitative capacity to catalogue your responses to life on a quantitative basis… so I am able to put some kinds of things in a workable order regardless of what kind of thing it is."[145]

Rivera's Rockefeller Center mural, *Man at the Crossroads*, has been covered for a year following attacks on it in the press as anti-Capitalist and the artist's refusal to remove its portrait of Lenin. On February 9, acting on orders from the center's developers, workmen destroy the mural. Davis joins the Artists' Committee of Action that is formed to protest its demolition and with the group's chairman, Hugo Gellert, organizes artists to picket on February 27 outside the *First Municipal Art Exhibition*, which is opening in the RCA Building where the mural was installed. As one of the artists in the exhibition, Davis is invited to the opening, but when he tries to enter the building, National Academy of Design president Jonas Lie demands that the police arrest him as the demonstration's ringleader. Police allow Davis to enter after he shows them his invitation to the opening, but they trail him for the remainder of the evening.

At the Jumble Shop one evening, Davis chances to meet Roselle Springer, who has recently lost her job as bookkeeper for the Guaranty Trust Company. A year prior, she separated from Reznikoff after he returned from a two-year teaching job at an art school in Cummington, Massachusetts, with one of his students, eighteen-year-old Genevieve Naylor. Davis soon becomes the focus of Roselle's life. As Romany Marie later explains, Roselle "bloomed" as "she and Stuart found in each other the sort of understanding and love he had known with his first wife."[146]

April. In an effort to demonstrate to Congress that the money allocated to the PWAP has been well spent, regional directors send the best art produced under the agency's auspices to an exhibition at the Corcoran Gallery of Art in Washington. On the eve of the show's opening, agency administrators deem the canvases of Davis, Gorky, Ben Shahn, and Burgoyne Diller too controversial and have them removed. Unconvinced by the art that remains on display, Congress fails to extend funding for the PWAP, which folds at the end of the month.

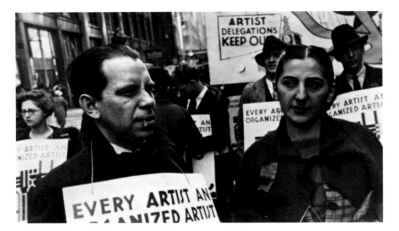

Stuart Davis and Roselle Springer at the May Day Parade, New York, 1934, photograph by Ben Shahn

The Downtown Gallery includes Davis's work in its spring show of watercolors and pastels; none of his art sells. The PWAP's demise three days after the opening and Halpert's increasingly erratic payments leave him without any steady source of income. As he later describes it, he "had [to] struggle at all times. Did not know when another sale might come thru—since sales were becoming lax."[147]

May. Having seen Davis's work at the Downtown Gallery, Hilla Rebay, a German baroness and art advisor to Solomon R. Guggenheim, asks the artist to leave a few of his watercolors at her suite at the Plaza Hotel, where she will decide whether to purchase any. When Davis returns a few days later, he finds she has "taken this water color of mine out of the frame and had it on a board, had drawn in certain circles, dots, lines, and so forth with the color written on them, and the maid said, 'She said that you were to fix it.'"[148] It was, Davis recalls, "the final insult. But I was in no position to object. I would have crawled in on my hands and knees, if necessary, because I needed the money, and that was the only place where I saw any possibility of getting any."[149]

August 1. Davis and Roselle move in together into a forty-dollar-a-month third-floor flat with high ceilings and arched windows in the rear of 43 7th Avenue. Despite having to contend with bedbugs, cockroaches, mice, and rats, all the while hauling coal to heat the room and ice to keep food cold, they remain there for the next twenty years.

October 27. Davis and others in the Artists' Committee of Action stage a march to agitate for a municipally sponsored, artist-operated gallery. "It wasn't a march about feeding the starving people, the hungry mobs. It was just about art," Davis later says.[150] Approximately three hundred people join the demonstration, including Gorky, who builds an enormous float topped with a gigantic cubist figure made

out of pressed wood that requires four men to carry. Davis describes the event:

When we went there that morning of the parade… there were cops all the way from 6th Avenue to 5th Avenue, all over the place, and fire engines out with hoses. There had been an order given that we couldn't march. There was a lot of telephoning—that we already had the permit, that it had been rejected or canceled. Anyhow, we finally got it… the parade was like one of those Italian fetes that you see where they carry huge religious things, forty or fifty people carry them down the street and bounce them up and down.[151]

As the artists march toward city hall, they are joined by Communists, a sight that so outrages Mayor Fiorello H. La Guardia he leaves the building through the back door in order to avoid hearing the protesters' demands.

November. The Artists Union and the Artists' Committee of Action, headquartered at 11 West 18th Street, launch the monthly magazine *Art Front* aimed at aligning the arts with left-wing political thought and action in order to advance the economic gains of artists and fight censorship in the face of "destructive and chauvinistic tendencies which are becoming more distinct daily."[152] Davis is on the editorial board, which consists of an equal number of members from both groups, many of whom are committed Communists. Davis does not join the party, but he reads extensively on political theory and fills many of his notebooks with Marxist analyses of the social role of art.

Davis applies for a Guggenheim Foundation Fellowship, citing his desire to work from the human figure in order to advance his mural career.

I have already had a great deal of experience in the subject matter of still life and landscape. In this field I have developed a style and technique which many people have felt and said was individual and important in contemporary modern painting. I need the opportunity to work from the human figure to be able to incorporate that material with my present equipment. This is important to me because I am aware of the increasing interest in American art and particularly in painting as a mural expression. To be able to function freely in this growing field the use of the figure as subject is essential. I feel capable of doing good work in this mural field and can reasonably expect commissions in the next few years. My mural in Radio City Music Hall, which had a still life subject matter, is a concrete example of achievement. As it is the first opportunity I do not consider it as other than a point of departure for future work.[153]

Davis hears in the spring that he did not receive the fellowship.

December. In an issue featuring Thomas Hart Benton's *Self-Portrait* on the cover, *Time* magazine lauds regionalism as an authentic American movement that is replacing "deliberately unintelligible" foreign-based art styles.[154]

1935

January. Davis becomes the unpaid editor in chief of *Art Front*. Under his leadership, the magazine expands from a house organ for the union into a leading art journal. During his yearlong tenure Davis designs one cover and authors six articles for the journal, including a condemnation of the removal of Ben Shahn and Lou Block's mural from Rikers Island, a positive review of Salvador Dalí's exhibition at Julien Levy's gallery, a call for a municipal art gallery in New York, and criticism of the Treasury Department's Section of Painting and Sculpture for its promotion of what he regards as aesthetically reactionary nationalist art.

Cover for *Art Front*, May 1, 1935

Mid-January. The Whitney Museum announces plans to mount a show of abstract painting and asks Davis to write the catalog's introductory essay. Discussing the exhibition one night at Romany Marie's, Graham, Gorky, de Kooning,

Reznikoff, Edgar Levy, and Smith decide to form a group whose members will only participate in the show if all are included. Davis is inducted into the group in absentia. When some but not all of the artists are invited to participate in the show and some accept, including Davis, the group disbands.

February. *Art Front* publishes Davis's denunciation of regionalism in response to *Time* magazine's cover article on the style.

This is the work of men who, to quote *Time*, "are destined to turn the tide of artistic taste in the United States." They offer us, says *Time*, "direct representation in place of introspective abstractions." Is the well-fed farmhand under the New Deal, as painted by Grant Wood, a direct representation or an introspective abstraction?

Are the gross caricatures of Negroes by Benton to be passed off as "direct representation"? The only thing they directly represent is a third-rate vaudeville character cliché with the humor omitted. Had they a little more wit, they would automatically take their place in the body of propaganda which is constantly being utilized to disfranchise the Negro politically, socially and economically. The same can be said of all people [Benton] paints including the portrait of himself which is reproduced on the cover of *Time*. We must at least give him credit for not making any exceptions in his general underestimation of the human race…

By John Steuart Curry we have a series of rural subjects, cheaply dramatic and executed without the slightest regard for the valuable, practical and technical contributions to painting which have been carried on in the last fifty years. How can a man who paints as though no laboratory work had ever been done in painting, who willfully or through ignorance ignores the discoveries of Monet, Seurat, Cezanne and Picasso and proceeds as though painting were a jolly lark for amateurs, to be exhibited in county fairs, how can a man with this mental attitude be considered an asset to the development of American painting?…

"Well-bred people are no fun to paint," says Reginald Marsh. A proletarian orientation might be suspected in this statement. An examination of his work, however, quickly dispels this illusion. We find merely that he means exactly what he says, namely that painting is fun, and that excursions to the Bowery and the burlesque show to make sketches constitute his artistic horizon—the psychology of the bourgeois art school taken seriously and carried through life as a handicap. His paintings are made of a lot of these sketches put together on a surface and submitted to a series of glazings and tonings to give them a superficial correspondence to an equally superficial concept of what a Renaissance painting is.

Can this be called "direct representation"? I think not. In his attitude toward his subject matter and in his attitude toward the technique of painting, Marsh reflects no objectivity. Would it be flattery to apply the term "introspective abstractionist" to him?[155]

Asked by *Art Front*'s editors whether he wants to answer the charges in Davis's article, Benton tells them that his position is too strong to warrant defending himself or to answer criticism that is primarily defensive. "In the case of an 'imitator of imitations' like Stuart Davis, the motives for a criticism of my work or of that of Curry, Marsh or Wood are plain. No verbiage can disguise the squawks of the defeated and impotent."[156] The next day, however, Benton reconsiders and invites the magazine's editors to submit ten questions to him to answer. His response, which *Art Front* prints in its next issue, ignites a series of vitriolic exchanges between Davis and Benton that play out in *Art Front* and *Art Digest* for many months, causing *New York Times* critic Jewell to predict that the public will eventually become fatigued by "this sometimes frenetic and sometimes heavy-footed bombardment," which leaves him with a "sense of sadness over so much wasted time and the generation of so much hindering animosity."[157]

February 12. *Abstract Painting in America* opens at the Whitney Museum with Davis's catalog essay affirming art's autonomy.

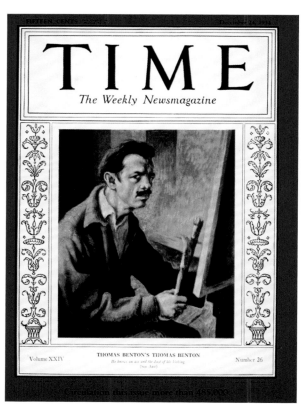

Thomas Hart Benton's 1925 *Self-Portrait*, as cover for *Time*, December 24, 1934

Art is not and never was a mirror reflection of nature. All efforts at imitation of nature are foredoomed to failure. Art is an understanding and interpretation of nature in various media... Our pictures will be expressions which are parallel to nature and parallel lines never meet. We will never try to copy the uncopiable but will seek to establish a material tangibility in our medium which will be a permanent record of an idea or emotion inspired by nature. This being so, we will never again ask the question of painting, "Is it a good likeness, does it look like the thing it is supposed to represent?" Instead we will ask the question, "Does this painting which is a defined two-dimensional surface convey to me a direct emotional or ideological stimulus?"... I believe that even in those cases where the artistic approach has been almost entirely emotional, the concept of the autonomous existence of the canvas as a reality which is parallel to nature has been recognized.[158]

February 23. In a demonstration of union solidarity, Davis and other Artists Union members join strikers protesting for higher wages outside Ohrbach's department store. He is arrested and jailed for the day along with 188 others. That evening, all of them are taken to court where the absence of chairs forces them to stand for five to six hours before being released.

April. In reviewing the Whitney Museum's *Abstract Painting in America* show, Clarence Weinstock, an *Art Front* editor and avowed Communist, accuses abstract art of ignoring "the claim of all meaningful experience," and of being "founded on a limited definition of painting," in which "form becomes like so much monopoly capital to which the society of art is sacrificed."[159] Davis defends the social relevance of abstract art in the magazine's next issue, arguing that all free and independent art is inherently critical of the status quo and therefore does not need to be explicitly political to have a social role.[160] He chides Weinstock for misunderstanding dialectical materialism.

Mr. Weinstock finds contradictions in abstract art in his comments on the Abstract Painting in America exhibition at the Whitney Museum. There is nothing surprising in this as Mr. Weinstock is supposedly an advocate of the general theory of dialectical materialism, in which nature and society are perceived to be in a constant state of revolutionary movement through the struggle of the contradictions or opposites present in all unities...

...In his desire to affirm the approaching revolutionary art of the international labor movement he is undialectical in his tendency to deny the reality of bourgeois origins and concomitants. For example, in the recent exhibitions of painting and sculpture at the Artists' Union, there were quite

a few exhibits well within the category of abstract art, and no one could say that they were among the worst of the exhibits. True, these abstractions were not in general the expression of that class consciousness which a more lengthy participation in any union activities tends to produce. But these, and all abstractions, were the result of a revolutionary struggle relative to the bourgeois academic traditions of the immediate past and even the present. In the materialism of abstract art, in general, is implicit a negation of many ideals dear to the bourgeois heart... If the historical process is forcing the artist to relinquish his individualistic isolation and come into the arena of life problems, it may be the abstract artist who is best equipped to give vital artistic expression to such problems—because he has already learned to abandon the ivory tower in his objective approach to his materials.[161]

Spring. As vice president of the Artists Union and an active member of the Artists' Committee of Action, Davis takes a leadership role in demanding that artists be paid a modest rental fee for exhibiting their art. To ensure the backing of the powerful American Society of Painters, Sculptors, and Gravers, he gets himself elected to its board. Over the next year, the rental policy becomes a source of conflict with Halpert.

May. Davis is appointed chairman of the John Reed Club committee selected to draw up plans for an Artists' Congress to fight against censorship and the suppression of civil liberties amid the ongoing economic crises around the world and rising political tensions in Europe. The group meets weekly for seven months, deciding early on to limit membership to established artists. Davis's prominence and his reputation for integrity are key to recruitment. By the time the congress is officially announced, 114 prominent artists have signed on.[162]

With income from his textile designs averaging only fifty dollars per month and Halpert unable to maintain even minimal payments to him, Davis's financial situation becomes precarious. "Stuart terribly worried—the financial state of affairs is down to 50¢ with no future expectancy for money," Roselle writes in their calendar.[163] Angry with Halpert for not fulfilling their contract, Davis demands an itemized sales report. The dealer responds testily that the gallery has advanced him $15,000 since 1930 for which it has only received $2,533 from sales of his art.[164] Unappeased, Davis warns her in September that he follows the rental policy of the American Society of Painters, Sculptors, and Gravers "to the letter" and insists that any picture of his that she has lent without the fee be recalled immediately.[165] That same month, Roselle's calendar notes, "Terrible strain and worry—no money—3 months in arrears with rent—Landlord makes visits."[166]

August. The Works Progress Administration (WPA), created in April by President Franklin D. Roosevelt to employ Americans on relief, expands to include the country's artists. Five divisions are established under what is called the Federal Art Project (FAP). Davis's close friend Cahill is named director of the visual arts section and appoints Davis to its National Advisory Board.

September. Davis and Roselle have been unable to marry because of complications with her divorce. The lawyer Davis hired to unravel the situation resigns, citing his work for the National Academy as a conflict of interest and telling Davis that Jonas Lie and others in the academy would object to his handling a suit for Davis. Throughout the next year, Davis tries unsuccessfully to obtain a marriage license in New York and New Jersey.

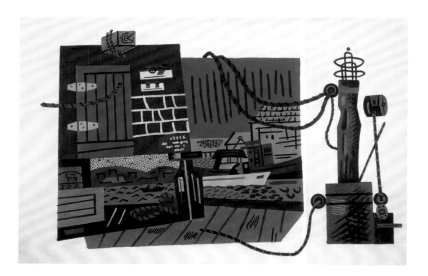

Waterfront, 1935, oil on Masonite, Fred Jones Jr. Museum of Art, The University of Oklahoma, WPA Collection, 1942

Davis is hired as an easel painter on the FAP for $26.54 a week. The requirement to sign in at nine in the morning forces an adjustment to his habit of staying out late and not getting up until the afternoon.

September 30. MoMA opens an exhibition of Léger's work, installed by Davis's friend, the American abstract painter George L. K. Morris, who briefly had studied with Léger in Paris and wrote an essay in the catalog. The show includes Léger's mural-sized painting *La Ville*, which will serve as an important precedent for Davis as he shifts from cubism to an allover compositional format.

October. Through Diller, senior project supervisor of the FAP's New York mural division, Wyatt is hired to photograph airplanes and hangars for Gorky to use in creating a gouache and photomontage mural for Brooklyn's Floyd

Bennett Airfield. In December, the mural is reassigned to the Newark Airport after Mayor La Guardia rejects the design. Years later, Davis recalls being on the jury that approved the final murals, which Gorky completed without Wyatt's involvement.

The jury was composed of politicians, professional people and artists. The murals were in a style commonly referred to as abstract and there was considerable reluctance on the part of the politicians to accept them. As a final suggestion toward making a decision an airplane pilot was called in for his opinion. He professed himself ignorant of art but said that if the meaning of reality of the forms was in question he could accept them because he had seen similar shapes and colors very often in his flying experience.[167]

October 4. Léger arrives in New York for his exhibition and delivers a speech, "The New Realism," that expresses ideas very similar to Davis's about the new aesthetic expression that modern life requires. Davis publishes Harold Rosenberg's translation of the speech in the December issue of *Art Front*.

For a half-century now, we have been living in an extremely rapid age, one rich in scientific, philosophical and social evolutions. This speed has, I think, rendered possible the precipitation and the realization of the new realism, which is quite different from the plastic conceptions that have gone before... It would require no great effort for the masses to be brought to feel and to understand the new realism, which has its origins in modern life itself, the continuing phenomena of life, under the influence of manufactured and geometrical objects, transposed to a realm where the imagination and the real meet and interlace.[168]

Mid-October. Léger asks the Artists Union for help in securing a mural commission for him on the FAP. Davis negotiates for months on Léger's behalf with project officials, arguing that hiring such an internationally recognized artist would immeasurably benefit American artists. The FAP initially rejects Léger's application because he is not a US citizen but finally agrees in December that he can be hired by a private company and use American artists on relief as assistants. Diller arranges with the French Line Shipping Company to sponsor Léger to design a mural for its pier. All goes well until Léger presents his design to the company's owner, who recognizes the artist as a Communist and cancels the commission.

November. *Art Front* publishes "Call for an American Artists' Congress," which Davis is instrumental in writing. The letter is signed by 107 artists.

This is a call to all artists, of recognized standing in their profession, who are aware of the critical conditions existing in world culture in general, and in the field of the Arts in particular. This Call is to those artists, who, conscious of the need of action, realize the necessity of collective discussion and planning, with the objective of the preservation and development of our cultural heritage. It is for those artists who realize that the cultural crisis is but a reflection of a world economic crisis and not an isolated phenomenon…

A picture of what fascism has done to living standards, to civil liberties, to workers' organizations, to science and art, the threat against the peace and security of the world, as shown in Italy and Germany, should arouse every sincere artist to action.

We artists must act. Individually we are powerless. Through collective action we can defend our interests. We must ally ourselves with all groups engaged in the common struggle against war and fascism.[169]

Davis follows up a month later in what will be his last article in *Art Front*.

The objectives of the Congress are to point to the threat of the destruction of culture by fascism and war; to point out specific manifestations of this threat in this country… But the objectives of the Congress are not only defensive. A prominent part in the discussion will be given to an analysis of contemporary art directions; to the historical role of the artist in society; to the relation of subject and form in art to environment… But the work of the Congress does not stop here. It is planned to form at the Congress a permanent organization of American artists on a national scale, which, unlike existing artists' societies, will seek to keep itself in live contact with world events that affect the artists, instead of forming an economic and esthetic clique.[170]

December. Tensions between Davis and Halpert escalate further over her refusal to support the society's rental policy and her silence about whether he will have a show in the gallery in the upcoming season, which he raises in a letter to her:

It has been your habit for some years to write to me as an exhibitor, before the opening of the gallery in the Fall, and ask for new work as well as to indicate the character of the opening exhibitions and the prospects for the coming season etc. This year however no such communication was sent to me and I naturally felt that some change of attitude on your part, with relation to my work, had taken place.[171]

1936

January. Davis resigns from *Art Front*, along with Glintenkamp and Gellert, to focus on organizing the first national convention of the American Artists' Congress.

February. Artist Jacob Kainen pens a brief character sketch of Davis in an article for the *Sunday Worker* on the upcoming session of the American Artists' Congress.

Looking up from a mass of documents, Davis said, "Sit down. I'll be with you in a minute." The Voice was hard-boiled and realistic, devoid of the soft manner of the professional esthete: a voice that disdained circumlocution and cut straight to the point at issue. Everything about him bore out the impression of a man who made no compromise with his convictions; the deep chest, cocky like a pouter-pigeon's; the blue eyes that looked at you appraisingly; the mobile mouth that twisted an emphatic word.[172]

February 14–16. The American Artists' Congress opens its first session at Town Hall. The event is sold out, with five hundred people turned away. Davis has been so busy organizing the sessions and arranging last-minute details that he does not have time to write his speech, which is scheduled to follow Lewis Mumford's opening address. Shortly before Davis's remarks are scheduled to be presented, Jerome Klein, art critic of the *Telegram*, races to Davis's apartment and writes them while Davis gets dressed. Even with such limited time, the speech takes six drafts to complete. With the final version finished at 7:45 p.m., Davis jumps into a taxi and arrives at Town Hall in time to deliver "Why an American Artists Congress?"

The American Artists' Congress is unique in the history of American art. That it takes place now is no accident. For it is the response of artists to a situation facing them today. How can we describe this situation?

Stuart Davis's American Artists' Congress membership card, 1936–1937, Estate of the Artist Archives

American Artists' Congress, 1936, Estate of the Artist Archives

Its immediate background is a depression unparalleled in the history of this country. The cracks and strains in the general social fabric resulting from the economic crisis inevitably reached the world of art, shaking those psychological and esthetic certainties which had once given force and direction to the work of artists…

There is a real danger of Fascism in America.

How Fascism is plunging headlong toward a devastating new World War is evident to every reader of the daily press. Fascists have no other solution for the crying needs of their people than an outburst of war.

To carry out their program of death and destruction they would enlist the services of even the artists…

It is because artists do not want their creative talents perverted and used to mask a barbaric war that they have signed the Call for an American Artists' Congress and come together here to show their solidarity. And this struggle against war cannot be divorced from the struggle against every manifestation of war-mongering reaction…

But we have faith in our potential effectiveness precisely because our direction naturally parallels that of the great body of productive workers in American industrial, agriculture and professional life.

The Congress will enable us to focus our objectives.

To realize them, we plan to form a permanent organization on a national scale.[173]

Opening night of the American Artists' Congress is followed by two days of closed sessions at the New School for Social Research. Twenty-one artists and intellectuals speak to 360 delegates from across the country. Davis calls the sessions the "most important event in American art since the Armory Show in 1913."[174] Max Weber is elected president; Davis is elected national executive secretary. For the next four years, he spends much of his time engaged in congress business. At its peak in 1939, the organization has almost nine hundred members and plays a major role in the cultural life of the nation.

March. Davis threatens Halpert with a lawsuit unless she pays him the money he says she owes him. Informing him that she has not been well and that her doctor has forbidden her from becoming involved in upsetting discussions, she sends Davis $450 and formally severs their relationship.

March 3. MoMA opens *Cubism and Abstract Art*, Alfred Barr's didactic chronicle of the development of abstract art from 1875 to 1935. Barr's declaration that "abstract art today needs no defense" vindicates the arguments Davis has been making for years on behalf of abstraction, but the director's prediction that "[t]he formal tradition of Gauguin, Fauvism and Expressionism will probably dominate for some time to come the tradition of Cézanne and Cubism" is at odds with Davis's long held belief that "A work of art… should be first of all impersonal in execution, that is to say it should not be a seismographic chart of the nervous system at the time of execution."[175] Although Davis makes no mention of his reaction to the show, he most likely saw it given its inclusion of the European masters he has long revered and the involvement of Cahill's future wife, Dorothy Miller, Barr's assistant since 1934, in organizing it.

Under pressure from congressional conservatives, the Roosevelt administration announces its intention to reduce the FAP's budget by 20 percent. Davis takes the lead in fighting the cuts, using his position as national executive secretary of the American Artists' Congress to write articles, give speeches, picket newspapers that support the cuts, and meet with critics who have written against the project. Despite such activism, the government lays off more than three thousand artists, musicians, and theater people in December.

June 30. Ed is transferred from Manhattan's Charity Hospital, which is overcrowded, to Pilgrim State Hospital in Brentwood, Long Island, thirty-nine miles outside New York City. Feeling guilty for having deserted him, Helen writes to him weekly, but receives no reply. His condition improves; by the end of July, he is able to walk around the ward, albeit with difficulty.

September 20. Jewell writes a negative review for the *New York Times* of an exhibition of FAP art at MoMA. Cahill asks Davis to write a rebuttal on behalf of the American Artists' Congress, which he does in exchange for Cahill's helping secure a job for Helen on the project in California, where she has recently moved.[176] Thanks to Cahill's intervention, Helen works for a few months in the fall for the project until authorities discover she is not an official California resident. She survives on money from her brother and Hazel until Davis is able to get her reinstated on the FAP, sculpting figures for dioramas in San Francisco's National Parks Museum.

September 23. Ed dies at Pilgrim State Hospital from peritonitis caused by a perforated stomach ulcer. Stuart uses the money from Ed's life insurance policy for burial expenses, including shipping the body to Petersburg, Virginia, his father's birthplace. Raising the amount not covered—$22.50—is difficult, even with Wyatt contributing. Helen's funds are so depleted she cannot afford even to telegraph or phone Wyatt about Ed's death.

Fall. Diller convinces the New York Housing Authority to commission twelve abstract artists, Davis included, to decorate the basement meeting rooms of the low-income housing complex in Williamsburg, Brooklyn, designed by William Lescaze. Davis finishes his first sketch for the Williamsburg mural by the following spring. In June, the sketch is approved. For the next eleven months, he works with two assistants to refine the design and transfer it to canvas in the FAP studio on 42nd Street.

November. Davis applies for a 1937 Guggenheim Foundation Fellowship to "make an objective study of the outstanding trends in contemporary painting in America."[177] He describes his proposed study as "<u>an integral part of my creative work as a painter</u>" in a letter to Rockwell Kent, who is on the fellowship jury:

I feel that I am competent, and, in fact, have special qualifications for carrying out this plan. I have a wide personal acquaintance with artists and critics of all schools, and besides am myself an artist with a first hand knowledge of modern art technology… I propose to go at it as a painter who wishes to clarify and develop his own understanding of the most fruitful sources on which to base his art practice with relation to contemporary life… I know that if I got the chance I could get up a pamphlet or book which would have real objective value and a realistic social viewpoint.[178]

He does not receive the fellowship.

1937

January. Davis begins taking medication for high blood pressure. For the next several years, he meets regularly with his doctor to monitor its effectiveness.

April. In early 1936, Davis sold two paintings to Kootz for the bargain price of $400, to be paid in monthly installments. With the last payment now overdue, Davis contacts Kootz, who promises to send a check within the next few days. When it does not arrive, Davis writes to his friend, who has his secretary send a letter explaining that he was unable to pay because he was called out of town. Davis responds in anger.

I have learned to be quite broad minded since my contact with hundreds of artists in the last couple of years. But the extent of this broadmindedness has certain definite limitations.

For example, it is not sufficiently broad to include in the category of ordinary polite and ethical intercourse, the letter which was sent to be signed by your secretary on April 6th.

This letter states that because you were called out of town you were unable to send me the $50.00 which you had promised to send me by April 5th or 6th. Now, really Kootz, isn't this being just a bit crude a tactic to be used between friends? I think so, especially since you had told me on April 2nd that you were going away this week. I'll admit that I am stupid in many ways but I think you do me an injustice in underestimating my intelligence as you do in the letter referred to above.[179]

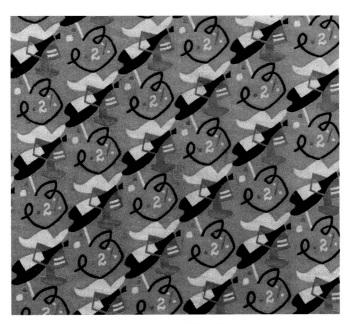

Fabric: Liquor and Prohibition Motif, c. 1938, silk, linens, cotton jersey, Brooklyn Museum, Gift of Mrs. Stuart Davis, 76.25.2d

July. Kootz sells his industrial design business, using income from the sale to settle his account with Davis and open the Samuel Kootz Textile Company. Over the next year and a half, Kootz produces a number of fabrics designed by Davis, some of which are based on his designs from 1934.

December. Davis is elected president of the American Artists' Congress at the group's second convention.

Always a heavy drinker, Davis increases his consumption of alcohol. He sometimes becomes so intoxicated that he falls in the street and needs to be carried to his apartment. One evening, he almost drowns in Cahill's bathtub; on another, he requires overnight hospitalization. His belligerency when intoxicated antagonizes even Roselle, who moves away for a few days in April. But despite frequent notations in the calendar about Davis's drinking, she remains intensely devoted to him.

February. Klein, who had worked with Davis to organize the first session of the American Artists' Congress, is now the *New York Post*'s art critic. In reviewing the congress's first annual exhibition, he dismisses abstract art as socially irresponsible. Davis counters with an argument he has developed in his journals and repeats many times in the years to come, that abstract art is a progressive social force because it gives coherence to modern life's "new materials, new spaces, new speeds, new time relations, new lights, new colors."[180]

Stuart and Roselle Davis, c. 1938, Estate of the Artist Archives

February 25. Naylor and Reznikoff have been living together in New York since 1933, keeping their relationship a secret from her family. On the eve of her twenty-third birthday, Reznikoff finalizes his divorce from Roselle, who hears the news only days before Davis is scheduled to testify in Washington in favor a permanent federal arts bill. Rather than wait, the couple decide to wed en route. Armed with Spanish brandy, they take the Friday morning train to Elkton, Maryland, with Elliot Paul and get married in the preacher's yard with Paul as witness. The three stop in Baltimore for lunch before continuing to Washington, where they celebrate until three in the morning. Paul returns to New York the next day. On Monday morning, Davis reads his prepared statement to the Senate Budget Committee, chaired by Florida senator Claude Pepper.

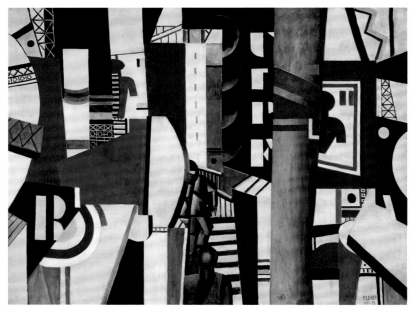

Fernand Léger, *La Ville*, 1919, oil on canvas, Philadelphia Museum of Art, A. E. Gallatin Collection, 1952

March. The last of the three show trials of intellectuals and former leaders of the Bolshevik Revolution takes place in Moscow. Although the trials challenge the view of the Soviet government as democratic, many on the Left are reluctant to criticize a country that is opposing fascism so vigorously. To preempt a potentially contentious debate on the issue by the American Artists' Congress, Davis and photographer Paul Strand circulate a letter sanctioning the trials that is signed by nearly 150 artists and writers, including Dashiell Hammett, Lillian Hellman, and Langston Hughes; it appears in the *New Masses* on May 3.[181]

Spring. Planning begins for the 1939 New York World's Fair. Deskey is put in charge of designing the interior of the Hall of Communications and begins discussions with Davis about creating a mural for it. Under pressure from myriad New York artists' societies, including the American Artists' Congress, fair organizers agree to hold an artist-selected exhibition of contemporary art entitled *American Art Today*. Cahill takes a leave of absence from the FAP to direct the exhibition and appoints Davis to the nine-artist jury. Over the next year, using a quota system based on the relative artistic populations in each region, Davis and his fellow jurors select two hundred works from more than twenty-five thousand entries submitted by eighty artists' juries from around the country. Davis writes pre-opening articles about the exhibition and joins Jonas Lie and Eugene Speicher in authoring the catalog text on painting. Once the show opens, he vigorously defends it in the press.

May. Davis races to complete his Williamsburg housing mural in time for a show of FAP murals at the Federal Art Gallery, New York. Titled *Swing Landscape* (pl. 40), the

mural's nonhierarchical, allover composition and densely packed, brightly colored shapes, all of equal intensity, announce a new vocabulary whose visually dynamic tempo echoes the syncopation and polyrhythms of big-band jazz. Davis's insistence that the mural "leave a single impression" involves his rejection of cubism, which he deems to be "impressionistic, eclectic and scattered," saying that it "divides the attention [i]nstead of concentrating it."[182] His likely model for this new style is Léger's *La Ville*, which he saw in the artist's 1935 MoMA retrospective and which now is on permanent view in A. E. Gallatin's Museum of Living Art, located in the South Study Hall of New York University. Graham sees Davis's mural before it is shipped and calls it "the greatest American painting."[183] But at the show's close, the mural is deemed inappropriate for the housing complex's social room and is put in storage.

June. Through Diller, Davis receives another FAP commission: to design a mural for Studio B of WNYC, New York's public radio station. He finishes the sketch in August and begins tracing it onto canvas in November in project studios on the top floor of a building with no elevator.

It used to kill me. When I got up there, I couldn't breathe. It's a killer of a walk up there. The first floor steps are two stories high. It's a killer: You've got to be a U.S. Marine to use these premises, and still all kinds of thin, decrepit people go up there every day… I could have dropped dead as well as not… I was glad to be out of breath because I could have had no breath at all.[184]

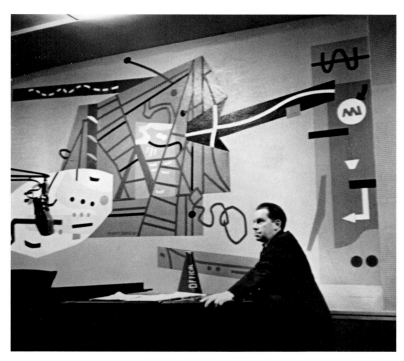

Stuart Davis in front of *Mural for Studio B, WNYC*, 1939, Estate of the Artist Archives

Davis shares the studio with Philip Guston, who observes the older artist at work.

He would mount his scaffold, lavishly spread paint on large areas with a palette knife, step down, and look at the results for a while in his suspenders smoking his cigar. Then he would mount his ladder again and scrape the whole thing off onto the floor. I remember how impressed I was by his lavish use of paint, and by his willingness to change in the process while I, in my bay, still under the spell of the Renaissance, was laboriously working on my big cartoon.[185]

Davis completes his mural (pl. 41) on March 5, 1939.

September. Leaders of France, Britain, Italy, and Germany sign the Munich Agreement, permitting Nazi Germany's occupation of Czechoslovakia's Sudetenland. Davis notes in his calendar, "Chamberlain sold out world Democracy to Fascism."[186] On March 15, 1939, Germany annexes the entire country.

December. *Harper's Bazaar* commissions Davis to make a gouache of what he imagines the World's Fair will look like. The picture appears in color on a double page in the magazine's February 1939 issue, three months before the fair opens.[187]

1939

Davis begins the practice of using the proportions of some of his earlier works as the basis for new paintings. "You have to have a subject. Why wander around?" he later tells Rudi Blesh.[188] The idea becomes central to his methodology: "I often compose paintings from old sketches, and develop them in terms of my current ideas and interest without any thought of recalling the mood in which the sketch was originally made."[189] And again: "I can work from Nature, from old studies and paintings of my own, from photographs, and from other works of art. In each case the process consists of a transposition of the spirit of the forms of the subject into a coherent, objective color-space continuum, which evokes a direct sensate response to structure."[190] He likens his recycling of older compositions to jazz improvisations, explaining that "it's the same thing as when a musician takes a sequence of notes and makes many variations on them."[191]

January. Davis finishes the preliminary design for his World's Fair mural, titling it *History of Communication*.

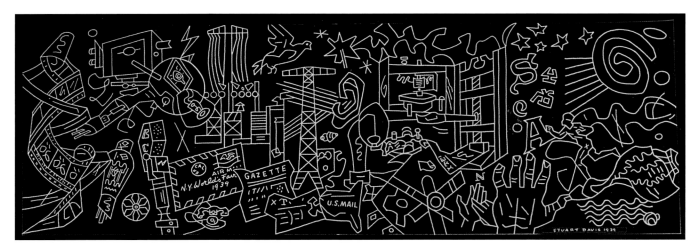

History of Communication Mural for the Hall of Communications, New York World's Fair 1939, 1939, commercial paint on wall, destroyed, photograph from Estate of the Artist Archives

Deskey approves the design in March, and Davis makes a black line drawing to be enlarged into a full-size cartoon for members of the mural guild to transfer to the building's 140-foot interior wall. He intends the mural to be executed in fluorescent paint to produce a glowing effect in the semi-darkened hall, but budgetary restrictions necessitate the use of white paint on a black background.

Spring. Davis is hired by the FAP's graphic arts division, whose rules allow him to set his own hours and keep an impression of each print. Over the next four months he makes three color lithographs. By August, however, the total amount of time he has been employed by the project hits eighteen months, the maximum allowed, and he is terminated. He applies for reinstatement on the basis of hardship: "I need employment on the Fed Art project because I have no other resources."[192] When his application is rejected, he reconciles himself to becoming his own dealer.

August. Solomon R. Guggenheim's Museum of Non-Objective Art opens in New York. Two years earlier, when Guggenheim announced his intention to establish the museum with Hilla Rebay as curator, her comments that nonobjective art was spiritual and without connection to reality had inflamed a number of abstract artists, seven of whom protested in a letter *Art Front* published in October 1937.[193] With the museum now a reality and poised to become a significant cultural force, refuting Rebay's claims assumes greater urgency. Her contention that art "is like music; without meaning... [it is] not for the masses, but for the elite of humanity" elicits a string of letters to the *New York Times* over the summer.[194] Davis takes the lead in asserting the realism of abstract art: "I have been trying to point out for years that abstract art is a realistic art, referring to objective natural relations, and I still insist on that

point... the artists today... don't want an art that means nothing and that is not for the masses."[195] He follows up with several more letters to the *Times*.

Abstract art is a truly democratic art... Abstract art expresses the consciousness of new speeds, lights, colors and spaces of our time... To regard abstract art as a mysterious and irrational bypath on the road of true art is like regarding electricity as a passing fad... The Baroness [Rebay] asks us to believe in an expression in art which is "absolute" but not "relative," and since this would involve extinction of the entire universe and leave only the painting we are forced to say that the Baroness has had a real thought but that it was an idle one.[196]

In October, *Art Digest* publishes Davis's summary of the debate, which closes with his condemnation of "subjective" art:

The "subjective" view degrades the very real achievements of man to the level of spiritualistic seance, and it is especially dangerous in this critical hour when the whole cultural level of civilization is threated with destruction. Subjectivism and absolutism is being used today by governments, as well as individuals in art, as a weapon for their aggrandizement.[197]

August 23. Germany and Russia sign a nonaggression pact. Despite Davis's disenchantment with this open alliance between fascist Germany and the Soviet Union, he defuses the issue within the American Artists' Congress by arguing that the organization should concern itself exclusively with cultural affairs. On September 1, Germany invades Poland. Britain and France declare war on Germany two days later, officially beginning World War II.

Fall. Davis and Roselle have occupied the rear half of the third floor of 43 7th Avenue since 1934. In September, the tenant in the front half moves out. Hoping to raise enough money to rent the space and give art classes, Davis appeals to Force and Phillips to buy one of his recent works. Force replies four weeks later, voicing sympathy for his situation but explaining that the Whitney has "no budget at the moment for any purchase whatsoever."[198] Phillips, however, immediately sends $400 for two pictures, which Davis parlays into eight months of free rent. That December, Davis thanks Phillips for financing his rental of the studio, adding that "It is the first time I have been able to work outside my bedroom for 6 years."[199]

November. Davis applies for a 1940 Guggenheim Foundation Fellowship "to continue my creative painting in the so-called 'abstract' style," the ideology of which he explains in his submission.

I conceive the function of art to be the recording in artistic form of the human and natural environment of the artists [*sic*] time. But this environment is not merely a single point in Time, nor a single place in political, social, or geological history…

 To accept that art must be an expression of the life of the times, of the artist, in order to have real social content and use, does not mean that the environment of the artist consists of his immediate surroundings alone…

 The artist who wants to paint an environment which surmounts the immediate environment is contemporaneously called an "abstract" artist…

 [T]he theory used by the abstract artist, who wants to tell the story of his environment is based on recognition of movement, as part of the reality of his subject matter. The abstract artist includes in his specifications for work the accepted condition that the objects, and the light, and the artist, are in a state of relative motion, and that his record of the event he paints is a record of an event in time.[200]

Again, he is rejected.

January. With most of Davis's art belonging to the government or to Halpert, he has very little to sell. To remedy that, he arranges with the dealer to consign nineteen oils and one watercolor to him that he then offers for sale to more than fifteen collectors and thirty museum directors during the next nine months. He sells *Summer Landscape* (pl. 26) to MoMA—his first painting to enter its collection—but otherwise he encounters the same challenges Halpert faced. With the Depression still ongoing, museums have no funds; if they do, they are disinclined to buy abstract art. Davis's exchanges with the Metropolitan Museum are particularly frustrating because the museum has a fund, named after the donor George A. Hearn, dedicated exclusively to purchasing art by living American artists. Davis submitted work to the museum the year before and was rebuffed. Now, after seeing the museum's display of recent acquisitions of contemporary art, which he found "innocent of any suggestion that the great discoveries of modern art had occurred," he writes to incoming director Francis Taylor, suggesting that the museum's apparent bias against abstract art could be remedied by purchasing his work.[201] Taylor answers that all great art is inherently abstract, and therefore the museum owns a great many examples of it, adding that possibly Davis's pictures were rejected because "they failed to meet the standards of the Museum," not because they were abstract.[202] A few days later, the museum's curator Harry Wehle acknowledges the futility of Davis's efforts.

If I thought there were any likelihood of your abstract paintings being bought by the Museum's Hearn Fund purchasing committee, I would ask you again to submit some of them. As the committee is now constituted nothing would be gained.[203]

Tenacious, Davis takes his complaint about the museum's discrimination against abstract styles to *New York Times* critic Jewell, quoting Wehle's letter as evidence of the museum's boycott of modern art. Jewell responds that the paper could print a more general statement about the museum's policies if Davis were to write one, but a letter based solely on the museum's decision not to purchase Davis's art is not one they can use. Davis obliges with a letter, which the *Times* prints in July, citing the museum's administration of the Hearn Fund as an example of the discrimination and censorship against abstract art existing at many of the nation's museums that he claims threaten free expression.[204]

February 7. Davis attributes the apathy toward abstract art on the part of cultural institutions to the "mountain of

'Americanism' in art propaganda."[205] He addresses the issue at MoMA's symposium "Is American Art Menaced by Alien Trends?," answering the titular question by suggesting that American art is menaced as much by critics, museums, art dealers, and reactionary artists as by war and Hitler. These menaces, Davis argues, can only be met by artists understanding that the social function of art involves assimilating the environment. He nominates abstract art as the most profoundly American expression because it renders harmonious the modern technological advances with which the nation is identified. "The revolutionary direction of modern art… toward order and unity," Davis says, is "living proof that the human spirit is still capable in the midst of the most horrible disorder of visualizing order and harmony."[206] Armed with this knowledge, artists "will be able to tell who their real enemies are. The[y] will know that the kind of social thinking which is chauvinistic and anti Semitic is associated with an outlook on reality which is out of date—untrue. And that the art forms of that outlook will be untrue and out of date and hence retrogressive."[207]

February 15. In an NBC radio broadcast from Town Hall on the question "is there a revolution in the arts," Davis elaborates on the idea that abstract art records the new experiences of time and space created by science and technology.

An artist who has traveled on a steam train, driven an automobile, or flown in an airplane doesn't feel the same way about form and space as one who has not. An artist who has used telegraph, telephone, and radio doesn't feel the same way about time and space as one who has not. And an artist who lives in a world of the motion picture, electricity, and synthetic chemistry doesn't feel the same way about light and color as one who has not. An artist who has lived in a democratic society has a different view of what a human being really is than one who has not…

Yes, there is a revolution in the arts, there always was a revolution in the arts, and I think it is a darn good thing.

Cubism is one of the forms of art which have reflected the artists' sensitivity to the environment that we live in. It shows the possibility of having a number of experiences in a very short space of time; of being in many parts of the city, in many parts of the country; of hearing sounds on records which have been made a long time before, and so forth. It simply reflects the possibility that the… experiences one has had five minutes ago, or ten years ago, or that will be in the process of being at the moment, are capable of coordinated expression; that they can be ordered…

The abstract art is a reassertion of feeling… that real order is the expression which art communicates… Abstract art affirms an art of real order.[208]

March. Davis and Roselle's funds become so low that Roselle resorts to leaving a note in the mailbox of their friend H. Bennett Buck asking him to "come and buy a picture as we are in need of fund[s]."[209] Similar entreaties to other friends yield a few sales of small-sized works, mostly at reduced prices, and an introduction to John Hammond, the record entrepreneur, to whom Davis sells a $500 painting for $100. But the infrequency of even these small sales leaves Davis on the precipice of insolvency for the next three years.

Davis has been augmenting his published articles on the meaning and form of art by writing extensively on the subject in his journal. With the aim of expanding these texts into a book on contemporary art, he contacts publishers—the Association of American Artists, the Carnegie Corporation, and Simon and Schuster—but to no avail. On March 22, he writes to Force proposing that the Whitney publish his proposed book, *Abstract Art in America Today*. She, too, turns him down:

I am more than sorry to have to tell you that the income of the Museum's endowment does not admit of purchases, nor anything outside the Museum's maintenance. Personally, I am also in a similar situation, so that I cannot do anything about your proposition… I am sorry for this, but facts these days are pretty desperate things.[210]

Spring. Pressure on the executive committee of the American Artists' Congress to issue a policy statement on the Soviet Union's invasion of Finland some four months earlier and on the Hoover committee's request for Finnish relief reaches a crescendo. At the group's April 4 meeting, it votes overwhelmingly to approve the invasion. To Davis, the vote signals that the congress has been overtaken by Stalinist sympathizers, and he resigns the next day.[211] More than thirty members follow suit within the next two weeks. By June, the dissenters have formed a counterorganization, the Federation of Modern Painters and Sculptors, which Davis does not join. Five years later, Ad Reinhardt laments that Davis's "present political inactivity and his lack of relation to the artists' group is regrettable for an artist of his integrity and stature."[212] But in reality, Davis simply replaces political with aesthetic activism, undertaking, as he later puts it, "a side-line of public controversy in the press and magazines whenever some misguided individual came out with ideas tending to confuse the topic of Modern Art."[213] Between 1940 and 1950, he writes more than twenty essays on modern art, some published, some not, each taking weeks to craft, and fills thousands of notebook pages with mathematical equations, drawings, and theoretical writings that analyze the social meaning and formal properties of modern art.

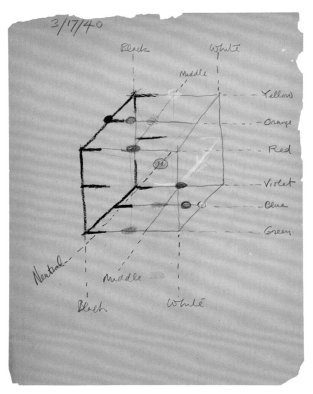

Color-Field-Space-Cube Diagram, from journal, March 17, 1940, graphite, colored crayon on tan wove paper, Harvard Art Museum/ Fogg Museum, Gift of Mrs. Stuart Davis, 1967.79.3

Summer. Davis's health deteriorates, exacerbated by drinking and financial stress. He has "jitters" on walks and declines dinner invitations because he lacks the strength to go.[214] Roselle's notations in her calendar describe him as "still nervous and low in energy" or "upset because of distressing circumstances we are in."[215] Friends lend him small amounts of money and Elliot Paul commissions him to design linoleum tiles for his kitchen and bathroom floors. But the handouts are insufficient, and Davis's calendar entry "worried all day and night about lack of money and fear that we will be liquidated" is typical.[216]

September 30. Davis begins teaching an evening class on modern composition at the New School for Social Research. The salary is meager but steady. His hope of earning a few extra dollars by teaching the same class privately in his studio yields only one student. Davis's instruction consists of having his class monitor, Jim Benton, set up a two-to-three-foot-high pile of objects covered with a fishnet and telling the class to paint the objects in it that they find most interesting. After walking around the room at the beginning of class and making laconic suggestions to students about how to improve their paintings, Davis leaves for two hours to get coffee. As he later describes it: "I go to an art class every Monday at the New School and watch some 30 odd strangers make drawings and paintings. At stated intervals I accost one of them and give exact instructions how to

improve and complete their work at once. They do it, and everybody is satisfied."[217] Davis continues teaching at the New School through 1951.

October. Davis writes Force again about buying a painting: "I would like to be able to tell people that the Whitney Museum was still interested enough in my work to have made a current purchase."[218] In frustration, Force asks him, "What would you do if you had no money?"[219] The answer is easy, he tells her.

I write to people with money asking them to buy my work so that I may be paid for some part of my hours of work. The really hard question comes after the one which you stated in your letter. This question goes, "What would you do if all the people you asked to buy your work said "No!"[220]

After a personal appeal from Roselle, Force volunteers to try to help Davis sell his work. Davis sends her six pictures, none of which she is able to interest anyone in buying. He earns a small fee by endorsing Grumbacher artists' materials and Schmincke oil paint in an advertisement that appears in *Parnassus*, but his goal of selling fabric designs to the industrial designer Russel Wright fails.[221] As Roselle records in her calendar: "Stuart in a very upset state — Distressed by failures of plans to materialize. Distressed because of lack of patronage. No funds — Rent in arrears."[222]

November. Roselle visits Henry Moe, head of the Guggenheim Foundation, to petition for funding for Davis's book on modern art. Davis follows up her visit with a letter saying that she acted without his knowledge but he does not condemn it "because it was impelled by my present deplorable economic situation."[223] He explains that he has "stopped making formal application for a Fellowship having become convinced of its futility because of a bias against abstract art in the policy of the juries of award," but that he hopes aid might be possible for him to write "a philosophical analysis and professional demonstration of how to make an abstract picture and its meaning in the American environment."[224] Moe responds in March that the foundation has no budget for funding books.

1941

February 3. Still drinking heavily, Davis falls and breaks his anklebone in three places, requiring hospitalization and a cast. A week later, the cast slips and cuts off circulation in his leg, causing a high fever. His condition does not improve and six days later, Graham and fellow abstract painter Carl

Stuart Davis, New York, 1941, Estate of the Artist Archives

Holty take him back to the hospital, where a second cast is applied from his foot to midthigh, making walking exceedingly difficult. Even when the top part of the cast is removed a month later, he is unable to walk without pain or to sit for more than a few hours at a time. Highly agitated that "the ultimate status of the thing is undetermined," Davis engages a specialist, who replaces the second cast with a lighter version that allows him to move about on crutches in his studio.[225] But with his mobility limited all summer, he has difficulty concentrating on painting. As Davis tells Hazel, "The very nature of art affirms freedom from pain of any kind. It is redundant then, to say that when pain comes in the door art flies out the window. This recent blow is the most cruel one I have ever rec[eive]d."[226] His only source of distraction is the steady stream of friends who stop by, often with alcohol, including Kootz; Romany Marie; the painters Kuniyoshi, his ex-wife Katherine Schubert (formerly Schmidt), Spencer, Holty, Gaulois, Graham, Matulka, Julian Levi, and Walter Quirt; the critic Ralph Pearson; the composer Edgard Varèse; and Cahill and Miller, his wife since the late 1930s.

April 14. Davis's hospital bill has been subsidized by Force, who purchased *House and Street* (pl. 30) for $500, and Graham has substituted for his class at the New School, but the loss of income from teaching leaves Davis without any regular source of funds. Swallowing his distaste over his earlier encounter with Rebay, Davis submits four paintings to her along with a letter expressing his hope that she will purchase one for the Guggenheim Museum. She replies that his work is "objective" and therefore not eligible for inclusion in the museum's collection of nonobjective art, but that it "might be possible" for her to give him fifteen dollars a month for paint materials.[227] When her check arrives, he sends it back.

May. Davis has long held that jazz is a genuine American expression akin to modern art. To proselytize the idea, he and Quirt propose staging a "Festival of Creative Swing Music and Modern Painting" to demonstrate "the relationship between the two art forms, and to show how both are authentic art expressions of our contemporary society."[228] They submit the plan to the Associated American Artists Galleries, which declines it on the basis of cost.

May 22. Davis meets Piet Mondrian at the home of Charmion von Wiegand, an abstract painter and critic who became friends with Mondrian after interviewing him earlier in the spring. Davis sees the Dutch artist only two more times: on July 5, 1942, when Harry Holtzman, an abstract painter and later executor of Mondrian's estate, takes the two of them to hear jazz at the Paramount Theater and Billy's Nightclub in Harlem, and on February 2, 1943, when Mondrian attends the opening of Davis's exhibition at the Downtown Gallery that follows his reconciliation with Halpert in 1941. Davis admires Mondrian but rejects his theory of absolute forms, asserting that "[t]he real order of art is not an ideal order, or system of beauty, because an ideal order would be timeless, and art exists in time."[229]

Late Spring. Conceding his failure to sell his work, Davis reaches out to galleries about taking him on. This effort, too, is futile. "The dealers were simply filled up and were preoccupied with the artists they already had. Places which would take my work did not seem to be in a position to do it justice."[230]

June. Davis applies for a teaching job at the Art Students League for the next season. The league declines his application, explaining that they "anticipate difficult times next year." [231]

July. The Albright Art Gallery has been deliberating for three months about purchasing one of Davis's paintings. On July 11, the museum's trustees vote to postpone the purchase. "No sale—terrible—terrible—leaves us with $15 and bills galore—$422 rent—etc.," Roselle notes in the calendar.[232] Davis describes his circumstances to Donald Bear, director of the Santa Barbara Museum:

I was more shaken because it meant a matter of life to me. If the sale had been made, as I had been assured it would be, I would have been able to pay some rent and make some new pictures for the coming season, but the result leaves me in the most crucial situation I have ever been in, and I am very familiar with crucial situations. Frankly, I can't see any way out and not from lack of serious effort.[233]

Davis makes one last attempt to rekindle the sale by offering to paint a picture for the Albright similar to his 1931 *House and Street*, which the trustees preferred over the painting he submitted to them. As he explains to the gallery's director Gordon Washburn, "the present threat to my very existence moves me to actions outside the usual consideration of regard for the rights of other people to be let alone."[234]

July 14. Fearing that he will be evicted from his apartment, Davis writes to Force's executive secretary, Alice Sharkey, that his "desparate [sic] situation" necessitates his "disagreeable and out-of-season appeal" for funds to support him over the summer.[235] He explains that the two museums he had expected to purchase his work reneged and another prospect deferred making a decision.

This leaves me penniless and I have no relatives or friends who are in a position to give direct assistance. The only asset I have is my work and if I can't get some reasonable breaks with that, the game is up… The only function I have in the community, to paint and to educate in art, remains without support sufficient to sustain continued life.[236]

With Force ill and forbidden from receiving mail, Sharkey promises to "do everything in my power with her and with any other sources I can think of."[237] Nothing comes of her efforts.

July 17. Roselle is offered a temporary job as an assistant librarian at MoMA, to which Davis finally consents after an all-night "meeting," as she calls it.[238] "[W]e stayed awake all night pondering over the seriousness of this situation and the adjustment we must make," she later writes to Hazel.[239] "Fortunately, we have come to a mutual agreement and so I am now a librarian, until they ask me to leave."[240] The next day, "in a very depressed state," Davis writes to Halpert about taking him back.[241]

Time has passed, conditions have changed, I have changed with them, and so at this time any previous obstacles on my part to opening the question with you have been removed. Being well aware that possibly they have not been removed in your own case, I nevertheless ask that you consider the proposal objectively in the light of the present situation.

It is my belief that what I am now developing can be regarded as commercially practical, that is, within the legitimate limits of art expression… if you can forget for the moment your previous opinions of myself, as I now freely forgo previous difficulties, possibly you might see a way to include my work in the program of your gallery.[242]

Halpert welcomes Davis's return.

August 10. Kootz writes a letter to the *New York Times* proclaiming "the probability that the future of painting lies in America," but lamenting that he has "not seen one painter veer from his established course. I have not seen one attempt to experiment, to realize a new method of painting."[243] Jewell calls the letter a "shattering bomb."[244] On October 12, the *Times* prints Davis's rejoinder to Kootz, in which he compares artists to chefs and the art establishment to restaurant managers, suggesting the blame for the current "barbaric cuisine" lies with the managers:

The "manager" as it refers to art, consists of that vast hierarchical superstructure that makes its living, or enhances its prestige, on the work of the artist. This group, because of its ownership of all the important channels of art distribution, both economic and educational, constitutes a real monopoly in culture…

The power of this group to dictate art policy and standards is enormous, and the artist has no voice whatever in its decisions.

With this in mind, I think it is a bit unrealistic of Mr. Kootz to demand more will-power and guts from our artists without distributing a few gross of blackjacks at the same time. The panzer divisions of monopoly subsidized professors, "authorities," both American and refugee, academic scholars, casual cataloguers, chiseling collectors and just plain, ordinary commercial exploiters, make a formidable enemy to oppose with will-power alone…

I would be interested in knowing whether Mr. Kootz would agree with me on the mere possibility of a connection between our monopoly's taste and the fog with the unpleasant odor that seems to hover over American art. It may simply be the cultural halitosis of our monopoly.[245]

October. Peggy Frank, soon-to-be wife of Davis's friend the artist Ralston Crawford, organizes a retrospective of Davis's and Hartley's work at the Cincinnati Modern Art Society. Davis lacks the money to travel to Cincinnati to see it.

November. Halpert announces Davis's return to the Downtown Gallery in a press release. As he has done from the outset of his career, he cautions her against describing his paintings as abstractions.

[W]ipe out the stupid idea that [they are] "abstract" once [and] for all. The term "abstract" is just a slang phrase which has gained currency in casual art conversation. It should not be used in any serious discussion of pictures. My pictures are not "abstract" because their subject-matter is not abstract. They are pictures of concrete things, American things… These things are the most direct physical realities of our optical and motor experience and to call them "abstract" merely diverts attention from their direct emotional impact, and their meaning. I have never had as my purpose in painting, the setting-forth of an abstract thesis or ideal system of color-space ratios, because I have no interest whatever in such things.[246]

December 17. Davis delivers "How to Construct a Modern Easel Picture," the first of two formal lectures at the New School. The second takes place on January 7, 1942.

1942

Picking up from where he had left off in *Swing Landscape*, Davis constructs a series of new paintings based on the "concept of serial configurations."[247] The result is an allover surface pattern of densely packed color-shapes of nearly equal visual intensity that fill the canvas. Davis describes the paintings' "singleness of effect or total quality" in his journal: "Instead of a center focus, fading into increasing obscurity, all parts of the field of observation are centers of focus, serial centers. The keynote of the total quality, the drama, is equality."[248] By abolishing conventional figure-ground relationships, these "serial centers" create a constantly fluttering dynamic space that evokes the speed and movement Davis associates with the experiences of modern life.

January. Hoping to exploit the publicity surrounding Kootz's bombshell letter, Macy's department store invites him to organize a show of new directions in American painting. He includes the work of Davis, Holty, Graham, and Gorky along with that of younger abstractionists such as Mark Rothko and Adolph Gottlieb. The exhibition, among the first signs of the art world's shift away from regionalism, situates Davis alongside the emerging artistic generation. Graham places Davis's work in a similar context in a show of French and American painting that he organizes for the interior design firm McMillen, Inc., at the end of the month. Davis's text in the exhibition catalog applauds the apparent crumbling of regionalism's supremacy.

The United States has tended more toward cultural refrigerators and washing machines than toward art as an integral social value, but now there should be room for a real art in painting. This can only be based on the healthy aspects of the vision of new art forms, an art which is anti-rural, in the same sense that rural electrification is anti-rural. It is an art of the city, just as our own most vigorous authentic art, Negro Jazz, is an art of the city. For too many years past, our artists, and their hierarchy of promoters, have been singing, "I've got those cultural isolationist blues"; "Bring back those dear old Renaissance days"; and "Slip the candid camera to me, John boy."

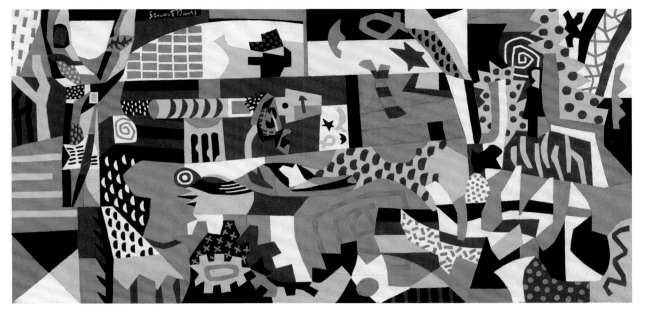

Arboretum by Flashbulb, 1942, oil on canvas, The Metropolitan Museum of Art (pl. 48)

The victims of this plague of cultural jitters are beginning to show signs of exhaustion, and this exhibition may function as a much needed shot-in-the-arm.[249]

February. Kootz makes plans to open a gallery and invites Davis to join it. While tempted by his friend's proposal, Davis tells him he will not consider switching dealers until the end of the season when his contract with the Downtown Gallery is due for renewal.

April 26. Davis is vigilant in his opposition to ideas about modern art that he views as erroneous. As he explains in his journal, "It is not enough to be tolerant."[250] Reactionary conceits "cannot be appeased, they must be challenged and repudiated on all fronts."[251] Hence, when Jewell dismisses Paul Burlin's exhibition at the Associated American Artists Galleries in the *New York Times*, Davis writes a protest letter — which is signed by fourteen artists, including Graham, Holty, Morris, Quirt, Spencer, and Byron Browne — to Arthur Sulzberger, then publisher of the newspaper. Citing the review as an example of Jewell's "flagrantly inadequate [statements on art] from any objective standard of critical competence," the letter asks Sulzberger to grant three of its signees a short interview to "clarify the situation" in order to "prevent similar harmful errors in the future."[252] Sulzberger declines the request. Two days later, angry that Jerome Mellquist's newly published *The Emergence of an American Art* characterizes him as "picket[ing] in paint," Davis writes to the critic and his publisher, Charles Scribner's Sons, demanding that an erratum slip be inserted in the book to correct the error "[a]s I have never painted a picture which was in any way related to picketing, or concerned with a social or political story."[253]

June. MoMA and V'Soske Inc., a carpet company known for its artist-designed handmade rugs, commission Davis and nine other artists to create rug designs that the company plans to manufacture and offer for sale in four sizes. Davis bases his design *Flying Carpet* on "sensations connected with airplane views."[254] Artists are to receive a 25 percent commission on the sales of their rugs, which are shown at the museum and in the windows of the high-end department store Bonwit Teller. When no buyers come forward, V'Soske sells the rugs at sacrifice prices.

Summer. Roselle loses her job at MoMA, a casualty of the sweeping layoffs the museum makes in the face of wartime austerity. She finds part-time employment as a secretary at Hyperion Press for a few weeks in August but is replaced because she cannot take dictation.

September. Halpert opens her season with a group show that includes Davis's new paintings. Jewell's praise of *Arboretum by Flashbulb* (pl. 48) as an abstraction elicits a protest from Davis.

I have been repudiating the term "abstraction," as applied to my work, for fifteen years. I do this not to make controversy or in a spirit of perversity but because my pictures are not abstractions. The term is empty, does not convey information, and perpetuates confusion as to my intention as an artist…

My pictures are partly the product of a number of abstract notions about the general character of color-space dimensionality, but I do not paint them to explain or describe these concepts. My purpose in painting is to make objects which are of the same order as the forms and colors of nature, but which are not merely replicas of some natural scene…

Every direction, color, position, size and shape in my pictures — all the serial configurations — are designed in accord with something I have seen, and wanted to recapture in terms of art, in the world in which we live.

The "Arboretum" was drawn from nature in a garden which I loved. The picture is an objective record of many of the forms and perspectives which were present there, for any one interested enough to have looked at them. But that is not all, because I have integrated in this interest many other observations, remote in time and place, with the general content, which was based on the initial interest felt in the color-space of the garden. The total result is a coherent dimensional statement, in terms of the three-dimensional color-space of painting, which has direct reference to the color-spaces, forms and tactile sensations we perceive in the world around us.[255]

The *New York Times* prints Davis's letter along with Jewell's postscript: "To the remarks of the critic, made in the course of a review of Mrs. Halpert's new group show, published last Tuesday, only this need be added: The public is urged to go and look at Mr. Davis's pictures and decide for itself whether 'Arboretum' is 'abstract.'"[256] None of Davis's paintings sell.

Davis hears that *Fortune* has rejected the cover design it commissioned him to make on the theme of scrap metal. Asserting that the work contained a message that "the autocrat owner of Fortune" did not want to hear, he angrily denounces the magazine in his journal:

Art is the evidence of a kind of Freedom which, like all freedom, is subversive of the power of the autocrat… It tells the story of scrap metal, but instead of telling it in terms of slave-art it tells it in terms of free-art… [The editors'] original enthusiasm was free expression, [their] subsequent suppression of it was the badge of their slavery to the Fascist, and the subversion of their moral character achieved thro[ugh] subsidy by the Fascist. That is why Stuart Davis's cover for Fortune was suppressed.[257]

October. Davis begins teaching an art class twice a week at New Jersey's Teachers' College in Newark. Two weeks later, both it and his class at the New School are canceled for lack of students.

November 18. With Roselle still unemployed and "money running very low," Davis applies to the National Institute of Arts and Letters for a grant of $130 in order "to still be able to retain possession of my apartment" through December and January.[258] In late December, Roselle finds work for a

few weeks at Macy's before being hired in the photography department of the Office of War Information, where she remains for two years.

December. In an effort to bolster civilian morale during the war, the Metropolitan Museum hosts *Artists for Victory*, an exhibition of 1,418 works billed as the "greatest exhibition of contemporary art the country has thus far seen."[259] In protest over the exclusion of younger abstract artists, a group calling itself the American Modern Artists, many of whose members belong to the American Federation of Painters and Sculptors, mounts a *salon des refusés* with an accompanying catalog authored by federation member Barnett Newman.

1943

Winter. With America's entry into World War II in December 1941, the search for a new form of expression that is American but not parochial gains momentum. To Kootz, Davis's art fulfills the prescription. In his book *New Frontiers in American Painting*, he praises the artist's work as "one of the most American expressions we have. It has an American intensity, aggression and positiveness that is thoroughly symbolical of the spirit of our most imaginative political, social and economical leaders. It is healthy and constructive."[260] The following year, Kootz asks Davis to participate in *Radio Forum on Art*, a series of radio broadcasts he hosts for WEVD. In these broadcasts, Davis draws on the aesthetic philosophy he has been clarifying for himself in his journals — art must preserve the intensity of subjective experience and simultaneously transcend its contingency and temporality. To communicate to others, it must derive its subject matter from the experiences everyone has of "the colors, objects, and spaces of the world in which we live" but express them in ways that render them universal.[261] The goal, Davis asserts, is to replace the "subjectively particular" with color-space configurations that are "inter-epochal, international, and inter-racial."[262]

My early landscapes showed enthusiastic emotion about the color-texture-shape-form of associative entities such as sky, sea, rocks, figures, vegetation. The purpose was to make a record of things felt and seen so that the total associations of the moment could be experienced. Today I disassociate the painting experience from general experience and attain a universal objective statement that transcends the subjectively particular. The emotion is given an intellectual currency beyond time and place.[263]

In a later journal entry, Davis expands on the idea of art's universality:

The idea of universality in art automatically presumes unity in humanity. It affirms the universality of the human spirit. When this idea is negated, as in Nazism or isolationist schemes, freedom of the human spirit is denied… the concrete example of the universal in the particular exemplified in art arouses that sense in the spectator… In art we see the human spirit aroused by reality, negating that reality in the creation of a new reality, the work of art… Through the dimensional equations of his painting the artist gives meaning and coherent unity to the elements of his awareness of reality.[264]

Thus, now, for Davis, "art is a universal human value, a spiritual expression, which transcends the immediate limitations of the subject matter in which it is manifested."[265]

February 2. A year and a half after reestablishing ties with Davis, the Downtown Gallery opens the artist's first one-person exhibition in New York in nine years. Davis is both excited and anxious in the run-up to the show, "touched" by the well-wishers and "the rallying around" him, which he calls "incredible."[266] The evening is a huge success; two hundred people attend, including Mondrian, Jacques Lipchitz, museum curators and directors, and jazz musicians Ellis Larkins, Duke Ellington, Red Norvos, W.C. Handy, and Mildred Bailey, who sings a set of songs with the jazz trio hired by Hammond and *New Yorker* cartoonist William Steig to play for the opening. Léger is too sick to come but sends a hand-delivered letter congratulating Davis. For two hours, guests listen to jazz while viewing Davis's paintings, eating sandwiches, and drinking martinis. Later

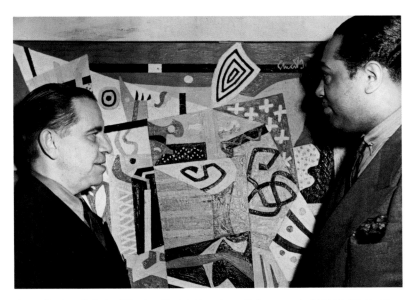

Stuart Davis with Duke Ellington, Davis's Downtown Gallery opening, 1943, Estate of the Artist Archives

that evening, radio host Ralph Berton devotes a half hour of his show to discussing Davis's paintings in relation to jazz and to playing Earl Hines's records in honor of the artist. Critical response to the show is positive. Greenberg voices support in the *Nation* for Davis's new work, and Robert M. Coates, art critic for the *New Yorker*, declares the artist "among the top ten American painters alive today."[267] Emily Genauer, at the *New York World Telegram*, Davis's "enemy," as he calls her, delivers the only "foul blow," writing that the artist's work, like swing music, lacks "anything in the least resembling emotional and intellectual depth."[268] But the complimentary reviews from others are sufficient for Davis to concede that the show "got off to a terrific start."[269] By year's end, eight works in it have sold.[270]

February 3. Timed to coincide with his Downtown Gallery show, *Art News* publishes Davis's article "The Cube Root," in which he calls on American artists to find new aesthetic forms that reflect the lights, speeds, spaces, and forms of contemporary life.

It has often been said, even by proponents of those pictures known in aesthetic slang as Cubist and Abstract, that they have no subject matter. Such a statement is equivalent to saying that life has no subject matter. On the contrary, modern pictures deal with contemporary subject matter in terms of art. The artist does not exercise his freedom in a non-material world. Science has created a new environment, in which new forms, lights, speeds, and spaces, are a reality. The perspectives and chiaroscuro of the Renaissance are no longer physically with us, even though their ghosts linger in many of the best modern work [*sic*].

In my own case I have enjoyed the dynamic American scene for many years past, and all of my pictures (including the ones I painted in Paris) are referential to it. They all have their originating impulse in the impact of the contemporary American environment…

Some of the things which have made me want to paint, outside of other paintings, are: American wood and iron work of the past; Civil War and skyscraper architecture; the brilliant colors on gasoline stations, chain-store fronts, and taxicabs; the music of Bach; synthetic chemistry; the poetry of Rimbaud; fast travel by train, auto, and aeroplane which brought new and multiple perspectives; electrical signs; the landscape and boats of Gloucester, Mass.; 5 & 10 cent store kitchen utensils; movies and radio; Earl Hines hot piano and Negro jazz music in general, etc. In one way or another the quality of these things plays a role in determining the character of my paintings. Not in the sense of describing them in graphic images, but by predetermining an analogous dynamics in the design, which becomes a new part of the American environment…

The development of modern art in Europe is probably at an end. Indeed, its strength seems to have been sapped for some years past. During its regime it broke down traditional concepts of composition unsuited to contemporary expression… But enormous changes are taking place which demand new forms, and it is up to artists living in America to find them.[271]

November. Jackson Pollock's first one-person show opens at Art of This Century, the museum-gallery Peggy Guggenheim launched in October 1942 to showcase contemporary art. MoMA's purchase of *She-Wolf* establishes Pollock as the prophet of a new kind of painting. At his second show, in the spring of 1945, Greenberg declares him "the strongest painter of his generation and perhaps the greatest one to appear since Miró"[272]

December. Davis's article "What about Modern Art and Democracy?" appears in *Harper's* in response to the criticism of modern art by the artist George Biddle, who had written two articles in the summer of 1940 pronouncing modern art irrelevant and contrasting the freedom American artists enjoy with the censorship and coercion artists face under fascism.[273] Concerned about the economic and psychological impacts of this attack and other condemnations of modern art by conservative pundits, Davis refutes Biddle's assertions, reprising his by-now-familiar claim that modern art brings "to its subject matter the new spatial concepts of our epoch that are being realized in all the forms of accelerated communication," but lending it a new urgency through his characterization of attacks on modern art as censorship and intimidation:

In America there is a tendency to look with suspicion on "abstract" ideas or creative innovations where they occur outside the field of technology or commerce…

It is not that the American artist is prevented from painting any way he chooses, but that he faces a public preconditioned to look with suspicion on anything beyond the literal, the sentimental, or the academic…

For many years past such men as Thomas Craven, Peyton Boswell, Jr., editor of *Art Digest*, Forbes Watson, and many others have been propagating their versions of the American Scene idea. Through books, magazines, newspapers, and lectures, they reach a vast audience which is told that Modern Art is un-American and devoid of content. The Modern artist is outlawed and deprived of cultural citizenship, and the idea of democracy in culture goes down the drain. The relations between art and politics are devious, and often obscure, but they exist. The American Scene ideology has in it germs which the Fascist-minded among us may find it profitable to cultivate.[274]

1944

Despite continuing attacks against abstract art by conservative critics, the shift in attitude toward it by the mainstream art world accelerates during the course of the year, with even Jewell acknowledging that abstraction is "not just a flash in the pan… It appears to have come to stay."[275] With the style's growing acceptance comes acknowledgement of Davis's stature as a major American artist. Personal commendations are buttressed by prizes and awards throughout the ensuing decade.[276] For the first time, Davis's income necessitates his paying income tax. As he tells the artist-scholar Erle Loran in July, "[I]n the last year my pessimism about exhibiting… has been changed by the facts. What I refer to is the fact that I have sold enough pictures to lift that pauperism terror. While still a bit shaky, this breeze of concrete results is refreshing."[277] His private life is likewise idyllic. Roselle refers to him repeatedly in her calendar as "my darling" and notes how in love they are, how happy they make each other, and what a wonderful experience it is to be with him.[278]

Mid-January. Davis falls again and severely injures his knee, which keeps him at home for more than a month and prevents him from attending Mondrian's memorial service on February 3. Holtzman arranges for him to see the Dutch artist's studio on March 23; unable to climb the steps to it, Davis postpones the visit to April 3.

Fall. Davis enters a period in which what he later calls his "alcoholic miasmas" reduce his productivity.[279] In October he completes a short autobiography that the American Artists Group commissions as part of its series of pocket-sized monographs on leading contemporary artists, and later that fall, he writes an article for *Think* magazine, "The 'Modern Trend' in Painting," in which he declares that art's purpose is "to express an emotional synthesis of the responses to life's subject matter" and "to realize innate capacities for spiritual experience within the limitations of the life of the time."[280] But between the article's publication in January 1945 and the autumn of 1946, he rarely writes in his journal and he completes only two paintings: *For Internal Use Only* (pl. 50) and its study, *G & W*.

1945

February. The relationship between Davis and Kootz crumbles over his sale to MoMA of *Egg Beater No. 5*, which he purchased from Davis in 1937 for $200, well below its market value. Accusing his longtime friend of acting

unethically, Davis demands that he make amends by turning over the proceeds of the sale to him, minus the original $200. "If you have already diverted this money to other channels then I suggest that you return the three pictures of mine you still have so that I can realize something on their sale."[281] Kootz fires back:

Somewhere in your ardent attempt to discover "ethical" conduct you went thru a disintegration of memory. Leave us not forget the record.

I asked Edith Halpert many times to sell the Egg Beater for me, and put the money against one of your later pictures. She refused. I asked you to exchange the Egg Beater for one of your later pictures, with additional cash to be paid to you, and you refused. "What do I want with an old picture?" you asked…

Did I sell the Egg Beater far below its current value? I had thought, from Mrs. Halpert's aversion to selling it and your refusal to exchange, that this picture had no value at all…

If you, or your dealer, had at any time wanted the Egg Beater it was yours for exchange. Both of you shied away from it as tho it were unalloyed poison. Now that I have sold it, you attempt to make it appear as tho I have committed some unmentionable crime. Perhaps it is a crime to keep money that represents many years cordial investment, made without any thought of profit. But I cannot see it that way. You had your opportunity to secure this picture at any time and brusquely rejected it.[282]

Spring. Halpert relocates her Downtown Gallery for the third time: having moved uptown from 113 West 13th Street to rented space at 43 East 51st Street in 1940, she now buys 32 East 51st Street, whose renovation costs and mortgage precipitate a financial crisis. Four artists in her stable—Davis, Spencer, Levi, and Louis Guglielmi—meet on July 21 to discuss how to help her. They decide to ask each of the artists in her gallery to loan her $500 or $1,000 depending on their financial circumstances. Davis's letter to Kuniyoshi, one of the gallery's top-selling artists, is typical.

As you know, Edith is opening her new gallery in October. A lot of dough is involved in this building enterprise and she could use a bit of a lift. There is no question about the thing but it still takes a lot of money—much more than was anticipated…

When you think about this, don't be afraid to think about a thousand bucks because the idea is that the total has to be $10,000. Don't be embarrassed however if you have to make it less.[283]

June 11. Davis begins what will be a six-year project painting *The Mellow Pad* (pl. 51).

Summer. MoMA postpones its planned Marc Chagall exhibition because of war-related difficulties in shipping art from Europe. As a substitute, James Johnson Sweeney, the museum's director of painting and sculpture, proposes a selective show of Davis's work, to which the artist agrees.

July. Kootz formally opens his gallery on 57th Street with a roster that includes Davis's friends Holty, Browne, and Romare Bearden and younger abstractionists Gottlieb, Robert Motherwell, and William Baziotes. Still "sore as hell" at Kootz, Davis refuses to visit.[284]

October. Cahill and Miller, now a curator of painting and sculpture at MoMA, host a dinner at their apartment that Davis and Pollock attend. It is the first time the two artists meet. During the next decade the couple introduce Davis to many of the leading abstract expressionist artists.

October 17. The survey exhibition of fifty-three of Davis's paintings opens at MoMA with a reception attended by eighteen hundred people, the largest turnout in five years. The catalog consists primarily of excerpts from Davis's published writings and interviews with Sweeney, which include Davis's comments on color.

Today I have a concept of color which I never even thought of before. Now I think of it as another element like line and space. I think of color as an interval of space—not as red or blue. People used to think of color and form as two things. I think of them as the same thing, so far as the language of painting is concerned. Color in a painting represents different positions in space. In drawing with color up and across you have also drawn a certain distance in relation to the polar extremes of the constants of the color solid. Color conceived in this way becomes a space or length interval. If you have monotony in the length of these intervals you have monotony in color. I believe color relations are not merely personal but objectively true.[285]

With the exception of Greenberg, who calls Davis's work "decorative to the point where it is hardly easel-painting any more," reviews confirm the artist as a significant American modernist, a view promoted by Cahill, whose laudatory cover article in *Art News* describes the artist's work as "vigorous, exciting as a jam session, filled with keen observation and humor."[286]

Fall. Following Davis's MoMA show, George Wettling, the well-known jazz drummer and amateur painter, becomes Davis's protégé, enrolling in the older artist's class at the New School and praising his work so much that radio host Fred Robbins jokingly introduces Wettling's records to his

listeners as being by "George Stuart Davis Wettling."[287] Through the drummer, Davis's connections to the jazz community intensify, leading to an increase in jazz lingo in his conversation and writing.

1946

January. Building on the momentum of Davis's MoMA retrospective, the Downtown Gallery mounts a survey of the artist's works on paper. In March, the Baltimore Museum of Art hosts a retrospective of twenty-two paintings. *Art Digest* assesses the convergency.

If there were such a thing as a duly elected Man of the Year in art, Stuart Davis would probably win this season… since the 1913 Armory Show he has pursued his aims with a singleness of purpose that admitted no observable compromise with popular taste. As a result, Davis was over 50 and long a major "influence" on other modern artists before the general public began to beat a path to his door and to clamor for his work.[288]

March. Through the advertising agency A.A. Ayer, the Container Corporation of America commissions Davis and fifty-two other artists to depict American states and territories for use in the company's promotional advertisements through 1950. Davis is assigned Pennsylvania. His inclusion of the state's name running along a zigzag vertical axis is his boldest use of words for both content and shape since his 1932 *American Painting*.

Spring. The US State Department purchases four of Davis's paintings for a collection of American art it plans to circulate for five years to Europe, China, and Latin America in three separate exhibitions.[289] The Metropolitan Museum hosts the painting portion of the exhibition, *Advancing American Art*, prior to its being sent abroad. Controversy ensues almost immediately, with conservative pundits attacking the art as degenerate, un-American, and a waste of taxpayer money. Halpert's artists are singled out for particular ridicule. In December, the *New York Journal-American* reproduces Davis's *Trees and El* on its cover under the headline "Exposing the Bunk of So-Called Modern Art."[290] A day later, a woman phones Davis saying that "something should be done to people who do work like that."[291] The uproar continues until May 1947 when the House Committee on Appropriations abolishes funding for the program and all three exhibitions are returned to New York. In May 1948, the Whitney Museum exhibits the entire State Department collection, which is offered for

sale in a public, sealed-bid auction by the War Assets Administration.

April. Davis's determination to express the "universal in the particular" does not diminish his commitment to celebrate experiences everyone shares.[292] Thus, when Goodrich, now a curator at the Whitney Museum, classifies the artist's paintings as nonobjective in the museum's *Pioneers of Modern Art in America* catalog, Davis requests an erratum slip, explaining to Goodrich that he has "spoken and written against [being associated with nonobjective art] on a number of occasions, because its ideal order and mysticism is alien to my idea of the nature of art."[293]

September. The federal GI Bill, passed in 1944 to fund tuition for veterans of World War II, influences the size of Davis's classes at the New School. Beginning this term and continuing for the remainder of his career there, he has what he jokingly calls "an enrollment greater than the total population of New York State."[294]

September 30. Sweeney resigns from MoMA after the museum's trustees appoint a five-person coordinating committee to oversee all the museum's various departments, including his. Davis drafts a letter in support of Sweeney, signed by twenty-eight prominent artists and addressed to Nelson Rockefeller, chairman of the museum's board of trustees; the *New York Times* prints it on November 3.

The role of the Museum of Modern Art, as leader in public education in modern art, has had in Mr. Sweeney one who is foremost in its interpretation. In the activities of the museum

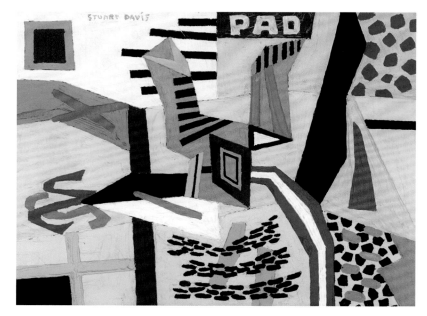

Pad #1, 1946, oil on canvas mounted on Masonite panel, Honolulu Museum of Art, Gift of Friends of the Academy, 650.1

which have specific reference to contemporary painting and sculpture, we feel that Mr. Sweeney's abilities to give meaningful direction are rare. The absence of his knowledge and vision would be a source of great regret to us, and to many others, artists and laymen alike.[295]

October. Signaling Davis's growing stature, Penguin Books hires art historian Robert Goldwater to write what is intended to be the first monograph on the artist's work. The book is never published.

1947

Winter. Davis's ill health and excessive drinking persist. He resumes writing extensively in his journal, but he produces very little painting, all of it small scale. He spends most evenings with Burlin, Guglielmi, Wettling, and Spencer, listening to music and drinking into the early morning hours. Constantly "pooped," as he describes it, he declines dinner and speaking engagements and sends Roselle to art openings in his stead; looking back, he acknowledges that he and a number of friends—Spencer and Wettling in particular—were "hardened alcoholics."[296] Their late night carousing provokes threats of legal action from at least one angry neighbor.[297]

Davis recounts his history with jazz for *Esquire's 1947 Jazz Book: A Yearbook of the Jazz Scene*.

Since the time I began to study painting at the Henri School of Art I have been addicted to hot music. They didn't teach it there, it was strictly my own idea. I implemented this side line with an Edison Cylinder Record that had come into my possession. It was titled, *Dust Explosion in a Dehydrated Silo*, by Glenn Coleman and his Cirrhosis Six. This unique hot Americana started me off in a good groove where music was concerned. I have followed its solid advices with little deviation since that time…

At the time I left art school I had the immediate need to get straight. My object was to make paintings that could be looked at, while listening to the "Silo" record at the same time, without incongruity of mood. I looked in vain for substantiation of this desire in the work of the contemporary American painters of the period. When I did finally find a school of painting that was really jumping, I had to dig it by remote control. It was located in Paris and was known under the generic term of "Modernism." Various considerations made it impossible for me to go there and get direct inspiration from these International cats who were giving out in art. I continued to get my kicks locally from jazz. Fortunately, this

modern musical art became increasingly available in various forms. I leaned on it heavily since it was the only thing I could find where creative ideas were somehow being expressed. American painters in general were messing around with the Old Masters. It was like living in some screwy community where the service station attendant filled your tank while wearing a sixteenth-century court costume. After wiping your windshield, he would hand you a tract on the philosophy of Leonardo Da Vinci, plus the technique of under-painting and glazing. Nothing intrinsically unsound in the jive, but too anachronistically square.

Finally, I did get to Paris in a fairly hip stage of development where painting was concerned. In the artistic climate engendered by the righteous cats who were giving out there, I got some new ideas. In fact, I am still using some of them because they wear well. I came back to America with the throttle wide open.[298]

February. In the opening of an article for *Life* magazine, Winthrop Sargeant observes that "abstraction seems to be sweeping American art," adding "there is nothing particularly new about abstraction. What is new is its sudden emergence as an esthetic band wagon on which young American artists are gleefully and perhaps somewhat indiscriminately jumping."[299] While the article's title, "Why Artists Are Going Abstract: The Case of Stuart Davis," would appear to suggest a sense of objective investigation, Sargeant's pervasive skepticism transforms the piece into a case against Davis. Calling him one of the best-known American pioneers of abstraction, Sargeant characterizes his paintings as "decorative compositions that might provide a spot of color and intricate geometry" and likens his methodology to that of "grandma… when she was making a patchwork quilt."[300] The article elicits a range of responses. Regionalist painter Aaron Bohrod writes in support of Sargeant's use of Davis's work as an example of what is wrong with abstraction: "The abstract idiom shrinks art to the point where it becomes merely pleasing decoration. There is little in it of the reflection of life and ideas which are an integral element in the works of great masters."[301] In subsequent issues, Guglielmi counters by reminding *Life*'s readers that Bohrod is an artist whose "ilk are on the defensive these days," while Davis himself answers Bohrod with his typical wit.[302]

I was gratified to learn that Aaron Bohrod believes art should be close to contact with life. I had no idea he was on our side. Knowing only his pictures, I had taken it for granted that he was strictly a How-to-Paint-without-Offense man. You know, like they teach in the art classes. But with this public statement a new Bohrod unveils himself, deeply imbedded in life, against a background of guaranteed Culture. Foolproof and authentic, like an unread edition of Shakespeare in the parlor.

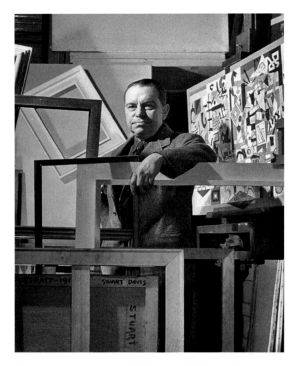

Stuart Davis in his studio, 1947, The *Life* Picture Collection

I want to say to Aaron: solid, old man. Dig that righteous classical jive. Hep yourself to this fine Modern Art we have been getting up for the people and which they all like so much. Forget that "abstract" psychosis. Don't be so square, Aaron, and before you know it you'll be out there jumping with all the cats. Better listen to me, old man, or else they'll soon have you playing second fiddle on the scrub team at the Metropolitan Museum.[303]

October. New York's Norlyst Gallery opens a show of Wettling's paintings, accompanied by a text written by Davis, one of the many he has written in support of a friend's art. He authored texts for Coleman's show at the Whitney Museum in 1932; Hananiah Harari's at the Mercury Galleries in 1939; Quirt's at the Pinacotheca Gallery in 1941; and Gar Sparks's at the Julien Levy Gallery in 1946. And Davis twice defended Burlin's work—in 1942 against Jewell and in 1947 against the painter-critic Henry Varnum Poor, who accuses it in *Art Digest* of being "outright a Picasso swipe."[304] Given that these artists work in a range of styles, friendship seems to be the primary factor motivating Davis's commentaries.

November 25. Davis participates in MoMA's symposium on Picasso's *Guernica*, using the occasion to reprise his view that art's social content does not depend on subject matter.

To paint is in itself a Social act. Apocalyptic revelation is not essential to Art to ensure its social use and function. Why should the painter be looked to for answers to political and more problems, that the strongest forces in the world today cannot answer?…

Art is not a catharsis, a purge, or a purification. It is an active use of faculties to meet the impact of reality on a day-to-day basis, and to understand it in the sense of those faculties. To do this, a method is required, and where the dimensional means of painting are the chosen medium, that understanding is had within the terms and limitations of dimensional logic. When those means are submitted to the personal sense of equilibrium and space, the result is the physical equilibrium in the work of art…

Art knocks you out on a physical level, without showing you its passport. The impact of *Guernica* rests on this basis.[305]

1948

Winter. Reactionary assaults on modern art continue, much to Davis's alarm. "The situation is very bad, take my word for it because I know," he tells Hazel in describing the removal of his painting *Ultra–Marine* (pl. 49) from an exhibition at the Pennsylvania Academy for use as an object of ridicule in a lecture decrying modern art.[306] Following this episode, the Boston Institute of Modern Art announces that it is changing its name to the Institute of Contemporary Art (ICA) in order to disassociate itself from modern art, which it describes as "dated and academic" and surrounded by "widespread and injurious misunderstandings."[307] The name change is embraced by *New York Times* critic Aline Louchheim and *New York World Telegram*'s Emily Genauer, who labels the ICA's decision "the first round in the battle which a number of critics and artists, all of them supporters or practitioners of modernism, have been waging against the proponents of unintelligibility in art [and which] is won."[308] Genauer's article is followed by Craven's "Is American Art Degraded?," in which he characterizes the contents of the State Department's aborted *Advancing American Art* exhibition as "imitative abstractions and boneless distortions" and laments that every time an indigenous American style begins to emerge "some personality or clique has operated to ruin our efforts."[309]

February. In a letter to Daniel Catton Rich, director of the Art Institute of Chicago, Davis voices his concern about the lingering hostility of prominent critics to modern art:

What is the matter with people, where is their spirit, and besides that, what in hell do they want. Maybe two world wars has something to do with it. I can't believe that people are so

Convinced that modern art must be defended against even nonlethal attacks, Davis appears as the prosecutor on the radio program *Books on Trial* speaking against T.H. Robsjohn-Gibbings's antimodernist diatribe *Mona Lisa's Moustache*.[311]

In the midst of the myriad attacks on modern art, *Look* magazine conducts a poll of critics and museum directors to choose the best American painters. Davis is ranked fourth after John Marin, Weber, and Kuniyoshi.[312]

March. Alarmed by the threat to freedom of expression that underlies the "wave of animosity directed against the spirit and name of Modern Art," Davis, Burlin, Holty, and Bradley Walker Tomlin assemble a group of prominent artists, among them Gottlieb, Motherwell, Pollock, Rothko, and Newman, to mount a counteroffensive.[313] The first planning session is held in Burlin's studio, the second in Davis's apartment. Persuaded that the best way to answer the reactionary criticism is at a large public meeting, Davis contacts MoMA, which agrees to host a forum on the subject.

May 5. "The Modern Artist Speaks" takes place at MoMA with 1,450 people attending. Holty moderates a round-table discussion. Burlin, Davis, Goldwater, Gottlieb, Morris, and Sweeney deliver papers. In his, Davis likens the recent attacks on modern art to censorship and defends abstract art against the charge of unintelligibility.

Pearson, in *Art Digest*, labels the forum "probably the most important cultural episode of the year," but Louchheim dismisses it as a small "tempest in a paint-pot," omitting mention of the event's venue or the names of any participants.[315] Davis, Holty, Tomlin, and Burlin demand that the paper's editor, Charles Mertz, remedy the affront by printing a factual report of the meeting, which he refuses to do. Genauer's account of the proceedings mentions only Davis, whom she misquotes. Not expecting a retraction, he writes to her nevertheless: "Your desire to belittle the importance of the meeting and the people concerned in it is your business, but I object to being quoted as having made a false and silly statement… My purpose here is simply to call your attention to a fact, and to suggest an objective reading of my speech."[316]

June 3. Calling Davis "America's leading abstract painter," a reporter from *Cue* magazine interviews him about the roiling controversy over modern art.[317] "We're living in a period of chaos, a strange-looking century," Davis says.[318] "Of course the youngsters are painting strange-looking stuff. Abstract art is an outgrowth of current things. The anti-Moderns today can't turn back the clock. And don't point to the Renaissance painters. They would all be painting abstract if they were alive today."[319]

Summer. Kootz closes his gallery and becomes the private representative of Picasso's paintings in the United States, leaving the American modernists in his stable "out on the street as far as a gallery is concerned," as Davis tells Quirt.[320]

Castleton China reproduces Davis's gouache *Town with Boats* on a set of dinner plates as part of its contemporary artists series.

September. Distressed by the implications to mankind of the atomic bomb, with its confirmation of the basic fragility and contingency of human life, Davis laments that "going to strange places and doing things is no longer meaningful because such places are sick from materialistic world plague. It therefore becomes necessary to create one's own values through the Method and language of Art."[321]

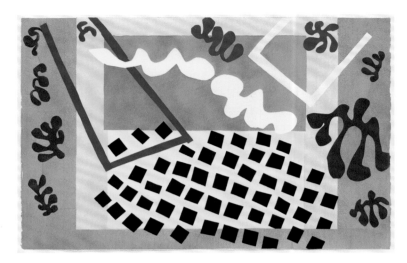

Henri Matisse, *The Codomas*, plate XI from the illustrated book *Jazz*, 1947, pochoir, The Museum of Modern Art, New York, Gift of the artist, 1948

October 1. MoMA opens an exhibition of its recently acquired European prints, including twenty from Matisse's *Jazz* series, made from the artist's cutouts as unbound pages for his 1947 limited edition book of that title. Based on cutout shapes arranged on painted sheets of paper, the prints resolve what Matisse called "the eternal conflict of drawing and color."[322] For Davis, who has long equated the two elements, the prints strike a chord. He soon will adapt their large forms and brilliant color to his own work.

1949

January. The opening of *Milestones of American Painting in Our Country* at Boston's ICA reignites the firestorm over modern art. *Life* magazine casts the exhibition as a conscious attempt to discredit abstract art by showing that the main trends in twentieth-century American art are rooted in realism and romanticism. According to the magazine, the exhibition aims to encourage artists to "break away from the totalitarian formulas of diehard abstractionists and assert themselves as individuals."[323] After a flurry of protests from leading museum professionals, *Life*'s editor asks ICA director James Plaut whether its article misinterpreted the exhibition's intent. Plaut responds: "We have no reason to believe that *Life* resorted to deliberate misinterpretation in reporting on the exhibition."[324]

Davis's ill health persists. He continues teaching at the New School but misses the openings of Weber's exhibition at the Whitney Museum and Jacob Lawrence's at the Downtown Gallery. When he does go out, he often requires assistance returning to his apartment. Mostly, he sees friends at home—Spencer, Burlin, Holty, Cahill, Wettling, Guglielmi,

and Crawford—who arrive after dinner with liquor and stay into the early morning, forming what Davis later calls a "community [of] alcoholism."[325]

July 22. Davis vomits blood during the night and into the next morning. Roselle phones the doctors who have been attending him, finally reaching one, who makes a Saturday house call and administers an intravenous infusion of protein. Two days later, the doctor returns and gives another intravenous infusion but recommends that Davis be hospitalized—advice that turns into insistence during a follow-up exam the next day. The doctor personally drives Davis to the New York Post-Graduate Medical School, where he is immediately admitted for alcohol abuse. During the next six days Davis receives multiple blood and dextrose transfusions and sleeping pills at night to quell his anxiety and restlessness. When the medical staff recommends that he be given an X ray to determine why he has trouble walking, he responds, "not now—one thing at a time."[326] The hospital releases him on August 7. Within the year he resolves to give up drinking and for the rest of his life generally refrains from consuming alcohol. Years later, Frederick Wight notes that "for physical or moral reasons [Davis] drinks glasses of water in slow and steady progression, at a man's pace, as though they were whiskey."[327]

September. Kootz opens a new gallery. In his earlier venture, his roster was split between older geometric abstractionists and younger abstract expressionists. Now, in a sign of the more general shift in the art world toward the newer movement, he eliminates the geometric abstractionists from his stable. To announce the gallery's new direction, he and critic Rosenberg organize *The Intrasubjectives*, an exhibition celebrating de Kooning, Gorky, Pollock, Gottlieb, Rothko, Motherwell, and Baziotes as leaders of a new, postcubist movement whose work expresses existential anxiety. Rosenberg describes the distinction in styles:

> We have had many fine artists who have been able to arrive at Abstraction through Cubism: Marin, Stuart Davis, Demuth, among others. They have been the pioneers in the revolt from the American tradition of Nationalism and of subservience to the object. Theirs has, in the main, been an objective art, as differentiated from the new painters' inwardness.
>
> The intrasubjective artist invents from personal experience, creates from an internal world rather than an external one.[328]

Kootz arranges with Gimbel's department store to sell the gallery's inventory of work by Holty, Bearden, and Browne at a 50 percent discount.

1950 – 1964

Winter. Davis is the first in his circle to have a television. "It's like having a window onto the street," he later says, adding, "We have information about events all over the world practically instantaneously with their happening."[329] He loyally watches sporting events, often with Wettling, Cahill, or Varèse. While painting, he keeps the set turned on with the sound off, enjoying the medium's abrupt shifts between spatially and temporally unrelated images and its compression of time and space. "I don't rely on television for culture but I like its liveliness and action," he tells critic Dorothy Gees Seckler.[330]

I may be watching a prizefight while I have a painting in progress, and some sort of action in the fight, or some sort of decision in it, may create an emotional attitude which gives me an idea for a painting. I don't mean in any sense of imitating the motion of the fighters, etc., but one which gives me an impulse to do something else in the painting. Without the outside stimulation of the fight there might not be any impulse to do something more on the picture.[331]

March. Davis completes *Little Giant Still Life* (pl. 52), announcing a new vocabulary of large shapes, saturated colors, and words, in this case "champion." In May, the Virginia Museum of Fine Arts purchases the painting for $3,400 from the exhibition *American Painting, 1950,* that Sweeney guest-curated for the museum.

November. MoMA asks Davis to participate in a panel, "What Abstract Art Means to Me," to be held in connection with its *Abstract Painting and Sculpture in America* exhibition, scheduled to open in January. Knowing that the panel will include abstract expressionists, Davis is eager that it not be lopsided in their favor and asks the show's curator, Andrew C. Ritchie, to include Morris in the program, which he does. Contemplating the panel leads him to reconsider his alliance with the Downtown Gallery: "The Kootz, Greenberg, Barr, Janis, etc., represent Art Ideas which are oriented toward progress. Halpert is unquestionably reactionary on the basis of her preferences. To count on her as the sole promotor of my work is stupid and unnecessary."[332] Two days later he elaborates: "The [dealer] Alternatives are Arty in character, Academic Snobbish, and all that, but they are essentially mobile. It is possible to use them to give some Realism to their Abstract attitude."[333] Despite these misgivings about Halpert, Davis remains with her gallery.

1951

January. Following Gorky's death by suicide in 1948, the Whitney Museum mounts a memorial exhibition of his art. Genauer's *New York Herald Tribune* review suggesting that what she calls the artist's "seduc[tion]" by European styles is "sadder than his suicide" elicits a protest letter that sixty-three artists sign.[334] Davis refuses Pollock's and Clyfford Still's request to lend his name to it. Seeing Gorky's exhibition confirms his view that the Armenian painter failed to live up to his early promise and instead put his unusual talents "to the service of an inner landscape where gusts of some very loose-leaf literature obscured the vista."[335] In his journal, he assesses Gorky as "Talented. Endless mimetic. Immature. Always a pose and a grand gesture… He was essentially a man without a country—no topical subject."[336]

In an effort to attract readers by exploiting the controversy over modern art, *Look* engages Davis and Rivera to write statements for an article it bills as "Two Famous Painters Fight the Battle of Abstract Art." Rivera's charge that "abstraction is the curse of the United States art" is easily refuted by Davis:

The simple fact is that abstract art has flourished and won out everywhere because its appeal is universal. Rivera's assertion that "it has been pretty generally abandoned in Europe" is false, unless he had in mind Hitler's Germany or Stalin's Russia. But the word "abandoned" is ill suited to those cases. It is unquestionably the abstractionists who have made the energy and scope of free contemporary thought a reality in art in a spirit of good will.[337]

January 23. MoMA opens *Abstract Painting and Sculpture in America*, which Davis calls "important and stimulating."[338] He is one of six artists in the exhibition chosen by the *New York Times Magazine* to describe his aesthetic philosophy. He uses the occasion to restate his view that art must derive from concrete experience: "Any kind of painting is always a likeness of something and the artist always uses contemporary subject matter. He seeks the most direct way of expressing direct perception of the object, perceiving the reality of that object in terms of the painting of it."[339]

February 5. MoMA holds its panel "What Abstract Art Means to Me," with Davis, Fritz Glarner, de Kooning, Calder, Morris, and Motherwell as participants. To ensure that the "Intrasubjectivists should not have the last word," Davis arranges to be the last to read his paper.[340] During his week-long preparation of the text, which leaves him tired and exhausted, he exhorts himself to be "violently partisan"

and to express "a personal viewpoint as the definitive one."[341] The result is a position paper that scholars later interpret as evidence of his hostility to abstract expressionism.

I think of Abstract Art in the same way I think of all Art, Past and Present. I see it as divided into two Major categories, Objective and Subjective. Objective Art is Absolute Art. Subjective Art is Illustration, or communication by Symbols, Replicas, and Oblique Emotional Passes…

Objective Art sees the Percept of the Real World as an Immediate Given Event, without any Abstract Term in it. But there is Consciousness of Change, of Motion in it…

Subjective Art is a "horse of Another Color," to use the current Bop phrase; as it refers to shots of "Horse," or Heroin, which come in different colors to suit the Esthetic Taste and Poetic Mood of the client. Unlike Objective Art it sees the Change between the Real Object, the Idea Object, and Real Design, as an Abyss, a Chasm, a Void… Spanning the Gaps in it is accomplished in an emotional Context of Anxiety, Fear, and Awe… Its Universal Principle has more the character of a Universal Bellyache…

Over thirty years ago, Learned Proponents for Expressionism variously identified its Content as a "Psychic Discharge"; "Soul-Substance"; and a "Belch from the Unconscious," communicating the Distress of the Suffering Artist, as a sort of Moral Cathartic.

My interest in Art does not arise from this kind of Distraction, which still has a number of Fans. Art is not a Subjective Expression to me, whether it be called Dadaism, Surrealism, Non-Objectivism, Abstractionism, or Intra-Subjectivism. But when paintings live up to these Advance Agent Press Releases, I turn on the Ball Game.[342]

Subsequent statements by Davis, both public and private, suggest that his allegiance to objective art does not equal a wholesale rejection of abstract expressionism. He concedes "that artists of talent and ability work in that manner," and his opinion of individual artists, particularly Pollock and de Kooning, is more often favorable than not.[343] He visits their shows and those of other abstract expressionists, and often rates them "very good" or "stimulating."[344] Asked who the significant American painters are in a radio broadcast in 1952, he names Pollock and de Kooning.[345] A year later, he tells Wight:

The fact that [abstract expressionists] made large paintings is a good thing in itself. Some of them have real talent. De Kooning has; Motherwell has. I don't care for the terminology of their propaganda, but I see them apart from the baloney and can look at them with pleasure. I admire this uneasy cohesion they've got up.[346]

What Davis opposes in abstract expressionism is its denial of the objective world, which negates what he sees as art's purpose: giving balance and cohesion to the disorder and dissonance of life, thus affirming "that a real order and harmony can be achieved between man and environment."[347] As he explains to Harlan Phillips at the end of his life:

So with the cubist angle, the cubist approach — just as Picasso himself, no matter what kind of work he did, his subject matter is always referent to something that you know about. There's always something in his pictures that indicates this world, not some other, not the insane asylum, or Sigmund Freud in Vienna, or something like that. It's always a world we know about. My nature leads me to adhere to that kind of an attitude. The current wave of abstract expressionism never bothered me. I know the people who do it. Some of them are good, some are not. If they want to do that, fine.[348]

February. The *Magazine of Art* publishes Davis's recollection of Gorky. Although generally affectionate, the article ends with his description of the dissolution of their friendship:

In the early part of 1934 the economic situation for artists became so bad that they were forced to look around for ways and means to save themselves. They were shoved together by mutual distress, and artist organizations of one kind or another began to form as a natural result. I was in these things from the beginning and so was Gorky. I took the business as seriously as the serious situation demanded and devoted much time to the organizational work. Gorky was less intense about it and still wanted to play. In the nature of the situation, our interests began to diverge and finally ceased to coincide altogether. Our friendship terminated and was never resumed.[349]

March. Concerned that the MoMA symposium has left the debate between subjective and objective art unresolved, Davis and Morris make plans to follow it up with another forum that "should leave no doubt about art as a direct continuity of thought about common experience today, as opposed to mystical or arty ideas."[350] Cahill agrees to serve as moderator. Problems with timing force the event's postponement and ultimate cancelation.

March 29. Davis finishes *The Mellow Pad*. He credits his prolonged work on the painting with helping him to formulate the theory that the "joy of the optical exercise" can be derived from any configuration, thus rendering all configurations valid.[351]

I started The Mellow Pad with the idea that its simplicity was a valid relationship which could be imaginatively developed and enriched. In the process the idea of the Neutral Subject Logic was discovered. All Color-Shapes were found to be Valid, and Meaning was found to reside exclusively in the Intuitively established Relations in The total Configuration.[352]

Halpert sells *The Mellow Pad* to her clients Edith and Milton Lowenthal almost immediately for $4,500, the highest price paid for a Davis painting up to this point. That October, it wins a $750 prize in the Art Institute of Chicago Annual.

April 10. Davis debates the question "does modern art make sense?" with Thomas Hart Benton and Perry T. Rathbone, director of the City Art Museum, St. Louis, in Urbana, Illinois, on ABC's weekly radio program *America's Town Meeting of the Air*, moderated by the show's longtime host, George V. Denny, Jr.[353] With the precipitous fall in regionalism's prestige since the war, the sparring between Davis and Benton is relatively gentle, leading the latter to suggest after their debate that they restage it around the country.[354]

Late April. Energized by the insights he gained in making *Little Giant Still Life*, Davis begins working simultaneously on *Visa* (pl. 53) and *Owh! in Sao Pão* (pl. 56), giving high visibility to the words "else" and "the amazing continuity" in *Visa* and "else" and "we used to be — now" in *Owh! in Sao Pão*. During the next fifteen years he introduces into his compositions other word-shapes that comment on his art, imbuing it with the vernacular energy of advertising and popular culture: any, facil-it is, speed, new drawing, eraser, lines thicken, it, unnecessary, tight, complet. As Davis put it, "I like popular art, Topical Ideas, and not High Culture or Modernistic Formalism. I care nothing for Abstract Art as such, but only as it evidences a contemporary language of vision suited to modern life."[355]

June 7. Davis sees the work of Newman, Rothko, and Reinhardt at the Betty Parsons Gallery and pronounces the latter two "very elementary in purpose. The one objectively positive thing in these people is the large canvas which constitutes an idea in itself."[356] Yet, he later makes drawings after several paintings by Rothko, as well as those by Kline, de Kooning, and Baziotes.

June 8. *The Ninth Street Show*, installed by Leo Castelli on the ground floor of a vacant storefront at 60 East 9th Street, confirms the arrival of abstract expressionism. Davis calls the show "very exhilarating."[357] Two years later, he is equally impressed by what will become an annual iteration of the artist-organized survey at Eleanor Ward's Stable Gallery:

"I liked the exhibition at that gallery called The Stable. The character reminded me of the first Independent Show in 1910. There was some affirmation about art in the exhibition itself apart from the individual items that composed it."[358]

September. To address her lack of inventory and the threat to her position by an emerging generation of gallerists, Halpert turns her building's first floor into a space for younger, unknown artists, mostly abstractionists. In a move that irritates her permanent roster, she buys $1,000 worth of art from each of the "New Jerks," as Davis describes them, whose prices range from $25 to $300.[359]

September 6. Roselle learns she is pregnant. During the next two weeks, with Davis's approval, she attempts to chemically induce a miscarriage multiple times, all of which fail. Haunted by the memory of his first wife's abortion, Davis consents to her having the baby. In December, he begins looking for a larger apartment.

September 7. Sloan dies. Four months later, after visiting Sloan's memorial show at the Whitney Museum, Davis concludes that his former mentor, whom he had not seen in decades, "had no real talent as a painter and does not communicate his personality."[360]

September 24. Josef Albers, chair of the department of design at Yale University, invites Davis to teach a weekly class in advanced art for six weeks in the fall semester. A month later, Albers asks Davis to stay on for the rest of the term. He continues teaching his evening class at the New School.

October. The Museu de Arte Moderna, São Paulo, includes *Arboretum by Flashbulb* and *Ursine Park* in the Bienal de São Paulo, giving Davis his first international exposure.

November 6. Davis applies for a Guggenheim Foundation Fellowship yet again, citing his desire for uninterrupted time in which to paint.

In the present situation, it is necessary for me to devote time to teaching, writing, giving talks, etc. to maintain a minimum living income as supplement to the infrequent sale of paintings. The time spent in planning and recovering from these activities is far greater than the number of hours involved in the performance of them. They constitute a disruption in the continuity of my ideas, resulting in decreased production.[361]

In April, he hears that the committee has voted in his favor. In preparing his biography for the press, the foundation's associate secretary queries the claim he made on his 1937

application that he studied with Léger in Paris. In clarifying what he calls a "minor infraction of factuality," Davis describes the change in status of European and American art in the intervening years:

It shows clearly how the relative prestige of American versus European Art has radically changed in 15 years. Of course I have been a student of Leger's work for 30 years, but the fact that I said I had studied "with" him indicates the weight I must have thought such an association would carry at the time of my application.

Today, the question of European approval would not be considered of the same importance as an Academic asset. The simple fact is that I met Leger three times in Paris. Was taken to his studio twice and on another occasion I showed him several of my paintings at a friend's studio and received his approval. So much for taking the kinks out of history.[362]

Davis later credits the fellowship with allowing him to take a leave of absence from the New School, thus giving him "a good year's work."[363]

November 21. Davis sees Matisse's retrospective at MoMA. Owing to shipping problems, the artist's cutouts do not go on view until December 7. Davis returns to the museum in January to see them.

December. As part of its Modern American Music Series, Columbia Records commissions Davis to design six album covers—for Charles Ives, Virgil Thomson, Aaron Copland, William Schuman, Douglas Moore, and Walter Piston. The records are released in 1952.

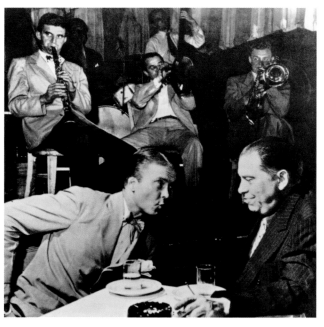

Stuart Davis with Eddie Condon, c. 1946, Estate of the Artist Archives

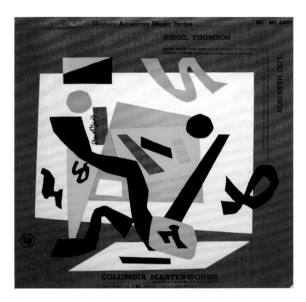

Album cover for Virgil Thomson, *Modern American Music Series*, 1952, Columbia Records

1952

January 6. At their annual meeting, Halpert's artists discuss the gallery's $9,000 loss the previous year despite very good sales. They agree to raise the dealer's commission from 33 ⅓ percent to 35 percent.

January. Davis's incorporation in his paintings of words unsettles critic Ross Valentine of the *Richmond Times Dispatch*, who unleashes a tirade against *Little Giant Still Life* after seeing it in the permanent collection galleries of the Virginia Museum of Fine Arts. He writes, "[W]hen turned upside down, we see cunningly worked into its poster pattern, a word which little boys were wont to inscribe on board fences… a sly obscenity."[364] Rising to Davis's defense and that of their former colleague Sweeney, whose exhibition at the museum had led to its purchase of the painting, Barr and René d'Harnoncourt, MoMA's former and current directors, write to demand an apology from the critic. He agrees to their request, but only if they admit their "impaired vision" in not being able to see the offending word, which he identifies as a "single-syllabled synonym for defecation."[365] Alarmed that Valentine's scabrous interpretation is an attack on modern art in general, Barr, d'Harnoncourt, and others encourage Davis to sue on the grounds of libel, which he forgoes, even after his lawyer's request for an apology from the critic is ignored.

April 17. Roselle and Stuart's only child, George Earl ("Earl") Davis, named after George Wettling and Earl Hines, is born at New York Hospital.

June. Davis, Edward Hopper, Calder, and Kuniyoshi are selected to represent the United States in the Venice Biennale, with each artist allocated one of the pavilion's rooms. Davis is represented by thirteen works surveying his entire career. Writing for *Art d'aujourd'hui*, Léon Degand, one of France's leading critics, singles out Davis's work: "It is necessary to congratulate those responsible for the US Pavilion for having presented, in addition to a very handsome gallery dedicated to various works by Calder, about ten paintings by their country's best modern artist, Stuart Davis."[366]

October. Davis sees Léger's retrospective at MoMA and finds it less gripping than he expected. Yet when Léger dies on August 17, 1955, Davis calls him "the strongest figure in modern art."[367]

November. Barr interviews Davis about *Visa* in anticipation of Gertrud A. Mellon gifting the work to MoMA. In answer to Barr's question about the meaning of the word "else" in the painting, Davis explains:

[The words] were a part of my continuing store of subject matter. And the use of the world "else" in this case was in harmony with my thought at the time that all subject matter is equal… the word "ELSE," while having different associations to different people, nevertheless has a fundamental dynamic content which consists of the thought that something else being possible there is an immediate sense of motion as an integrant of that thought… The word "amazing" was in my mind at that period as being appropriate to the kind of painting I wanted to look at. The word "continuity" was also in my thoughts for many years as a definition of the experience of seeing the same thing in many paintings of completely different subject matter and style. It has no further significance than that.[368]

Stuart and Earl Davis, 1952, Estate of the Artist Archives

December. Halpert temporarily interrupts her exhibition lineup to capitalize on her representation of Davis and Kuniyoshi by reconstituting their Venice Biennale shows on her gallery's first and second floors. She gives the upstairs gallery to the recently hospitalized Kuniyoshi because, as she explains to Davis, "[H]e was sicker and need[ed] the boost."[369]

1953

February 25. The Wildenstein Gallery includes Davis's *Report from Rockport* (pl. 47) in its *Landmarks in American Art, 1670–1950* exhibition, hanging it without a frame above a Pollock painting in the gallery's main room. Faced at the opening with a big crowd and a five-flight walk-up, Davis decides to skip the party in favor of hearing Hines perform at a nearby nightclub.

March 16. De Kooning's third solo show opens at the Sidney Janis Gallery with paintings from his *Woman* series. Many of de Kooning's colleagues, Pollock in particular, feel betrayed by the artist's return to figurative subjects and criticize the show. Davis, however, judges it as "very good."[370] Over the course of the decade his view of de Kooning's work fluctuates. He dislikes the artist's 1956 abstract urban landscapes, calling them "Dutch & Smaltz [*sic*]—authentic crowd bait," but responds favorably to the broad brushstrokes and more expansive pictorial spaces in the artist's abstract landscapes three years later.[371] Despite his occasional criticism, Davis actively endorses de Kooning's membership in the National Academy of Arts and Letters following his own election to the academy in 1956.

April. Davis applies for a renewal of his 1952 Guggenheim Foundation Fellowship. Despite being rejected, he tells New School administrators who invite him to return to teach that they will need to offer him more money to entice him. Their unwillingness to do so ends his eleven-year teaching career there.

Ritchie includes six of Davis's paintings in MoMA's *Twelve Modern American Painters and Sculptors*, which travels to six European countries.

May. Davis describes his painting process during an interview with Fred Wight for *Art Digest*. "I make a black and white drawing [on canvas] as a starter… then I decide on the number of colors to be used in the final execution and mix their exact intervals before starting work… In no case is the color held together by lines and edges… shapes are

defined by their own color intervals."[372] Questioned about whether these color-shapes are in front or back of one another, Davis responds:

It's reversible… you can see the same planes as either advancing or receding in front or in back. What is basic is that there are different planes. I never think of coming forward or going back, that old idea that certain colors are advancing and others are retiring. They're *not*—except in the context of an analogy to some subject matter in the mind of the spectator.

What is required is that all areas be simultaneously perceived by the spectator. You see things as a unit at the same time. What there is, *all* at the same time.[373]

Late Spring. Charles Alan, Halpert's longtime assistant, decides to open his own gallery in the fall and arranges with Halpert to represent half of the artists currently on her roster, including all the young abstractionists and established figures such as Arthur Dove and Lawrence. Rather than replacing them, Halpert decides to focus exclusively on her remaining stable—Davis, Shahn, Marin, Georgia O'Keeffe, Charles Sheeler, and William Zorach—a plan Davis calls "revolutionary."[374]

Summer. Seckler makes several visits to Davis's studio for her *Art News* article "Stuart Davis Paints a Picture," in which she traces the evolution of his *Rapt at Rappaport's* (pl. 55). She recounts how the artist began by reworking the motif of a sketch he made years before in Gloucester, using tape marked with charcoal dashes to create a composition whose "actions" exert equal pull on every part of the canvas.[375] After finalizing the configuration and securing it with turpentine, he applies color using Tri-Tec, an emulsion of casein, oil, water, and wax.[376] Only after he is satisfied with these "color intervals" does he apply a thick coat of oil paint over the Tri-Tec.[377]

September. Charles Alan opens his gallery with a group show of his artists. The exhibition's inclusion of painters previously on Halpert's roster leads Sidney Janis to assume that the Downtown Gallery has closed, and he asks Davis to join his stable. Although Davis earlier disparaged Halpert's adequacy as a promoter of his work, he remains with her, thus perceptually linking his work with early American modernism rather than with the New York school. Davis stays on friendly terms with Janis and sees nearly every show at his gallery.

Fall. Despite steady sales of his work, Davis continues to hedge against the possibility that his success is transitory by accepting paid jury assignments and writing jobs, a

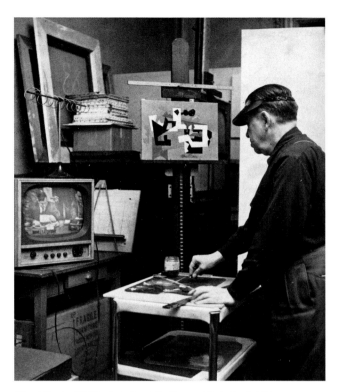

Stuart Davis, 1953, photograph by Bernard Cole for *Art News*

function of what he calls "an economic terror up to this very day."[378] In December, he joins the advisory faculty of the Famous Artists School, a correspondence school in Westport, Connecticut, that advertises itself on matchbook covers. In exchange for visiting the school four times a year to give a lecture and meet with its teaching staff, he receives $2,500 annually, payable in monthly installments. He remains with the school in this capacity through 1962.

1954

January 4. Janis includes Davis's *Rapt at Rappaport's* in his exhibition *Nine American Painters Today* along with work by Pollock, de Kooning, Gorky, Rothko, Still, Hans Hofmann, Kline, and Mark Tobey.

January 15. *Art Digest* publishes Davis's contribution to its issue on the creative process. He takes the opportunity to "drop a few remarks," as he puts it, about his attitude toward picture making:

I should say that first-class Art occurs when the artist becomes able to tell the difference between the content of his subject-matter-feelings-complex and the painting he is working on. In other words, at that point where he no longer imagines himself to be an expressionist, even an abstract expressionist, with a compulsion to act like one. Ability to make the

distinction, and beyond that to see it as a product of simple logic rather than unpredictable and fortuitous revelation, is an obligatory but gratifyingly possible step...

But no formula is foolproof, and this one is sometimes misinterpreted in assuming the painting to have no feelings of its own... The painting does have feelings which are concerned with its own rectilinear mode of existence. If you respect it, you can bend it into a pretzel without protest. In what context of Subject Matter, Theory, Feeling, you bend it is secondary. What is primary is to bend without fracture. The capacity to bend, of course, is a Given Constant, requiring no work. The Subject Matter of one's attention is one's own business. Feelings about these things are what you are stuck with. Making the painting is simply an intelligent and economical deployment of the organic need to activate these elegant faculties.[379]

February. Eero Saarinen, the architect overseeing the expansion of Drake University in Des Moines, visits Davis to discuss a commission for a thirty-three-foot-long mural for the university's newly opened Hubbell Dining Hall to be funded by the Gardner and Florence Cowles Foundation. Davis consults with Halpert about the commission and his plan to hire Guglielmi as an assistant-collaborator. Negotiations over the contract begin in April. By the time it is signed two months later, Guglielmi has made plans to summer outside New York and is unavailable to assist.

March 1. The Downtown Gallery opens an exhibition of Davis's recent work that he calls an "unqualified success with everybody."[380] Halpert sells four major paintings within the first week, three to museums.[381] Critical acclaim comes from a wide range of publications, including *Time*, which calls Davis "as American as bourbon on the rocks" in an article that focuses as much on his personality as on his art:

A dumpy, bejowled man who talks with down-to-earth honesty in a good-natured nasal growl, Davis likes television, football, prizefighting, hot jazz and Manhattan skyscrapers... Davis lives and works in a Manhattan studio, where he puts in long hours at his easel... Davis, who used to play a hot piano himself ("I discovered I could paint better"), admits that his feeling for sharp rhythms and raucous tones is carried over into his clean-cut, hotly colored abstractions.[382]

Howard Devree's review in the *New York Times* assesses Davis's work:

[Davis] has always denied, I believe, that his work was in the generally accepted sense "abstract." In such a painting as "Midi"... there are clearly representational elements such as suggestions of walls and windows. In other pictures he

employs letters, integrated into the over-all design through their shapes and colors. Most of all he makes use of color forms to suggest movement, tension, activity, a certain jazz spirit as typical of the life of our time. Architecture and advertising and package design have admittedly learned much from modern art; so, one may imagine Davis reflecting, these things are now all parts of our life and are legitimate themes for the painter in turn to embody by inference and suggest in his painting.[383]

Spring. With Earl now a toddler and negotiations under way for the Drake University mural commission, Davis accelerates his efforts to find larger living quarters. On April 10, he looks at an eighteen-by-thirty-foot duplex apartment with eighteen-foot ceilings on the ground floor on 15 West 67th Street. Six days later, after showing the apartment to Roselle and Halpert, he signs a two-year lease, with occupancy to begin July 1. During the next two months he arranges every detail involved in the move, including shopping for furniture. Roselle's role is negligible.

June 5. Davis visits Drake University with Saarinen to see the dining hall. The artist's most vivid impression is of "the whiteness of the room—its ceilings and walls—the black floor, the blue sky outside those high windows, and the red rectangles of the brick dormitories."[384] Back in New York, he conceives the mural in three parts because his studio is not large enough to allow him to paint it in one section. By August, he finishes sketching an initial design that he bases on his memories of the severe rectilinearity of the room and the four colors of its surroundings. He later credits the mural's vibrancy to his having limited his palette, a strategy he will use in his subsequent easel paintings.

October. Davis travels to Chicago with Morris and Sweeney to jury the Art Institute of Chicago Annual. While there, he sees Seurat's *Sunday on La Grande Jatte* for the first time. Long an admirer of the French artist's work, Davis later cites Seurat as his favorite artist.[385]

October 22. The Whitney Museum relocates to 54th Street, next door to MoMA. Davis attends the inauguration and pronounces the building "very good" and the opening "very friendly and successful."[386] The next day, he participates in a televised tour of the galleries with other artists.

1955

Winter. Davis has worked all fall finalizing his Drake mural sketch. In January, he projects the design onto three small canvases and draws the configurations in black Tri-Tec. After Saarinen and the Cowles family approve the design, Davis hires his former New School monitor, Jim Benton, to assist him in painting it full size. They finish on April 9. Of the thirty-three-foot-long work, Davis comments:

Allée is a French word meaning an alley or long vista. It is a long painting. Its length overpowered my studio and made a deep impression on my mind. Also, there is another French word with the same sound which means "go." I like this association. I like the variety, the animation, the vigorous spirit which is part of college life. This feeling of energy and vigor was in my mind during the painting of the mural.[387]

The three canvases sit in Davis's studio for five months while experts debate how to frame them. Finally, in August, the paintings are mounted on aluminum stretchers. On September 1, fourteen months after Davis began sketching, the mural is installed in the Hubbell Dining Hall.

February. H. H. Arnason, curator of the Walker Art Center, Minneapolis, begins organizing a retrospective of Davis's work that will open at the Walker before traveling to the Des Moines Art Center, the San Francisco Museum of Art, and ultimately the Whitney Museum.

March. MoMA circulates *Modern Art in America* throughout Europe for a year as part of a government-sponsored Cold War effort to demonstrate American freedom and innovation.

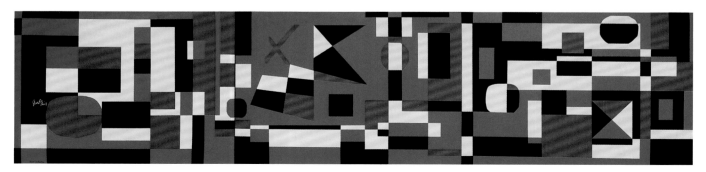

Allée, 1955, oil on canvas, Collection of Drake University, Des Moines, commissioned by the Gardner and Florence Cowles Foundation for Drake University

Davis's inclusions—*Lucky Strike* (pl. 2), *Salt Shaker* (pl. 29), and *Visa*—are touted as a successful union of American subject matter and European formal innovations, as critic Aline Saarinen notes in her review of the show's Paris presentation.

Rather than cooking up much indigenous fare, American painters have, in the main, added varying doses of native flavoring and spices to essentially European recipes. Occasionally they arrive at something "very American" as Stuart Davis's work which in color and jazzy rhythm motifs is as American as a hot dog.[388]

Spring. The National Council for US Art, Inc., a private foundation started by philanthropist and art collector Margaret Lewisohn in 1953, votes to commission contemporary artists to decorate the United Nations headquarters in New York. Two sites are chosen: a conference room and the terrace of the General Assembly Building. The council appoints an advisory committee of museum directors from around the country to nominate sixty artists to submit photographs of their recent work to media-based juries of painters or sculptors.[389] The two juries select five individuals in each category. Davis hears on June 4 that he has made it through both rounds. He visits the conference room in early September and completes his sketch during the following six weeks.

Summer. Worried about having sufficient inventory since she downsized her roster a year earlier, Halpert consults Davis about artists she might add to her stable. He advises against Weber and Abraham Rattner, telling her their work has "too much smaltz [*sic*] for the character of her gallery."[390] At Halpert's request, Davis asks de Kooning if he will allow her to exhibit a few of his pictures, which he declines.

October 4. Halpert opens her season with a show celebrating the gallery's upcoming thirtieth year of operation.[391] Davis works nonstop the week prior to the opening to complete *Cliché* (pl. 65), which Halpert hangs in a room with O'Keeffe's large-scale geometric door painting, a departure for the artist. Davis regards O'Keeffe's new style as a benefit to him, describing opening night as "quite classy because O'Keefe [*sic*] going abstract in large sizes… threw the balance in my favor."[392]

October 24. The Whitney Museum opens an exhibition of the mural sketches and models selected for the UN competition. Davis and Lawrence share the $2,000 painting prize. A Whitney guard tells him that his entry is "best" and that visitors are "for it too," but Genauer, after pronouncing the entire competition futile, blasts Davis's entry as "revealing no apparent conception of or concern for the function—other

than purely decorative—of a work [of] art to be seen by many millions in a setting of such immense symbolic significance as the United Nations."[393] She goes on: "The Stuart Davis abstraction, incorporating the letters U.N., would, magnified to thirty-five feet in length, almost beyond question be as obvious and superficial as a highway bill-board."[394] Never one to let an accusation go unanswered, Davis responds immediately, chiding Genauer for the "irresponsibility" of her critique.

A clear impression is created that I had no integrity of purpose in this project, no understanding or concern with its potential public function, and no artistic capacity to decide what is or is not appropriate to the mural space in question. These charges are factually untrue and probably illegal. As a "well known and gifted" artist I ask that some kind of face-saving apology be made in print… to repair an idle and random libel to my reputation.[395]

Genauer's overall negative appraisal of the sketches and models is shared by the United Nations, which judges the entries incompatible with the organization's mission and abandons the project.

December 5. Davis sees Pollock's show at the Janis Gallery. He applauds the artist's 1950–1951 pictures as "the most direct and uncluttered specimens of the essential content," but dismisses the younger artist's recent work as "heavy handed ballad-type lyricism in large economy size."[396]

1956

January. Davis is elected to the National Institute of Arts and Letters.

February. Despite Davis's earlier doubts that casein is "just a fad, some kind of commercial promotion," he switches from Tri-Tec to casein as his underpaint.[397] The change corresponds with a heightened impact in his paintings as he amplifies the saturation of his color and expands the scale of his shapes. Davis deems the result "a new era of drawing" and "a new sense of a 'wall' painting to be hung without a frame."[398]

February 7. Of Guston's show at the Janis Gallery, Davis notes: "Very good. Free brushwork. No familiar subject but directly referential to Monet's lilyponds."[399] Two years later, Guston's work disappoints him: "pissed out in relation to his show of 2 years ago. No composition hence no direction."[400]

March. Davis is one of seven artists *Fortune* commissions to paint a still life of supermarket products. The magazine reproduces *Package Deal* (pl. 70) in its September issue. Six years later, Davis explains his process for creating the gouache:

[I] brought a lot of groceries from the store and laid them down there on the floor and looked at them and made several compositions over a number of days until I found something in a drawing that looked like a painting, or was paintable. And then I did it and the names in it… have a certain wit. I just made a composition which was directly inspired by sensory impact of the stuff. I can't seem to get away from that… after I had done it I had the feeling I could do something more with it… I was interested in this idea about yellow which I had used in several canvases… When I use color I use it in the sense that a color is a place, a position different from another color.[401]

March 10. Davis meets Kootz by chance on the street and exchanges greetings with the dealer for the first time since their quarrel. Thirteen days later, he visits Kootz's gallery.

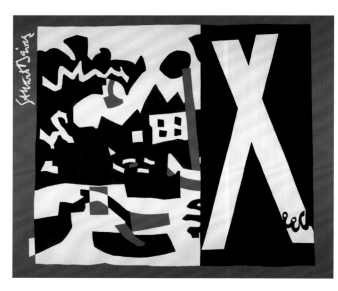

Lesson One, 1956, oil on canvas, Yale University Art Gallery, Charles B. Benenson, B.A. 1933, Collection

May 10. Not realizing that Davis's upcoming Walker Art Center retrospective is scheduled to travel to the Whitney, Ritchie proposes organizing one for MoMA. As Davis later recalls: "I said, 'Hell, it's too bad. You're just a day too late, but if you can convince Whitney to drop it, I would be willing to have it in the Modern Museum,' so he talked about it to whoever, but they insisted on having it at the Whitney, so that's where it was held."[402] Disappointed, Ritchie tells Davis he has wanted to organize a retrospective of his art for the last ten years.[403]

June. *Something on the 8 Ball* (pl. 59) is exhibited in the US Pavilion at the Venice Biennale in a group show of realistic and abstract paintings of urban environments. Davis declares the city "man's greatest invention" in the text he drafted for the catalog:

All of my paintings affirm an urban continuity, a measurable juxtaposition. One might say they have a sense of neighbor-hood,—mutually exclusive neighborhoods of course.

Since a painting is only a drawing after all, it is a mistake to look for identifications among its elements that are alien to its reality. I refer to the demand, occasionally made by some people, for the name, meaning, and creden-tials of certain shapes in the painting. Such identification is not impossible, but the odds are heavily against it. In a way it is like asking a New York traveler in Europe whether he knows a friend of yours in Bolivia. Similar inquiries about the meaning of a painting's title are not uncommon. But the making of a good title is mostly a process of elimination. One does not seek a set of words that immediately confuse them-selves with a drawing already presumed complete. The validity of an attractive title, its appropriateness, depends on the faculty of total non-recall: 'Something on the Eight Ball', for all practical purposes, is simply a headline on somebody else's newspaper.[404]

Halpert plans to organize a show of Davis's recent work at her gallery to coincide with his retrospective at the Whitney Museum. When Goodrich, now associate director of the museum, hears the news, he phones her to say that the show "should not be held in the same year" as the retrospective.[405] Davis considers the request "absurd," but ultimately agrees to hold the gallery show that November.[406]

June 9. Davis appears on Malcolm Preston's WOR televi-sion program *American Art Today*. He describes the setup: "We talked about some reproductions of my work at a desk then we walked over to [the] easel where he made some sketches of types of abstract art then we stood in front of repro's on wall and talked about them. Went off without a hitch."[407] Preston phones later that evening to say how pleased he was with the program, which he regards as one of the "tops of the series."[408]

Fall. The Guggenheim Foundation establishes the Guggen-heim International Award. Twenty-two nations participate in the contest, each selecting five artists who are represented by one work apiece. Davis's *Colonial Cubism* (pl. 62) represents the United States, along with paintings by Tobey, de Kooning, Charles Burchfield, and Jack Levine. Ben Nich-olson of England wins the international award; Tobey wins

the US prize. *Colonial Cubism* is included in the exhibition of all nominated works at the Guggenheim Museum in March and at the Musée National d'Art Moderne, Paris, in November.

November 6. The Downtown Gallery opens its exhibition of fourteen of Davis's recent paintings and gouaches, including *Cliché*, *Ready-to-Wear* (pl. 63), *Stele* (pl. 66), *Memo* (pl. 69), and *Tropes de Teens* (pl. 67). As a surprise, Halpert hires Wettling's trio to play at the opening, which more than one hundred artists, collectors, and museum professionals attend. Viewer response is enthusiastic. De Kooning tells a mutual friend that he is "impressed with [Davis's] achievement of 'completeness,'" while Hilton Kramer praises the artist for having modernized Ashcan realism by "stripp[ing] it of its romanticism" and making it "face up to the bright new vulgarities of our mechanistic civilization" in his piece in *Arts Magazine*.[409]

In [the] process he substituted for the realism of his elders a montage-like abstraction which derived its components from the urban life around him but which were now, under the dispensations of modernism, purified and re-designed to form a more direct plastic equivalent of the local emotion he was trying to convey… just as the Ash Can painters touched upon something genuine in their images of American life, Davis too has his own vein of truth, his truly indigenous side. It consists, I believe, in fastening upon the whole vulgar surface of New York… and making out of it an artistic statement for its vitality. I suspect that anyone who finds these qualities in our civilization distasteful will never be very comfortable in the presence of Davis's work, but that—as I said earlier—may be a measure of his success.[410]

December 27. Davis sees Pollock's memorial show at MoMA and concedes that the younger artist "has Art quality but it is very generalized and arrived at the hard way."[411]

1957

February. The H. J. Heinz Company commissions Davis to create a seventeen-by-eight-foot mural in red, white, blue, and black for the lobby of its new Gordon Bunshaft–designed research center in Pittsburgh. In Davis's preliminary conversations with Bunshaft, they agree that the mural should be in one piece and considered "a 'painting' not an integral decoration."[412]

March 5. Davis receives the Brandeis Creative Arts Award at New York's Ambassador Hotel, presented by Nelson

Rockefeller, who gives him a "flattering introduction."[413] Typically self-confident, Davis observes that he made a "few remarks that went over good."[414]

March 29. The Walker Art Center opens *Stuart Davis*, a survey of fifty-five works representing the spectrum of his career but emphasizing his art since 1946. In an interview published in the exhibition's catalog, Davis explains his aesthetic philosophy:

The old type of painting, which was valid for its time, was one wherein things were seen in a slower-living atmosphere. The speeds of moving from place to place were very much slower; the communication of ideas was thousands, literally thousands, of times slower than it is today. Today the visualization of an image which would express the content of an artist's thought about what things are, what the visual character of the subject matter of his thoughts was at any time, is a multi-faceted affair. We have information about events all over the world practically instantaneously with their happening…

These events and incidents which are the subject matter of our interest in living today, follow one another in rapid succession. And it doesn't stop on Sundays or holidays—it's a continuous thing. So in order to establish any sense of balance in this multiple impact of life, we use what I suppose you would call abstract generalizations, which can stand for a whole group of things. We maintain our balance under the impact of this multiple series of events, but we also have the capacity, in maintaining our balance, to group them.[415]

Elaine de Kooning reviews the show for *Art News*:

Today, when hectic, automatist techniques so often and so surprisingly result in ingratiating, decorative, and vaguely naturalistic imagery, a painting by Stuart Davis, with its strong, "ready-made" colors and sharply cut-out shapes, has somewhat the effect of a good sock on the jaw…

His style, developed between two continents and two wars, is as insistently remote from Synthetic Cubism that was his starting point as it is from the American Action-Painting that surrounds him today…

Cubism, after all, is an indoor art, full of nice, comfortable, old furniture and friends of the family. But, although for Davis, a pack of Lucky Strike could be unobtrusively substituted for a guitar, you really can't have Whitman's Open Road run through the parlor without changing the look of things…

More intensely than any painter in our history, he offers a specific, objective national experience. It is the experience not of our natural landscape but of America as man-made. The brittle animation of his art relates to jazz, to movie marquees, to the streamlined décor and brutal colors

of gasoline stations, to the glare of neon lights, to the flamboyant sweep of three-level parkways, to the fool-proof shine of stainless steel diners, to the big, bright words that are shouted at us from bill-boards from one end of the country to the other… he expresses in his work the concept that one glance should be enough to see what you're looking at, since the chances are you're going someplace else fast.[416]

April 3–5. Davis participates in the American Federation of the Arts' three-day conference in Houston, at which Duchamp delivers his now-famous paper "The Creative Act."[417] Davis is on the Sweeney-moderated keynote panel, "The Place of Painting in Contemporary Culture," with Meyer Schapiro and Randall Jarrell, poetry consultant at the Library of Congress. In his prepared remarks, "The Easel Is a Cool Spot at an Arena of Hot Events," Davis reiterates his belief in the superiority of objective over subjective art.

My personal guess as to the Meaning and Enormous Popularity of Modern Painting goes somewhat as follows: – I see the Artist as a Cool Spectator-Reporter at an Arena of Hot Events. Its continuing appeal to me since the Armory Show of 1913 is due, I believe, to its American Dynamics, even though the best Reporters then were Europeans operating in terms of European Identifications. Fortunately, we have our own share of Aces today. In his Professional Capacity the Modern Artist regards the subject of Subjective Feelings as a Casualty and never confuses them with the Splendor of the Continuity of Process, the Event itself. I see the Paintings as being made by Competent Workmen outside the self — not as a Signed Convulsion communicating an Enormous Capacity for Frustration with the Outside. I am aware that a number of excellent Artists today might seem to fall into the latter category and would regard my remark as offensive. But Offense is no part of my intention which is entirely one of Notation. I believe that there is a vast Audience which, like myself, is more interested in the Scenery than the Familiar Furnished Room of their own Short-Circuited Emotional Wiring.[418]

Art News reprints Davis's speech in its summer issue.

May 6. Davis's mother, Helen, who has been spending winters in Florida and living the rest of the year in a rented studio in Gloucester, suffers a heart attack after months of experiencing pain in her left side and periods during which she cannot speak more than a few words. Upon her release from the hospital, she moves in with Alice Winter. Stuart dutifully checks on his mother every week and sends her money when she needs it.

May 23. Davis completes his preliminary design for the Heinz mural, basing its composition and color on

photographs and a model of the site. H. J. ("Jack") Heinz II sees the sketch with Bunshaft and objects to its palette. Davis describes the meeting:

[Heinz] argued for 1 ½ [hours] about the Blue without being able to make any concrete suggestions. I went along with him explaining why Red and Blue were the Logical colors for the Architectural Color Scheme. I satisfied the "reasonable changes" clause. Actually Heinz wanted to dictate the colors without the ability to do so, or the right.[419]

That evening, Bunshaft phones Davis to say that Heinz was not persuaded by Davis's arguments and wants the mural redone in a dominantly blue color, which Davis refuses to do. "I told him it was not possible and that I would carry out my agreement… to do a small section in oil."[420] Once Heinz sees the small oil version of the mural, he approves it.

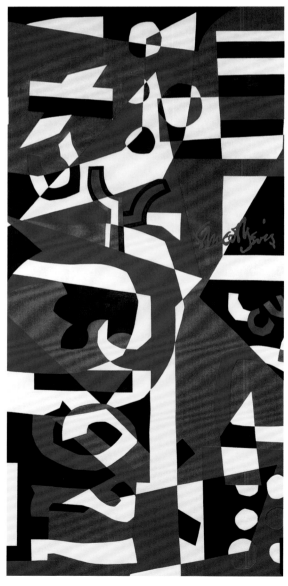

Composition Concrete, 1957, oil on canvas, Carnegie Museum of Art, Pittsburgh, Gift of the H. J. Heinz Company, 79.42

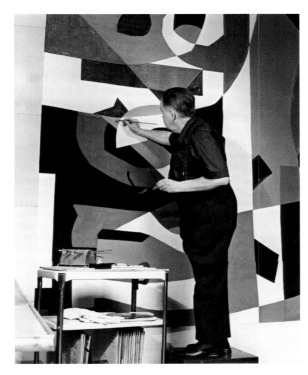

Stuart Davis working on *Composition Concrete*, 1957, Estate of the Artist Archives

Summer. Davis sends Roselle and Earl to Fire Island, an islet off the shore of Long Island, for the summer and hires Jim Benton to assist him in painting the Heinz mural. He solves the problem of painting such a large canvas in his studio by devising a wooden roller suspended from the ceiling over which he swings the canvas. For twenty-one days, Davis and Benton work together on the mural. Then, on July 30, Benton is diagnosed with hepatitis and hospitalized, leaving Davis to manipulate the roller and paint the mural by himself. On August 19, he finishes it, writing, "41 days from start/20 days by myself/well done—and thank God I've still got enough strength to do it."[421] Bunshaft agrees to have *Composition Concrete*, as Davis titles the work, mounted on a panel without a frame and adhered to the wall with beeswax. In February, workmen install the mural in the Heinz Research Center without Davis. At its formal unveiling in May, Jack Heinz declares it to be "exactly what we wanted. It gives vitality to the whole room."[422]

September 13. The Whitney Museum schedules the opening of its Bradley Walker Tomlin show for the same night as the private viewing of Davis's retrospective. Davis reacts immediately: "A scandal and typically Whitney stupid. Halpert agrees... I phoned [Whitney director Hermon] More and told him what I thought. He said he was sorry but nothing could be done about it as invites were already sent."[423] After Halpert speaks to John Baur, the Whitney curator assigned to install the show, the museum postpones Davis's opening. More apologizes to Halpert, telling her

that the "Whitney wouldn't want to lose such an old friend."[424] Davis refuses to write a note of thanks to the Whitney director.

October 3. The Whitney opens Davis's retrospective with a party for a select crowd of about one hundred guests. Press response is favorable. James Thrall Soby writes what Davis calls an "unexpected eulogy" in the *Saturday Review*.[425]

It therefore comes...as a relief to find an artist who gets a second wind in midcareer and is not pushed aside in terms of public and professional esteem by younger men. A case in point is Stuart Davis... There was a time during the very late 1930s and early 1940s when Davis seemed less vital as an artist than he had been earlier. The Museum of Modern Art's retrospective exhibition of 1945 appeared to confirm this view in that only one picture in the show was dated later than 1942. And then suddenly Davis jumped to his feet again, spryer and more inimitable than ever.[426]

Davis assesses the show a "great success and liked by everybody."[427]

October 10. John Wingate interviews Davis for *Night Beat* on Channel 5. "T.V. program went off as per schedule and apparently made good impression," Davis notes in his calendar.[428]

Fall. Norman Cousins, editor of the *Saturday Review*, asks Davis to review Ethel Schwabacher's biography of Gorky. Calling it a "miserable task," Davis completes the article in November.

I wrote the review on Gorky with difficulty because there was a conflict between the subjective personal and the greater objective fact. The subjective includes the Author, the Whitney, Janis and other commercial interests. The objective part is *Art* and the role of Gorky as a public man with responsibility to uphold the highest standards of art. I chose the latter.[429]

In the review, Davis commends Schwabacher's monograph for being "adequately illustrated" but regrets that this is as far as he can go in "validating" the book.

I find a complete disparity between the avowed intention to present Gorky the artist, and the subjective sentimental, and at times gossipy manner of its doing. Mrs. Schwabacher indicates that we are to take Gorky as an artist of originality, an inspirer of the young, a genius, and a maker of masterpieces... But actually I find a continuing stress on Gorky, handmaiden of Misery... Her emphasis on the poverty angle takes time out to misinterpret some stimulating remarks

I wrote about Gorky at her request a number of years ago. They seemed "derisive" to her, and she warns that poverty is not a pose… The simple fact is that Gorky was continuously poor, and that he shared this "un-posed" condition with practically the entire artist-population of Greenwich Village at that time. He had many unique qualities but poverty was not one of them… A more serious diversion from the main point occurs in the numerous explanations and lengthy interpretations of meaning of his pictures. Interpretation of symbolic identifications is a parlor-game that has no end, and little relevance. Gorky's prodigious appetite for art materials was matched by his need to verbalize to all and sundry about his art enthusiasm at the moment… It is possible that Mrs. Schwabacher, as his student, took these discourses at face value.[430]

Willem de Kooning and Goldwater praise the review; Goodrich is "outraged."[431]

December. The *New York Times Magazine* asks museum directors which post–World War II American artist will endure. Davis receives the most nominations.[432]

Sales of Davis's work yield sufficiently high income for the year that his accountant recommends that he donate art to offset taxes. He gives one painting each to the Wadsworth Atheneum and the Lane Foundation, whose president, William Lane, is a major patron of the Downtown Gallery.[433]

1958

January. The Whitney Museum opens *Nature in Abstraction: The Relation of Abstract Painting and Sculpture to Nature in Twentieth-Century American Art*. Davis's catalog statement reveals the philosophical change that has occurred since his early days when he roamed the hills of Gloucester with painting supplies in tow: "I can take nature or leave it… Mostly the latter. I am more interested in what man does to nature than what nature does to man."[434]

January 20. George Braziller Inc. proposes producing a monograph on Davis's art. Discussions about the book continue through the fall, with Fred Wight, Elaine de Kooning, and Robert Cato suggested as authors at various times. In February 1959, Braziller selects art critic and historian E. C. Goossen.

March. MoMA takes the lead in disseminating abstract expressionism abroad. Under the auspices of its International Council, Dorothy Miller organizes *The New American Painting*, an exhibition of the work of seventeen abstract expressionists. The show's yearlong tour to eight European countries solidifies the movement's ascendancy.

Mid-Spring. Relations between Davis and Roselle have been strained for years, most likely over Roselle's volatility and Davis's absorption in his art, which he considers "self-realization in the most complete sense."[435] Now, tensions escalate over the pressure Roselle feels as a mother and Davis's aversion to sentimental displays of love, which he once called "the Poor Man's substitute for Art."[436] On April 13, Roselle suffers a perforated ulcer. Her sister, Marie, accompanies her by ambulance to New York Hospital, where Roselle is given multiple blood transfusions and fed intravenously. She continues to bleed for days. Davis arranges for babysitters to care for Earl and to cook for them during her absence, but at her request, he rarely visits—an appeal she also makes to her sister.[437] Roselle returns home on April 30. That evening, her doctor phones to remind them that they "must prevent scenes."[438] Frictions persist, however, and in late May, her doctor advises her, without success, to go to the country for a few weeks.

April 17. Davis's *Place Pasdeloup* is included in the US Pavilion at the Brussels World's Fair.

May 6. Charlotte Willard of *Look* magazine asks Davis to select an unrecognized artist he considers worthy of attention. He chooses Joseph Glasco, a young abstract expressionist painter-turned-sculptor with whom he has been spending time. The article does not appear until November 1959.[439]

May 26. Lack of circulation in Davis's right leg, which has troubled him for decades, becomes so acute that he consults a doctor, who prescribes keeping it elevated for a week, soaking it, and using it in moderation for the next month. Six years later, doctors remove an ulcer on the leg.

May 31. Gilbert Seldes, host of the NBC television program *The Subject Is Jazz*, exhibits reproductions of art by Mondrian, Calder, and Davis while playing jazz records. Davis phones Seldes the next day to ask why he was not told in advance that his work was going to be featured on the program.

June 12. Relations between Davis and Roselle reach a breaking point, and she moves with Earl into the Walton Hotel for almost two months. Davis sees Earl by appointment and Roselle only rarely, noting about one of their meetings, "She explained her position and I could see its logic."[440] In August, Roselle and Earl return to the apartment, but the couple's relationship remains fraught.

Summer. Interviewed by John Ashbery for the summer edition of *Art News* on contemporary artists' attitudes toward art of the past, Davis recounts the impact the Armory Show had on him.

I was struck first of all by Van Gogh and Gauguin. They used color in a creative instead of a descriptive way, and this free color invention was easy for me to understand.

Later on I felt the influence of Cezanne and especially of Seurat. Seurat has no color, but… his vision of objects in an environment of space taught me a great deal and still does.

Then there was Cubism, in line with the feeling about space that Seurat had. I found it tremendously inspiring, though I never did a Cubist picture. What I got out of it was the fact that you could think about space as freely as you could about color.[441]

June 30. Davis's *Memo* is nominated for the US section of the Guggenheim International Award, along with one work each by Rothko, Hopper, Willem de Kooning, and Kline. Miró wins the international prize; Rothko receives the US award.

October. Abrams proposes publishing a portfolio of Davis's work with an introductory essay by Arnason and short texts by Davis on ten paintings to be reproduced in color in the portfolio. After Braziller agrees it will not jeopardize sales of their forthcoming monograph, Davis signs a contract with Abrams and begins writing the texts. Over a year later, the publishing house cancels the project.

Winter. The US Information Agency includes Davis's *Summer Twilight* in *Nine Generations of American Art*, an exhibition that circulates to Europe and Israel for two years.

1959

March 5. The Whitney Museum opens a loan exhibition of art selected by its patrons; included are four paintings by Davis, which he notes in his calendar "knocked everybody out."[442] In a sign of his esteem within the museum, the show's catalog contains a partial reprint of his 1943 article "The Cube Root."

April 3. Appearing on Bill Leonard's CBS program *Eye on New York*, Davis freezes when the cameras go on and shouts out a blasphemy that the program editors cut. He later recalls it as a "depressing experience and a shameful performance before the entire T.V. watching world."[443]

April 4. In *Arts Yearbook* Davis discusses the relationship between artists and the art establishment:

I wish to note in passing, without revealing any trade secrets that the Artist is a Foundling, an Orphan, whose miserable foster parents consist of Dealer, Museum, Critic, Collector and the like. From that status as given, his actuarial potential improves relative to the availability of these vultures. He can layoff some of his bets. That is what makes New York so great. The Place is crawling with entrepreneurs in the field of Art whose motivations cover the entire range of human ingenuity. The rate of their voracity complements the voltage of the artist's vector. Of course, it's a fight to the finish, but that's the way it is.[444]

May 16. At the close of Miró's exhibition at MoMA, Monroe Wheeler, MoMA's director of publications and exhibitions, invites Davis, de Kooning, Motherwell, Guston, and Rothko to have drinks with the Spanish painter, followed by dinner at the home of MoMA curator Peter Selz. It is the first time Davis meets the artist who so powerfully influenced his work earlier, yet he makes no mention of the evening other than noting its occurrence.

May 20. Grove Press commissions jazz critic and record producer Rudi Blesh to write a monograph on Davis.

June. The US Information Agency organizes the *American National Exhibition*, a massive display of American art and consumer products to be shown in Moscow to encourage cultural exchange between the United States and the Soviet Union during the Cold War. A four-person committee selects sixty-seven examples of American art made since 1918, including Davis's *Combination Concrete #2*. Immediately after the list of selected artists is made public, the House Un-American Activities Committee investigates the artists' political affiliations and recommends that the works of more than half of them—Davis's included—be removed because of what the committee claims is their involvement with Communist fronts and causes. Only the intervention of President Dwight D. Eisenhower averts a crisis. On opening night, US Vice President Richard Nixon and Soviet Premier Nikita Khrushchev get into a heated argument over the relative merits of Communism and Capitalism as they tour the exhibition. Recorded on film and aired in the United States and the Soviet Union, the "kitchen debate"—so called because it takes place while the men are standing in the exhibit's model kitchen—becomes an infamous episode of the Cold War.

Summer. Braziller publishes Goossen's monograph *Stuart Davis* as part of its Great American Artists series. Goossen opens his text with praise for Davis's aesthetic tenacity.

[Davis's] is an art so resolutely founded in principle that even when an individual painting can be judged unsuccessful it

suggests the fineness of the principles behind it. At a moment when vagueness about pictorial structure is being used to support all kinds of rationalizations after the fact, Davis' clean-cut assertions make weaker painters uneasy. The best of the younger artists, however, recognize and respect what he stands for and thus assure the permanence of his position in the chronology of American (now International) painting. The larger public, mesmerized by the violent and episodic careening of modern art and artists, often seems to have forgotten that painting is an art involving composition as well as personality. Astute eyes, however, have never turned away from Davis. They see why and how he has purposefully and patiently worked to create again and again the kind of pictures he wanted to paint, pictures with the kind of pictorial structure which characterizes the best in the greatest painting traditions. And when the younger artists are howling about commitment, they need only to turn to Davis for an example of the highest order.[445]

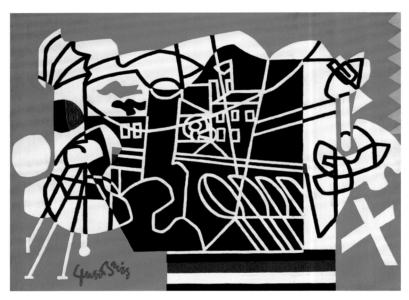

Ways and Means, 1960, oil on canvas, Private collection

August 4. Blood tests show a malfunction of Davis's liver.

August 7. Bob Brown dies. Five months earlier, Davis took a break from painting *The Paris Bit* (pl. 78), based on his 1928 *Rue Lipp*, which includes the image of an imaginary poster advertising Brown's recently published poems. With Brown's death, Davis takes up the composition again, creating an homage to his poet friend by adding the color black and the words "unnecessary" and "Eraser." In October, he sells the painting to the Whitney for $13,500.

1960

January. Davis's work pace becomes more methodical, with each painting taking him months to complete. With his last show at the Downtown Gallery now three years past, Halpert proposes an exhibition for March. When he tells her it is "ill-advised… artistically, qualitatively, and business," she suggests hosting a show of the paintings Grove Press is reproducing in color in its upcoming monograph on the artist.[446]

February 1. Davis signs a letter supporting the visa extension of Yayoi Kusama, a young Japanese artist Kline sent to him shortly after she arrived in New York in June 1958. Having seen her work multiple times at the Brata Gallery on 10th Street, he endorses it as having "great singleness of purpose. Original."[447]

Spring. Davis's *Première* (pl. 73) is nominated, along with one work each by Kline, Still, Robert Mallary, and Nathan Oliveira, for the Guggenheim International Award by the US jury. In October, Davis hears that it has won the $1,000 US award. Karel Appel of the Netherlands receives the $10,000 international award.[448]

April. Davis is diagnosed with arteriosclerotic heart disease and put on diuretics and digitalis, medications he stops taking six months later owing to their side effects.

May. Grove Press publishes Blesh's monograph *Stuart Davis*, which Halpert deems "good."[449] Davis's response is more reserved: "all things considered it is pretty good. At least his attitude is friendly."[450] As planned, Halpert mounts a show of ten of the paintings the book reproduces in color. Davis judges the show "successful," but with no new work included, it generates little attention.[451]

June 24. Hazel undergoes an operation to remove a tumor. The news unnerves Davis, who does not hear from her for nine days. "Your letter of July 3 was the first direct word from you since you went to the hospital. It sounds healthy, as the tone of anxiety is checked by faith. I will pray for you in the faith that prayer is real."[452]

July 7. Despite his previous mishap on the CBS program *Eye on New York*, Davis is invited to appear again, with Leonard interviewing him on the relationship between art and jazz in connection with MoMA's weekly jazz concerts. Davis describes his return visit to the television station as a success: "[I]t was agreed that I didn't have to move out of the chair and stand around different chalk marks as on the previous occasion. It was the latter requirement that created havoc before…I am glad to report that everything went off perfect. Wettling was there which helped my morale."[453]

August 23. Halpert discovers that her longtime employee Lawrence Allen has been embezzling money from the gallery for years. She fires him immediately, freezes his pension account, and threatens to have him arrested unless he signs a confession in front of the police. Some of Halpert's clients believe her accusations; others do not. Davis is silent on the issue.

Winter. Davis describes his concept that drawing and color are synonymous in an article for *Famous Artists Magazine*:

I gradually learned that it is impossible to make any mark on a surface without setting up a positional and a color relationship.

I compose and develop my picture as a line drawing… I do not regard this drawing process as a thing apart from or preliminary to making the painting. I consider that it is the painting at a certain stage of its maximum development, and I continue the drawing until I feel that its over-all configuration has reached a degree of complexity and completeness satisfactory to the impulse that initiated it…

What remains is to increase its visual impact through the use of stimulating color intervals.[454]

In *Daedalus*'s special issue entitled "The Visual Arts Today," Davis restates his view that simultaneity is the defining quality of contemporary experience:

Contemporary Culture as a Subject includes the Past in the form of the Past and the Present Individual Formulations of it. These exist on the same plane of our Awareness with what is Uniquely Immediate to the Twentieth Century. The latter includes New Lights, Speeds, Sounds, Communications, and Jazz in general, as the Ornaments of daily Experience. Their continuous presentation to the Front Page of our Common Sense constitutes a Montage Perspective—a Short Cut to the necessary Implementation for Knowing you are Alive. It holds the promise of an Automation Psychology suited to the Know-How for a Pre-Fabricated Humanism. It suggests a Button for the Correct determination of Obligatory Moral Categories.[455]

1961

January. *Pochade* (pl. 75) wins a $750 cash prize in the Art Institute of Chicago Annual.

February 26. Davis, de Kooning, Motherwell, Newman, Schapiro, Thomas B. Hess, and John Cage are among the fifty-two artists, critics, and collectors who sign a letter to the *New York Times* protesting the views expressed by the newspaper's chief art critic, John Canaday: "[W]e regard as offensive his consistent practice of… input[ting] to living artists en masse, as well as to critics, collectors and scholars of present-day American art dishonorable motives, those of cheats, greedy lackeys or senseless dupes."[456] The letter generates more than six hundred responses, both pro and con, a number of which the *Times* prints. Hopper writes in support of the critic:

There have been, I believe, other efforts to silence John Canaday's voice, but heretofore they have failed.

There are, I have heard, strong forces of money and influence against him, as there would naturally be, but I believe John Canaday is the best and most outspoken art critic the Times has ever had.[457]

February. In a text for an exhibition at the Krannert Art Museum, located at the University of Illinois at Urbana-Champaign, Davis reiterates his conviction that art's effectiveness rests on its objective expression of the pleasurable experiences of everyday life:

I have always held that a painting has effective public currency as an independent object, not a subjective reflection of one. The *content* of the best *art* corresponds to the freshness of subjective experience that initiated it, but communicates in an objective visual grammar and syntax. Art of this kind doesn't wear out because it is based on the gift of pleasurable response to simple things in daily life, a faculty shared by most people. These remarks constitute a fast rundown on an attitude, not a philosophical pretention.[458]

March. Katharine Kuh interviews Davis for her 1962 Harper and Row book *The Artist's Voice*.

Question: Why do you use words so often in your paintings?

Davis: …The artist sees and feels not only shapes but words as well. We see words everywhere in modern life; we're bombarded by them. But physically words are also shapes… In choosing words I find that the smallest idea is equal to the greatest. I've used insignificant words and drawn insignificant objects because at times these were all that were at hand. By giving them value as experiences and by equating great with little, I discovered that the act of believing was what gave meaning to the smallest idea…

Question: Do you make preliminary sketches?

Davis: Yes, I make a lot of preliminary sketches, but the process of arriving at a satisfactory one takes weeks, even months. Mostly I use black and white drawings as sketches. The next step is to put the black and white drawing on the canvas. Then I define the larger areas in color…

Question: What part does color play in your work?

Davis: It doesn't play any part in and by itself; my color is not decorative. But I consider that visual images exist only through color and the artist always has the choice of two or more colors. Even just two colors can define a front and back space, though which is front and which is back is irrelevant. What is important is that the two colors are not in the same place… They're either in front or in back but they change as you look at them. It's a common optical experience to differentiate between front and back. In daily living it's practical and necessary to do this; but in a painting, space doesn't involve practical hazards. You can't break your neck in a painting. Even though you use the same sense of space in a picture that you use in crossing a street, you don't have the same obligations. With a painting you're completely *free* to *appreciate* your optical faculties.[459]

Hazel Foulke dies, leaving Davis as executor of her estate. Roselle goes to Philadelphia with Earl to handle its logistics, planning to stay several months. In her absence, Davis writes out instructions about what to do with his body when he dies.

It is my wish that my body be cremated following my death. Following that, I ask that anyone who may be in charge of this ultimatum shall find a way to dump the ashes on the West side of Broadway, N.Y.C. between 65th/66th Sts. If the preceding suggestion is frustrated I propose that a similar attempt be made on 7th Ave., N.Y.C., the East side of the street between 13th and 14th Sts. Finally, if the 2 preceding suggestions turn out to be unfeasible, I ask that the mess be taken to Secaucus, N.J. and dumped on an abandoned pig farm.[460]

April 2. Alarmed by Davis's acute shortness of breath, Halpert phones Roselle in Philadelphia, telling her to return immediately to New York. As soon as she arrives, she arranges with Davis's doctors to have him taken by ambulance to Gracie Square Hospital, where he is diagnosed with congestive heart failure. He remains in the hospital for two weeks. Once he returns to painting, he substitutes masking tape for the T-square he had used previously to lay out long lines, telling a friend he is not "keen on" physical exertion since his illness.[461] For the rest of his life, poor circulation of blood to his heart leaves him feeling weak.

May. Davis contributes a reminiscence on Mondrian to *Arts Yearbook*, warmly describing his two encounters with the Dutch artist but dismissing his "preposterous notion that you could get rid of all the paraphernalia of pictorial usage and still have a satisfactory painting left."

All that concerns us for the purposes of these remarks is that he set off a bomb.

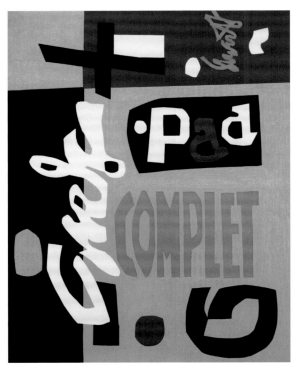

Standard Brand, 1961, oil on canvas, The Detroit Institute of Arts (pl. 79)

Under the impact of its shock waves the rigorous and splendid images of Cubism seemed to take on the appearance of an uncured yak-hide rug for the time being. A hard-sell campaign developed in which the key words, "Pure" and "Plastic" were stressed. The Scotch Tape division of the Minnesota Mining Co. called in experts to trace an enormous but unexplainable increase in sales. I passed through these events without becoming too deeply involved, due to a slight touch of Rococo in the code of my genetic alphabet…

I found him to be a most amiable and sympathetic man, despite certain minor semantic oppositions in the designation of our enthusiasms. His preference for the term "Abstract" left me unmoved, but there seemed to be mutual unstated agreement that Nature was a great thing provided you didn't get mixed up with it.[462]

June 12. Davis tapes an interview with Brian O'Doherty in the basement studio of Riverside Church, inaugurating a warm friendship with the artist-writer, who later writes a chapter on Davis for his book *American Masters: The Voice and the Myth*.

Summer. Helen moves into a nursing home, precipitating a series of recriminating letters between Stuart and his brother about financing her care. Stuart demands on moral and legal grounds that Wyatt contribute fifteen dollars a month; Wyatt fires back, accusing Stuart of being "offhand, bored, callous and fundamentally irresponsible" in relation to their mother and refusing to send money on the basis of his own financial responsibilities and Stuart's far greater prosperity.[463]

Davis increasingly has difficulty breathing. His doctor prescribes new medication for his heart, but an inconclusive cardiogram leaves the artist without a clear path to recovery. The critic for *Time* magazine observes that Davis "complains a good deal these days about not feeling too well. When asked specifically what ails him, he sweepingly announces, 'I'm sick!'"[464]

February 2. The American Institute of Architects notifies Davis that he has won its annual award, to be presented at the group's convention in Dallas in May. Poor health prevents him from accepting the award in person, as he explains to the committee chair: "I regret very much that some recent medical problems have made it impossible to join you in Dallas. I had looked forward to the convention with great interest and had hoped to express my thanks to the Comm. of Awards in person."[465]

March. Davis is nominated for the Philadelphia Arts Festival Award in painting but is not well enough to attend the ceremony, a prerequisite for receiving the award. Unable to travel even ten blocks to the Downtown Gallery without difficulty, he sends Roselle to the opening of the gallery's *Abstract Painting in America 1903–1923*, in which his work is featured. On March 28, however, he summons the strength to see de Kooning's new work at the Janis Gallery, but finds it disappointing. "He has turned into a painter of pretty, tasty, pictorial fragments. What happened to the 'fight?'"[466]

March 19. Canaday sends Davis a copy of *Embattled Critic: Views on Modern Art*, which consists of a selection of the critic's reviews, a reprint of the 1961 letter that Davis and others had sent to the *New York Times* protesting Canaday's views, and a number of responses to it. Canaday includes a note to Davis along with the book saying that he remains "puzzle[d] and hurt" by Davis's decision to sign "the letter attacking me" the year prior.[467] Davis responds:

I am truly sorry that you are still "hurt", but am completely puzzled as to how you could be "puzzled" by the position I took… To continue in the broadest generalities, while not a student of your writings I hold the conviction from casual samplings that you are an anti-Modern Art man. I think the visual make-up of your Sunday page substantiates my impression. Your choice of reproductions does not reflect the vitality of the Art panorama today. I have the feeling that one of these typical pages could be slipped into a turn-of-the-century edition without upsetting the constant reader of that time. I regard it as most regrettable that this should be the case in the Sunday Times which reaches so many people. I think they deserve better fare and are way ahead of you.[468]

April 24. The Downtown Gallery opens what will be Davis's last show there during his lifetime. The exhibition receives enthusiastic reviews, with sculptor Donald Judd, working as a critic for *Arts*, opening his article with unbridled praise:

There should be applause. Davis, at sixty-seven, is still a hot shot. Persistent painters are scarce; painters with only a decade or less of good work are numerous… The "amazing continuity" of Davis's work does not seem to have been kept with blinders, in fact, could not have been. Neither has Davis been startled into compromises with newer developments. Some older artists abandoned developed styles for one of the various ideas included under "Abstract Expressionism," spoiling both. Davis must also have faced the fact of increased power and different meanings. Instead of compromising, he kept all that he had learned and invented and, taking the new power into account, benefited… It takes a lot not to be smashed by new developments and a lot to face power and learn from it.[469]

Time concurs, noting that the artist "has never seemed more vigorous" and characterizing the "razzle-dazzle, man-made world" he paints as "a world of cities, honky-tonks and brightly packaged products, a confection of vulgarities superbly composed into symphonies of brash and breathless beauty."[470] O'Doherty heralds him in the *New York Times* as "the most American of American abstractionists" and predicts that the show will "give spirits wilted by the relentless bombardment of bad art a real lift."

[Davis] is still honking his neon-like yellows and greens and reds, still slicing precisely his poster-placard shapes, still signing his large squiggly signature that looks as if it were squeezed out of a toothpaste tube. And he is still putting them all together to create from very simple means a hot and electric visual tension that makes the delirium of Times Square and Forty-second Street more bearable.[471]

May 3–June 12. Harlan Phillips interviews Davis about his life and career over the course of twelve nonconsecutive days for the Smithsonian Institution's Archives of American Art.

Summer. In an interview with Mary Anne Guitar published in *Famous Artists Magazine*, Davis describes his approach to art making and the equivalency of drawing and color.

I think drawing is all-important. It's impossible to use color without making some kind of a drawing. Drawing is simply the dividing up of a space. What you do with it is the important thing. If you take a sponge filled with red paint and throw it onto a canvas, you've made a drawing because you've divided up the space… Drawing is, essentially, the constructing of an object… Painting itself can open up ways

to say things you couldn't say before. I always have the need to express moods and deeper feelings…

[My first response to a subject is] a spontaneous, unpredictable response to something — a nonanalytical, personal reaction of excitement and interest. Of course, something else has entered the situation already which causes you to formulate this subjective feeling in an objective visual vocabulary.

I couldn't have painted any other way than I did. It simply didn't interest me.[472]

Halpert develops tremors in her arm and experiences periods of memory loss that cause problems with billing, sales, and the daily operation of her gallery, lapses that are more noticeable since the departures of both Charles Alan and Lawrence Allen. Her solution is to reorganize her gallery, as she details in a letter to Davis:

I have decided to start with a clean slate by firing part of my staff, including my accountant, etc. I don't intend to yap here-after about my gallery problems and am avoiding the third sex as employee. There must be some normal gents available in New York and I am trying desperately to find one. Got any tips for an assistant?[473]

October. Adverse side effects cause Davis to stop taking his heart medication.

Sidney Janis opens *The New Realists*, announcing the arrival of what will come to be called pop art. In protest, all the abstract expressionists in his gallery resign, with the exception of de Kooning. Although Davis's long-stated aims for his art fundamentally differ from those that will be articulated by practitioners and advocates of pop, his art will be seen as a precursor of the style.

December 6. Davis's stature continues to rise. The same day that *Combination Concrete #2* sells at the Parke-Bernet auction for $8,000, one of the highest prices paid for work by a living American artist, he is interviewed for the CBS television program *Contemporary American Painters* that will air on March 10.

1963

January. Breathing difficulty and physical weakness restrict Davis to painting small-scale works. During the next nine months he loses forty-five pounds.

September 8. Davis suffers cardiac arrest and is taken to Lenox Hill Hospital, where he stays through the end of the month. While he is there, doctors remove an advanced cataract in his left eye. After he returns home, an attending nurse monitors him through October 25.

December 2. Walking to the kitchen after dinner, Davis feels dizzy and calls to Earl for help before falling unconscious to the floor. He is taken by ambulance to Roosevelt Hospital, where he is given oxygen and sodium luminal until he wakes. Doctors remove the ulcerating lesions on his right leg, which have made walking difficult for decades, and apply a skin graft. Davis remains in the hospital until January 11, 1964. After his return home, he sleeps on the couch in his studio because he cannot climb the stairs to his bedroom. For months, he is unable to paint.

1964

Winter. Davis's *Letter and His Ecol* wins the Joseph E. Temple Gold Medal at the Pennsylvania Academy Annual in January. The following month, *Standard Brand* (pl. 79) receives the prestigious Mr. and Mrs. Frank G. Logan Medal and Prize at the Art Institute of Chicago Annual.

January 5. Writing in the *New York Times*, O'Doherty compares Davis's compositions to those of the new generation of hard-edged color abstractionists, noting their shared immediacy of impact and constantly shifting space: "The eye is not free to wander… but is instantly forced to complete perceptions that are purposely made unstable and ambiguous."[474]

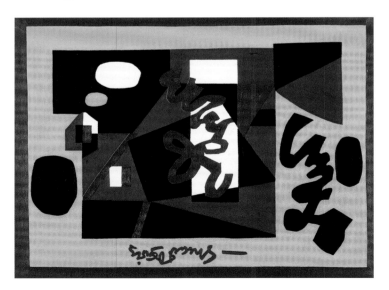

General Studies, 1962, oil on canvas, Board of Trustees of the University of Illinois on behalf of its Krannert Art Museum, Museum purchase, 1963.16.1

Spring. Aline Saarinen interviews Davis for a special episode of NBC's *Sunday* occasioned by the opening of MoMA's Philip Johnson expansion. She also interviews Calder, Marc Chagall, Miró, Henry Moore, and Alberto Giacometti for the program, which airs on May 24.

June 23. William Inness Homer interviews Davis for the September issue of *Art News*. Davis credits Henri as his "main and best influence" and attributes to him his own desire to employ modern European styles to portray the experiences of everyday American life.[475] That evening, after watching a French film on television, Davis adds the word "fin" to the painting (pl. 84) on his easel before going to bed.

June 24. Davis suffers a stroke and dies in the ambulance on the way to Roosevelt Hospital.

June 27. Roselle holds Davis's funeral at the Frank E. Campbell Funeral Home on the Upper East Side. Overriding his wish to be cremated, she buries his body the next day in the Green River Cemetery in Springs, East Hampton, on Long Island. During the following year Davis is memorialized as a major American artist. O'Doherty praises him in the *New York Times*:

A pioneer, he never profited greatly from the revolution he helped win—the cause of abstract art in America. He didn't believe greatly in revolution, he simply wanted recognition for the new ideas, not total triumph. "I'm in favor of ideas and their execution, but I don't think everyone has to be," he said.

He had no sympathy with artistic anarchy. "You don't add to tradition by destroying it," he said once. "I'm not interested in overthrow. I believe in permanent values. Isn't anything permanent for the future, in the future?"

This is the final paradox for those who saw him as some sort of hipster ancestor living at his nerve endings. The deceptively matter-of-fact exterior (he looked like someone who was going to go and shoot craps any minute) concealed a classic spirit, a spirit of the sort that could find some principle of eternal order in the neon wilderness of Times Square. He searched disorder for its unifying principle. Not long before his death, he told me: "The value of impermanence is to call attention to the permanent."

It becomes his epitaph.[476]

Levi delivers Davis's eulogy at the annual meeting of the American Academy of Arts and Letters:

It is startling to realize that before Stuart Davis there was no American painting which was, in subject motivation at least, indigenous. All of our previous painting had sprung from

sources in our colonial past—specifically from Europe. Unencumbered by nostalgia (which he loathed) Davis perceived with stunning clarity the visual phenomenon of twentieth-century America, and in so doing, revealed it to all of us in a metaphor which seemed especially invented for the purpose. He nailed down in colors of the wildest intensity the clanging vulgarity, the energy, the mechanized, the dehumanized statement of our civilization's shrill heartbeat, all in the hard rhythms of jazz which he loved obsessively.

Stuart and Earl Davis, 1964, photograph by William Innes Homer, courtesy of *Art News*

Stuart died on June twenty-fourth in an ambulance en route to Roosevelt Hospital. I cannot help speculating on how this curiously apt circumstance would have appealed to his sense of irony—this fast-moving vehicle, siren blaring, dashing through crowded streets festooned with neon lights— and not making it. Being a rationalist with a particularly skeptical attitude towards the medical profession, he would have understood failures in the improvisations characteristic of our life, without questioning their authenticity.

The biographical facts of Stuart Davis's life will never lend themselves to fictional treatment. They have a strangely astringent matter-of-factness which was so characteristic of the man who looked like a horse-player, led a life of domestic tranquility with his wife Roselle and son Earl, who spoke esoteric jive while contemplating the ideas of the greatest subtlety, expressed frequently in tidy prose...

Success (that is, the success that can be measured in material terms) came late to Stuart, although the highest assessments granted by his peers, the critics and the art world in general, were of long standing, and he was widely recognized as one of the great forces of twentieth-century art.[477]

My deepest thanks go to the artist's son, Earl Davis, for generously granting me unhindered access to his father's unpublished archives. Without his support and encouragement, this chronicle would not have been possible. I am also profoundly indebted to my curatorial assistant Sarah Humphreville and the interns and researchers she supervised—Caroline Barnett, Rachel Garbade, Jacqueline Snyder, Zoe Tippl, and Orly Vermes—who performed the herculean feat of researching the endnotes for this volume.

1. Edward Wyatt Davis was born in 1868 in Petersburg, Virginia. As a teenager, Ed traveled up and down the East Coast painting outdoor signs for a paint company before settling in Philadelphia in 1887. Helen Stuart Foulke was born in 1869 in Philadelphia into a Welsh family that traced its ancestors to King Henry II of England. She studied at the Philadelphia School of Design for Women from 1885 to 1887 before enrolling in the Pennsylvania Academy.

2. John Loughery, *John Sloan: Painter and Rebel* (New York: Henry Holt, 1995), 49; Bruce St. John, ed., *John Sloan's New York Scene* (New York: Harper and Row, 1965), 3.

3. Ed's promotion is likely due to the departure of the press's former art editor, Frank Crane, who moved to New York.

4. Stuart Davis, quoted in Harlan Phillips, "Stuart Davis Reminisces: As Recorded in Talks with Dr. Harlan B. Phillips," May and June 1962, transcript 41, Archives of American Art, Washington and New York (hereafter cited as AAA).

5. Davis to John Hammond, March 12, 1940, Estate of the Artist Archives, Fort Lee, NJ, and New York (hereafter cited as EAA). All rights reserved. © Estate of Stuart Davis/Licensed by VAGA, New York, NY.

6. For Davis's report cards, see Scholarship Records for Stuart Davis, 1908, East Orange High School, East Orange, NJ, EAA.

7. Robert Henri, "The New York Exhibition of Independent Artists," *Craftsman* 18 (May 1910): 162.

8. Stuart Davis, *Stuart Davis*, American Artists Group Monographs, no. 6 (New York: American Artists Group, 1945), n.p.

9. Davis 1945, n.p. Davis repeats the idea in his 1962 interview with Harlan Phillips that "there was a big accent on the saloon, beer mostly, at that time." Davis, quoted in Phillips 1962, 36, AAA.

10. Stuart Davis, Autograph manuscript diary, May 29, 1921, MA 5062, 39, Department of Literary and Historical Manuscripts, The Morgan Library and Museum, New York (hereafter cited as SDD, The Morgan); Stuart Davis, quoted in Katharine Kuh, "Stuart Davis," in *The Artist's Voice: Talks with Seventeen Artists* (New York: Harper and Row, 1962), 53.

11. Stuart Davis, draft of talk for Color in Art in Science, a summer course taught by Professor Filipowski, Massachusetts Institute of Technology (MIT), July 30, 1958, EAA; Davis, quoted in Kuh 1962, 53.

12. Davis 1945, n.p.

13. Davis, quoted in Phillips 1962, 43, AAA.

14. Stuart Davis Papers, reel 1, undated [1923], Fogg Art Museum, Harvard University Art Museums, Gift of Mrs. Stuart Davis (hereafter cited as SDP, Harvard). All rights reserved by the President and Fellows of Harvard College. Some pages of the Stuart Davis Papers are dated, and others are not. Dates in brackets that follow "undated" are the author's estimate based on the sequence of journal entries on the given reel. Pagination of the Harvard journals is not continuous, and some pages are numbered while others are not; thus, page numbers are not given here to avoid confusion.

15. Davis to Hazel Foulke, June 1911, EAA.

16. Stuart Davis, quoted in William Innes Homer, "Stuart Davis, 1894–1964: Last Interview," *Art News* 63, no. 5 (September 1964): 56.

17. Joseph Edgar Chamberlain, "Artists at MacDowell Club," *Evening Mail*, December 8, 1911. Davis's paint handling in this group of works was inspired by Édouard Manet's *The Funeral*, which the Metropolitan Museum of Art acquired in 1909 and Davis saw.

18. Davis, quoted in Phillips 1962, 61, AAA.

19. Stuart Davis, quoted in Robert Schulman, *Romany Marie: The Queen of Greenwich Village* (Louisville: Butler Books, 2006), 117.

20. Stuart Davis, quoted in James Johnson Sweeney, *Stuart Davis* (exh. cat., Museum of Modern Art [MoMA], New York), 1945, 9.

21. Stuart Davis, quoted in Mary Anne Guitar, "Close-up of the Artist— Stuart Davis," *Famous Artists Magazine* 10, no. 4 (Summer 1962): 21.

22. Stuart Davis, quoted in Frederick S. Wight, "Profile of Stuart Davis," *Art Digest* 27, no. 16 (May 15, 1953): 13.

23. Stuart Davis, quoted in Sweeney 1945, 10.

24. Davis, quoted in Rudi Blesh, *Stuart Davis*, Evergreen Gallery (New York: Grove Press, 1960), 14.

25. *The Masses* 4 / 6, no. 22 (March 1913): 15.

26. Davis to Hazel Foulke, April 1913, EAA.

27. Franklin Adams, "Always in Good Humor," *Evening Mail*, May 22, 1913; Oliver Herford, "Pen and Inklings," *Harper's Weekly* 58, no. 2959 (September 6, 1913): 28; "A Poem for "The Masses," *Globe and Commercial Advertiser*, May 24, 1913.

28. Davis, quoted in Phillips 1962, 114–115 and 22, AAA.

29. Davis 1945, n.p.

30. Davis 1945, n.p.

31. Davis, quoted in Wight 1953, 23.

32. Davis, quoted in Wight 1953, 23.

33. [Henry McBride], "News of the Art World: Art News and Comment," *Sun*, October 25, 1914, sec. 7.

34. Carlotta Russell Lowell, "The Masses and the Negro," *The Masses* 6 (May 1915): 6.

35. Max Eastman, "The Masses and the Negro," *The Masses* 6 (May 1915): 6. The protesting reader was likely writing in response to Davis's *Untitled (Shouting Woman)*, which was the back cover of the magazine's April 1915 issue.

36. Davis to Hazel Foulke, August 5, 1915, EAA; Davis 1945, n.p.

37. Davis 1945, n.p.

38. Davis 1945, n.p.

39. "Clash of Classes Stirs 'The Masses,'" *Sun*, April 8, 1916.

40. Stuart Davis, Gar Sparks, and Henry Glintenkamp, *The BLA!*, no. 1, 1916, EAA. *The BLA!* was published by Davis and Sparks, but Glintenkamp's involvement in its production is evidenced by the inclusion of his name in the broadsheet's credits and the existence of three distinct handwritings on the program cover.

41. Stuart Davis, "How to Construct a Modern Easel Picture," SDP, Harvard, reel 4, December 17, 1941.

42. Robert Coady, "American Art," *Soil* 1, no. 1 (December 1916): 3.

43. Coady 1916, 3–4.

44. Davis, quoted in Phillips 1962, 149–150, AAA.

45. Davis, quoted in Phillips 1962, 246, AAA.

46. Davis, quoted in Blesh 1960, 17.

47. Certificate of Discharge for Stuart Davis, issued by State of Massachusetts, Local Board of Gloucester, August 20, 1917, EAA.

48. Davis to Hazel Foulke, March 13, 1918, EAA.

49. Davis to Hazel Foulke, March 13, 1918, EAA.

50. Branch Davis was born in 1877 in Petersburg, Virginia.

51. Davis, quoted in Sweeney 1945, 15–16.

52. Davis, quoted in Phillips 1962, 116, AAA.

53. Davis to Hazel Foulke, December 29, 1917, EAA.

54. W. G. Bowdoin, "Modern Work of Stuart Davis a Village Show," *New York Evening World*, December 13, 1917.

55. Davis copied the text from the back of his painting *Gloucester Street with Later Added Configurations, Too Moons* into his journal on two different occasions. Stuart Davis, "Man on an Ice Floe," SDP, Harvard, reel 2, undated [1939 or 1940] and reel 11, undated [1951 or 1952]. See Ani Boyajian and Mark Rutkoski, eds., *Stuart Davis: A Catalogue Raisonné*, vol. 3 (New Haven, CT: Yale University Art Gallery; Yale University Press, 2007), 74, for a reprint and photograph of the original text.

56. SDD, The Morgan, May 1920, 3.

57. "Critics Laud Young Artist: Paintings of Stuart Davis, East Orange Youth, Well Received," *Newark Morning Ledger*, June 1, 1918.

58. Davis to Helen Davis, January 14, 1920, EAA.

59. SDD, The Morgan, March 11, 1921,15.

60. SDD, The Morgan, undated [November 1921], 56; March 11, 1921, 15; and March 12, 1921, 18.

61. SDD, The Morgan, October 28, 1922, 165.

62. Marsden Hartley to Alfred Stieglitz, October 21, 1920, quoted in Dickran Tashjian, *William Carlos Williams and the American Scene, 1920–1940* (New York: Whitney Museum of American Art, 1978), 144.

63. William Carlos Williams, quoted in Tashjian 1978, 62.

64. Davis to William Carlos Williams, quoted in Tashjian 1978, 62.

65. Davis's August 1920 portraits are of John Synge, N. Ostrovsky, Theodore Dreiser, and Fyodor Dostoyevsky. *The Dial* published his portrait of James Joyce in June 1922 and his caricature of Igor Stravinsky in August 1922.

66. SDD, The Morgan, May 29, 1921, 38–39.

67. Henry McBride, "News and Reviews of Art: Whitney Studio Club Opens an Exhibition," *New York Herald*, May 8, 1921, sec. 3.

68. McBride 1921.

69. SDD, The Morgan, March 12, 1921, 19.

70. Stuart Davis, "Mr. Stuart Davis Wants to Know," *New York Herald*, February 5, 1922, sec. 3.

71. Davis, "Wants to Know," 1922.

72. Davis, quoted in Phillips 1962, 120, AAA; Davis's resignation angers Sloan. "I don't think he ever got over it," Davis later says to Phillips. "It was a repudiation of him in some way." Davis, quoted in Phillips 1962, 120, AAA.

73. Davis to Hazel Foulke, December 30, 1922, EAA.

74. Davis to Helen Davis, July 10, 1923, EAA.

75. Davis, quoted in Sweeney 1945, 15.

76. SDP, Harvard, reel 1, undated [1923].

77. SDP, Harvard, reel 1, December 30, 1922.

78. "Cross Word Puzzle Motif in Art Expressed on Canvas at Museum," *Newark Evening News*, February 7, 1925.

79. Sweeney 1945, 17.

80. Stuart Davis, quoted in Brian O'Doherty, *American Masters: The Voice and the Myth in Modern Art* (New York: E. P. Dutton, 1974), 73; SDP, Harvard, reel 4, September 1941.

81. Bessie Chosak was born on July 31, 1905.

82. Romany Marie, quoted in Schulman 2006, 126.

83. Davis to Katherine Dreier, September 25, 1926, quoted in John D. Angeline, "Davis, Dreier, Lissitzky: New Thoughts on an Old Series," *Part 2, http://www.brickhaus.com/amoore/magazine/Davis.html* (accessed July 27, 2015).

84. Davis to Katherine Dreier, April 5, 1927, quoted in Angeline, "New Thoughts on an Old Series."

85. Stuart Davis, quoted in John I. H. Baur and Hermon More, "Recollections of the Whitney," summary transcript of an interview with the artist for broadcast on WNYC American Art Festival, September 29, 1953, box 3, 3, Artists' Correspondence and Ephemera Collection, Frances Mulhall Achilles Library, Whitney Museum of American Art (hereafter cited as SD Artist's File, Whitney).

86. Henry McBride, "Retrospective Show of Stuart Davis," *Sun*, December 11, 1926.

87. Forbes Watson, "Art Notes," *World*, December 13, 1926; Margaret Breuning, "Christmas Week Brings a Wide Variety of Exhibitions to Art Galleries…Stuart Davis," *New York Evening Post*, December 18, 1926, sec. 5.

88. Davis to Hazel Foulke, January 27, 1928, EAA.

89. Davis, quoted in Blesh 1960, 13.

90. Davis, quoted in Sweeney 1945, 17.

91. Davis, quoted in Phillips 1962, 152, AAA.

92. Davis to Edith Halpert, August 1, 1927, EAA.

93. Stuart Davis, manifesto published in Edward Alden Jewell, "Davis Tames a Shrew," *New York Times*, April 29, 1928, sec. 10.

94. Davis, quoted in Baur and More 1953, 4–5, SD Artist's File, Whitney.

95. Davis, quoted in Baur and More 1953, 4, SD Artist's File, Whitney.

96. Davis, quoted in Sweeney 1945, 19.

97. Davis to Helen Davis, January 25, 1929, EAA.

98. Quote references "Paris: Capital of America," *American Review* (European ed.) (February 1924): cover, quoted in Elizabeth Hutton Turner, *Americans in Paris (1921–1931): Man Ray, Gerald Murphy, Stuart Davis, Alexander Calder* (exh. cat., The Phillips Collection, Washington, 1996), 13.

99. Davis to Hazel Foulke, January 28, 1929, EAA.

100. Davis, quoted in Phillips 1962, 158, AAA; Robert Carlton Brown to Davis, June 14, 1948, EAA.

101. Davis to Ed Davis, September 17, 1928, EAA.

102. Davis to Ed Davis, October 12, 1928, EAA.

103. Elliot Paul, "Stuart Davis, American Painter," *transition*, no. 14 (Fall 1928): 148. Paul was coeditor of *transition* with Eugene Jolas from April 1927 to March 1928, contributing editor from summer 1928 to fall 1929, and an advisory editor in June 1929. Arnold Goldman, "Elliot Paul's 'Transition' Years: 1926–28," *James Joyce Quarterly* 30, no. 2 (Winter 1993): 241–275.

104. Davis, quoted in Sweeney 1945, 20.

105. Clement Greenberg, "Art Column," *Nation* 161 (November 17, 1945): 534.

106. Davis to Helen Davis, January 25, 1929, EAA.

107. Davis to Gertrude Stein, June 1, 1929, EAA.

108. Davis, quoted in Sweeney 1945, 22.

109. Malcolm Cowley, *Exiles Return: a Literary Odyssey of the 1920s* (New York: Penguin Books, 1976), 107.

110. Stuart Davis, "Self-Interview," *Creative Art* 9, no. 3 (September 1931): 211.

111. Willem de Kooning, quoted in James T. Valliere, "De Kooning on Pollock," *Partisan Review* 34, no. 4 (Fall 1967): 603.

112. Roselle Springer was born on June 8, 1907, in Brooklyn to Russian immigrant parents.

113. Misha Reznikoff, quoted in Nouritza Matossian, *Black Angel: The Life of Arshile Gorky* (Woodstock, NY: The Overlook Press, 2000), 178.

114. Henry McBride, "Work of Four American Painters," *Sun*, November 30, 1929.

115. Stuart Davis, "Dear Mr. McBride," *Creative Art* 6, no. 2 (February 1930): sup. 34–35.

116. Davis, quoted in Sweeney 1945, 23.

117. "New York Season," *Art Digest* 4, no. 9 (February 1, 1930): 17.

118. Lloyd Goodrich, "In the Galleries," *Arts* 16, no. 6 (February 1930): 432, 434.

119. Davis, quoted in Phillips 1962, 271, AAA.

120. Murdock Pemberton, "The Art Galleries," *New Yorker* 7, no. 8 (April 11, 1931): 98.

121. Henry McBride, "Stuart Davis Comes to Town: Downtown Gallery's Exhibition of His Work Proves a Lively One," *Sun*, April 4, 1931.

122. McBride 1931.

123. Davis, "Self-Interview," 1931, 211.

124. Stuart Davis, "Arshile Gorky in the 1930's: A Personal Recollection," *Magazine of Art* 44, no. 2 (February 1951): 58.

125. John Graham to Duncan Phillips, December 28, 1931, The Phillips Collection Archives, Washington, D.C.

126. Davis to Hazel Foulke, January 13, 1932, EAA.

127. Davis to Hazel Foulke, January 13, 1932, EAA.

128. Edward Alden Jewell, "Art in Review: Stuart Davis Offers a Penetrating Survey of the American Scene—Native Talent in Drawing Shown," *New York Times*, March 10, 1932; Henry McBride, "Attractions in the Galleries," *Sun*, March 12, 1932.

129. Davis to Hazel Foulke, May 16, 1932, EAA.

130. Davis to Edith Halpert, September 9, 1932, EAA.

131. Davis to Robert Carlton Brown, October 2, 1932. Robert Carlton Brown Papers, Special Collections, Morris Library, Southern Illinois University at Carbondale.

132. Stuart Davis Calendar, January 23, 1951, EAA.

133. Davis to Hazel Foulke, January 13, 1933, EAA.

134. Davis, quoted in Phillips 1962, 331, AAA.

135. Davis, quoted in Sweeney 1945, 29.

136. Welfare Island is now known as Roosevelt Island.

137. Davis quoted in Sweeney 1945, 29.

138. Davis to Edith Halpert, September 20, 1933, EAA.

139. Stuart Davis, "Accomplishments," 1935 Guggenheim Fellowship Application, EAA.

140. Davis, quoted in Phillips 1962, 350, AAA.

141. Davis, quoted in Sweeney 1945, 29.

142. Davis, quoted in Sweeney 1945, 29.

143. Davis, quoted in Phillips 1962, 184–185, AAA.

144. Stuart Davis, "The Artist Today: The Standpoint of the Artists' Union," *The American Magazine of Art* 28, no. 8 (August 1935): 476–478, 506. For information on the Artists Union, see Gerald M. Monroe, "The Artists Union of New York," *Art Journal* 32, no. 1 (Autumn 1972): 17–20.

145. Davis, quoted in Phillips 1962, 375, AAA.

146. Romany Marie, quoted in Schulman 2006, 127.

147. Stuart Davis, biography for the Application for Home Relief, June 9, 1937, EAA.

148. Davis, quoted in Phillips 1962, 283, AAA.

149. Davis, quoted in Phillips 1962, 283, AAA.

150. Davis, quoted in Phillips 1962, 320, AAA. Davis describes the need for an artist-run municipal art gallery in Stuart Davis, "Letters from Our Friends," *Art Front* (November 1934): n.p.

151. Davis, quoted in Phillips 1962, 318–319, AAA.

152. *Art Front* (November 1934): n.p.

153. Stuart Davis, "Plans for Study," 1935 Guggenheim Fellowship Application, EAA.

154. "U.S. Scene," *Time* 24, no. 26 (December 24, 1934): 26.

155. Stuart Davis, "The New York American Scene in Art," *Art Front* (February 1935): n.p.

156. Thomas Hart Benton, "Why Mr. Benton!," *Art Front* 1, no. 4 (April 1935): n.p.

157. Edward Alden Jewell, "When Cobblers Turn from the Last," *New York Times*, April 7, 1935, sec. 9.

158. Stuart Davis, "Introduction," in *Abstract Painting in America* (exh. cat., Whitney Museum of American Art, New York, 1935), n.p.

159. Clarence Weinstock, "Contradictions in Abstractions," *Art Front* 1, no. 4 (April 1935): n.p.

160. Davis's position anticipates that later expressed by Diego Rivera and André Breton, in their 1938 article "Manifesto: Towards a Free Revolutionary Art," trans. Dwight Macdonald, *Partisan Review* 6, no. 1 (Fall 1938): 49–53.

161. Stuart Davis, "A Medium of 2 Dimensions," *Art Front* 1, no. 5 (May 1935): n.p.

162. For discussion of the American Artists' Congress, see Gerald M. Monroe, "The American Artists Congress and the Invasion of Finland," *Archives of American Art Journal* 15, no. 1 (1975): 14–20; Matthew Baigell and Julia Williams, *Artists against War and Fascism: Papers of the First American Artists' Congress* (New Brunswick, NJ: Rutgers University Press, 1986); David Shapiro, ed., *Social Realism: Art as a Weapon* (New York: Frederick Ungar, 1973).

163. Roselle Davis, "Record of Stuart Davis—Year 1935," Calendar for Stuart Davis, May 12, 1935, EAA.

164. Edith Halpert to Davis, May 29, 1935, EAA.

165. Davis to Edith Halpert, September 28, 1935, EAA.

166. Roselle, "Record of Stuart Davis," Calendar, September 22, 1935, EAA.

167. "Museum of Modern Art Exhibits New Rugs by American Artists," press release, MoMA, June 30, 1942, 2.

168. Léger later gave a similar speech: "The New Realism Goes On," *Art Front* 3, no. 1 (February 1937): 7–8.

169. "Call for an American Artists Congress," *Art Front* (November 1935): 6.

170. Stuart Davis, "The American Artists' Congress," *Art Front* 2, no. 8 (December, 1935): 8.

171. Davis to Edith Halpert, December 8, 1935, EAA.

172. Jacob Kainen, "Historic Congress of Artists to Represent Finest Traditions of American Culture," *Sunday Worker*, February 9, 1936.

173. Stuart Davis "Why an Artists' Congress?," in Baigell and Williams 1986, 65, 68–69.

174. Davis to Hazel Foulke, February 28, 1936, EAA.

175. Alfred H. Barr, *Cubism and Abstract Art* (exh. cat., MoMA, New York, 1936), 13, 200; SDP, Harvard, reel 1, December 30, 1922.

176. The *Times* publishes Davis's letter, followed by Jewell's rejoinder. Stuart Davis, letter to the editor, in Edward Alden Jewell, "Opinion under Postage: American Artists' Congress Apparently Wants Project Unreservedly Praised," *New York Times*, September 27, 1936, sec. 10.

177. Davis, "Plans for Study," 1937 Guggenheim Fellowship Application, EAA.

178. Davis to Rockwell Kent, January 3, 1936, EAA.

179. Davis to Samuel Kootz, April 7, 1937, EAA.

180. Stuart Davis to Jerome Klein, quoted in Klein, "Stuart Davis Criticizes Critic of Abstract Art," *New York Post*, February 26, 1938.

181. "The Moscow Trials: A Statement by American Progressives," *New Masses* 27, no. 6 (May 3, 1938): 19.

182. SDP, Harvard, reel 1, September 28, 1937.

183. Stuart Davis Calendar, January 5, 1938, EAA.

184. Davis, quoted in Phillips 1962, 393–394, AAA.

185. Philip Guston, quoted in Musa Mayer, *Night Studio: A Memoir of Phillip Guston by His Daughter* (New York: Da Capo Press, 1997), 31.

186. Stuart Davis Calendar, September 29, 1938, EAA.

187. Stuart Davis, "Impressions of the New York World's Fair," *Harper's Bazaar* 72, no. 2719 (February, 1939): 60–61.

188. Davis, quoted in Blesh 1960, 57.

189. Stuart Davis, "This Is My Favorite Painting," *Famous Artists Magazine* 9, no. 2 (Winter 1960): 12.

190. SDP, Harvard, reel 6, November 21, 1942.

191. Stuart Davis, quoted in Dorothy Gees Seckler, "Stuart Davis Paints a Picture," *Art News* 52, no. 4 (Summer 1953): 74.

192. Stuart Davis WPA Personnel Application, August 18, 1939, 1, EAA.

193. The letter was signed by Hananiah Harari, Jan Matulka, Herzl Emanuel, Byron Browne, Leo Lances, Rosalind Bengelsdorf, and George McNeil. "Letter to the Editor," *Art Front* 3, no. 7 (October 1937): 20–21.

194. Hilla Rebay, quoted in Stuart Davis, "Art and the Masses," *Art Digest* 14, no. 1 (October 1, 1939): 13.

195. Stuart Davis, "Opinion under Postage: Abstraction," *New York Times*, August 20, 1939, sec. 9.

196. Stuart Davis, "Abstraction Is Realism—So Asserts Stuart Davis in New Letter on Non-Objective Art Controversy," *New York Times*, October 8, 1939, sec. 9.

197. Davis, "Art and the Masses," 1939, 34.

198. Juliana Force to Davis, October 10, 1939, box 3, SD Artist's File, Whitney.

199. Davis to Duncan Phillips, December 15, 1939, The Phillips Collection Archives, Washington.

200. Stuart Davis, "Plans for Work," 1940 Guggenheim Fellowship Application, EAA.

201. Davis to Francis Henry Taylor, March 29, 1940, EAA.

202. Francis Henry Taylor to Davis, April 1, 1940, EAA.

203. Harry B. Wehle to Davis, April 10, 1940, EAA.

204. Stuart Davis, "Davis Asks a Free Art," *New York Times*, July 7, 1940, sec. 9. The Metropolitan Museum will acquire Davis's *Iris* in 1948 and *Semé* (pl. 57) in 1953 through the Hearn Fund.

205. Stuart Davis to Elizabeth Navas, August 16, 1944, Elizabeth S. Navas Papers, AAA.

206. SDP, Harvard, reel 3, undated [January 1940].

207. SDP, Harvard, reel 3, undated [January 1940].

208. "Is There a Revolution in the Arts?," interview transcript, *Town Meeting* 5, no. 19 (February 19, 1940): 12–14, 26–27. Arthur E. Bestor moderated the radio broadcast, and Aaron Copland, Walter Damrosch, Clifton Fadiman, William Lyon Phelps, and Albert Sterner were the other participants.

209. Davis, writing in Roselle Davis Calendar, March 13, 1940, EAA.

210. Juliana Force to Davis, April 1, 1940, SD Artist's File, Whitney.

211. Stuart Davis, "Opinions under Postage: Our Readers," *New York Times*, April 14, 1940, sec. 9.

212. Ad Reinhardt, "About Artists by Artists," *New Masses* 57, no. 9 (November 27, 1945): 15.

213. Davis 1945, n.p.

214. Roselle Davis Calendar, June 16, 1940, EAA.

215. Roselle Davis Calendar, June 16, 1940, and August 17, 1940, EAA.

216. Stuart Davis Calendar, September 10, 1940, EAA.

217. Davis to Walter Quirt, March 7, 1950, EAA.

218. Davis to Juliana Force, October 29, 1940, SD Artist's File, Whitney.

219. Juliana Force to Davis, November 1, 1940, SD Artist's File, Whitney.

220. Davis to Juliana Force, November 4, 1940, SD Artist's File, Whitney.

221. Advertisement for Grumbacher Brushes and Schmincke Finest Oil Colors, *Parnassus* 12, no. 6 (October 1940): 36.

222. Roselle Davis Calendar, October 30, 1940, EAA.

223. Davis to Henry Allen Moe, November 28, 1940, EAA.

224. Davis to Henry Allen Moe, November 28, 1940, EAA.

225. Davis to Donald Bear, July 13, 1941, EAA.

226. Davis to Hazel Foulke, March 2, 1941, EAA.

227. Hilla Rebay to Davis, April 20, 1941, EAA.

228. Stuart Davis and Walter Quirt, "A Project to Be Conducted by the Associated American Artists," project proposal, May 11, 1941, EAA.

229. "Is There a Revolution in the Arts?," interview transcript, 1940, 13.

230. Davis to Edith Halpert, July 18, 1941, EAA.

231. Stewart Klonis to Davis, June 3, 1941, EAA.

232. Roselle Davis, writing in Stuart Davis Calendar, July 11, 1941, EAA.

233. Davis to Donald Bear, July 13, 1941, EAA.

234. Davis to Gordon Washburn, July 12, 1941, EAA.

235. Davis to Alice Sharkey, July 14, 1941, SD Artist's File, Whitney.

236. Davis to Alice Sharkey, July 14, 1941, SD Artist's File, Whitney.

237. Alice Sharkey to Davis, July 15, 1941, EAA.

238. Roselle Davis to Hazel Foulke, August 30, 1941, EAA.

239. Roselle to Hazel Foulke, August 30, 1941, EAA.

240. Roselle to Hazel Foulke, August 30, 1941, EAA.

241. Roselle Davis, writing in Stuart Davis Calendar, July 18, 1941, EAA.

242. Davis to Edith Halpert, July 18, 1941, EAA.

243. Samuel M. Kootz, quoted in Edward Alden Jewell, "The Problem of 'Seeing': Vitally Important Matter of Approach—American Artist and His Public," *New York Times*, August 10, 1941.

244. Jewell, "The Problem of 'Seeing,'" August 10, 1941.

245. Stuart Davis, "To the Art Editor," *New York Times*, October 12, 1941, sec. 9.

246. Davis to Edith Halpert, November 10, 1941, EAA.

247. SDP, Harvard, reel 5, October 15, 1942.

248. SDP, Harvard, reel 6, January 3, 1943.

249. Stuart Davis, "Art of the City," in *Masters of Abstract Art*, ed. Stephan C. Lion and Charmion Wiegand (exh. cat., Helena Rubinstein's New Art Center, New York, 1942), 13.

250. SDP, Harvard, reel 6, February 14, 1943.

251. SDP, Harvard, reel 6, February 14, 1943.

252. Davis to Arthur Sulzberger, May 19, 1942, EAA.

253. Jerome Mellquist, *The Emergence of American Art* (New York: Charles Scribner's Sons, 1942), 303; Davis to Jerome Mellquist, April 28, 1942, EAA.

254. "Museum of Modern Art Exhibits New Rugs," press release, MoMA, 1942, 1–2.

255. Stuart Davis, "Davis and Abstraction—Letter to the Art Editor," *New York Times*, September 27, 1942, sec. 8.

256. Edward Alden Jewell, Editor's Note to Davis's "Abstraction—Letter to the Art Editor," 1942.

257. SDP, Harvard, reel 5, September 2, 1942.

258. Stuart Davis Calendar, November 18, 1942, EAA; Davis to Felicia Gessen, November 25, 1942, EAA.

259. Hobart Nichols, "The Artists for Victory Exhibition Opening December 7, 1942," *The Metropolitan Museum of Art Bulletin*, n.s., 1, no. 3 (November 1942): n.p.

260. Samuel M. Kootz, *New Frontiers in American Painting* (New York: Hastings House, 1943), 38.

261. Stuart Davis, "Hot Still-Scape for Six Colors," SDP, Harvard, reel 5, April 28, 1942.

262. SDP, Harvard, reel 7, undated [July 1943], and April 1, 1943.

263. SDP, Harvard, reel 7, undated [July 1943].

264. SDP, Harvard, reel 6, April 4, 1943.

265. SDP, Harvard, reel 6, May 14, 1943.

266. Davis to Hazel Foulke, January 24, 1943, EAA.

267. Clement Greenberg, "Stuart Davis: Selected Paintings at the Downtown Gallery, until February 27," *Nation* 156, no. 8 (February 20, 1943): 284; Robert M. Coates, "The Art Galleries: Davis, Hartley, and the River Seine," *New Yorker* 18, no. 52 (February 13, 1943): 58–59.

268. Davis to Hazel Foulke, February 5, 1943, EAA; Emily Genauer, "Two Americans Give Solo Shows," *New York World Telegram*, February 6, 1943.

269. Davis to Hazel Foulke, February 5, 1943, EAA.

270. The works sold by the end of 1943 are the gouache *Radio Tube* and the oils *Cape Ann Landscape*, *New York Waterfront*, *Autumn Landscape*, *Hot Still-Scape for Six Colors—7th Avenue Style*, *Synthetic Souvenir*, *Still Life in the Street*, and *New York Under Gaslight*.

271. Stuart Davis, "The Cube Root," *Art News* 41, no. 18 (February 1–14, 1943): 23, 33–34.

272. Clement Greenberg, "Art," *Nation* 160, no. 14 (April 7, 1945): 397.

273. George Biddle, "Art under Five Years of Federal Patronage," *The American Scholar* 9, no. 3 (Summer 1940): 327–38; Biddle, "Can Artists Make a Living?," *Harper's Magazine* 181 (June 1, 1940): 394–401.

274. Stuart Davis, "What about Modern Art and Democracy?," *Harper's Magazine* 188, no. 1123 (December 1, 1943): 18, 19, 21.

275. Edward Alden Jewell, "Abstraction Once More to the Fore," *New York Times*, February 16, 1941, sec. 10.

276. Davis receives awards from the Carnegie Institute and Pepsi-Cola Company in 1944, the Pennsylvania Academy in 1945, the Robert C. Vose Galleries in Boston in 1947, and the Art Institute of Chicago and New York's Riverside Museum in 1948. Additionally, in 1945, V'Soske receives five orders for *Flying Carpet*, with more following in subsequent years.

277. Davis to Erle Loran, July 16, 1944, EAA.

278. Roselle Davis, writing in Stuart Davis Calendar, February 15, 1941, and June 8, 1947, EAA; for other examples of Roselle's affection for her husband, see Roselle, writing in Stuart Davis Calendar, October 16, 1945, EAA.

279. Davis to Walter Quirt, September 30, 1945, EAA.

280. Stuart Davis, "The 'Modern Trend' In Painting," *Think* 11, no. 1 (January 1945): 36–37.

281. Davis to Samuel Kootz, February 18, 1945, EAA.

282. Samuel Kootz to Davis, February 20, 1945, EAA.

283. Davis to Yasuo Kuniyoshi, July 29, 1945, EAA.

284. Davis to Walter Quirt, September 30, 1945, EAA.

285. Davis, quoted in Sweeney 1945, 33–34.

286. Clement Greenberg, "Art," *Nation* 161, no. 20 (November 17, 1945): 533–534; Holger Cahill, "Stuart Davis: In Retrospect 1945–1910," *Art News* 44, no. 13 (October 15–31, 1945): 24–25, 36.

287. Stuart Davis Calendar, February 10, 1947, EAA.

288. Jo Gibbs, "Stuart Davis Paints the Better Eggbeater," *Art Digest* 20, no. 9 (February 1, 1946): 9.

289. The State Department purchased two gouaches, *Impression of the New York World's Fair* and *Shapes of Landscape Space* (pl. 42), and two oils, *Still Life with Flowers* and *Trees and El*.

290. "Exposing the Bunk of So-Called Modern Art," *New York Journal-American*, December 3, 1946.

291. Roselle Davis, writing in Stuart Davis Calendar, December 4, 1946, EAA.

292. SDP, Harvard, reel 6, April 4, 1943.

293. Davis to Lloyd Goodrich, April 10, 1946, SD Artist's File, Whitney.

294. Davis to Walter Quirt, March 15, 1949, SDP, Harvard, reel 9, March 15, 1949.

295. "Artists Uphold Sweeney." *New York Times*, November 3, 1946, sec. 2.

296. Stuart Davis, quoted in "Recollections of the Whitney," draft manuscript of his interview broadcast on WNYC American Art Festival, September 29, 1953, box 3, 3, SD Artist's File, Whitney; Stuart Davis Calendar, July 27, 1947, and August 4, 1947, EAA.

297. Davis, quoted in Phillips 1962, 343, AAA.

298. Stuart Davis, "Friends, It's Here to Stay," *Esquire's 1947 Jazz Book: A Yearbook of the Jazz Scene* (Chicago: Esquire, 1946): 27–28.

299. Winthrop Sargeant, "Why Artists Are Going Abstract: The Case of Stuart Davis," *Life* 22, no. 7 (February 17, 1947): 83.

300. Sargeant 1947, 76, 83.

301. Aaron Bohrod, "Abstract Art—Letters to the Editors," *Life* 22, no. 10 (March 10, 1947): 7–8.

302. Louis Guglielmi, "Letters to the Editors," *Life* 22, no. 13 (March 31, 1947): 9.

303. Stuart Davis, "Battle of the Artists—Letters to the Editors," *Life* 22, no. 13 (March 31, 1947): 9–10.

304. Henry Varnum Poor, "Henry Varnum Poor Answers," *Art Digest* 22, no. 4 (November 15, 1947): 31.

305. Stuart Davis, in *Symposium on "Guernica,"* Museum of Modern Art (New York: Master Reporting, 1947), 59, 61. The other participants in the symposium are Alfred H. Barr, Juan Larrea, Jacques Lipchitz, Jerome Seckler, and José Luis Sert.

306. Davis to Hazel Foulke, March 28, 1948, EAA.

307. "'Modern Art' and the American Public," February 17, 1948, reprinted in Serge Guilbaut, "The Frightening Freedom of the Brush: The Boston Institute of Contemporary and Modern Art, 1948–1950," in *Dissent: The Issue of Modern Art in Boston* (Boston: Institute of Contemporary Art, 1985), 52–53.

308. Emily Genauer, "Boston Museum Hits 'Cult of Bewilderment,'" *New York World Telegram*, February 17, 1948.

309. Thomas Craven, "Is American Art Degraded?" *'48: The Magazine of the Year* 2, no. 6 (June 1948): 68.

310. Davis to Daniel Catton Rich, February 9, 1948, EAA.

311. Davis uses the phrase "not lethal" in his letter to Daniel Catton Rich. Davis to Rich, February 9, 1948, EAA.

312. "Are These Men the Best Painters in America Today? A *Look* Poll Gives the Opinion of Forty Art Critics and Curators," *Look* 12, no. 3 (February 3, 1948): 44–45.

313. Davis, unaddressed letter, March 9, 1948, EAA.

314. Stuart Davis, manuscript of speech for "The Modern Artist Speaks," forum at MoMA, May 5, 1948, 4, 6, EAA.

315. Ralph Pearson, "Modern Artists Speak," *Art Digest* 22, no. 16 (May 15, 1948): 16; Aline B. Louchheim, "Artist vs. Critic: An Age Old Issue," *New York Times*, May 9, 1948, sec. 2.

316. Davis to Emily Genauer, May 13, 1948, EAA.

317. "Modern Art in Chaos," *Cue* 17, no. 5 (June 19, 1948): 17.

318. Davis, quoted in "Chaos," 1948, 17.

319. Davis, quoted in "Chaos," 1948, 17.

320. Davis to Walter Quirt, August 18, 1948, EAA.

321. SDP, Harvard, reel 8, July 1948.

322. Henri Matisse, quoted in John Elderfield, *Henri Matisse: A Retrospective* (exh. cat., MoMA, New York, 1992), 413.

323. "Revolt in Boston: Shootin' Resumes in the Art World," *Life* 26, no. 8 (February 21, 1949): 84.

324. James Plaut to Daniel Longwell, telegram, quoted in ICA exhibition history, EAA.

325. Davis, quoted in Phillips 1962, 133, AAA.

326. Roselle recounted this conversation in the couple's calendar. Roselle Davis, writing in Stuart Davis Calendar, August 4, 1949, EAA.

327. Wight 1953, 13.

328. *The Intrasubjectives* (New York: Samuel M. Kootz Gallery, 1949).

329. "The All-American," *Time* 63, no. 11 (March 15, 1954): 86; Stuart Davis, quoted in H. H. Arnason, *Stuart Davis* (exh. cat., Walker Art Center, Minneapolis, 1957), 44.

330. Davis, quoted in Seckler, "Davis Paints a Picture," 1953, 32.

331. Davis, quoted in Arnason 1957, 44.

332. SDP, Harvard, reel 9, December 17, 1950.

333. SDP, Harvard, reel 9, December 19, 1950.

334. Emily Genauer, "Art and Artists: The Whitney's Memorial Exhibit and the Arshile Gorky Tragedy," *New York Herald Tribune*, January 7, 1951.

335. Stuart Davis, "Handmaiden of Misery," review of *Arshile Gorky*, by Ethel K. Schwabacher, *Saturday Review* 40, no. 52 (December 28, 1957), 17.

336. Stuart Davis Calendar, January 16, 1951, EAA.

337. Stuart Davis and Diego Rivera, "Two Famous Painters Fight the Battle of Abstract Art," *Look* 15, no. 3 (January 30, 1951): 68.

338. Stuart Davis Calendar, January 23, 1951, EAA.

339. Stuart Davis, "For Internal Use Only," in Aline B. Louchheim, "Six Abstractionists Defend Their Art," *New York Times Magazine*, January 21, 1951.

340. Stuart Davis Calendar, January 22, 1951, EAA.

341. Stuart Davis, "Forum," SDP, Harvard, reel 10, undated [1951].

342. Stuart Davis, "What Abstract Art Means to Me: Statements by Six American Artists: Stuart Davis," *The Museum of Modern Art Bulletin* 18, no. 3 (Spring 1951): 15.

343. Davis, talk for Color in Art in Science course, MIT, July 30, 1958, EAA.

344. See, for example, Davis's comments in Stuart Davis Calendar, November 27, 1951, and March 20, 1953, EAA.

345. Stuart Davis Calendar, March 26, 1952, EAA.

346. Davis, quoted in Wight 1953, 23.

347. SDP, Harvard, reel 3, undated [January 1940].

348. Davis, quoted in Phillips 1962, 88, AAA.

349. Davis, "Arshile Gorky in the 1930's," 1951, 56–58.

350. Stuart Davis Calendar, March 22, 1951, EAA.

351. SDP, Harvard, reel 3, June 30, 1940.

352. SDP, Harvard, reel 8, July 4, 1947.

353. Stuart Davis, Thomas Hart Benton, and Perry T. Rathbone, "Does Modern Art Make Sense?," transcript of radio broadcast from American Broadcasting Network, Urbana, IL, George V. Denny, Jr., moderator, *Town Meeting: Bulletin of America's Town Meeting of the Air* 16, no. 50 (April 10, 1951): 1–12.

354. Davis, quoted in Phillips 1962, 379–380, AAA.

355. SDP, Harvard, reel 9, December 17, 1950.

356. Stuart Davis Calendar, June 7, 1951, EAA.

357. Stuart Davis Calendar, June 8, 1951, EAA. *The Ninth Street Show* included artists such as Willem de Kooning, Jackson Pollock, Hans Hofmann, Mark Rothko, Barnett Newman, Adolph Gottlieb, and Robert Motherwell. Archives on the show are located at the AAA in the Leo Castelli Gallery Collection.

358. Davis, quoted in Wight 1953, 23.

359. Stuart Davis Calendar, November 5, 1951, EAA.

360. Stuart Davis Calendar, January 18, 1952, EAA.

361. Stuart Davis to Henry Allen Moe, November 6, 1951, in 1952 Guggenheim Fellowship Application, EAA.

362. Stuart Davis to Josephine Leighton, May 29 1952, EAA.

363. Stuart Davis Calendar, May 31, 1953, EAA.

364. Ross Valentine, "A Question for Mr. d'Harnoncourt," *Richmond Times Dispatch*, February 21, 1952.

365. Ross Valentine, "Well, They Asked for It," *Richmond Times Dispatch*, March 21, 1952.

366. Léon Degand, "La XXVI Biennale De Venise," *Art d'aujourd'hui* (June 1952): 17.

367. Stuart Davis Calendar, August 18, 1955, EAA.

368. Stuart Davis, "Visa (1952)," in Diane Kelder, ed., *Stuart Davis* (New York: Praeger, 1971), 101–102.

369. Stuart Davis Calendar, December 6, 1952, EAA; Kuniyoshi underwent a stomach operation on November 13, Stuart Davis Calendar, November 13, 1952, EAA.

370. Stuart Davis Calendar, March 20, 1953, EAA.

371. Stuart Davis Calendar, April 4, 1956, EAA.

372. Davis, quoted in Wight 1953, 23.

373. Davis, quoted in Wight 1953, 23.

374. Stuart Davis Calendar, May 26, 1953, EAA.

375. Seckler, "Davis Paints a Picture," 1953, 73.

376. Tri-Tec, an abbreviation for Triple Technic, was a water-based paint made by Permanent Pigments that was designed to function like oil, tempera, or watercolor depending on the amount of water mixed in.

377. Seckler, "Davis Paints a Picture," 1953, 74.

378. Davis, quoted in Wight 1953, 23.

379. Stuart Davis, "Symposium: The Creative Process," *Art Digest* 28, no. 8 (January 15, 1954): 16, 34.

380. Stuart Davis Calendar, March 27, 1954, EAA.

381. The Philadelphia Museum of Art bought *Something on the 8 Ball*, the Munson Williams Proctor Arts Institute, Museum of Art, bought *Tournos* (pl. 60), and the Wadsworth Atheneum bought *Midi* (pl. 61).

382. "The All-American," 1954, 86.

383. Howard Devree "Symbolism and Vision: In Four New Shows Artists Illustrate the Problem of Interpretation," *New York Times*, March 7, 1954, sec. 2.

384. Stuart Davis, "About the Mural," in *Drake University Presents Allée: A New Mural by Stuart Davis* (Des Moines, IA: Drake University, 1955), n.p.

385. Davis, quoted in Homer, "Last Interview," 1964, 56.

386. Stuart Davis Calendar, October 22, 1954, EAA.

387. Davis, "About the Mural," in *Drake University Presents Allée*, 1955, n.p.

388. Aline B. Saarinen, "Our Arts Salute France," *New York Times Magazine*, April 3, 1955.

389. Jan Juta, Leon Kroll, George L. K. Morris, William Baziotes, and Henry Schnackenberg serve on the painting jury, and Paul Manship, Oronzo Maldarelli, William Zorach, Jacques Lipchitz, and David Smith serve on the sculpture jury.

390. Stuart Davis Calendar, June 29, 1955, EAA.

391. The Downtown Gallery celebrated its thirtieth anniversary a year early, marking the beginning, rather than the conclusion, of its thirtieth year of operation.

392. Stuart Davis Calendar, October 3, 1955, EAA.

393. Stuart Davis Calendar, November 2, 1955, EAA; Emily Genauer, "Art Contest for U.N. Proves Great Disappointment," *Herald Tribune Book Review*, October 30, 1955, 17–18.

394. Genauer, "Art Contest for U.N.," 1955, 18.

395. Davis to Emily Genauer, November 1955, EAA.

396. Stuart Davis Calendar, December 5, 1955, EAA.

397. Davis to Walter Quirt, March 15, 1949, in SDP, Harvard, reel 9, March 15, 1949.

398. Stuart Davis Calendar, June 28, 1956, and February 10, 1956, EAA.

399. Stuart Davis Calendar, February 7, 1956, EAA.

400. Stuart Davis Calendar, February 25, 1958, EAA.

401. Stuart Davis, quoted in James Elliot, "Premiere," *Bulletin/Los Angeles County Museum of Art* 14, no. 3 (1962): 9–11.

402. Davis, quoted in Phillips 1962, 410, AAA.

403. Stuart Davis Calendar, May 10, 1956, EAA.

404. Stuart Davis, "Something on the 8 Ball," unpublished manuscript, 1954, EAA.

405. Stuart Davis Calendar, June 22, 1956, EAA.

406. Stuart Davis Calendar, June 22, 1956, EAA.

407. Stuart Davis Calendar, May 31, 1956, EAA. Davis's entry refers to the program's rehearsal on May 31.

408. Stuart Davis Calendar, June 9, 1956, EAA.

409. Stuart Davis Calendar, November 14, 1956, EAA; Hilton Kramer, "Month in Review," *Arts Magazine* 31, no. 2 (November 1956): 54.

410. Kramer 1956, 54–55.

411. Stuart Davis Calendar, December 27, 1956, EAA.

412. Stuart Davis Calendar, February 26, 1957, EAA.

413. Stuart Davis Calendar, March 5, 1957, EAA.

414. Stuart Davis Calendar, March 5, 1957, EAA.

415. Stuart Davis, quoted in *Stuart Davis* (exh. cat., Walker Art Center, Minneapolis, 1957), 44.

416. Elaine de Kooning, "Stuart Davis: True to Life," *Art News* 56, no. 2 (April 1957): 41–42.

417. For more information on the conference, see Lauri Gwen Nelson, "'This kind of circus, all in cordiality': Marcel Duchamp's speech 'The Creative Act'" (MA thesis, Rice University, 1994).

418. Stuart Davis, "The Place of Painting in Contemporary Culture: The Easel Is a Cool Spot at an Arena of Hot Events," *Art News* 56, no. 4 (Summer 1957): 30.

419. Stuart Davis Calendar, May 23, 1957, EAA.

420. Stuart Davis Calendar, May 23, 1957, EAA.

421. Stuart Davis Calendar, August 19, 1957, EAA.

422. Jack Heinz, quoted in "Painting for Preserves," *Time* 71, no. 20 (May 19, 1958), 82.

423. Stuart Davis Calendar, September 13, 1957, EAA.

424. Stuart Davis Calendar, September 16, 1957, EAA.

425. Stuart Davis Calendar, October 19, 1957, EAA.

426. James Thrall Soby, "Stuart Davis," *Saturday Review* 11, no. 45 (November 9, 1957): 32, review of Stuart Davis's retrospective at the Whitney Museum of American Art.

427. Stuart Davis Calendar, November 17, 1957, EAA.

428. Stuart Davis Calendar, October 10, 1957, EAA.

429. Stuart Davis Calendar, November 26, 1957, EAA.

430. Davis, "Handmaiden of Misery," review of *Arshile Gorky*, 1957, 16–17.

431. Stuart Davis Calendar, December 26, 1957, EAA.

432. "Will This Art Endure?," *New York Times Magazine*, December 1, 1957, 48–49.

433. *Still Life — Three Objects* was given to Wadsworth Atheneum. *Gloucester Street* was given to Lane Foundation.

434. Stuart Davis, artist's statement in John I. H. Baur, *Nature in Abstraction: The Relation of Abstract Painting and Sculpture to Nature in Twentieth-Century American Art* (exh. cat., Whitney Museum of American Art, New York, 1958), 63.

435. SDP, Harvard, reel 4, undated [March 1942]. For examples of strife between Davis and Roselle, see Misha Reznikoff's letter to Willem de Kooning stating "Davis is having trouble with Rozelle [*sic*]" and the couple's calendar entry of February 6, 1958. Reznikoff to Willem de Kooning, September 13 or 23, 1949, Reznikoff Artistic Partnership; Stuart Davis and Roselle Davis, writing in Stuart Davis Calendar, February 6, 1958, EAA.

436. SDP, Harvard, reel 11, November 15, 1951.

437. Stuart Davis Calendar, April 18, 1958, EAA.

438. Stuart Davis Calendar, April 30, 1958, EAA.

439. Charlotte Willard, "Four Masters of Modern Art Select New Talents," *Look* 23, no. 24 (November 24, 1959): 60–61.

440. Stuart Davis Calendar, June 23, 1958, EAA.

441. Stuart Davis, quoted in John Ashbery, "Is Today's Artist with or against the Past? Stuart Davis," *Art News* 57, no. 4 (Summer 1958): 43.

442. Stuart Davis Calendar, March 4, 1959, EAA.

443. Davis to Hazel Foulke, July 12, 1960, EAA.

444. Stuart Davis, "Foreword: New York," in *Arts Yearbook 3: Paris/New York* (New York: Art Digest, 1959): 47.

445. E. C. Goossen, *Stuart Davis*, Great American Artists Series (New York: George Braziller, 1959), 12.

446. Stuart Davis Calendar, January 26, 1960, EAA.

447. Stuart Davis Calendar, February 1, 1960, EAA.

448. Lloyd Goodrich, George L.K. Morris, and Monroe Wheeler were the jurors. Franz Kline and Japan's Yoshihige Saito received Honorable Mentions. *Guggenheim International Award 1960* (New York: Solomon R. Guggenheim Museum, 1960).

449. Stuart Davis Calendar, April 24, 1960, EAA.

450. Davis to Hazel Foulke, July 12, 1960, EAA.

451. Stuart Davis Calendar, May 9, 1960, EAA.

452. Davis to Hazel Foulke, [July] 5, 1960, EAA.

453. Davis to Hazel Foulke, July 12, 1960, EAA.

454. Davis, "My Favorite Painting," 1960, 12.

455. For this publication, Davis reworked the text of his speech for the April 1957 American Federation of the Arts conference. Stuart Davis, "Statements and Documents: Artists on Art and Reality, on Their Work, and on Values: Stuart Davis," in "The Visual Arts Today," special issue, *Daedalus* 89, no. 1 (Winter 1960): 118–120.

456. Stuart Davis et al., "A Letter to the New York Times," *New York Times*, February 26, 1961.

457. Edward Hopper, in "Letters in Reaction to a Letter" *New York Times*, March 5, 1961, sec. 5.

458. Stuart Davis, "Ways and Means," in *Contemporary American Painting and Sculpture* (exh. cat., Krannert Art Museum, University of Illinois Press at Urbana-Champaign, 1961), 44.

459. Davis, quoted in Kuh 1962, 52, 56, 58.

460. Stuart Davis, Funerary Requests, March 18, 1961, EAA.

461. Brian O'Doherty, "Stuart Davis: A Memoir," *Evergreen Review* 10, no. 39 (February 1966): 22–27, 24.

462. Stuart Davis, "Memo on Mondrian," *Arts Yearbook* 4 (New York: Art Digest, 1961), 67–68.

463. Wyatt Davis to Stuart Davis, August 14, 1961, EAA.

464. "Blaring Harmony," *Time* 79, no. 20 (May 18, 1962): 68.

465. Davis to Roy R. Carroll, Jr., American Institute of Architects, May 1962, EAA.

466. Stuart Davis Calendar, March 28, 1962, EAA.

467. John Canaday to Stuart Davis, March 19, 1962, EAA.

468. Davis to John Canaday, May 16, 1962, EAA.

469. Donald Judd, "Stuart Davis," *Arts Magazine* 36, no. 10 (September 1962): 44.

470. "Blaring Harmony," *Time*, 1962, 68.

471. Brian O'Doherty, "Art: Paintings of the Honk and Jiggle," *New York Times*, May 1, 1962.

472. Davis, quoted in Guitar, "Close-up of the Artist," *Famous Artists Magazine*, 1962, 21–23.

473. [Edith Halpert] to Stuart Davis, August 13, 1962, EAA.

474. Brian O'Doherty, "Color and a New Abstraction," *New York Times*, January 5, 1964. Long after Davis's death, other scholars will link his work with that of late-1950s and early-1960s color abstraction. William C. Agee, "Stuart Davis in the 1960s: 'The Amazing Continuity,'" in Lowery Stokes Sims, *Stuart Davis: American Painter* (exh. cat., The Metropolitan Museum of Art, New York, 1991), 82. Lewis Kachur, "Stuart Davis: A Classicist Eclipsed," *Art International* (Paris), no. 4 (Autumn 1988), 17–21.

475. Davis, quoted in Homer, "Last Interview," 1964, 43, 56.

476. Brian O'Doherty, "Major American Artist: Davis's Work Was Never Out of Date—He Anticipated Movements in Art," *New York Times*, June 26, 1964.

477. Julian Levi, "Stuart Davis, 1894–1964," *Proceedings of the American Academy of Arts and Letters and the National Institute of Arts and Letters*, n.s., 15, no. 226 (1965), 481–482.

SELECTED BIBLIOGRAPHY

**PUBLISHED WRITINGS BY
STUART DAVIS**

"Abstract Art in the American Scene."
 Parnassus 13, no. 3 (March 1941):
 100–103.

"Abstract Painting Today." In *Art for
 the Millions: Essays from the 1930s
 by Artists and Administrators of
 the WPA Federal Art Project*, ed.
 Francis V. O'Connor, 121–127.
 Greenwich, CT: New York Graphic
 Society, 1973.

"The American Artist Now." *Now* 1,
 no. 1 (August 1941): 7–11.

"The American Artists' Congress." *Art
 Front* 2, no. 8 (December 1935): 8.

"Arshile Gorky in the 1930's: A Personal
 Recollection." *Magazine of Art* 44,
 no. 2 (February 1951): 56–58.

"Art in Painting." In *Marsden Hartley,
 Stuart Davis*, 7–8. Exhibition
 catalog. Cincinnati: Cincinnati
 Modern Art Society, 1941.

"The Artist Today: The Standpoint
 of the Artists' Union." *American
 Magazine of Art* 28, no. 8 (August
 1935): 476–478, 506.

"The Artists' Congress and American
 Art." In *American Artists'
 Congress: Second Annual Member-
 ship Exhibition*, n.p. Exhibition
 catalog. New York: American
 Artists' Congress, 1938.

"The Cube Root." *Art News* 41, no. 18
 (February 1–14, 1943): 22–23,
 33–34.

"Davis' Rejoinder." Response to
 Thomas Hart Benton. *Art Digest* 9,
 no. 13 (April 1,1935): 12–13,
 26–27.

"Dear Mr. McBride." *Creative Art* 6,
 no. 2 (February 1930): suppl.
 34–35.

"Does Modern Art Make Sense?" With
 Thomas Hart Benton and Perry T.
 Rathbone. Transcript of radio
 broadcast from American Broad-
 casting Network, Urbana, IL.
 George V. Denny, Jr., moderator.
 *Town Meeting: Bulletin of Ameri-
 ca's Town Meeting of the Air* 16,
 no. 50 (April 10, 1951): 1–12.

"Friends, It's Here to Stay." In *Esquire's
 1947 Jazz Book: A Yearbook of the
 Jazz Scene*, 27–28. Chicago:
 Esquire, 1946.

"Handmaiden of Misery." Book review
 of *Arshile Gorky*, by Ethel K.
 Schwabacher. *Saturday Review* 40,
 no. 52 (December 28, 1957): 16–17.

"Introduction." In *Abstract Painting in
 America*, n.p. Exhibition catalog.
 New York: Whitney Museum of
 American Art, 1935.

"Is There a Revolution in the Arts?"
 With Aaron Copland, Walter
 Damrosch, Clifton Fadiman,
 William Lyon Phelps, and Albert
 Sterner. Transcript of radio broad-
 cast in association with NBC, New
 York City. Arthur E. Bestor, moder-
 ator. *Town Meeting: Bulletin of
 America's Town Meeting of the Air*
 5, no. 19 (February 19, 1940): 3–29.

"Letters from Our Friends: Stuart Davis."
 Art Front (November 1934): n.p.

"A Medium of 2 Dimensions." *Art Front*
 1, no. 5 (May 1935): n.p.

"Memo on Mondrian." In *Arts Year-
 book* 4, 67–68. New York: Art
 Digest, 1961.

"The 'Modern Trend' in Painting."
 Think 11, no. 1 (January 1945):
 19–20, 36–37.

"The New York American Scene in Art."
 Art Front (February 1935), n.p.

"The Painters Write: Stuart Davis."
 In *Pictures, Painters, and You*. By
 Ray Bethers. New York: Pitman
 Publishing, 1948. 226–227.

"Paintings by Salvador Dali: Julien Levy
 Gallery." Exhibition review. *Art
 Front* 1, no. 2 (January 1935): 7.

"The Place of Painting in Contemporary
 Culture: The Easel Is a Cool Spot
 at an Arena of Hot Events." *Art
 News* 56, no. 4 (Summer 1957):
 29–30.

"Self-Interview." *Creative Art* 9, no. 3
 (September 1931): 208–211.

"Some Chance!" Response to Forbes
 Watson. *Art Front* 1, no. 7
 (November 1935): 4, 7.

"Statements and Documents: Artists
 on Art and Reality, on Their Work,
 and on Values: Stuart Davis."
 Special issue, "The Visual Arts
 Today," *Daedalus* 89, no. 1 (Winter
 1960): 118–120.

Stuart Davis. American Artists Group Monographs, no. 6. New York: American Artists Group, 1945.

Symposium on "Guernica," Museum of Modern Art. With Alfred H. Barr, Jr., Juan Larrea, Jacques Lipchitz, Jerome Seckler, and José Luis Sert. New York: Master Reporting, 1947.

"Symposium: The Creative Process." Statement by the artist. *Art Digest* 28, no. 8 (January 15, 1954): 16, 34.

"This Is My Favorite Painting." *Famous Artists Magazine* 9, no. 2 (Winter 1960): 12.

"Two Famous Painters Fight the Battle of Abstract Art." With Diego Rivera. *Look* 15, no. 3 (January 30, 1951): 68–69.

"'We Reject'—The Art Commission." *Art Front* 1, no. 6 (July 1935): 4–5.

"What about Modern Art and Democracy? With Special Reference to George Biddle's Proposals." *Harper's Magazine* 188, no. 1123 (December 1, 1943): 16–23.

"What Abstract Art Means to Me: Statements by Six American Artists: Stuart Davis." *The Museum of Modern Art Bulletin* 18, no. 3 (Spring 1951): 14–15.

"Why an Artists' Congress?" In *First American Artists' Congress*, 3–6. New York: American Artists' Congress, 1936.

PUBLISHED INTERVIEWS WITH STUART DAVIS

Ashbery, John. "Is Today's Artist with or against the Past? Stuart Davis." *Art News* 57, no. 4 (Summer 1958): 43.

Guitar, Mary Anne. "Close-up of the Artist—Stuart Davis." *Famous Artists Magazine* 10, no. 4 (Summer 1962): 20–23.

———. "Stuart Davis: Abstract Art." In Mary Anne Guitar, 22 *Famous Painters and Illustrators Tell How They Work*, 34–43. New York: David McKay, 1964.

Homer, William Innes. "Stuart Davis, 1894–1964: Last Interview." *Art News* 63, no. 5 (September 1964): 43, 56.

Kuh, Katharine. "Stuart Davis." In *The Artist's Voice: Talks with Seventeen Artists*, 52–67. New York: Harper and Row, 1962.

"Modern Art in Chaos: Stuart Davis Takes a Stand for Non-Objectivity against the Unbelievers." *Cue* 17, no. 25 (June 19, 1948): 17.

ARCHIVAL SOURCES

Davis, Stuart. Autograph manuscript diary, May 1920–November 28, 1922. MA 5062. Department of Literary and Historical Manuscripts. The Morgan Library and Museum, New York.

Davis, Stuart, Artist's File. Includes correspondence and summary transcript for "Recollections of the Whitney" with John I. H. Baur and Hermon More for broadcast on WNYC, American Art Festival (September 29, 1953). Artists' Correspondence and Ephemera Collection. Box 3. Frances Mulhall Achilles Library. Whitney Museum of American Art, New York.

Davis, Stuart, Papers. Archives of American Art, Washington and New York.

Davis, Stuart, Papers. Journals by the artist, 1923–1964. Fogg Art Museum, Harvard University Art Museums. Papers Gift of Mrs. Stuart Davis. All rights reserved by the President and Fellows of Harvard College.

Downtown Gallery Records. Archives of American Art, Washington and New York.

Estate of the Artist Archives. Includes Stuart Davis's calendars, correspondence, manuscripts, and other written ephemera. Fort Lee, New Jersey, and New York. All rights reserved. © Estate of Stuart Davis/Licensed by VAGA, New York, NY.

Halpert, Edith, Papers. Archives of American Art, Washington and New York.

Phillips, Harlan. "Stuart Davis Reminisces: As Recorded in Talks with Dr. Harlan B. Phillips." Compiled unpublished interviews, May and June 1962. Archives of American Art, Washington and New York.

Simon, Sidney. "Stuart Davis: Interview, 1957." Interview with the artist. Walker Art Center Archives, Minneapolis.

MONOGRAPHIC BOOKS, EXHIBITION CATALOGS, AND ARTICLES

Agee, William C. *Stuart Davis: The Breakthrough Years, 1922–1924*. Exhibition catalog. New York: Salander-O'Reilly Galleries, 1987.

Ager, Cecelia. "Stuart Davis." *Vogue* 107, no. 2 (January 15, 1946): 80–81, 126–127.

Arnason, H. H. *Stuart Davis*. Exhibition catalog. Includes excerpts of an interview with the artist and selected artist's writings and correspondence. Minneapolis: Walker Art Center, 1957.

Arnason, H. H. *Stuart Davis, 1894–1964*. Exhibition catalog. London: United States Information Service, 1966.

Birmingham, Mary. *Dynamic Impulse: The Drawings of Stuart Davis*. Exhibition catalog. New York: Hollis Taggart Galleries, 2007.

Blesh, Rudi. *Stuart Davis*. Evergreen Gallery Book. New York: Grove Press, 1960.

Boyajian, Ani, and Mark Rutkoski, eds. *Stuart Davis: A Catalogue Raisonné*. 3 vols. Essays by William C. Agee and Karen Wilkin. Preface by Earl Davis. New Haven, CT: Yale University Art Gallery; Yale University Press, 2007.

Cahill, Holger. "Stuart Davis in Retrospect, 1945–1910." Exhibition review. *Art News* 44, no. 13 (October 15–31, 1945): 24–25, 32.

Cooper, Harry. "Une peinture jazz? Le cas de Stuart Davis." Trans. Jean-François Allain. In *Sons et Lumières: Une histoire du son dans l'art du XXe siècle*, 41–49. Paris: Centre Pompidou, 2004.

Davis, Stuart. *Stuart Davis, New York 1926*. Facsimile of a sketchbook. Introduction by Earl Davis. New York: Estate of Stuart Davis, 1991.

———. *Stuart Davis Sketchbooks*. Facsimile edition of three sketchbooks from 1932 and 1933. Foreword by Earl Davis. New York: Estate of Stuart Davis; Grace Borgenicht Gallery; Arts Publisher, 1986.

de Kooning, Elaine. "Stuart Davis: True to Life." Exhibition review. *Art News* 56, no. 2 (April 1957): 40–42, 54–55.

Goossen, E. C. *Stuart Davis*. Great American Artists Series. New York: George Braziller, 1959.

Gorky, Arshele [*sic*]. "Stuart Davis." *Creative Art* 9, no. 3 (September 1931): 212–217.

Grad, Bonnie L. "Stuart Davis and Contemporary Culture." *Artibus et Historiae* 12, no. 24 (1991): 165–191.

Hills, Patricia. *Stuart Davis*. New York: Harry N. Abrams; Washington: National Museum of American Art, Smithsonian Institution, 1996.

Judd, Donald. "Stuart Davis." Exhibition review. *Arts Magazine* 36, no. 10 (September 1962): 44.

Kachur, Lewis. "Stuart Davis: A Classicist Eclipsed." *Art International* (Paris), no. 4 (Autumn 1988): 17–21.

———. *Stuart Davis: An American in Paris*. Exhibition catalog. New York: Whitney Museum of American Art at Philip Morris, 1987.

———. "Stuart Davis and Bob Brown: *The Masses* to *The Paris Bit*." *Arts Magazine* 57, no. 2 (October 1982): 70–73.

Kelder, Diane, ed. *Stuart Davis*. Includes selected artist's writings and articles and reviews on the artist. Documentary Monographs in Modern Art. New York: Praeger, 1971.

———. *Stuart Davis: Art and Theory, 1920–31*. Exhibition catalog. Includes excerpts from the artist's journal. New York: Pierpont Morgan Library, 2002.

———. "Stuart Davis: Pragmatist of American Modernism." *Art Journal* 39, no. 1 (Fall 1979): 29–36.

Koriyama Museum of Art. *Stuart Davis: Retrospective 1995*. Exhibition catalog. Essays by Earl Davis and Wayne L. Roosa. Tokyo: Yomiuri Shinbunsha and the Japanese Association of Art Museums, 1995.

Kramer, Hilton. "Stuart Davis at the Met." *New Criterion* 20, no. 5 (January 1992): 4–8.

Lane, John R. "Stuart Davis and the Issue of Content in New York School Painting." *Arts Magazine* 52, no. 6 (February 1978): 154–157.

———. *Stuart Davis: Art and Art Theory*. Exhibition catalog. Includes excerpts from the artist's journals. New York: Brooklyn Museum, 1978.

Levi, Julian. "Stuart Davis, 1894–1964." *Proceedings of the American Academy of Arts and Letters and the National Institute of Arts and Letters*, n.s., 15, no. 226 (1965): 481–483.

Lucas, John. "The Fine Art Jive of Stuart Davis." Exhibition review. *Arts Magazine* 31, no. 10 (September 1957): 32–37.

Myers, Jane, ed. *Stuart Davis: Graphic Work and Related Paintings with a Catalogue Raisonné of the Prints*. Exhibition catalog. Catalogue raisonné by Sylvan Cole and Jane Myers; essay by Diane Kelder. Fort Worth: Amon Carter Museum, 1986.

O'Doherty, Brian. "Art: Paintings of the Honk and Jiggle." Exhibition review. *New York Times*, May 1, 1962.

———. "Stuart Davis: A Memoir." *Evergreen Review* 10, no. 39 (February 1966): 22–27.

Paul, Elliot. "Stuart Davis, American Painter." *transition*, no. 14 (Fall 1928): 146–148.

Riley, Maude Kemper. "Stuart Davis Retrospective." Exhibition review. *Limited Edition* no. 4 (November 1945): 1–2.

Rylands, Philip, ed. *Stuart Davis.* Exhibition catalog. Essays by Rudi Fuchs, Lewis Kachur, Federica Pirani, Wayne L. Roosa, Ben Sidran, and Karen Wilkin; entries by Diane Kelder. Includes transcript of television interview with John Wingate and the artist. Milan: Electa, 1997.

Salander-O'Reilly Galleries. *Stuart Davis, Scapes: An Exhibition of Landscapes, Cityscapes and Seascapes Made between 1910 and 1923.* Exhibition catalog. Essay by Earl Davis. New York: Salander-O'Reilly Galleries, 1990.

Sargeant, Winthrop. "Why Artists Are Going Abstract: The Case of Stuart Davis." *Life* 22, no. 7 (February 17, 1947): 78–83.

Seckler, Dorothy Gees. "Stuart Davis Paints a Picture." *Art News* 52, no. 4 (Summer 1953): 30–33, 73–74.

Sims, Lowery Stokes. *Stuart Davis: American Painter.* Exhibition catalog. Essays by William C. Agee, Robert Hunter, Lewis Kachur, Diane Kelder, John R. Lane, Lowery Stokes Sims, and Karen Wilkin; entries by Lowery Stokes Sims, Lisa J. Servan, and Lewis Kachur. New York: The Metropolitan Museum of Art, 1991. Distributed by Harry N. Abrams.

Sims, Patterson. *Stuart Davis: A Concentration of Works from the Permanent Collection of the Whitney Museum of American Art.* Exhibition catalog. New York: Whitney Museum of American Art, 1980.

Soby, James Thrall. "Stuart Davis." Exhibition review. *Saturday Review* 40, no. 45 (November 9, 1957): 32–33.

Sweeney, James Johnson. *Stuart Davis.* Exhibition catalog. Includes interview with the artist and selected artist's writings and interviews. New York: Museum of Modern Art, 1945.

Weber, Bruce. *Stuart Davis' New York.* Exhibition catalog. West Palm Beach, FL: Norton Gallery and School of Art, 1985.

Wight, Frederick S. "Profile of Stuart Davis." *Art Digest* 27, no. 16 (May 15, 1953): 13, 23.

Wilkin, Karen. *Stuart Davis.* New York: Abbeville Press, 1987.

———. *Stuart Davis in Gloucester.* Exhibition catalog. Includes selected artist's writings and interview excerpts. West Stockbridge, MA: Hard Press, 1999.

———. "Stuart Davis in His Own Time." Exhibition review. *New Criterion* 6, no. 5 (January 1988): 50–55.

Wilkin, Karen, and Lewis Kachur. *The Drawings of Stuart Davis: The Amazing Continuity.* Exhibition catalog. New York: American Federation of Arts; Harry N. Abrams, 1992.

Wilson, William. *Stuart Davis's Abstract Argot.* San Francisco: Pomegranate Artbooks, 1993.

Zabel, Barbara. "The Avant-Garde Automaton: Two Collages by Stuart Davis." *Archives of American Art Journal* 32, no. 1 (1992): 11–15.

———. "Stuart Davis's Appropriation of Advertising: The *Tobacco* Series, 1921–1924." *American Art* 5, no. 4 (Autumn 1991): 56–67.

DISSERTATIONS AND THESES

Ballantyne, Margo S. "The Effect of Advertising on the Early Works of Stuart Davis." MA thesis. University of Oregon, 1991.

Birmingham, Mary. "Stuart Davis in 1940: New Subject Matter." MA thesis. City University of New York, Hunter College, 2004.

Christ, John X. "Painting a Theoretical World: Stuart Davis and the Politics of Common Experience in the 1930s." PhD dissertation. City University of New York, Queens College, 1997.

Lane, John R. "Stuart Davis: Art Theory." PhD dissertation. Harvard University, 1976.

Roosa, Wayne L. "American Art Theory and Criticism during the 1930s: Thomas Craven, George L. K. Morris, Stuart Davis." PhD dissertation. Rutgers, The State University of New Jersey–New Brunswick, 1989.

Stuart, Carolyn. "American Autoscapes: Stuart Davis and the View from the Road, 1920–1940." PhD dissertation. University of California, Los Angeles, 2010.

Winkles, Loring N. "The Problem of European Influence in the Murals of Stuart Davis." MA thesis. University of Cincinnati, 1977.

GENERAL BOOKS, EXHIBITION CATALOGS, AND ARTICLES

Agee, William C., Irving Sandler, and Karen Wilkin. *American Vanguards: Graham, Davis, Gorky, de Kooning, and Their Circle, 1927–1942.* Exhibition catalog. Andover, MA: Addison Gallery of American Art, 2011.

Angeline, John D. "Davis, Dreier, Lissitzky: New Thoughts on an Old Series." *Part 2.* Accessed July 27, 2015. *http://www.brickhaus. com/amoore/magazine/Davis.html.*

Baigell, Matthew. "American Art and National Identity: The 1920s." *Arts Magazine* 61, no. 6 (February 1987): 48–55.

Baigell, Matthew, and Julia Williams. *Artists against War and Fascism: Papers of the First American Artists' Congress.* Includes reprint of "Why an Artists' Congress" and "The Artists' Congress and American Art" by Stuart Davis. New Brunswick, NJ: Rutgers University Press, 1986.

Berman, Avis. *Rebels on Eighth Street: Juliana Force and the Whitney Museum of American Art.* New York: Atheneum, 1990.

Cassidy, Donna M. *Painting the Musical City: Jazz and Cultural Identity in American Art, 1910–1940.* Washington: Smithsonian Institution Press, 1997.

FitzGerald, Michael. *Picasso and American Art.* Exhibition catalog. New York: Whitney Museum of American Art, 2006.

Hemingway, Andrew. *Artists on the Left: American Artists and the Communist Movement, 1926–1956.* New Haven, CT: Yale University Press, 2002.

Henderson, Linda Dalrymple. "Reintroduction." In *The Fourth Dimension and Non-Euclidean Geometry in Modern Art,* 1–96. Cambridge: The MIT Press, 2013.

Kozloff, Max. "Larry Rivers, Stuart Davis and Slang Idiom." *Artforum* 4, no. 3 (November 1965): 20–24.

Louchheim, Aline B. "Six Abstractionists Defend Their Art." Includes statement by the artist. *New York Times Magazine,* January 21, 1951.

Monroe, Gerald M. "The American Artists Congress and the Invasion of Finland." *Archives of American Art Journal* 15, no. 1 (1975): 14–20.

———. "Art Front." *Archives of American Art Journal* 13, no. 3 (1973): 13–19.

———. "Artists as Militant Trade Union Workers during the Great Depression." *Archives of American Art Journal* 14, no 1. (1974): 7–10.

———. "The Artists Union of New York." *Art Journal* 32, no. 1 (Autumn 1972): 17–20.

O'Doherty, Brian. *American Masters: The Voice and the Myth in Modern Art.* New York: E. P. Dutton, 1974.

Pearson, Ralph M. "Modern Artists Speak." Includes statement by the artist. *Art Digest* 22, no. 16 (May 15, 1948): 16, 30–31.

Platt, Susan Noyes. *Art and Politics in the 1930s: Modernism, Marxism, Americanism: A History of Cultural Activism during the Depression Years.* New York: Midmarch Arts Press, 1999.

Pollock, Lindsay. *The Girl with the Gallery: Edith Gregor Halpert and the Making of the Modern Art Market.* New York: Public Affairs, 2006.

Shapiro, David, ed. *Social Realism: Art as a Weapon.* Includes reprint of "Davis' Rejoinder" and "The Artist Today: The Standpoint of the Artists' Union" by Stuart Davis. New York: Frederick Ungar, 1973.

Silver, Kenneth E. "From *Nature Morte* to Contemporary Plastic Life: Purism, Léger, and the Americans." In *A Transatlantic Avant-Garde: American Artists in Paris, 1918–1939,* ed. Sophie Lévy, 29–45. Exhibition catalog. Giverny: Musée d'Art Américain Giverny, 2003.

Somma, Thomas. "Thomas Hart Benton and Stuart Davis: Abstraction versus Realism in American Scene Painting." *Rutgers Art Review* 5 (Spring 1984): 46–55.

Turner, Elizabeth Hutton. *Americans in Paris (1921–1931): Man Ray, Gerald Murphy, Stuart Davis, Alexander Calder.* Exhibition catalog. Essays by Elizabeth Garrity Ellis and Guy Davenport. Washington: Counterpoint; Phillips Collection, 1996.

Whiting, Cécile. *Antifascism in American Art.* New Haven, CT: Yale University Press, 1989.

Zurier, Rebecca. *Art for "The Masses" (1911–1917): A Radical Magazine and Its Graphics.* Foreword by Alan Shestack; contributions by Earl Davis and Elise K. Kenney. New Haven, CT: Yale University Art Gallery, 1985.

COMPILED BY
SARAH HUMPHREVILLE

CHECKLIST OF EXHIBITED WORKS

1 SWEET CAPORAL, 1921

oil and watercolor on lined cardboard, 51 × 47 cm (20 ¹⁄₁₆ × 18 ½ in.), Museo Thyssen-Bornemisza, Madrid
New York, Washington only

2 LUCKY STRIKE, 1921

oil on canvas, 84.5 × 45.7 cm (33 ¼ × 18 in.), The Museum of Modern Art, New York, Gift of the American Tobacco Company, Inc.

3 CIGARETTE PAPERS, 1921

oil, watercolor, ink, and pencil on canvas, 48.6 × 35.9 cm (19 ⅛ × 14 ⅛ in.), The Menil Collection, Houston
New York, Washington only

4 BULL DURHAM, 1921

oil and watercolor on canvas, 77 × 38.7 cm (30 ⁵⁄₁₆ × 15 ¼ in.), The Baltimore Museum of Art, Edward Joseph Gallagher III Memorial Collection
New York, Washington only

5 LANDSCAPE, GLOUCESTER, 1922/1951/1957

oil and wood on panel, 30.5 × 41 cm (12 × 16 ⅛ in.), Ted and Mary Jo Shen

6 EDISON MAZDA, 1924

oil on cardboard, 62.2 × 47.3 cm (24 ½ × 18 ⅝ in.), Lent by The Metropolitan Museum of Art, Purchase, Mr. and Mrs. Clarence Y. Palitz Jr. Gift, in memory of her father Nathan Dobson

7 ELECTRIC BULB, 1924

oil on board, 61 × 45.7 cm (24 × 18 in.), Dallas Museum of Art, Fine Arts Collectible Fund

8 ODOL, 1924

oil on cardboard, 60.9 × 45.7 cm (24 × 18 in.), The Museum of Modern Art, New York, Mary Sisler Bequest (by exchange) and purchase

9 ODOL, 1924

oil on cardboard, 62.2 × 44.7 cm (24 ½ × 17 ⅝ in.), Cincinnati Art Museum, The Edwin and Virginia Irwin Memorial

10 LUCKY STRIKE, 1924

oil on paperboard, 45.7 × 60.9 cm (18 × 24 in.), Hirshhorn Museum and Sculpture Garden, Smithsonian Institution, Washington

11 SUPER TABLE, 1925

oil on canvas, 122.2 × 86.7 cm (48 × 34 ⅛ in.), Terra Foundation for American Art, Chicago, Daniel J. Terra Collection

12 MATCHES, 1927

oil on canvas, 66 × 50.8 cm (26 × 20 in.), The Chrysler Museum of Art, Norfolk, Bequest of Walter P. Chrysler

13 PERCOLATOR, 1927

oil on canvas, 91.4 × 73.7 cm (36 × 29 in.), Lent by The Metropolitan Museum of Art, Arthur Hoppock Hearn Fund
New York, Washington only

14 EGG BEATER NO. 1, 1927

oil on linen, 74 × 91.4 cm (29 ⅛ × 36 in.), Whitney Museum of American Art, New York, Gift of Gertrude Vanderbilt Whitney

15 EGG BEATER NO. 2, 1928

oil on canvas, 74.3 × 92.1 cm (29 ¼ × 36 ¼ in.), Amon Carter Museum of American Art, Fort Worth

16 EGG BEATER NO. 3, 1928

oil on canvas, 63.8 × 99.4 cm (25 ⅛ × 39 ⅛ in.), Museum of Fine Arts, Boston, Gift of the William H. Lane Foundation

17 EGG BEATER NO. 4, 1928

oil on canvas, 68.9 × 97.2 cm (27 ⅛ × 38 ¼ in.), The Phillips Collection, Washington
New York, Washington only

18 PLACE DES VOSGES NO. 2, 1928

oil on canvas, 65.3 × 92.3 cm (25 ¹¹⁄₁₆ × 36 ⁵⁄₁₆ in.), Herbert F. Johnson Museum of Art, Cornell University, Ithaca, Dr. and Mrs. Milton Lurie Kramer, Class of 1936, Collection, bequest of Helen Kroll Kramer
New York, Washington, San Francisco only

19 PLACE PASDELOUP, 1928

oil on canvas, 92.1 × 73 cm (36 ¼ × 28 ¾ in.), Whitney Museum of American Art, New York, Gift of Gertrude Vanderbilt Whitney

20 ADIT #1 (INDUSTRY), 1928

oil on canvas mounted on
Masonite, 72.4 × 59.7 cm (28 ½ ×
23 ½ in.), The University of
Arizona Museum of Art, Tucson,
Gift of C. Leonard Pfeiffer

21 LAVOIR NO. 2, 1929

oil on canvas, 44.5 × 54.6 cm
(17 ½ × 21 ½ in.), Private collection
Washington only

22 CAFÉ, PLACE DES VOSGES, 1929

oil on canvas, 73.7 × 92.7 cm
(29 × 36 ½ in.), Private collection
San Francisco only

23 ARCH HOTEL, 1929

oil on canvas, 73 × 100.3 cm
(28 ¾ × 39 ½ in.), Sheldon Museum
of Art, University of Nebraska–
Lincoln, Anna R. and Frank M.
Hall Charitable Trust, H-268.1947

24 ARCADE, 1930

oil on canvas, 30.5 × 40.6 cm
(12 × 16 in.), Aaron I. Fleischman
Washington only

25 TOWN SQUARE, C. 1929

watercolor, gouache, ink, and
pencil on paper, 39.4 × 58.1 cm
(15 ½ × 22 ⅞ in.), The Newark
Museum, Purchase 1930,
The General Fund
New York, Washington only

26 SUMMER LANDSCAPE, 1930

oil on canvas, 73.7 × 106.7 cm
(29 × 42 in.), Private collection of
Pitt and Barbara Hyde

27 NEW YORK — PARIS NO. 2, 1931

oil on canvas, 76.8 × 102.2 cm
(30 ¼ × 40 ¼ in.), Portland
Museum of Art, Maine, Hamilton
Easter Field Art Foundation
Collection, gift of Barn Gallery
Associates, Inc., Ogunquit, Maine,
1979.13.10
New York, Washington only

28 STILL LIFE: RADIO TUBE, 1931

oil on canvas, 127 × 81.9 cm
(50 × 32 ¼ in.), Rose Art Museum,
Brandeis University, Waltham,
Bequest of Louis Schapiro, Boston

29 SALT SHAKER, 1931

oil on canvas, 126.7 × 81.3 cm
(49 ⅞ × 32 in.), The Museum
of Modern Art, New York,
Gift of Edith Gregor Halpert

30 HOUSE AND STREET, 1931

oil on canvas, 66 × 107.9 cm (26 ×
42 ½ in.), Whitney Museum of
American Art, New York, Purchase

**31 LANDSCAPE WITH GARAGE
LIGHTS, 1931–1932**

oil on canvas, 81.3 × 106.7 cm
(32 × 42 in.), Memorial Art Gallery
of the University of Rochester,
Marion Stratton Gould Fund

32 NEW YORK MURAL, 1932

oil on canvas, 213.4 × 121.9 cm
(84 × 48 in.), Norton Museum
of Art, West Palm Beach, Purchase,
R. H. Norton Trust

33 RED CART, 1932

oil on canvas, 81.9 × 127 cm
(32 ¼ × 50 in.), Addison Gallery
of American Art, Phillips Academy,
Andover, Museum purchase

**34 STUDY FOR MEN WITHOUT WOMEN,
RADIO CITY MUSIC HALL MEN'S
LOUNGE MURAL, 1932**

gouache and pencil on paper,
27.3 × 42.6 cm (10 ¾ × 16 ¾ in.),
Currier Museum of Art,
Manchester, Museum purchase
in honor of Marilyn F. Hoffman,
Director 1988–1995; bequest of
Phyllis E. Hodgdon, Anne Slade
Frey, Ilya T. Bonnecaze, Olga
Wheeler Fund, Memorial Gifts
Fund, Gift of the Friends and
by Exchange
New York, Washington only

**35 MURAL (RADIO CITY MEN'S
LOUNGE MURAL: MEN WITHOUT
WOMEN), 1932**

oil on canvas, 327.2 × 518 cm
(128 ⅞ × 203 ⅞ in.), The Museum
of Modern Art, New York,
Gift of Radio City Music Hall
Corporation 1399.74
Not in Exhibition

36 LANDSCAPE, 1932/1935

oil on canvas, 82.6 × 74.3 cm
(32 ½ × 29 ¼ in.), Brooklyn
Museum, Gift of Mr. and Mrs.
Milton Lowenthal

**37 AMERICAN PAINTING,
1932/1942–1954**

oil on canvas, 101.6 × 127.6 cm
(40 × 50 ¼ in.), Joslyn Art Museum,
Omaha, On extended loan from
the University of Nebraska at
Omaha Collection

38 MEN AND MACHINE, 1934

oil on canvas, 81.3 × 101.6 cm
(32 × 40 in.), Lent by The
Metropolitan Museum of Art,
Gift of Mr. and Mrs. Jay R. Braus

**39 ARTISTS AGAINST WAR AND
FASCISM, 1936**

gouache and pencil on paper,
29.5 × 39.4 cm (11 ⅝ × 15 ½ in.),
Collection of Fayez Sarofim

40 SWING LANDSCAPE, 1938

oil on canvas, 220.4 × 439.7 cm
(86 ¾ × 173 ⅛ in.), Indiana Univer-
sity Art Museum, Bloomington,
Museum Purchase with Funds from
the Henry Radford Hope Fund
New York, Washington only

**41 MURAL FOR STUDIO B, WNYC,
MUNICIPAL BROADCASTING
COMPANY, 1939**

oil on canvas, 213.4 × 335.3 cm
(84 × 132 in.), Lent by The
Metropolitan Museum of Art,
Lent by the City of New York, 1965
New York, Washington only

42 SHAPES OF LANDSCAPE SPACE, 1939

oil on canvas, 91.4 × 71.1 cm (36 × 28 in.), Neuberger Museum of Art, Purchase College, State University of New York, Gift of Roy R. Neuberger
New York, Washington only

43 COMPOSITION, 1939

gouache on paper, 29.5 × 39.1 cm (11 ⅝ × 15 ⅜ in.), Seattle Art Museum, Gift of Mrs. Theodosia Young in Memory of Zoe Dusanne

44 COLORS OF SPRING IN THE HARBOR, 1939

gouache on watercolor board, 30.5 × 40.6 cm (12 × 16 in.), Munson Williams Proctor Arts Institute, Museum of Art, Utica, Edward W. Root Bequest
New York only

45 SHAPES OF LANDSCAPE SPACE #3, 1940

oil on canvas, 39.4 × 49.5 cm (15 ½ × 19 ½ in.), The Columbus Museum, Georgia, Purchase made possible by the Ella E. Kirven Charitable Lead Trust for Acquisitions

46 LANDSCAPE WITH CLAY PIPE, 1941

oil on canvas, 30.5 × 45.7 cm (12 × 18 in.), Brooklyn Museum, Bequest of Edith and Milton Lowenthal

47 REPORT FROM ROCKPORT, 1940

oil on canvas, 61 × 76.2 cm (24 × 30 in.), Lent by The Metropolitan Museum of Art, Edith and Milton Lowenthal Collection, bequest of Edith Abrahamson Lowenthal, 1991
New York, Washington only

48 ARBORETUM BY FLASHBULB, 1942

oil on canvas, 45.7 × 91.4 cm (18 × 36 in.), Lent by The Metropolitan Museum of Art, Edith and Milton Lowenthal Collection, bequest of Edith Abrahamson Lowenthal, 1991

49 ULTRA – MARINE, 1943 / 1952

oil on canvas, 50.8 × 101.9 cm (20 × 40 ⅛ in.), Courtesy of the Pennsylvania Academy of the Fine Arts, Philadelphia, Joseph E. Temple Fund

50 FOR INTERNAL USE ONLY, 1944 – 1945

oil on canvas, 114.3 × 71.1 cm (45 × 28 in.), Courtesy of Reynolda House Museum of American Art, Winston-Salem, An Affiliate of Wake Forest University, Gift of Barbara B. Millhouse

51 THE MELLOW PAD, 1945 – 1951

oil on canvas, 66.7 × 107 cm (26 ¼ × 42 ⅛ in.), Brooklyn Museum, Bequest of Edith and Milton Lowenthal

52 LITTLE GIANT STILL LIFE, 1950

oil on canvas, 83.8 × 109.2 cm (33 × 43 in.), Virginia Museum of Fine Arts, Richmond, The John Barton Payne Fund

53 VISA, 1951

oil on canvas, 101.6 × 132.1 cm (40 × 52 in.), The Museum of Modern Art, New York, Gift of Mrs. Gertrud A. Mellon

54 LITTLE GIANT STILL LIFE (BLACK AND WHITE VERSION), 1953

casein and pencil on canvas, 83.5 × 109.2 cm (32 ⅞ × 43 in.), Private collection
New York, Washington only

55 RAPT AT RAPPAPORT'S, 1951 – 1952

oil on canvas, 132.1 × 101.6 cm (52 × 40 in.), Hirshhorn Museum and Sculpture Garden, Smithsonian Institution, Washington

56 OWH! IN SAO PÃO, 1951

oil on canvas, 132.7 × 106.1 cm (52 ¼ × 41 ¾ in.), Whitney Museum of American Art, New York, Purchase

57 SEMÉ, 1953

oil on canvas, 132.1 × 101.6 cm (52 × 40 in.), Lent by The Metropolitan Museum of Art, George A. Hearn Fund

58 MEDIUM STILL LIFE, 1953

oil on canvas, 114.3 × 91.4 cm (45 × 36 in.), Museum of Fine Arts, Boston, Gift of the William H. Lane Foundation

59 SOMETHING ON THE 8 BALL, 1953 – 1954

oil on canvas, 142.2 × 114.3 cm (56 × 45 in.), Philadelphia Museum of Art, Purchase, Adele Haas Turner and Beatrice Pastorius Turner Memorial Fund, 1954

60 TOURNOS, 1954

oil on canvas, 91.1 × 71.1 cm (35 ⅞ × 28 in.), Munson Williams Proctor Arts Institute, Museum of Art, Utica, Museum purchase

61 MIDI, 1954

oil on canvas, 71.1 × 92.1 cm (28 × 36 ¼ in.), Wadsworth Atheneum Museum of Art, Hartford, The Schnakenberg Fund
New York, Washington only

62 COLONIAL CUBISM, 1954

oil on canvas, 114.6 × 153 cm (45 ⅛ × 60 ¼ in.), Collection Walker Art Center, Minneapolis, Gift of the T. B. Walker Foundation, 1955

63 READY-TO-WEAR, 1955

oil on canvas, 142.6 × 106.7 cm (56 ⅛ × 42 in.), The Art Institute of Chicago, Restricted gift of Mr. and Mrs. Sigmund W. Kunstadter; Goodman Endowment
New York, Washington only

64 DETAIL STUDY FOR "CLICHÉ," 1955

gouache and pencil on paper, 32.4 × 38.1 cm (12 ¾ × 15 in.), Private collection

65 CLICHÉ, 1955

oil on canvas, 142.8 × 106.6 cm
(56 ¼ × 42 in.), Solomon R.
Guggenheim Museum, New York

66 STELE, 1956

oil on canvas, 132.7 × 101.9 cm
(52 ¼ × 40 ⅛ in.), Milwaukee Art
Museum
San Francisco, Bentonville only

67 TROPES DE TEENS, 1956

oil on canvas, 114.9 × 153 cm
(45 ¼ × 60 ¼ in.), Hirshhorn
Museum and Sculpture Garden,
Smithsonian Institution,
Washington

68 MEMO #2, 1956

oil on canvas, 61 × 81.3 cm
(24 × 32 in.), Private collection

69 MEMO, 1956

oil on linen, 91.4 × 71.8 cm (36 ×
28 ¼ in.), Smithsonian American
Art Museum, Washington, Gift
of the Sara Roby Foundation

70 PACKAGE DEAL, 1956

gouache and pencil on paper,
54.6 × 47.3 cm (21 ½ × 18 ⅝ in.),
Lawrence B. Benenson Collection
*New York, Washington,
San Francisco only*

**71 DETAIL STUDY #1 FOR "PACKAGE
DEAL," 1956**

gouache and pencil on paper,
41.3 × 33.3 cm (16 ¼ × 13 ⅛ in.),
The Art Institute of Chicago,
Gift of Leo S. Guthman
New York, Washington only

**72 STUDY FOR "PACKAGE DEAL" #1,
1956**

ballpoint pen on paper, 16.2 ×
12.7 cm (6 ⅜ × 5 in.), Los Angeles
County Museum of Art, Gift of
Earl Davis
San Francisco, Bentonville only

**STUDY FOR "PACKAGE DEAL" #2,
1956**

ballpoint pen on paper, 16.2 ×
12.7 cm (6 ⅜ × 5 in.), Los Angeles
County Museum of Art, Gift of
Earl Davis
New York, Washington only

**STUDY FOR "PACKAGE DEAL" #3,
1956**

ballpoint pen on paper, 15.9 ×
12.7 cm (6 ¼ × 5 in.), Los Angeles
County Museum of Art, Gift of
Earl Davis
San Francisco, Bentonville only

**STUDY FOR "PACKAGE DEAL" #4,
1956**

ballpoint pen on paper, 15.9 ×
12.7 cm (6 ¼ × 5 in.), Los Angeles
County Museum of Art, Gift of
Earl Davis
New York, Washington only

**STUDY FOR "PACKAGE DEAL" #5,
1956**

ballpoint pen on paper, 16.2 ×
12.7 cm (6 ⅜ × 5 in.), Los Angeles
County Museum of Art, Gift of
Earl Davis
San Francisco, Bentonville only

**STUDY FOR "PACKAGE DEAL" #6,
1956**

ballpoint pen on paper, 15.9 ×
12.7 cm (6 ¼ × 5 in.), Los Angeles
County Museum of Art, Gift of
Earl Davis
New York, Washington only

**STUDY FOR "PACKAGE DEAL" #7,
1956**

ballpoint pen on paper, 16.2 ×
12.7 cm (6 ⅜ × 5 in.), Los Angeles
County Museum of Art, Gift of
Earl Davis
San Francisco, Bentonville only

**STUDY FOR "PACKAGE DEAL" #8,
1956**

ballpoint pen on paper, 16.2 ×
12.7 cm (6 ⅜ × 5 in.), Los Angeles
County Museum of Art, Gift of
Earl Davis
New York, Washington only

**STUDY FOR "PACKAGE DEAL" #9,
1956**

ballpoint pen on paper, 13.5 ×
10.2 cm (5 ⁵⁄₁₆ × 4 in.), Los Angeles
County Museum of Art, Gift of
Earl Davis
San Francisco, Bentonville only

**STUDY FOR "PACKAGE DEAL" #10,
1956**

ballpoint pen on paper, 17.2 ×
12.7 cm (6 ¾ × 5 in.), Los Angeles
County Museum of Art, Gift of
Earl Davis
New York, Washington only

**STUDY FOR "PACKAGE DEAL" #11,
1956**

ballpoint pen on paper, 16.2 ×
12.7 cm (6 ⅜ × 5 in.), Los Angeles
County Museum of Art, Gift of
Earl Davis
San Francisco, Bentonville only

**STUDY FOR "PACKAGE DEAL" #12,
1956**

ballpoint pen on paper, 15.9 ×
12.7 cm (6 ¼ × 5 in.), Los Angeles
County Museum of Art, Gift of
Earl Davis
New York, Washington only

**STUDY FOR "PACKAGE DEAL" #13,
1956**

ballpoint pen on paper, 16.2 ×
12.7 cm (6 ⅜ × 5 in.), Los Angeles
County Museum of Art, Gift of
Earl Davis
San Francisco, Bentonville only

**STUDY FOR "PACKAGE DEAL" #14,
1956**

ballpoint pen on paper, 16.2 ×
12.7 cm (6 ⅜ × 5 in.), Los Angeles
County Museum of Art, Gift of
Earl Davis
New York, Washington only

**STUDY FOR "PACKAGE DEAL" #15,
1956**

ballpoint pen on paper, 15.9 ×
12.7 cm (6 ¼ × 5 in.), Los Angeles
County Museum of Art, Gift of
Earl Davis
San Francisco, Bentonville only

STUDY FOR "PACKAGE DEAL" #16, 1956

ballpoint pen on paper, 16.2 × 12.7 cm (6 ⅜ × 5 in.), Los Angeles County Museum of Art, Gift of Earl Davis
New York, Washington only

STUDY FOR "PACKAGE DEAL" #17, 1956

ballpoint pen on paper, 16.2 × 12.7 cm (6 ⅜ × 5 in.), Los Angeles County Museum of Art, Gift of Earl Davis
San Francisco, Bentonville only

STUDY FOR "PACKAGE DEAL" #18, 1956

ballpoint pen on paper, 15.9 × 12.7 cm (6 ¼ × 5 in.), Los Angeles County Museum of Art, Gift of Earl Davis
New York, Washington only

STUDY FOR "PACKAGE DEAL" #19, 1956

ballpoint pen on paper, 15.9 × 12.7 cm (6 ¼ × 5 in.), Los Angeles County Museum of Art, Gift of Earl Davis
San Francisco, Bentonville only

STUDY FOR "PACKAGE DEAL" #21, 1956

ballpoint pen on paper, 20.3 × 12.7 cm (8 × 5 in.), Los Angeles County Museum of Art, Gift of Earl Davis
Not in Exhibition

STUDY FOR "PACKAGE DEAL" #22, 1956

ballpoint pen on paper, 20.3 × 12.7 cm (8 × 5 in.), Los Angeles County Museum of Art, Gift of Earl Davis
New York, Washington only

STUDY FOR "PACKAGE DEAL" #23, 1956

ballpoint pen on paper, 20.3 × 12.7 cm (8 × 5 in.), Los Angeles County Museum of Art, Gift of Earl Davis
San Francisco, Bentonville only

STUDY FOR "PACKAGE DEAL" #24, 1956

ballpoint pen on paper, 20.3 × 12.7 cm (8 × 5 in.), Los Angeles County Museum of Art, Gift of Earl Davis
New York, Washington only

STUDY FOR "PACKAGE DEAL" #25, 1956

ballpoint pen on paper, 20.3 × 12.7 cm (8 × 5 in.), Los Angeles County Museum of Art, Gift of Earl Davis
San Francisco, Bentonville only

STUDY FOR "PACKAGE DEAL" #26, 1956

ballpoint pen on paper, 20.3 × 12.7 cm (8 × 5 in.), Los Angeles County Museum of Art, Gift of Earl Davis
New York, Washington only

STUDY FOR "PACKAGE DEAL" #27, 1956

ballpoint pen on paper, 20.3 × 12.7 cm (8 × 5 in.), Los Angeles County Museum of Art, Gift of Earl Davis
San Francisco, Bentonville only

STUDY FOR "PACKAGE DEAL" #28, 1956

ballpoint pen on paper, 20.3 × 12.7 cm (8 × 5 in.), Los Angeles County Museum of Art, Gift of Earl Davis
New York, Washington only

STUDY FOR "PACKAGE DEAL," 1956

ballpoint pen and pencil on paper, 20.3 × 12.7 cm (8 × 5 in.), Estate of the Artist

73 PREMIÈRE, 1957

oil on canvas, 147.3 × 127 cm (58 × 50 in.), Los Angeles County Museum of Art, Museum purchase, Art Museum Council Fund
New York, Washington, San Francisco only

74 INT'L SURFACE #1, 1957–1960

oil on canvas, 144.8 × 114.3 cm (57 × 45 in.), Smithsonian American Art Museum, Washington, Gift of S. C. Johnson & Son, Inc.

75 POCHADE, 1956–1958

oil on canvas, 132.1 × 152.4 cm (52 × 60 in.), Museo Thyssen-Bornemisza, Madrid
New York, Washington only

76 UNTITLED (BLACK AND WHITE VARIATION ON "POCHADE"), C. 1956–1958

casein on canvas, 114.3 × 142.2 cm (45 × 56 in.), Estate of the Artist

77 STUDY FOR "THE PARIS BIT," 1951/1957–1960

oil on canvas, 71.1 × 91.4 cm (28 × 36 in.), Private collection
New York, Washington only

78 THE PARIS BIT, 1959

oil on canvas, 116.8 × 152.4 cm (46 × 60 in.), Whitney Museum of American Art, New York, Purchase, with funds from the Friends of the Whitney Museum of American Art

79 STANDARD BRAND, 1961

oil on canvas, 152.4 × 116.8 cm (60 × 46 in.), The Detroit Institute of Arts, Founders Society purchase, General Membership Fund

80 SWITCHSKI'S SYNTAX, 1961

casein and masking tape on canvas, 106.7 × 142.2 cm (42 × 56 in.), Yale University Art Gallery, New Haven, Katharine Ordway Fund
New York, Washington only

81 UNFINISHED BUSINESS, 1962

oil on canvas, 91.5 × 114.3 cm (36 × 45 in.), Private collection
New York, Washington only

82 CONTRANUITIES, 1963

oil on canvas, 172.7 × 127 cm (68 × 50 in.), Private collection
New York, Washington only

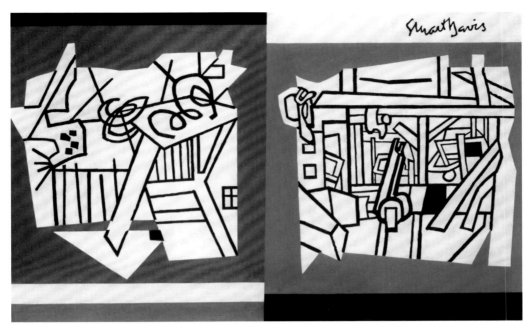

Deuce, 1951–1954, oil on canvas, San Francisco Museum of Modern Art, Gift of Mrs. E.S. Heller

83 BLIPS AND IFS, 1963–1964

oil on canvas, 180.7 × 134.9 cm (71 ⅛ × 53 ⅛ in.), Amon Carter Museum of American Art, Fort Worth, Acquisition in memory of John de Menil, Trustee, Amon Carter Museum, 1961–1969

84 FIN, 1962–1964

casein and masking tape on canvas, 136.8 × 101 cm (53 ⅞ × 39 ¾ in.), Private collection

NOT IN PLATES

LANDSCAPE WITH SAW, 1922

oil and pencil on canvas mounted on board, 40 × 29.8 cm (15 ¾ × 11 ¾ in.), Phyllis and Jerome Lyle Rappaport (page 41, fig. 11)

RED STILL LIFE, 1922

oil on canvas, 127 × 81.3 cm (50 × 32 in.), Collection of Jan T. and Marica Vilcek, Promised gift to the Vilcek Foundation (page 37, fig. 10)
Washington only

PERCOLATOR, 1927

gouache on board, 45.1 × 36.5 cm (17 ¾ × 14 ⅜ in.), Myron Kunin Collection of American Art (page 4, fig. 2)
San Francisco, Bentonville only

STUDY FOR "EGG BEATER NO. 3," 1928

pencil and colored pencil on paper, 43.2 × 54.3 cm (17 × 21 ⅜ in.), Whitney Museum of American Art, New York, Purchase, with funds from the Charles Simon Purchase Fund
San Francisco, Bentonville only

EGG BEATER NO. 4, 1928

gouache on illustration board, 33.7 × 47.3 cm (13 ¼ × 18 ⅝ in.), Ted and Mary Jo Shen (page 164)
San Francisco, Bentonville only

RUE DES RATS NO. 1, 1928

oil and sand on canvas, 60 × 92.1 cm (23 ⅝ × 36 ¼ in.), Myron Kunin Collection of American Art (page 167)
San Francisco, Bentonville only

THE TERMINAL, 1937

oil on canvas, 76.5 × 101.9 cm (30 ⅛ × 40 ⅛ in.), Hirshhorn Museum and Sculpture Garden, Smithsonian Institution, Washington
San Francisco, Bentonville only

DEUCE, 1951–1954

oil on canvas, 66 × 107.3 cm (26 × 42 ¼ in.), San Francisco Museum of Modern Art, Gift of Mrs. E. S. Heller (above)
San Francisco, Bentonville only

LESSON ONE, 1956

oil on canvas, 132.1 × 152.7 cm (52 × 60 ⅛ in.), Yale University Art Gallery, New Haven, Charles B. Benenson, B.A. 1933, Collection (page 210)
San Francisco, Bentonville only

COMPOSITION CONCRETE (STUDY FOR MURAL), 1957–1960

oil on canvas, 108.6 × 50.8 cm (42 ¾ × 20 in.), Cleveland Museum of Art
San Francisco, Bentonville only

WAYS AND MEANS, 1960

oil on canvas, 61 × 81.3 cm (24 × 32 in.), Private collection (page 216)
Washington, San Francisco only

ACKNOWLEDGMENTS

Some great artists are prolific; others are not. Stuart Davis's mature, post-1920 works—the focus of this exhibition—are relatively rare, which means it is not easy for their owners, whether museums or private collections, to part with them. We offer our first thanks, therefore, to the many lenders to the exhibition, listed on their own page in this volume. Whether they lent one or two works or several—as with the Brooklyn Museum, the Hirshhorn Museum and Sculpture Garden, the Los Angeles County Museum of Art, the Metropolitan Museum of Art, the Museum of Modern Art, and the Whitney Museum of American Art itself—we wish to thank the directors, curators, conservators, registrars, and private individuals, too numerous to name, who understood that a new generation deserved the opportunity to see the best of Davis's work. We are also grateful to those who helped facilitate specific loans, including Phil Alexandre, Jonathan Boos, and Ed Shein.

Earl Davis, the artist's only child, not only lent works of art but also shared a trove of sketchbooks, journals, desk calendars, photographs, and ephemera from the archives of the artist's estate. If he had not entrusted us with these often-personal materials and helped us to understand them in several discussions, the exhibition and its catalog would have been much poorer. We are also indebted to the Archives of American Art, the Harvard Art Museums, and the Morgan Library and Museum for giving us access to their own collections of Davis materials. Finally, we appreciate the many scholars whose work is cited in the notes and bibliography. Although we decided to write the catalog ourselves, we were cognizant throughout of the indispensable work they have done.

Exhibition preparation was divided equally between the Whitney, which led the research effort, and the National Gallery of Art, which was responsible for producing the catalog. Colleagues at both institutions shared the task of obtaining loans and offered vital and varied support at every stage of the process.

At the Whitney, we are indebted to Adam D. Weinberg, Alice Pratt Brown Director, whose unwavering commitment ensured the success of the exhibition, and to Donna De Salvo, deputy director for international initiatives; Scott Rothkopf, deputy director and Nancy and Steve Crown Family Chief Curator; John Stanley, chief operating officer; Alexandra Wheeler, deputy director for advancement; Beth Huseman, director of publications; Nicholas S. Holmes, general counsel; Dana Miller, Richard DeMartini Family Curator and director of the collection; Christy Putnam, associate director for exhibitions and collections management; Emily Russell, director of curatorial affairs; and Beth Turk, editor, for their involvement at crucial junctures. Sarah Humphreville, the project's exemplary curatorial assistant, contributed to all aspects of the exhibition, including research, loan requests, manuscript preparation, and supervision of an outstanding team of interns. Those interns—Caroline Barnett, Anna Blum, Olivia Chuba, Rachel Garbade, Lindsay Greenspoon, Jacqueline Snyder, and Orly Vermes—spent countless hours assembling archival material and writing endnotes. Maura Heffner, Lynn Schatz, and Stacey Traunfeld skillfully coordinated details of exhibition preparation and tour logistics; Stephanie Adams, Morgan Arenson, Courtney Bassett, and Hillary Strong procured funding; conservators Matt Skopek and Clara Rojas-Sebesta, under the leadership of Carol Mancusi-Ungaro, Melva Bucksbaum Associate Director for Conservation and Research, ensured that delicate works would be available for loan; and Anita Duquette, manager of rights and reproductions, helped obtain images of Davis's works in the Whitney's collection. Others helped make the presentation of the exhibition at the Whitney a success: Mark Steigelman and Anna Martin created an exhibition design that reflects the joyful spirit of Davis's art; Kathryn Potts, associate director and Helena Rubinstein Chair of Education, along with Megan Heuer and Anne Byrd, expertly oversaw interpretive materials and programs; Hilary Greenbaum, director of graphic design, created the distinctive graphics with her team; Adrian Hardwicke, director of visitor experience, and John Balestrieri, director of security, as well as their dedicated staffs ensured a wonderful experience for our diverse audience; and Stephen Soba and Jeff Levine managed publicity and marketing.

At the Gallery, Earl A. Powell III, director; Franklin Kelly, deputy director; and D. Dodge Thompson, chief of exhibitions, propelled the exhibition with their enthusiasm for Davis's work. Naomi Remes, exhibition officer, was crucial in arranging loans and organizing the show's tour, with assistance from Olivia Wood. In the office of the registrar, Melissa Stegeman, associate, working under Michele Fondas, chief registrar, coordinated the movement of artworks. Jay Krueger, head of painting conservation, assisted in obtaining loans of delicate paintings and led Gallery conservators in the evaluation of artworks. Senior editor Julie Warnement and design manager Wendy Schleicher, under the leadership of Judy Metro, editor in chief, were instrumental in producing this beautiful volume, with additional help from their program assistant Katie Adkins. Permissions coordinators Sara Sanders-Buell and Barbara Wood collected photographic images and obtained reproduction rights. In the development department, Christine Myers, Cristina Del Sesto, and Patricia Donovan led the Gallery's successful effort to secure support. The stunning exhibition design in the Gallery's West Building was the work of Donna Kirk, designer, and Mark Leithauser, chief of design. Succinct educational texts were prepared by Lynn Matheny, associate curator, and a lively film was produced by Carroll Moore with his colleagues Elizabeth Laitman Hughes and David Hammer, all led by Susan Arensberg, head of exhibition programs. Auxiliary events (films, concerts, lectures, and symposia) at the Gallery were organized by Peggy Parsons, head of film programs; Faya Causey, head of academic programs; and Danielle Hahn, head of music programs. Anabeth Guthrie, chief of communications, publicized the exhibition, and Julian Saenz, associate general counsel, provided legal advice. Last but not least, Paige Rozanski, curatorial assistant at the Gallery, worked hard to keep all the parts of this machine running smoothly.

Finally, and however awkwardly, we would like to thank each other for a wonderful and fruitful partnership.

HARRY COOPER
BARBARA HASKELL